Living in Squares
Loving in Triangles

ABOUT THE AUTHOR

Amy Licence is a historian of women's lives. She has studied Woolf for two decades, and has enthused, taught and published on her work and life. She is the author of *The Six Wives & Many Mistresses of Henry VIII*, *25 Royal Babies that Changed the World*, *In Bed with the Tudors*, *Elizabeth of York*, *Cecily Neville: Mother of Kings*, *Anne Neville: Richard III's Tragic Wife*, *Richard III: The Road to Leicester* and, most recently, *Edward IV & Elizabeth Woodville*.

Living in Squares
Loving in Triangles

The lives and loves of Virginia Woolf
and the Bloomsbury Group

Amy Licence

AMBERLEY

for Tom, Rufus and Robin

First published 2015
This edition published 2016

Amberley Publishing
The Hill, Stroud
Gloucestershire, GL5 4EP

www.amberley-books.com

ISBN 978-1-4456-6008-0 (paperback)
ISBN 978-1-4456-4579-7 (ebook)

British Library Cataloguing in Publication Data.
A catalogue record for this book is available from the British Library.

Typesetting and Origination by Amberley Publishing
Printed in the UK.

By nature [we] were explorers, revolutionists, reformers.
But our surroundings were at least fifty years behind the times.

Virginia Woolf, 'A Sketch of the Past'

CONTENTS

INTRODUCTION

Someone has to die in order that the rest of us should value life more.
 Virginia Woolf

Virginia Woolf no longer owns her own face. Her sparrow-like features, with the fragile forehead, sad, hooded eyes, Stephen family nose and sardonic smile, have become iconic. From the haunting photograph taken of her at the age of twenty by Beresford, to Man Ray's cover for *Time* magazine, to the awkward Beck and Macgregor sitting for *Vogue* in 1924, where she sits uncomfortably in her dead mother's voluminous gown, Virginia is instantly recognisable. She has become something of a national symbol: the beautiful mad genius related, like Gatsby, to 'one of those intricate machines that register earthquakes ten thousand miles away', a writer of impenetrable text, an exacting diarist, the member of a social elite, and an Ophelia-like suicide. She can be purchased and taken home on tea towels, mugs, bookmarks, tote bags and T-shirts.

This book is an attempt to assemble the many jigsaw pieces of Virginia into something of a helpful introduction to her life, work and milieu. While she remains the primary focus, the book also explores her relationship with her sister Vanessa Bell, and six key figures who formed the core of what has become known as the Bloomsbury Group: Virginia's husband Leonard Woolf, Vanessa's husband Clive Bell, Vanessa's lovers Roger Fry and Duncan Grant,

and their friends Lytton Strachey and John Maynard Keynes. The nature of the group's identity, its members, and the changing perceptions of it through the twenty-first century are also central to this work, if it can be argued that such a clique existed at all. The label of 'Bloomsbury' has stuck, for better or for worse, and must be addressed, even embraced, as a semiotic sign, if only in recognition of the durability and width of its spread.

This is certainly not the first book about Virginia Woolf, nor will it be the last. I stand in awe of the long shadow cast by the impressive work of my predecessors. Yet the art of biography is a ticklish one, an attempt to drive stakes into the shifting sands of literary tastes, as Virginia herself discovered when concluding that a frank biography of the homosexual Lytton was not an option in the 1930s. Sensibilities vary across decades: today nothing in the private lives of the famous remains sacred and a balance must be struck between the airing of dirty laundry and the prim distance of deference, both of which can obscure the picture. The conclusions of a biographer in 2015 will not be the same as those drawn in 1985 or 2045, simply because times change.

This biography does not present *my* Virginia Woolf. I was born thirty-two years after she died; I am one of the generation of 'future biographers' to whom Clive Bell addressed his concerns in *Old Friends*, in the hope that they would define exactly who and what they meant by 'Bloomsbury' before attempting to comment upon or draw conclusions about it. I have followed his lead, allowing the words of the members, as he defines them, to speak for themselves. Prioritising letters, diaries, photographs, reviews, published and unpublished works over the interpretation of other biographers, I have constructed the best version I can of Virginia's world, a century after the publication of her first novel. Yet it is still only one part of a cultural kaleidoscope of Woolfs and was, inescapably, coloured by the reappraisal of her work that placed

Virginia's novels on the A-level syllabus by the time I sat my exams. I was too young to appreciate *To the Lighthouse* at the time, but my parents' gift to me of *Orlando* on my twentieth birthday was the start of my fascination with what had seemed, until then, to be a distant and inscrutable canonical figure. After that, I raided the shelves of early twentieth-century literature in the library basement at Royal Holloway, where each dark row had its individual light switch, carrying home bags full of biographies and photographic collections to my chilly student flat. Once, on the way back from Brighton, my parents were persuaded to take a detour off the A27 (Lewes to Polgate Road), down an uneven, overgrown track that lacked any signpost, up to the gates of Charleston Farmhouse. It was off-season in the early '90s – the house was all closed up, decidedly wintry looking and the worse for wear, but for all that it was somehow better, a hidden gem made bricks and mortar, which had previously only existed for me on the page.

Since those days, Woolf has been my benchmark. I have returned to Charleston on numerous occasions, for talks during the festival, or to let my children explore the garden; I have taught *To the Lighthouse* to responsive and sensitive students and I have kept a copy of *The Waves* beside my bed, to open at random, when I have felt in need of inspiration. I have bought and planted seeds in my garden from Charleston Farmhouse shop, a delicious and delicate sweet pea in shades of purple and blue. And yes, I have drunk out of my Virginia Woolf mug. This is the book I have wanted to write for twenty-five years.

Amy Licence
Canterbury, February 2015

Part I

HYDE PARK GATE

ONE

The Birth of Bloomsbury, 1878

We are the words; we are the music; we are the thing itself.[1]

The very name of the Bloomsbury Group evokes a certain place and time. It swells with the essence of Englishness, with bath buns devoured in the ABC tea rooms, walks in Kensington Gardens and windy rides on the tops of omnibuses. We picture nursery teas in stuffy Victorian attics swathed in lace, libraries of dark leather, windows covered with lace and ivy, blue Cambridge skies and country houses set amid rambling gardens. It echoes with the sound of cricket balls glancing off willow bats, the sea lapping the shore at St Ives and the cries of seagulls circling lighthouses. We can almost hear the scratching of Woolf's pen or smell the roses at Charleston.

The name derives from that part of London which sits snugly around the present University of London, with its museums, colleges and tall eighteenth-century houses, although like most comparable handles, it was not chosen by its members as their defining label. It wasn't a school, or a conscious movement, when it first formed in 1905 in Gordon Square. From there to Fitzroy

Square, Bedford Square and back, a circle of family and friends met to drink cocoa and eat buns, to discuss or sit in sympathetic silence, seeking personal and artistic liberation through what writer Dorothy Parker described as 'living in squares and loving in triangles'. As the years passed, it stretched to Sussex, Surrey, Hampshire and France, drawing in new friends and the lives of the next generation, and their children.

Through the twentieth century, 'Bloomsbury' came to represent something more than just a handful of people living in geographical proximity; it became metonymic for a certain style in the fine and applied arts, a set of beliefs and priorities, freedom and experimental living, a new way of thinking and existing. It has been used as a synonym for that other culturally imprecise yet redolent term, 'bohemian', sometimes as a compliment, sometimes by way of insult, to the extent that original member Clive Bell, writing in the 1950s, feared for the way future historians would interpret these varying definitions. The group's membership has been hotly debated, creating a model of concentric circles, with friends and contemporaries clustering around an inner core of 'old Bloomsbury' and the group expanding with the passage of time, just as any friendship group evolves. Parcelled up and labelled in hindsight, the name provides a useful enough shorthand, a historian's handle, a stick in the shifting sand of biographical study, but little more.

The Bloomsbury Group began with a single family, a single couple. Their marriage produced the four children whose early friendships were the crucible in which this set was forged and whose talents placed them at the vanguard of English culture in the early twentieth century. Thus, this couple, Leslie and Julia, can truly be considered the parents of Bloomsbury. Leslie Stephen was born in 1832, into a distinguished Kensington family, whose father, James, was Undersecretary of State for the Colonies, a lead

player in the Slavery Abolition Act and, later, Regius Professor of Modern History at Cambridge. His son Leslie was an author and rambler, a fellow of Trinity College, who had been ordained into the clergy before losing his faith soon after the publication of Darwin's *Origins of the Species* in 1859. Walter Sickert's sister Helena described Leslie as a 'gaunt figure with the ragged red brown beard ... a formidable man, with an immensely high forehead, steely-blue eyes and a long pointed nose',² while the young Thomas Hardy claimed he was 'the man whose philosophy was to influence his own for many years'.³ As Leslie himself wrote, he had the 'opportunity of knowing most of the literary people of mark ... clever young writers and barristers, chiefly of the radical persuasion ... we used to meet on Wednesday and Sunday evenings, to smoke and drink and discuss the universe and the reform movement'.⁴ As member of the Victorian Clapham Set and the editor of the *Cornhill Magazine*, he befriended such well-known writers as Henry James, Robert Louis Stevenson and William Makepeace Thackeray. In fact, Stephen had married Thackeray's daughter Harriet Marian, known as Minnie; she bore him a daughter in 1870, but died five years later.

The widower was consoled by a close neighbour, Mrs Julia Jackson, a great beauty from an Anglo-Indian family, who had suffered a similar loss of her own. Fourteen years Stephen's junior, some of the most poignant surviving images of the young Julia, taken by her aunt, Julia Margaret Cameron, were of a fragile, almost ethereal figure, with large soulful eyes and long, wild hair. She was a perfect model for the Pre-Raphaelites, sitting for G. F. Watts and Burne-Jones, attracting proposals of marriage from William Holman Hunt and Thomas Woolner. However, at the age of sixteen, while in Venice with her ailing mother, Julia had fallen madly in love with handsome barrister Herbert Duckworth, whom Leslie had known at Cambridge: a 'thorough gentleman in the best

sense of the phrase ... a man of honour, of fair accomplishment ... fitted to take his place in any society ... a singularly modest and sweet-tempered man'.[5] Darkly handsome, Duckworth had followed and wooed her in the romantic setting of Lake Lucerne in Switzerland. The engagement was announced on 1 February 1867, a week before her twenty-first birthday; they married on 4 May from the Jackson house of Saxonbury, overlooking the rolling green weald of Kent, just outside Tunbridge Wells. Julia bore two children, a son and a daughter, and was pregnant again when, on a September Sunday at Upton Castle in Wales, Herbert reached to pick a fig from a tall tree, burst an undiagnosed abscess and died within twenty-four hours. Julia was prostrate with grief but gave birth to their third child, a son, six weeks later.

Julia and Leslie already knew each other, in the way that most of the closed artistic late Victorian elite did. Their social circle overlapped in many ways, through her aunt Julia Margaret Cameron and her Prinsep aunts, through the Thackeray sisters and mutual friends from Cambridge and through the employer of many of its graduates, the East India Company, with whom Julia could have reminisced about her Calcutta roots. Writing in the weeks following her death, Leslie's first definite memory of his future wife was at a picnic in the country at Leith Hill in 1866, where he stood on the green before the inn at Abinger Hatch and watched the twenty-year-old Julia, dressed in white, with blue flowers in her hat, standing with a group of girls. 'What do you think of Julia Jackson?' asked his companion, to which Leslie replied that she was the most beautiful girl he ever saw.[6] He added in his memoirs, 'I saw and remembered her, as I might have seen and remembered the Sistine Madonna or any other presentation of superlative beauty. Her loveliness thrills me to the core, whenever I call up the vision.'[7] They met again when he was invited to dinner at the Jackson's London house in Bryanston Square, and he was

pleased when she praised his recent letter to the *Pall Mall Gazette*. In the summer of 1870, he glimpsed her from his boat while on a rowing expedition on the Thames at Kingston. She was standing on the bank, where the river road met the track coming from the station, 'in a state of painful anxiety'[8] because Herbert had missed his train. He had already been showing signs of ill-health, and within weeks he was dead.

As Julia later wrote to Leslie, 'I was only twenty-four when it all seemed a shipwreck ... and the only thing to be done was to be as cheerful as possible ... and so I got deadened ... sometimes I have felt ... that the world was clothed in drab ... all shrouded in a crape-veil.'[9] His sister-in-law, Anny Thackeray, helped the young widow, visiting and helping with her children, leading her 'into some sort of shelter and made things more real to [her] again'.[10] Julia even visited the Stephens on the night before Minnie died, finding them sitting together 'in perfect happiness and security', unprepared for the convulsions that would claim her life in the coming hours. Julia provided the widower with sympathy and support, travelling with him and Anny down to Brighton, taking lodgings nearby and doing 'all she could to soothe us in our sorrow'.[11] When, by coincidence, Leslie moved next door into No. 11 Hyde Park Gate the following summer (later No. 20), Julia offered them cool drinks, guidance and walked regularly with Leslie in Kensington Gardens.

Yet the romance did not progress smoothly. Convinced that she bored him, Julia avoided the 'skinless' Leslie on his return from the Alps in January 1877, for what he confessed to be his 'silent, cold and sarcastic' temperament; he, however, had a moment of epiphany when walking past Knightsbridge Barracks. 'It came upon me as a flash of revelation,' he wrote, 'I suddenly said to myself, "I am in love with Julia"' and felt it as a 'joy and revival ... a music running through me, not altogether cheerful, very far from

altogether unhesitating, but yet delicious and inspiring. Julia was that strange solemn music to which my whole nature seemed to be set.'[12] On 5 February, he asked her to dinner and, when it was time for her to depart, handed her a note confessing his newfound feelings. She took it 'with a little glance of surprise' and, in the safety of her own home, opened his letter and read his words; the admission that he loved her 'as a man loves the woman he would marry' yet never dared hope for more than close friendship. As he was retiring to his study, there was an unexpected knock at the door: Julia had returned and promised they would 'be on terms of the closest friendship.'[13] Marriage, she insisted, though, was out of the question.

However, marriage is exactly what did follow, after a further year of intimacy – of letters exchanged, advice sought and given, visits to Saxonbury and Brighton, scruples and concerns over their individual griefs. By April 1877, Julia was writing that she loved Leslie tenderly, as a blessing, a peace and shelter, which lightened the 'burden' of her life; she dreamed of him and thought of him constantly.[14] He replied that 'to live for you and make you happy is all I want.' They were in the habit of sitting together in the evening and on 5 January 1878, in her armchair by the fire, she suddenly looked up and said 'I will be your wife and will do my best to be a good wife to you.'[15]

The Stephen Children, 1879–1887

The sun of those summer days still seems to shine for me.[1]

The wedding of Leslie Stephen and Julia Duckworth took place on 26 March 1878 at St Mary Abbots Church, Kensington, just a ten-minute walk away from Hyde Park Gate. Julia's aunt Virginia Somers-Cocks offered them the mock-medieval Eastnor Castle in Herefordshire for their honeymoon, on which they were accompanied by the Duckworth children, George, Stella and Gerald. Designed during the Regency at a cost equivalent to around £26 million, Eastnor had been remodelled by Pugin and was a beautiful, if gloomy, simulacrum of a grey stone, turreted defensive castle, symmetrical and massive in the Norman revival style. In the 1870s, the estate stretched to over 13,000 acres of land, giving the newly-weds and the three children plenty of land to explore. Leslie recalled how Julia's eldest son, George, then aged eight, rose in chivalric defence when Leslie playfully pulled her down a little slope, 'assaulting' the new husband 'on the spot', before having the circumstances explained to him.

On their return to London, the two separate households were

consolidated in the five-storied, white-fronted No. 13 Hyde Park Gate, later renumbered 22, which would become the Stephen family home for the next twenty-five years. It was there that the couple's children were born. Vanessa arrived on 30 May 1879, followed by Julian Thoby on 8 September 1880, after which they decided that, along with Leslie's daughter Laura and Julia's three, their family was complete.[2] However, in spite of whatever contraceptive attempts they made, Julia fell pregnant twice more, giving birth to Adeline Virginia on 25 January 1882 and Adrian on 27 October 1883. Vanessa, leaning over the cradle of her infant sister, whose bow-lips and large eyes were closed in sleep, already had the visual sensibilities of an artist as she pictured her 'as a sweet pea of a special flame colour'.[3] A poem written by Virginia's godfather, or sponsor, J. R. Lowell, 'Verses, Intended to go with a Posset Dish to my Dear Little Goddaughter, 1882', wished her the traditional blessings of health, wealth and wisdom, as well as her father's wit and her mother's beauty:

> I've wished her healthy, wealthy, wise,
> What more can godfather devise?
> But since there's room for countless wishes
> In these old-fashioned posset dishes,
> I'll wish her from my plenteous store
> Of those commodities two more,
> Her father's wit, veined through and through
> With tenderness that Watts (but whew!
> Celia's aflame, I mean no stricture
> On his Sir Josh-surpassing picture) –
> I wish her next, and 'tis the soul
> Of all I've dropt into the bowl,
> Her mother's beauty – nay, but two
> So fair at once would never do.

Recalling Hyde Park Gate almost two decades after leaving it, Virginia painted her childhood home as the embodiment of Victoriana – of cluttered possessions, heavy draped fabrics, black-painted wood lined with gold and raspberry red, framed oil paintings by G. F. Watts, Dutch cabinets, patterned china, busts shrined in crimson velvet mounds of plush and the gleam of glass and silverware in the lamplight. It was permanently dark, even in summer, with the curtained windows closed tightly shut and a heavy Virginia creeper obscuring the light from the lower floors. There was no electric light, but there were three 'water closets' or toilets as well as a single bath in a small room off the landing, which served the entire household. Through the veil of years, it seemed to her to be 'a house of innumerable small oddly shaped rooms', and the cul-de-sac was so dark and quiet that 'save for the occasional hansom or butcher's cart nothing ever passed the door'. It was intimate, personal and crowded, with servants running up and down the stairs and, across the narrow street, Virginia could see their neighbour Mrs Redgrave washing her neck in her bedroom.[4] The garden is strikingly absent from many of Woolf's reminiscences; its shadows, patchiness and smell of dust did not tempt the Stephen children, who preferred to exercise among the flower walks and pond of nearby Kensington Gardens. Its potential place in the history of art was tested one day by the young Vanessa, who attempted unsuccessfully to dig up the soil and use it as clay.

Virginia's first memory was of sitting on her mother's lap. This may have been in a train or one of the omnibuses that Julia was so proud of having mastered, but what struck the infant Virginia were the red, purple and blue patterns of anemones on her mother's black dress. After that, she recalled lying half-awake, half-asleep in the early morning on holiday in St Ives; from her bed in the nursery she could hear the sound of the waves breaking and see the wind billow in a yellow blind, making it swell and drag its

little acorn pull-cord across the floor. It gave her a sensation of the purest ecstasy at the simple fact of her existence:[5] a sensation she was able to replicate in the perception of children in her fiction, along with the thousand other small epiphanies of impassable puddles, sinister trees, sheep's skulls, hopes and frustrations. Two and a half years her elder, Vanessa's memories centred on her siblings: Thoby needing his bottle, an inarticulate Virginia in her high chair, drumming impatiently as breakfast arrived. In turn, Virginia would recall her teaching Thoby his letters and insisting the nurse strapped him into his high chair securely before he ate his morning porridge.[6]

In 'Reminiscences', a memoir later written by Virginia for Vanessa's children in the tradition of Leslie's *Mausoleum Book*, the sisters' early days are described as passing in 'plain duties' and 'appropriate pleasures'. The world was an immense and mysterious place, with realms to be discovered in the darkness under the furniture and in the long grass of the park. Sometimes there were 'little warfares' and, at other times, the children came together to discuss such significant questions as whether black cats had tails. Virginia and Vanessa became aware of each other in the 'continuous romance' of the nursery floor, drifting together 'like ships in an immense ocean ... happily encircled by firelight' while the adult world of 'legs and skirts' continued around them.[7] Virginia's genius was at its most poignant and accessible when describing her childhood: the white moths of summer evenings and the whittled firewood of winter nights, the dead leaves and chestnuts, the stormy passions that could 'flood the brain',[8] which she imparted to Rhoda in *The Waves* and James Ramsey, longing to visit the Lighthouse. Ambition and possibility hovered about them, in Virginia's stories whispered in the nursery at night and Vanessa's scrawls of 'a great maze of lines' in white chalk on the back of a black door.[9]

A photograph owned by Leslie, now in the Smith College Collection, captures Julia dressed in a thick dark gown, sitting in a wooden chair outdoors with the newborn Vanessa on her lap. She looks gaunt, her eyes hollow, a reminder of Leslie's comment that she 'suffered a good deal' after the child's arrival. By 1881, the two-year-old Vanessa had blossomed into a beauty, with the pouting mouth, rounded limbs and large, alluring eyes of a little cherub when she was snapped half-clothed, wrapped in a white blanket. A couple of years later, aged three or four, she posed on her mother's lap in a studio portrait, her dark dress with white cuffs and collar echoing Julia's clothes and her little booted feet crossed as she looks into the lens. Around a similar time, a picture of Thoby features him in a sailor suit, with his bare feet dangled towards a net resting on wave-like folds of cloth. Another photograph of Julia and the infant Virginia, taken by Eugene, son of Julia Margaret Cameron, shows Julia's head bent towards her daughter while the chubby, bright-eyed Virginia looks out at the camera. It was Leslie's favourite picture; 'When I look at that photograph … I at least see a mouth that is an embodiment of such delicacy and tenderness as makes my heart tremble.'[10] Finally, around 1886, a bonneted Julia appears with Adrian: while she looks serenely, almost regally into the camera, with her bow tied under her chin, both her gloved hands are used to keep Adrian in place as he looks almost fearfully towards the camera, his eyes uncertain.

A letter written by Stella Duckworth in 1884, when she was fifteen, Vanessa five and Virginia two, describes life in Hyde Park Gate to their absent mother. She had been left in charge of her younger siblings, 'the little ones', who had just gone up to bed after a dinner of curry and rice, replacing the pie she had planned, as the weather was so cold. For the next day, she intended to feed them cold beef, chicken and macaroni. They had spent the morning in

Kensington Gardens and although Thoby's cold had quite cleared up, he still had 'a little cold in his head'.[11] As the eldest girl in the family, Stella often looked after the younger children, a role which Vanessa would also adopt, rubbing Virginia with scent and tucking her into bed. There was also the reliable Sophie, the family's cook, who would remain with them through the changing years ahead, and a wide range of family members who played a significant role in the Stephen siblings' childhoods.

One of the early influences was their maternal grandmother Maria Jackson, *née* Pattle, a beauty from a family of renowned beauties raised in Calcutta and Versailles; sisters whom Ruskin dubbed as 'Elgin marbles with dark eyes'. Romantic tales followed them, of women giving birth on board ship, of aristocrats fleeing Paris as the guillotine fell, and of their great-grandfather James' dissolute life and explosive end; stories which so beguiled Virginia that she often repeated the tale of the body in the cask of rum which burst mid-storm on the boat home to Blighty. From the marriages of the Pattle sisters, the Stephens derived a wide range of relations, from the Prinsep salon of Little Holland House frequented by Herschel and Carlyle, Rossetti and Tennyson, Disraeli and Gladstone, the site of which Julia once visited with Virginia, to the photographic canvas of Dimbola, where the Camerons transformed daily life into art. Aunts and uncles had exotic connections and houses full of dark, carved ebony furniture, mysterious colonial artefacts and parrots, which found their way into early Stephen letters and writings. The marriages of Julia's sisters also brought a swathe of Vaughan and Fisher cousins, of which Emma Vaughan, her sister-in-law Madge and Florence Fisher were particularly appreciated by Virginia. In fact, Virginia had been named Adeline in 1882, following the death of Julia's sister of that name, although the sad connection meant that the name was never used by the family.

A letter surviving from around 1885, penned by the six-year-old

Vanessa, gives a glimpse of the Stephen children on holiday in Brighton, visiting Maria Jackson, who had returned from India due to ill health. They were staying in lodgings from which they could 'see the see' [*sic*] and were fed mutton, potatoes and tapioca pudding for dinner. Virginia and Thoby had ridden 'in a goat carriage', and all three enjoyed a donkey ride on mounts named Black Bess, Polly and Topsy, picking up shells and bits of glass on the beach 'nearly right into the sea'. Vanessa reported to her father that their grandmother had given them some chocolates and that while the three-year-old Adrian was a 'nice pretty little boy', her half-brothers George and Gerald were 'agravaking' [*sic*]. She sent her love to the dog and its puppy.[12]

Eventually, the house in Hyde Park Gate proved too small for a family with eight children, visitors and servants. In July 1886, Leslie commissioned architect J. W. Penfold to extend it upwards and outwards, creating nurseries in the attics and adding an extra top floor which was divided into three bedrooms and a study. The surviving plans show the new gable-ended front imposed on top of a typical stuccoed London town house of 1845, made by the building firm Grissell and Peto, who were also contracted to work on the new Houses of Parliament. Architecturally, the new residence was something of a hybrid, like the extended family the Stephens had created. Virginia recalled it in her memoir 'Old Bloomsbury' as a 'very tall house ... which begins by being stucco and ends by being red brick; which is so high and yet ... so rickety that it seems as if a very high wind would topple it over'. Its division was symbolic too: downstairs, around the oval tea table, it was 'pure convention: upstairs, pure intellect'. Into its drawers and cupboards Julia and Leslie 'poured' their respective pasts and families, with the artefacts and letters of her life with Herbert, including his barrister's wig that Thoby Stephen would sometimes produce, and the relics of Leslie's life with Minnie, including reams

of drawings by Thackeray. The past was packed in tightly, darkly, heavy with emotion: as Virginia noted, you could almost smell it.

The clearest picture of Stephen family life survives in the children's newspaper *Hyde Park Gate News*, written by Vanessa, Thoby and Virginia in the style of their favourite magazine, *Tit-Bits*, which they used to buy from the white sweet shop near the palace gate, and consume along with a three-penny bar of chocolate, divided into fours. When the first issue was produced in February 1891, Vanessa was eleven, Thoby ten, Virginia just past her ninth birthday and Adrian seven: their mother's response to the paper, casually left where she would find it after dinner, was, 'Rather clever I think.'[13] The handwriting of the first surviving editions, which date from April, are a mix of Vanessa's fluid and Thoby's thick, dark scripts, with the occasional spelling mistake and crossing-out; Virginia's hand appears in time, in tight, spiky, controlled strokes. As Vanessa later described in her memoir of her sister's childhood, Virginia was the most frequent author of the paper, while she took the role of editor. In fact, Virginia's writing career had already begun, as in 1890 she had entered a 'wildly romantic'[14] story about a young woman on a ship into a competition run by *Tit-Bits*. It is not difficult to find the seeds of her first novel, *The Voyage Out*, in this rejected entry and the imagined conversations and letters between lovers, 'to show young people the right way to express what is in their hearts', that feature in the family paper.

In the first editions of the *Hyde Park Gate News*, we learn of the simple details of the children's lives: that Virginia has been scared by the large Newfoundland dog who barks as she passes its gate, that Laura 'Her Ladyship of the Lake' has painted a picture of a child with a cockatoo on her shoulder and was also the victim of an April Fool's joke. Images of the same bird appeared again in December, when Vanessa had been to the hairdressers and had had

her fringe cut by Mr Goberg and 'now looks so like a cockatoo that she is ridiculed on all sides'. The paper relates how Stella brought home pears for her sisters, which 'may seem but a small donation to some people' but 'it was big in their eyes' and how they sought to preserve birds' nests and when a lamp in the nursery flared up 'in a most ominous manner', it had to be blown out for fear of explosion. In November 1891, Vanessa and Virginia paid a visit to their cousins for 'juvenile festivity' and, fog permitting, were to attend a dancing class at Queensberry Hall. Christmas 1891 saw the double drawing room of the house crowded with presents and guests, including their grandmother Mrs Jackson and her singing canary, whose song was admitted to excel that of Vanessa's own pet bird. On Virginia's tenth birthday, she received an ink-stand, a clock, a blotter, a drawing book and a box containing writing implements, but her 'bull-dog' of a music mistress refused to be put off due to the celebrations and promised to call again the next morning. Julia's birthday that year brought her gifts of blue glass vases, photographs, china, serge and velvet for dresses, a gum pot for stamps 'and such-like things'.[15]

Early in 1892, George and Stella took the four Stephen children to see Imre Kiralfy's spectacle *Venice: The Bride of the Sea* at the newly opened Olympia, with dancing, singing and gondolas rowed by swarthy men. They popped out during the fifteen-minute interval to visit the glass-blowing, which sent Thoby 'into a reverie'. At family parties in the winter, they played Oranges and Lemons and gazed in awe at Christmas trees; in the summer, they recorded the first consumption of ices, which took place on 16 May 1892, a 'hot and sultry' day 'stamped deeply in the minds of the juveniles'. A few weeks later, they recorded eating the first cherries of the season, to Virginia's delight. There was also the daily adventure of Kensington Gardens, where they played Hide and Seek and Tom Tiddler's Ground and where Vanessa habitually lost keys

and umbrellas. Virginia sailed her Cornish lugger, *The Fairy*, on the Round Pond, while Thoby piloted *The Thistle* and their father recited Newbolt's *Admirals All*. Both boats were lost and dredged up again by obliging park keepers, who brought *The Thistle* to the back door in February 1892, while Virginia recognised *The Fairy* lying in a punt when visiting the park a week later. A photograph of the pond taken in 1896 shows several boats afloat, as well as a large, impressive vessel with full sets of white sails. It is being steered by a boy in a sailor suit and straw boater, who holds a long tiller to control it; further along, another boy without a boat stares wistfully across the water.[16] In such occupations, the years of childhood passed at Hyde Park Gate.

If Hyde Park Gate was dark and restrictive, Talland House, standing on the cliff top overlooking the sparkling St Ives Bay, was full of light and open space. The family's year, and their life between 1882 and 1894, was split between London and Cornwall. From June to October, they passed 'happy days in laziness',[17] hunting moths, playing cricket, exploring the rock pools and finding wildflowers on the moors. Travelling third class, with servants, luggage, books and sandwiches, they climbed into two compartments on the Great Western Railway at Paddington station each summer and settled down for the long day's ride. They knew the end was almost in sight when the train pulled into St Erth station, 300 miles and many hours away from the noise and bustle of Kensington. From there, at around seven in the evening, they changed on to the little branch line, travelling a further four miles along the coast, with its view of the bay, across sand dunes, through woods and into the station nestling against Porthminster beach. Those first moments were magical. St Ives was a rugged town, ancient and ageless, stacked up around the bay in primitive walls, gleaming with whitewash or grey with rugged slate and granite: a 'windy, noisy, vociferous, narrow-streeted town, the colour of

a mussel or a limpet, like a bunch of rough shell fish clustered on a grey wall together', set on the very 'toe-nail of England'. Above the station sat Talland House, bathed in the sunshine, dripping with passion flowers, behind terraces of escallonia hedges. Its windows overlooked the Godrevy Lighthouse, which Virginia would immortalise in her fictional account of family life in St Ives. Here, in Cornwall, the young Vanessa was truly awakened as an artist, beginning to 'feel within her the spring of unsuspected gifts, that the sea was beautiful and might be painted one day'.[18]

Leslie had found the house on a walking tour in 1881 and the family first visited the following year, when Vanessa was three and Virginia a babe in arms. It was, as Leslie described, a 'very nice house', 'small but roomy ... with a garden of an acre or two all up and down hill ... a kitchen garden and orchard'; there were also 'a fountain and grapes and strawberries and peaches'. The sea breezes were 'soft as silk', with a 'fresh sweet taste like new milk' and a 'dozen little gardens full of romance for the children ... intricate thickets of gooseberries and currants, and remote nooks of potatoes and peas ... and corners in which you come upon unexpected puppies, altogether a pocket-paradise with a sheltered cove of sand in easy reach'.[19] The dining room had tall French windows opening on to the gardens, inviting nature inside. Julia and her children were often photographed here between overflowing urns. The Stephens erected greenhouses, created a tennis lawn that doubled as a cricket pitch, an arbour surrounded by flowers called the 'loo corner', or the seat amid the purple jackmanii, and a 'coffee garden' in the shade of the hedge while, according to Virginia, a pair of mischievous spirits, Beccage and Hollywinks, haunted the compost heap.[20] Leslie also managed to purchase the plot of land before the house, ensuring that their view of the bay would not be obscured by new buildings. The little path to the beach, found in the break in the hedge, was zealously

guarded by a cluster of kniphofia, or red-hot pokers. He tended their little idyll with care, visiting alone in January 1883 to check on the housekeeping couple, the Lobbs, and inspect the grapes and pond, returning again in April 1884 to see the new housing that was being built in the neighbouring Albany Terrace, and in spring 1885 he visited again to ensure all was in order for the family's annual summer stay.[21] Stella put her birthday present of a camera to good use, capturing images of her younger siblings playing cricket, the girls in heavy frilled dresses and boys in their ill-fitting suits, as well as Julia writing letters at her desk, Vanessa and visitor Lisa Stillman cooking at the huge black kitchen range and Virginia sitting behind her parents as they read in the drawing room with its floral, Morris-style wallpaper.

There was a constant stream of guests and visitors to Talland House: Fisher cousins, the Lushington sisters, Stella's suitor John or Jack Hills, family friends Walter Headlam, Dr Wolstonholme, Madge Symonds and Charles Norton, Virginia's American godfather James Lowell, neighbouring poet George Meredith, novelists Edmund Gosse and Henry James, young boys who were roped into playing cricket such as Holman Hunt's son Hilary and Rupert Brooke and his brother, the Llewelyn Davieses, and others, staying in the house, town or at nearby Tregenna Castle Hotel. At night the children hunted moths, using a lamp and syrup to attract them; by day they romped in the gardens, played on the sands and let down baskets from their bedroom windows in the hope that their cook Sophie would fill them with some treat. Kitty Lushington and Leo Maxse got engaged in the garden, on the love seat by the greenhouses, whispering so that Thoby thought it was 'Paddy talking to his boy'.

There were regular walks, including the Sunday trek to Tren Crom, from where St Michael's Mount was visible. There was an underground stream bubbling up in the garden, fishing trips,

the annual regatta, painting and reading, with live blue lobsters from Mrs Adams writhing on the kitchen table and their mother matchmaking in one of the fragrant green dells. A letter which Leslie wrote from St Ives to Norton on 23 August 1885, while he was editing the *Dictionary of National Biography*, described Thoby, aged almost five, producing a 'contradictionary box', which was so-called because it was full of rubbish. 'What muddled notions had got into his little noddle I cannot imagine,' wrote his father, 'but there were gleams of epigrammatic satire, as it seemed to me.'[22] In September 1892, they celebrated Thoby's twelfth birthday with charades and miniature balloons, a game of Cat and Mouse, a birthday cake which Thoby cut into too-large slices, and fireworks despite the rain, although the 'super-exuberant' children pushed and shoved until the gate was broken off its hinges. For Leslie, it was 'a long series of scenes of intense domestic happiness'.

The children's lessons were not abandoned for the summer, but they were reduced to a few hours a day, with the tantalising sea visible to them from the dining-room table. Back in London, they were taught at a huge baize table, sitting on the carved oak chairs set with plush red fabric. Julia was their first teacher, pairing them by age, as one surviving but very faded photograph taken at St Ives shows in around 1894, with her sitting between her two youngest. There were also Swiss and French governesses, and Leslie recounted tales of his adventures in the Alps as a young man, read them poetry and was proficient at cutting animals out of newspaper. Among other things they studied Latin, French and history, mathematics and literature, until the arrangement was broken by the boys starting school, Thoby as a boarder at Evelyns in Colham Green near Slough and Adrian as a day boy to Westminster. Vanessa took Thoby's departure badly and slept with his toy monkey Jacko; the *Hyde Park Gate News* is full of excitement at his impending return home, also recording boxes of

oranges that were sent to him at school and a visit made by his family to watch a school cricket match. Vanessa and Virginia's days were spent in the cheerful small room at the back of the house 'almost entirely made of glass, with a skylight, windows all along one side looking on to the back garden, a window cut in the wall between it and the drawing room'.[23] There, Vanessa would draw, perhaps with the chalks Stella had given her, and Virginia would read or write the family paper, imagining the conversations of star-crossed lovers or the experiences of a cockney farmer; these were the prototypes of future paintings and novels. With the boys absent at school, the sisters drew together, beginning what was to be a life-long closeness.

Something in the Shadows, 1887–1895

Children never forget.[1]

And yet, this idyll of bright summers against a sparkling bay, of sailing boats and walks in the park, early artistic ambition and the favourite nursery tea of bacon and eggs, had its darker side, a side sometimes diminished by biographers.[2] First there was Thoby. By the time of his departure from Hyde Park Gate, the elder Stephen brother was no longer the 'clumsy, awkward little boy, very fat, bursting through his Norfolk jacket' that Virginia recalled being easily 'dominated and led'. His school years were not easy ones and the prize he won in 1892 was greeted with surprise and delight as something of an anomaly. Yet he would relate wonderful stories to his younger sister; he was full of tales from Greek literature and anecdotes that brought his fellow schoolmates to life, although he later found it impossible to talk about his feelings, relationships or grief. He could be outgoing and active, sporty and fond of nature, keeping an illustrated notebook in the tradition of Victorian public school boys, but he was also reserved and reflective. There was a strange incident when he allowed a fellow pupil to 'stick a

knife into his femoral artery'[3] at the age of eleven and, in 1894, tried to jump out of a window in a state of delirium following illness; 'he was half way through the window which he had smashed to shivers'. According to his teacher, he suffered attacks of delirium through that April too, meaning it was 'never safe to leave him alone for a moment'.[4] The question remains whether this was actually a genuine side-effect of illness, unconscious and involuntary, or whether it was an act of desperation by a child trapped in a situation he found intolerable? As such, it would connect with Virginia's later behaviour, as well as a comment reputedly made by Leslie that both Vanessa and Virginia suffered from depression as teenagers in the early 1890s.[5] Thoby clearly did not flourish at Evelyns; there is a hint of darkness in these accounts, reminiscent of Virginia's later experiences. He failed to get the scholarship to Eton that would have enabled him to follow in his father's footsteps and was sent instead to Clifton School, near Bristol.

Childhood could also be a time of occurrences that exerted disproportionate terror. Virginia's 'Sketch of the Past' records two significant incidents from her childhood which remained with her as 'moments of being': the sharp, sudden intense epiphany or recognition, the mosaic pieces that were the most colourful, in contrast with the 'non-being' or 'cotton-wool' days she likened to being trapped inside a grape.[6] In them, Virginia explores the seemingly random nature of childhood memory, acknowledging that she could not remember being thrown naked into the sea by her father, in contrast with the strange, apparently insignificant incidents that she did recall. There was the moment of the puddle in the path, 'when for no reason ... everything suddenly became unreal' and she could not cross it. Another occasion of terror was the 'idiot boy' who 'sprang up with his hand outstretched mewing, slit-eyed, red-rimmed', to whom she replied in the currency of

childhood, pouring toffees into his hands.[7] Nor did his image leave her. It returned that night in the bath, connecting with a deeper sense of horror and realisation: 'that hopeless sadness, that collapse … as if I were passive under some sledge-hammer blow, exposed to a whole avalanche of meaning that had heaped itself up and discharged itself upon me, unprotected, with nothing to ward it off.'[8] She was fearful at night too, afraid when the fire remained alight after they had gone to bed, trying to wake the others just 'to hear someone's voice'. After Thoby's departure, Virginia began amusing Vanessa and Adrian at night with embroidered tales about their affluent neighbours, the Dilkes, and their governess, delivered in a drawling voice that began 'Clémenté dear child', and sprawled over gold discovered under the floorboards and great feasts of frizzled, fried eggs.[9]

Then there was Laura. Born in 1870, Laura Stephen's presence in the house was a constant reminder of human frailty, the secret counterpart to her talented, intelligent and attractive siblings. What appears to a modern reader to have been a case of mental handicap, perhaps even Down's Syndrome, was misunderstood by her family. Their dismissal of her inability and frustration as wilful disobedience was typical of middle-class responses of the time, in an era when such conditions were poorly understood. The syndrome had not even been specifically identified and named by John Langdon Down until four years before Laura's birth; if she was born with the rarer form, Mosaicism, which today affects around 1 per cent of the population,[10] her needs would not have been recognised, let alone met.

A collection of photographs compiled by Leslie in 1895 includes some of Laura, which might assist a posthumous identification. In one, taken soon after her birth in 1870, she lies propped up on a cushion, with a white frilly hat, clothing and blankets. With her eyes half closed and her lips pursed, she looks tired, perhaps on

the verge of tears, but there is little in her appearance to indicate anything that might give her parents cause for concern, even though she had been born three months prematurely. A second picture, taken around the same time, shows her in Leslie's arms, well grown and alert, but with the same puffy eyes, button nose and protruding lower lip. When these images are compared with a photograph taken of her as a mature woman at the Earlswood Asylum, her later features appear equally childish; Laura's gaze meets the camera but her half-closed eyes capture the same mood of sleepy babyhood, perhaps tinged with an additional sense of disappointment and defiance. There is something raw and animal, even simian, about her features as an adult, with her short nose, large nostrils and small slanted eyes: these would have been intrinsic indicators to a Victorian mentality that saw such outward lack of refinement as correlative with an inner vice and degeneration. Today, it is understood that a flattened nasal bridge, upward slanting eyes and the protruding lower lip due to the relative size of the tongue in a smaller-than-average oral cavity are typical of Down's.

The Stephen children's responses to their half-sister veered between their Arthurian nickname for her, the 'Lady of the Lake', which bestowed upon her a sort of distance and mystery, and a sharp, sarcastic impatience. Virginia recalled Laura in 1922 as 'Thackeray's granddaughter, a vacant-eyed girl whose idiocy was becoming daily more obvious, who could hardly read, who would throw scissors into the fire, who was tongue-tied and stammered, and yet had to appear at table with the rest of us.'[11] Leslie's attempts to teach Laura to read left him frustrated and impatient; it is telling that he actually consulted Langdon Down in 1885, and while the details of this meeting are unclear, it appears the doctor offered the diagnosis that she was unlikely to improve. Laura was sent away temporarily to the country and, after worsening, was permanently

incarcerated in 1891, where she remained until her death in 1945. Laura did continue to join the family in Cornwall for another two years, but her Stephen siblings did not maintain contact with her in adult life. Again, this response was typical of the time, but Laura's existence, tucked away in the upper storeys of the house, emitting her eerie cries and howls that echoed through the rooms, must have resonated with the sisters as they read Charlotte Bronte. They had their own mysterious 'Lady of the Lake', who disturbed their dreams and brought the Victorian literary trope of the madwoman in the attic into their daily lives.

If there was a madwoman in the Stephen attic, a madman was being made welcome at the tea table. Leslie's nephew J. K. Stephen, known to the family as Jem, was a generation older than his young cousins, having been born in February 1859. He had attended Eton then King's College, Cambridge, before becoming tutor to Queen Victoria's grandson, Prince Eddy, and was described by Rudyard Kipling as a genius for his poetry. Jem was believed in the family to hold great promise, and Julia was particularly fond of the handsome young man with the piercing blue eyes. Leslie described his nephew's life in detail in the biography he wrote of his brother, *The Life of Sir James Fitzjames Stephen*, writing of his 'unusual physical strength ... good looks and singular combination of power and sweetness'. However, while staying in Felixstowe in Suffolk, late in 1886, Jem suffered an accident, 'the effects of which were far more serious than appeared at the time'. Leslie relates that on 29 December, while inspecting an engine that was pumping water, 'he received a terrible blow upon the head' and, despite displaying superficial signs of recovery, Jem was never the same again. From 'eccentricities of behaviour' he progressed to 'painful periods of excitement and depression'. In his fondness, Leslie overlooks elements of misogyny and violence in the 'playful verses' Jem published in Cambridge in 1890, as

well as the disturbing and threatening behaviour he exhibited on visiting the family.

The object of Jem's attentions at Hyde Park Gate was Stella Duckworth. In May 1890 she had turned twenty-one, older than her mother on her first wedding day, and with something of her mother's pre-Raphaelite look, with the hooded eyes cast down, finely moulded forehead, cheekbones and lips. Virginia described her as escaping Duckworth genes entirely and possessing a pair of 'very large ... pale blue eyes ... dreamy candid eyes ... a white faint moon in a blue sky suggests her. Or those large white roses that have many petals and are semi-transparent. She had beautiful fair hair ... and no colour in her face at all.'[12] Yet she had a softer, more earthly look than the ethereal images of her mother and even her sister Virginia, with their thinner, sharper features. Stella, nicknamed 'the old cow' among the family, perhaps after the June elder-blossom or cow parsley she also evoked, was closest in looks to Vanessa and, despite the decade between their births, the two are easily mistaken for each other in photographs. Stella and her mother were the 'sun and moon to each other', with the daughter 'reflecting and satellite',[13] to a level of passive acceptance and self-negation. Unable to go out alone, Stella took Virginia as her habitual companion and chaperone about London as they paid calls, ran errands, rode in hansom cabs and then sat down to milk and biscuits in a café with marble table-tops. The elder girl's beauty had attracted a number of admirers, including Arthur Studd, Ted Sanderson and Charles Norton's youngest son Richard. Now, the attentions of her brothers' Cambridge friend began to border on obsession.

Starting in the year Stella came of age, Jem pursued her with a level of aggression and persistence that must, at the very least, have been unsettling for her and the young children. Virginia described him as something of a 'tormented bull', a 'great figure with the deep voice and the wild eyes', who would burst into the nursery 'with

his madness on him', and 'spear the bread on his swordstick'.[14] He would arrive in Hyde Park Gate in a cab after driving around all day, leaving Leslie to pay the huge cost of a sovereign for it, and make dramatic announcements, such as 'Savage (another family doctor) has just told me I'm in danger of dying or going mad.'[15] Although the Stephens pitied him, and considered him 'charming' and 'pathetic', overlooking the time when he 'abducted'[16] Julia and Virginia, taking them to his rooms in De Vere Gardens, where he 'painted [her] on a small bit of wood',[17] eventually they found his attentions overwhelming. On one occasion, the children were urged to leave the house by the back door and, if asked, to lie to Jem and tell him that Stella was away. The timing and extent of his madness, along with his royal connections and certain poems that have been read as misogynistic, have led to some speculation that J. K. Stephen might have been Jack the Ripper. Although this has long been dismissed as implausible, purely on logistics alone, it demonstrates the increasingly dangerous lack of balance in his mind. After running naked through the streets of Cambridge, Jem was admitted to an asylum in November 1891. The following February he died tragically young, still incarcerated, possibly as a result of starving himself to death.

Yet there were worse skeletons lurking in the Stephen family closet. One of the most alarming and explicit incidents, about which much has been written, occurred when Virginia was around the age of six. In 'Sketch of the Past', her fragment of autobiography written in 1939, she described what took place on a summer's day at Talland House:

There was a slab outside the dining room door for standing dishes upon. Once when I was very small Gerald Duckworth lifted me onto this, and as I sat there he began to explore my body. I can remember the feel of his hand going under my clothes: going firmly

and steadily lower and lower. I remember how I hoped that he would stop; how I stiffened and wriggled as his hand approached my private parts. But it did not stop. His hand explored my private parts too. I remember resenting, disliking it – what was the word for so dumb and mixed a feeling? It must have been strong, since I still recall it. This seems to show that a feeling about certain parts of the body; how they must not be touched; how it is wrong to allow them to be touched; must be instinctive.

Virginia was even more open about the incident in a letter to her close friend Ethel Smyth in January 1941, in a context that makes its physicality even more graphic and intrusive:

But as so much of life is sexual – or so they say – it rather limits autobiography if this is blacked out. It must be, I suspect, for many generations, for women; for its like breaking the hymen – if thats [*sic*] the membrane's name – a painful operation, and I suppose connected with all sorts of subterranean instincts. I still shiver with shame at the memory of my half-brother, standing me on a ledge, aged about 6, and so exploring my private parts.

Virginia's use of the image of the hymen may well have been a conscious metaphor for the process of memoir writing, as one biographer has suggested. It stood for the realisation of women writers that they must confront and articulate aspects of their sexual being, and reject self-censorship, which was a paradoxically necessary but painful epiphany.[18] Yet there is more to it. The juxtaposition of this image with her incestuous violation at St Ives and the identification of 'subterranean instincts' is akin to Freud's methods of free association, and quite deliberately so. Her appropriation of a sexual metaphor for her writing, embedded in the description of that event which follows, is a connecting

feature that would otherwise be a literary non sequitur if it were referring to her work alone. This is Virginia's way of telling us that the exploration of her 'private parts' was not just symbolically and psychologically damaging, but physically intrusive in a literal sense. It was a defining moment in her life; a shadow from which she would never emerge.

As a child, this incident became linked for Virginia with a nightmarish vision of a terrifying face reflected in a mirror: 'I dreamt that I was looking in a glass when a horrible face – the face, or an animal – suddenly showed over my shoulder.'[19] It indicates the blurred line between memory, the subconscious and fiction, as an associated terror; Virginia was in no doubt about her abuse by Gerald, but was uncertain of whether the mirror beast was real, or part of a dream: it, or she, was 'de-realised' or disconnected by the incident. The worlds of nightmares and reality briefly coincided. It may have been that she glimpsed the reflection of the half-brother she would later liken to a pig, an 'alligator in her tank', or recognised the bestial face of male sexuality, or that the location became imprinted with the shock of the moment, absorbing its horror. This association of human suffering with the inanimate world is repeated in her St Ives memoirs, after Virginia had overheard her parents discuss the death of a neighbour, which fixed itself to a familiar and previously untainted image in her childish sphere; 'It seemed to me that the apple tree was connected with the horror of Mr Valpy's suicide.'[20] Virginia's fictional alter egos also experience similar fears: Cam in the autobiographical *To the Lighthouse* is afraid of a boar's head, while Rhoda of *The Waves* cannot cross the seemingly innocent puddle and shies away from her own reflection in the mirror. These psychophysiological responses and intellectual escapes are the tools Virginia employed to survive the incident.[21] Yet worse was to come.

A number of images survive from the family's final few summers

at St Ives. The Stephen children, whom Leslie called his 'ragamice', were growing up: Vanessa, the 'saint', 'dolphin', 'Sheepdog' or 'Old Tawny'; Thoby, the 'Goth'; Virginia, the 'billy goat', 'ape' or 'kangaroo' and Adrian, his mother's 'joy', her 'Benjamin' or 'blue mouse'; all appear against the backdrop of Talland House, sitting on the steps, on the terrace and playing cricket. Vanessa and Virginia are often clothed in heavy, dark dresses and stockings, despite the summer weather – Virginia applauds as Vanessa bats, they watch their parents reading, or are pictured huddled shoulder to shoulder in a family group. Virginia's pen portrait of Vanessa describes her 'trotting' about with butterfly nets, painting in watercolours, or 'scratching a number of black little squares' after the instructions of Ruskin's book *The Elements of Drawing*.[22] One haunting photograph shows Julia standing beside a flowering shrub against an exterior wall of the house. Dressed in her habitual black, made more severe by her white collar, her head droops down while her cheeks appear drawn and her mouth downturned, perhaps lined, her eyes sunken, her hair more grey than dark: she looks significantly older than her forty-eight years. Writing to Norton on 25 September, Leslie confided that he regretted the loss of the Cornish arcadia and the resumption of work: 'I am coming to the end of my holidays and looking forward with some dread to the task that awaits me at home.'[23] It was indeed the end of an idyll, with construction beginning that year of the huge Porthminster Hotel, spoiling their view. As they packed up the fishing nets and gathered the last of the grapes, the Stephens did not know they would not be returning to Talland House.

Back in London, Virginia resumed the *Hyde Park Gate News*. Her first new edition was No. 1 of Volume Five, suggesting that many papers have been lost since the conclusion of Volume Two in 1892. The first paper contained the story of Gerald purchasing a meerkat for his cousin Mrs Florence Maitland, which animal was, at the

time of writing, sitting outside its cage in the drawing room, dressed in a flannel nightgown, 'toasting its body' before the fire. Also in January, Julia took the four Stephens to the Santa Claus pantomime at the Lyceum, but although Virginia stated conventionally that it was 'heartily enjoyed by the children', her own feelings appear more ambiguous, and she admitted that she found the dog 'Tatters' to be 'the most interesting character'. There was also a family wedding that month, with the Stephens' cousin Millicent Vaughan marrying a Captain Vere Isham, and Julia hosting the reception at Hyde Park Gate. It threw the house temporarily into turmoil, with 'the front room ... devastated of its table and chairs, and a long table covered with red baize ... erected in their stead' and adorned with presents guarded by a detective. The double drawing-room doors were taken off their hinges, 'multitudes of lamps and flowers were placed in both rooms', a new carpet was bought, the staircases were covered in more red baize and an awning was erected from the front door to the street. Gerald and Vanessa threw handfuls of rose petals over the happy couple as they departed. At the end of the month, Adrian and Thoby returned to school.[24]

The following weeks were dominated by the cold weather and family illness. On 4 February 1895, the thermometer 'registered eight degrees of frost at four in the afternoon', making it cold enough for skating in the park; 'The Round Pond, the Long Water and Wimbledon Lake, are all good ice and are abundantly patronised.' Stella was unable to enjoy it, though, retiring to bed with a severe cold, but was considered well enough to supervise the children while Leslie and Julia visited Leslie's sister at Malvern the following week. The frost remained, with the ice between seven and eight inches thick. An ice carnival was held in Regent's Park and the pipes at the house froze up, putting the kitchen boiler out of use. On 11 February, weeks after her thirteenth birthday, Virginia recorded an extraordinary dream. She was God, 'a man

alone playing with Time ... people scheming below, trying to dissect life and death and knowing nothing. There was no Heaven and no Hell. Heaven is held out as a kind of sugar-plum after medicine, Hell as a scourge if you rebel.' Then she wondered, as God, whether she really existed, and who had made her. 'Was everything a dream, but who were the dreamers? ... The only solution I could find was by waking and finding myself a person.'[25]

On 4 March, Virginia recorded that Julia had spent a fortnight in bed with the flu and was still 'very weak'. She had been allowed by her doctor to sit in an armchair in Stella's bedroom and, a week later, was permitted to venture downstairs and to lie on the drawing-room sofa. Julia was defying doctor's orders not to exert herself: 'She hops about, writing letters and generally superintending the household as if she had never been ill in her life.' Only a spell of stormy weather prevented her from going to visit Adrian, who lay ill at school with measles; instead, she had been out round the park in a carriage. On 11 March, Virginia hoped by the next issue 'to be able to report her being well or at any rate very nearly so'. But it was Adrian whose health was the top story the following week, as he had been sent home to recover, while Virginia was sent to stay with her Aunt Duckworth to avoid infection. The next edition was full of news of the annual Oxford and Cambridge boat race, which was won that year by the former, and on 8 April, Virginia reported the return from school of Thoby, who had grown at least two inches taller and whose legs had 'assumed gigantic proportions'.[26] That month, Julia accompanied the Stephen children to High Ashes, the country home of Sir Roland Vaughan Williams, whose wife was Vanessa's godmother, but when Leslie visited them there on 15 April both she and Virginia had fallen ill. He was 'haunted by [her] looks – [she was] so tired and weak'[27] and he hurried her home.

That spring, Virginia created a fictional Miss Smith for the *Hyde*

Park Gate News, who delighted in Virgil at twelve and wrote sonnets at fourteen but decided that the 'position of men and women towards each other was altogether disgraceful'. In the eyes of Virginia's character, 'men were brutes and the only thing that women could do was to fight against them'. She did this, when a male approached, by sticking 'out her bristles like a porcupine and [making] herself as disagreeable as possible'. Having hoped for applause, Miss Smith was sincerely and deeply disappointed to find that 'no one took much notice of her; men disliked her and women tolerated her as plain and ordinary'. Perhaps something of the teenaged author's sensitivities are reflected in her fictional heroine, or a blend of herself and her sister, as Vanessa approached her sixteenth birthday. Virginia's final entry in the paper that April is a vision of herself in the future: a 'lank' female sitting in a bare room on a black box, dipping her pen in an inkpot, watching the sun 'dive behind a black stretch of cloud'. 'Let us hope,' wrote Virginia, that 'the author thinks of her childhood', whereupon a 'most disagreeable expression crosses her face'.[28]

That spring, in the belief that their mother had recovered, Stella accompanied her brothers abroad, but 'half-way through the journey she became convinced by sign of handwriting or phrase, that her mother lay ill at home'. It may be that Leslie summoned her home by letter, amid increasing concerns about Julia's health. Returning to Hyde Park Gate, she found her mother in bed 'with the chill that was to end ten days later in her death'.[29] Suspecting that she was dying, Julia jotted down some poignant requests, informally and evocatively, just as Mrs Wilcox bequeaths Howards End on a scrap of paper: Virginia was to have an opal ring, Irish lace and a box of her godfather Lowell's letters, while the cutlery and crockery bearing Duckworth crests were to go to George. She died on 5 May. On their birthdays, which would follow four weeks after Julia's death, Leslie gave Stella a chain he

had given Julia on their wedding day and Vanessa a photograph of their mother taken by Julia Margaret Cameron.[30]

As Leslie wrote, Julia's end was unexpected. No doubt, as he admitted, her 'unsparing labours for us and for others had produced [a] weakness of the heart'. The family had believed her to be recovering from her bout of influenza, maintaining hope even after the doctor diagnosed the dangerous rheumatic fever. Virginia had also been ill shortly prior to Julia's death, as her mother wrote to Leslie on 16 April about her 'difficulties', which may indicate she was suffering from the same fever, or was experiencing the onset of her menstruation. These may, however, not have been physical ailments but emotional or behavioural ones. The seeds for Virginia's breakdown may have been planted before Julia's death, although it appears that Leslie felt an equal measure of sympathy for his daughter and annoyance that Julia was being troubled during her illness; 'Poor darling 'Ginia, it is maddening.' It was George who summoned Leslie in the early hours of the morning of 5 May, 'to see [his] beloved angel sinking quietly into the arms of death'.[31] The children had been brought into her room by George to kiss their mother goodbye; a scene Virginia recalled numbly, while her mother bade her: 'Hold yourself straight, my little goat.' Then, after she died, they were wrapped in towels and given brandy in warm milk, before being returned to Julia's bedroom, where 'candles were burning ... and the sun was coming in'. They passed their father staggering out of the room; Virginia stretched out her arms to him but he brushed her aside, muttering words she could not hear. She kissed her mother's face, 'it was still warm. She had only died a moment before.' Years later, Virginia recalled crying at the window of the day nursery, as she watched Dr Seton walking down the street away from the house, with his hands behind his back, at about six in the morning. When he had gone, doves descended 'to peck in the road ... with a fall and descent of infinite peace'.[32]

Tragedy, 1895–1898

A period of Oriental gloom.[1]

Julia Stephen was dead at the age of forty-nine. Having typified the ideal of the Victorian wife, Coventry Patmore's 'Angel in the House', she had opposed the enfranchisement and education of women and spread herself too thinly, caring for family and friends, the poor and sick, in London and St Ives. Her desk was returned from Talland House 'with all the letters received that morning freshly laid in it ... a letter from a woman whose daughter had been betrayed and asked for help; a letter from George, from Aunt Mary, from a nurse who was out of work, some bills, some begging letters, and many sheets from a girl who had quarrelled with her parents and must reveal her soul, earnestly, diffusely'.[2] It sat in Hyde Park Gate as a stark reminder of her absence, a focal point for all the clamours of aid and sympathy that had finally overwhelmed her, while Leslie shut himself away to write his *Mausoleum Book*, a sepulchre in words, filled with emotion and memory. Addressed to her children, the book distanced him from them physically during this crucial time as effectively as he

had avoided Virginia's arms. The weeks following Julia's death would change her children's lives forever. None more so than her youngest daughter.

Virginia's first response to Julia's death was numbness. 'I feel nothing whatever,' she wrote, 'when I kissed her, it was like kissing cold iron.'[3] She was 'afraid of not feeling enough' and laughed at the crying nurse in her mother's bedroom, thinking 'she's pretending',[4] perhaps also as a reaction to the theatricality of her father's wailing and moaning. For the thirteen-year-old girl, shock would be a perfectly natural reaction to what she called 'the greatest disaster that could happen'.[5] In Virginia's mind, the rapidity of Julia's decline was coupled with her fears that her own illness may have contributed an additional burden over the last few weeks. As she later recalled, Julia's death came in the 'very middle of that amorphous time between adulthood and childhood', a dramatic and sudden severance of the innocence of the nursery, just as her enquiring adolescent mind was grappling with the questions of identity, time and existence that emerge in the final editions of the *Hyde Park Gate News*.

Virginia Woolf's literary reputation is perhaps equalled, if not overshadowed, by her status as a 'mad genius'. It is from this early part of her life that the legend of her madness stems, with her subsequent adult illnesses often diagnosed in the light of it, as if they are manifestations of the same inevitable state. Yet what exactly was this 'madness', and how was it identified? Was this something psychological or biological, something inherent in the Stephen genes, as her family believed, or the response to circumstances? Was it always present, lying dormant, waiting to 'pounce'? There seems little doubt that Virginia suffered from depression, either cyclothymic or bipolar, perhaps as a combination of chemical and circumstantial factors, but depression is not a synonym for madness.

In the early summer of 1895, Virginia began to feel increasingly ill at ease and angry about the way she was expected to behave in response to Julia's death. The late Victorian model of mourning was inflexible, a choking morass of veils and crêpes, dark heaviness, the pungent scent of lilies and women weeping into handkerchiefs at the side of marble statues raised to the dead. Elaborate rituals were outlined in household manuals such as *Cassell's* or *The Queens*, listing exactly who should wear what, and for how long, and entire shops, such as Jay's in Regent Street, were devoted to attiring mourners.[6] More morbid customs included commissioning portraits of the dead, or items of jewellery incorporating locks of hair, or covering mirrors over, while some widows eschewed colour forever, remaining heavily veiled and bonneted in black for the rest of their days. Julia herself had set the standard for this when, as a young widow, she would go and lie inconsolably on Herbert Duckworth's grave. It was a grief of paradoxes, of demonstration, display and ostentation, in contrast with the Stephen stoicism of silence and endurance. Between the two, there was little space for the sensitive teenager to explore and express genuine emotion. The theatricality alienated the young Virginia.

In a later draft of her memoir, Virginia described her symptoms in a way which sounds very much like a mixture of anxiety and depression. She was 'terrified of people'. She writes, '[I] used to turn red if spoken to. Used to sit up in my room raging – at father, at George ... and read and read and read. But I never wrote ... for two years I never wrote. The desire left me.'[7] For a fledgling writer, the inability to communicate, to release cathartic emotions on the page, was both a symptom of, and exacerbation of, what she described as a 'breakdown'. The inability to write was a direct psychological parallel with the family's inability to communicate effectively and the disconnection she felt with the ordinary, with things that were normal, especially her home, her parents and

their daily routine. A strange atmosphere dominated the house, which was filled with weeping visitors, and Julia's name suddenly became a taboo: 'we never spoke of' her. Yet the effect of this was that Virginia 'suddenly developed perceptions': she keenly felt the discrepancy between her feelings and the social mores, and suffered as a result. Between Leslie's histrionics and her siblings' silence, the family's grieving process failed to address the actual grief Julia's children were experiencing, enshrining her and replacing 'a true and most vivid mother (with) nothing better than an unlovable phantom'. What she felt was at odds with what was considered 'normal' at the time: thus there was a sort of anachronism, a clash created between her feelings and their context, between her raw emotion and the social construct by which they were decoded.

Taking Virginia's own words as primary evidence, what she appears to have experienced, among other things, was an existential divide, a split between the needs of her private and public selves, an inability to reconcile her inner feelings with social convention. Exploring this in her fifties, she stated that it wasn't the intense grief she felt for Julia's death that made it a tragedy for her, but the difficulties arose because it made her 'self-conscious'. She and her siblings, she writes, were 'made to act parts that we did not feel; to fumble for words that we did not know. It obscured, it dulled. It made one hypocritical and enmeshed in the conventions of sorrow. Many foolish and sentimental ideas came into being,' resulting in a period of intense personal struggle. She was 'half-insane with shyness and nervousness' feeling 'intermittent waves of very strong emotion – rage sometimes; how often I was enraged by father then!'[8] Virginia had experienced a crushing rejection as her father stumbled past her on the landing, and on subsequent days she felt the weight of his histrionic grief and self-absorption, giving his favourite daughter, aged thirteen, legitimate enough cause to feel anger. It would follow that this response also provoked her to

guilt. As her nephew Quentin Bell later wrote, 'She went through a period of morbid self-criticism, blamed herself for being vain and egotistical, compared herself unfavourably to Vanessa and was at the same time intensely irritable.'[9] She was caught between her father's demonstrations and her siblings' internalisation. It appears that Virginia's illness of 1895 owed as much to the effect of stifling social codes as it did to the loss of her mother.

That summer, the family went to stay at Dimbola Lodge on the Isle of Wight, which had formerly been owned by Julia's aunt, Julia Margaret Cameron, who had died in 1879. Perhaps considering it too full of painful memories, Leslie had decided to relinquish Talland House, signalling the end of the Cornish idyll, the end of childhood. Yet Dimbola Lodge and Freshwater Bay were also redolent of Julia, with her photograph adorning the walls and the house and garden haunted by her walks with Tennyson, her lingering grief over Herbert and the dinner-table talk of mutual friends such as Palgrave, Browning and Carlyle. Virginia wrote that the place evoked 'other memories of hot rooms and silence' and the atmosphere was 'all choked with too luxuriant feelings, so that one had at times a physical need of ruthless Barbarianism and fresh air'.[10] Two photographs from that August show the family in mourning, firstly seated in a group in the gardens, with Vanessa and Virginia close together, shaded by a parasol, intent on their books, their faces hidden by wide-brimmed summer hats. The second captures Vanessa alone, reading at the foot of the staircase in the hallway, dressed in white, with her hair pulled back into a plait. A mirror immediately behind her records her reflection, dark in comparison with the blinding whiteness from the summer sunlight in the doorway that obscures one side of the image.

At some point after this, the family decided that it was necessary to consult a doctor about Virginia's health. While all Julia's children were experiencing grief, the others appear to have been

better able to conform to their roles in the social drama, with Stella fussing over her dead mother's clothing and assuming her duties regarding the household accounts, Vanessa mothering her younger siblings and Thoby remaining tight-lipped, burying the pain under public schoolboy stoicism. Even at the age of eleven, Adrian was still considered something of a baby by the other three, too young and distant to be included in their triumvirate. Why did Virginia respond differently to the rest of her family? Simply because she was not them. The depression and anxiety Virginia was experiencing, perhaps even an existential crisis about her own identity, was externalised in a way that drew her father's attention to a 'problem'. That problem needed a label. This was the first time that Virginia is described as being 'mad', by her family, biographers and possibly by the Victorian medical profession.

While the term 'madness' encompasses a spectrum of behaviours, its connotations of hereditary illness and irrationality may strike the modern eye as unsuitable for behaviour that was, for Virginia, the logical reaction to her mother's death. 'Madness' can result from differences in the function and size of portions of the brain as well as the abnormal functioning of neurotransmitter systems, but its identification is essentially a social construct, through the observation of behaviour. In its simplest sense, it defines behaviour that does not conform to expectation, and Virginia's rages and public terrors were considered a departure from her previous self and the stoicism of her siblings. However, in 1895, she was diagnosed in accordance with late Victorian medical understanding, a discipline which still embraced the concept of female hysteria, supposedly caused by the habit of the womb to dislodge and wander about the body.

The Stephens' main family doctor was David Elphinstone Seton. A contemporary of Leslie, the two men's family lives had much in common. In 1879, Seton had married a young widow named

Mary, inheriting a stepson, and his own two boys had been born in the same years as Thoby and Virginia. Known as 'Myra', Mrs Seton's photograph shows a pleasant, round-cheeked face, with curly, dark hair parted in the centre; she ran the household while David's career progressed and the children grew. He was a member of the Obstetrical Society of London from 1875, appearing in the transactions for their meetings through the 1880s and sitting on the society's council from 1884. Having previously worked in partnership with a Dr Coates, Seton appears in the *London Gazette* in 1891 on the dissolution of that arrangement, which had been based on the corner of Cromwell Road and Gloucester Road, a ten-minute walk south from Hyde Park Gate. The society records place his permanent residence at 1 Emperor's Gate, a double-fronted, six-storied house of grey-brown brick, with the generous front door flanked by pillars, minutes away from his surgery. When Virginia observed him walking home on the blue May morning in 1895, he would have passed along Palace Gate and into Gloucester Road, turning right and arriving home to his wife and two teenaged sons. Returning later to diagnose Virginia, he prescribed the cessation of all lessons and four hours of outdoor exercise daily.

If Virginia's depression of 1895 had been an isolated incident, it may not have attracted so much subsequent attention but, as it would prove, this was the first in a series of episodes that punctuated her life at times of extreme duress. Between these occasions, she was essentially a well person, able to function in society in a way that her half-sister Laura could not. The question of whether Virginia was 'mad' is a complex one, debated by medical professionals, psychologists and biographers, whose differing interpretations of her behaviour have led them to classify her as depressive, cyclothymic or bi-polar, the latter a condition also known as manic-depressive disorder. Her mental health has

also been discussed as the result of childhood sexual abuse from her half-brothers, as a by-product of her creative genius and as the construct of a profession that sought to diagnose her based on deficient understanding, making her a victim of male medicine. It seems unlikely that Dr Seton, and subsequent doctors like Dr Savage, Dr Head and Dr Wilberforce, who treated Virginia, had anything but good intentions towards her, but her illness was not fully understood then, just as it is not now.

There may have been physical aspects to Virginia's suffering too, with the suggestion that her bout of rheumatic fever at the time of Julia's death, or the commencement of her menstruation around that time, added a distressing bodily dimension. Stella's diary for 1896 shows that Virginia's menstrual cycle was already regular by January and the onset of the menarche the previous summer might account for her red-faced embarrassment around visitors. Treated as a definite taboo in Victorian society, the difficulties created by erratic periods for young girls could be devastating. Vanessa and Virginia's letters contain frequent references to the 'curse' as they scheduled bed rest during that time and avoided exertion and travel. The first wife of T. S. Eliot, Vivienne Haigh-Wood, who was born in the same year as Virginia, began menstruating at a young age, causing mood swings, abdominal cramps and heavy bleeds that would be controllable with medication today. She developed an obsession with washing her bed linen and, at the age of sixteen, her mother required the family doctor to prescribe Vivienne with bromide to dampen her central nervous system, which was the common treatment for women suffering from hysteria.[11] Ironically, Virginia would feel little sympathy with her, writing in 1930, 'Oh – Vivienne! Was there ever such a torture since life began! – to bear her on one's shoulders, biting, wriggling, raving, scratching, unwholesome, powdered, insane, yet sane to the point of insanity, reading his letters, thrusting herself on us, coming in wavering

trembling,'[12] and Eliot would later incarcerate her in an asylum. Yet Vivienne's early suffering probably mirrored Virginia's: with the loss of one mother and the lack of sympathy of another, the mental well-being of both was compromised by the difficult transition to womanhood.

Virginia's mental state in 1895 has triggered much debate. The legend of her illness became an established Stephen family discourse, passed down to subsequent generations in a way which blurred the lines between emotion and scientific diagnosis. This is common in most families, who refashion their own histories and can replace facts with myths, such as the belief that J. K. Stephen 'just went mad', when severe head trauma was in fact the catalyst for the alterations in his behaviour.[13] It would be erroneous, in the twenty-first century, to attempt the kind of diagnosis of Virginia's psychological condition that is possible with illnesses that can be identified by posthumous forensic testing. Equally, there is no certain link between her demonstrations of grief in 1895 and the subsequent episodes of illness she experienced. Whatever underpinned her state of mind must be considered to be a complex and possibly shifting set of circumstances, so that Quentin Bell's description of it as 'her madness, or whatever it was',[14] may come as close as any.

A change of scene and the benefits of fresh air would have been considered an essential part of Virginia's recovery. In the spring of 1896, Stella organised a holiday for the family to Brighton, a town already familiar from their visits to Maria Jackson, who had lived there until her death in 1892. According to Stella's diary, they were away from 18 to 27 April, staying at 57 Church Road in order to be near their aunt Mary Fisher, whose house was just around the corner.[15] Today, the house they stayed in is a very unassuming two-storied white terrace, with the door opening on to the pavement and a bay window extending up both floors. The

road leads straight down to the bank of the River Adur, branching off the natural coastline, which is now inaccessible as a result of industrial work. George and Gerald stayed with them for two nights before heading back to London, leaving the Stephens to dine with their Fisher cousins, visit Devil's Dyke, and ride on the Downs.

In July they left London again, staying at Hindhead House, near the fashionable town of Haslemere in Surrey. The house had been designed by the physicist John Tyndall for his retirement, declaiming the benefits of the location in a similar style to Leslie's rhapsodising about St Ives – that the air was as pure as that in the Alps and Hindhead was England's Switzerland. Lady Tennyson lived nearby and the following year, Arthur Conan Doyle would also become a resident. In fact, Doyle was already in the area – a photograph from the Bell family album, entitled 'Kodaking Dr Conan Doyle', shows Doyle and Thoby Stephen together in a garden at Hindhead. The author is seen from the back, walking along with a bicycle, about to disappear behind a bush, while Thoby follows at a distance, his distinctive black armband of mourning visible on his upper left arm.

The Stephens found themselves in a large red-brick villa set in complete isolation, miles from any other house and surrounded by huge screens made from larch and heather, erected by the eccentric Tyndall. Sketches of the interior and exterior of the house had been published in the *Illustrated London News* of 16 December 1893, just two weeks after Tyndall's tragic death from an accidental overdose of chloral. It is depicted from the driveway, three storeys high with ornate chimneys and a semicircular balcony on the top floor, where Vanessa was photographed that summer sitting beside George, who clings to her side, sporting his own armband. Other sketches show the entrance hall and staircase, Tyndall's hat, staff and cloak from his last Alpine adventure, his study with its sloping

roof, desk, round table and little fireplace, as well as the view from its window, showing the screens he erected for privacy. By a twist of fate, the accompanying article was written by Richard Garnett, whose grandson David would become Vanessa's son-in-law.

It was during the holiday at Hindhead that Stella became engaged to Jack Hills. He was, according to Virginia, a 'lean, rather threadbare young man' of 'sheer determination' and 'solid integrity' who had been a family friend for years, a guest at St Ives and a devotee of Julia, who had encouraged his courtship of Stella. He was a 'perfect gentleman ... affectionate, honest, domestic', a 'passionate countryman' who rode, fished, bought the children butterfly nets and had 'a vein of poetry about him ... he read philosophy too'. He would train as a solicitor with Roper and Whatley and was scrupulously honest, to the extent that he was prepared to speak plainly with Virginia and Vanessa about matters of sex 'cleanly, humorously, openly', which was a welcome change from the usual Victorian restraint. Stella had previously rejected him; 'After her mother's death however, [she] became less exacting' and 'grew to depend upon [his] visits.' At the end of August, Jack appeared at Hindhead, having been cycling to visit nearby friends, and was invited to stay to dinner. After the meal, Virginia recorded that a 'strange lapse occurred in the usual etiquette', when Jack and Stella left the table to explore the gardens, firmly closing the door behind them. Darkness had fallen and her younger siblings soon followed, seeking out the moths they hoped to trap by the light of a lantern. Yet the insects and the courting couple proved elusive: 'once or twice we saw them, always hasting round a corner; once or twice we heard her skirts brushing and once a sound of whispering ... It was no ordinary night and ominous things were happening.' Eventually, after Thoby had seen off a tramp who had ventured on to the land, Stella returned, 'blushing the loveliest rose colour, and told us how she was very happy'.[16] A

photograph taken days later shows the pair standing on the path, having visited nearby Haslemere to buy two gold engagement rings, which lie on a piece of tissue paper at their feet. Virginia was excited at the thought of the impending wedding, appreciative of 'the exquisite tremor of life [that] was once more alight in Stella'. Other photographs from the Bell album show Virginia sitting in front of one of Julia Margaret Cameron's photographs of her mother, her standing close beside Stella with Gerald grinning in the background, the painter Arthur Studd's dog Simon, and Virginia sitting in the garden, wearing a white beret.

While 1896 may have seen an interruption to Virginia's writing, it was the year that Vanessa's formal art career began, with lessons at Arthur Cope's school. Virginia later wrote of her sister that 'her natural development, in which the artistic gift, so sensitive and yet so vigorous, would have asserted itself, was checked; the effect of death upon those that live is always strange, and often terrible in the havoc it makes with innocent desires ... in this sense [Julia's] death was disastrous'.[17] Yet it may also have been the catalyst for Vanessa to throw herself into her art, to seek an absorption and distraction from the difficult atmosphere of Hyde Park Gate. Leslie had previously employed education reformer and artist Ebenezer Cooke to instruct her and there was an informal mentorship with a Mrs Flower, who aptly painted floral still lifes, but now Vanessa's artistic education became a more formal, permanent arrangement. She attended Cope's school three mornings a week: Monday, Wednesday and Friday, bicycling just over a mile south across Cromwell Road and, as Virginia's diary for 1897 would record, refusing to be deterred by bad weather.

Arthur Stockdale Cope had trained at the Royal Academy, becoming a successful portrait painter and regular exhibitor, as well as setting up his own school in 1889, at Park Cottage, Pelham Street, South Kensington. His work was characteristically

dramatic in the style of Walter Sickert and James Whistler, using a 'muddy' palette of browns and greys, creams and beiges, with small touches of red, contrasted with bright artificial light, creating a chiaroscuro effect. In this respect, his work echoed elements of that of his father, Charles Cope, who had specialised in traditional genre and historical scenes. The English art world was changing, slowly. Having been raised in a family intimately connected with the work of the Pre-Raphaelites, it is unsurprising that the young Vanessa's aesthetic tastes in 1896–97 were Catholic enough: she had visited the studios and admired the work of the typically Victorian G. F. Watts, Frederick, Lord Leighton and Arthur Studd. Two regular destinations for the Stephen siblings were the Royal Academy and the National Gallery, where 'we saw everything – old Italians, Dutches [*sic*], English and a great room full of Turner watercolours'.[18] Across the channel, momentous changes were taking place as the Post-Impressionists began to push the *fin de siècle* experiment in style, colour and subject matter to extremes, but this would not impact upon the work of Vanessa and her friends for a few years yet.

In the spring of 1897, the preparations for Stella's wedding began in earnest. Virginia was excited – it was the standard by which she was to measure romantic love in the future. 'Through that engagement,' she wrote in 'A Sketch of the Past', 'I had my first vision – so intense, so exciting, so rapturous – ... my first vision then of love between man and woman. It was to me like a ruby ... glowing, red, clear, intense. It gave me a conception of love ... a sense that nothing in the world is so lyrical, so musical, as a young man and a young woman in their first love for each other.' Sitting shielded behind the folding drawing-room doors, reading Fanny Burney, 'half insane with shyness and nervousness', Virginia felt the quiver of 'ecstasy' of their love, and glimpsed a few lines of a letter Jack had sent Stella, saying, 'There is nothing sweeter

in the whole world than our love.' And she saw that Stella was brought to life with a 'colour, an incandescence' that lit her pallor and made her eyes seem bluer, telling her half-sister, 'There's never been anything like it.'

Leslie was reluctant to relinquish Stella, wanting the newly-weds to move in to 22 Hyde Park Gate, a plan to which Jack objected. Eventually, a compromise was reached, or rather, extracted recalcitrantly from Leslie, that they might be permitted to reside next door, at No. 24, but he proved 'increasingly tyrannical', jealous and possessive, likening Jack's name to the smack of a whip.[19] At the end of March, Vanessa and Virginia heard the banns read in the church of St Mary Abbots, where their parents had been married, then there were clothes to be ordered; a suit for Leslie from Bond Street, for Adrian from Hyams in Oxford Street and for Virginia at Mrs Roberts in Westbourne Grove, where she was 'forced to wear certain underclothing for the first time in [her] life'. Stella's wedding dress was made by Mrs Young in South Audley Street, the 60 lb cake was ordered from Gunters at 63 New Bond Street, at a price of six or seven guineas. Stella experimented with her wedding hairstyle at a salon on Kensington High Street and Virginia purchased a lamp from Bensons in Bond Street for the couple's gift. Other presents began arriving: 170 in total by 3 April, which took 'three or four hours of labour' to unwrap, along with putting all the flowers in water and getting everything labelled before guests arrived to enjoy a 'scrumptious Charbonnel tea' with iced coffee.[20] The day before the wedding, Stella visited Julia's grave in Highgate Cemetery and stayed up talking with her brothers until two in the morning, while Vanessa and Virginia 'resolved to be calm and most proper behaved, as if Stella's marriage were nothing at all touching us'.[21]

On the morning of the wedding, Saturday 10 April, huge boxes of flowers and guests arrived at the house, as well as a Monsieur

Emile, who arranged the bride's hair. Stella and Jack gave Vanessa and Virginia beautiful gold watches as bridesmaids' presents, engraved with their initials. There were wedding favours to be made, combining orange flowers with white satin cockades, and there was new underwear to be struggled into before, adorned in their lace-trimmed dresses, the three sisters arrived at the church for the two o'clock ceremony. 'It was half a dream, or a nightmare,' the self-conscious Virginia confided to her diary; 'Stella was almost dreaming ... but probably hers was a happy one.' It was soon all over, the goodbyes were said and the couple departed, amid a scattering of white rose petals and red tulips.[22]

The following week, having seen the Hills off on their honeymoon to Italy, the Stephens headed to Brighton. Despite the wind and rain, they walked, cycled and visited their Fisher cousins, with Virginia also managing to keep up her reading, having taken works by Macaulay, Gaskell and Lamb with her. The weather eventually cleared up to allow them to take a day trip to Arundel Castle and search for primroses in the nearby woods. When they returned home on Wednesday 28 April, they were met at Victoria by George Duckworth, who explained that Stella and Jack had arrived back in Hyde Park Gate, and that Stella was in bed with a 'bad chill', being attended by a nurse while Dr Seton visited three times a day. Peritonitis was suspected, an inflammation of the lining of the abdomen, which was further complicated by Stella's realisation that she had already fallen pregnant. Despite rallying, her health continued to deteriorate. By early June, she was experiencing severe pain at night, causing Dr Seton to visit three times a day and advise her not to eat cherries or chocolate. On 10 July, the Stephen sisters attended the annual cricket match at Lord's between Eton and Harrow, and called in on Stella on the way home.

A few days later, Virginia fell ill, being 'miserable and achey with rheumatism', which developed into a fever. Having visited

Stella in the morning, she was due to go out for a walk with Leslie, but Stella wrote him a note explaining that Virginia was too ill to go. Dr Seton was summoned, and on 13 July, Virginia was put to bed in Jack's dressing room at 24 Hyde Park Gate, where she would remain for four days. On the night of 14 July, Virginia had 'the fidgets very badly',[23] and Stella sat up with her until almost midnight, stroking her until they went away and she fell asleep. The next morning Stella checked on her before going down to breakfast. It would be the last time Virginia saw her. As her sister worsened, Virginia was carried home, calling out goodbye through the open door, to where Stella now lay in bed. With Seton suffering from sciatica, two new doctors had been called in to attend the invalid, who now pronounced that an emergency operation was required. It was carried out at seven that evening; eight hours later, Virginia was woken to the news that Stella had died.

The rest of Virginia's diary for 1897 dwindles. The weeks following Stella's death were added retrospectively, with some days were not filled in at all, and others containing a few brief factual notes of visits and news of their extended family. Thoby and Adrian returned to school, Vanessa carried on attending art school and Virginia was judged well enough to attend lectures at King's College. Reflecting on the year, on 1 January 1898, weeks before her sixteenth birthday, she described it as 'the first really lived year of my life'. 'Still,' she urged herself, she should have 'courage and plod on,' as the years ahead 'must bring something worth the having.' Vanessa had told her that 'our destinies lie in ourselves ... here is life given us each alike and we must do our best with it.'[24] It was a ringing endorsement of life and hope, a glimmer of light shining out from the dark years of grief and illness that Virginia described as 'Oriental gloom'.

Into Society, 1898–1903

*To be tumbled out of the family shelter, to see cracks and gashes
in that fabric, to be cut by them, to see beyond them.*[1]

Following Stella's death, Vanessa was expected to step into her
shoes in more ways than one. As the eldest female in the household,
although she was only just eighteen, the burden of the household
accounts and Leslie's emotional demands fell heavily upon her
shoulders. The weekly cheque, which was presented to him for
signing each Wednesday afternoon, became an occasion for her
to dread because of his extreme emotional reaction. Occasionally
she colluded with Sophie the cook in advance, in a vain attempt
to make the household expenses appear less, or to cut costs, but
ultimately, the family enjoyed a standard of living that required
a certain level of expenditure. As Vanessa later conceded, 'none
ever considered it possible that cream should be limited', so she
spent hours 'classifying' expenses under the headings of 'doctor',
'education', 'furnishing' and 'sundries', which had to be balanced
annually in spite of her having 'no head for arithmetic'.[2] Bills
simply had to be paid.

Each week, she approached Leslie's study with trepidation and an increasing determination not to bend to his wild accusations. On these occasions, the characters of father and daughter combined to make a difficult situation worse. While Leslie demanded sympathy and emotional support – 'when he was sad ... she should be sad, when he was angry ... she should weep' – Vanessa became increasingly silent and unyielding, frozen 'like a stone', and refusing to respond, as a means of self-preservation. The more the 'skinless' Leslie declared they were on the verge of bankruptcy and headed for the workhouse, in spite of a healthy £3,000 in the bank, the more Vanessa was dismayed by his unreasonableness. Her son Quentin would describe these scenes as 'assaults', beginning with groans and sighs and escalating into bellows and sobs, accompanied by Leslie beating himself on the breast: he was 'ruined, dying ... tortured by their wanton extravagance.'[3] Vanessa, the stoic, 'the Saint', was incapable of subterfuge; witnessing this, Virginia would describe her 'devastating frankness' as alternately appalling and at times, comic,[4] but she always sided with her sister and had never felt such 'rage and frustration' at Leslie's behaviour.[5] The weekly drama drew to a close when Leslie had vented his emotion and finally signed the cheque, but the effect upon his relationship with his daughters was damaging. His violent displays of rage were 'sinister, blind, animal, savage. He did not realise what he did ... He suffered. We suffered.'[6]

But a second man was also clamouring for Vanessa's attention. Since Stella's death, her widower Jack Hills had been a regular evening visitor in the Stephen house and, in the summer when they took a house at Painswick, in Gloucestershire, he wrote daily and visited at weekends. With his father mostly absent in Egypt and a distant relationship with his mother in Corby, his grief over the loss of Stella, the loss of their future life together, drove Jack to return to the Stephens as the only people with whom he could share

his feelings. Virginia recalled a scene where they sat in a garden house and Jack gripped her hand, groaning, and saying 'it tears one asunder', referring to his grief and unsated physical desire. Even Leslie was sympathetic, although his comment 'Poor boy, he looks very bad' was sufficiently audible to reach its subject, which added to Jack's discomfort. The anniversary of his engagement to Stella fell during the uncomfortable Painswick holiday, when Leslie and George argued, and Jack and his sisters-in-law decided that everything had become 'hopeless and strange.'[7] At the end of the holiday, Jack urged them to accompany him north to the Hills family home and they reluctantly agreed.

That September, Vanessa and Virginia set out from Euston station for a week to Corby Castle, near Carlisle, an experience the girls found very difficult: 'Everything [was] grand and strange ... Mrs Hills talkative and rather unpleasant ... [Virginia and Vanessa] silent and miserable.'[8] Described in a guidebook of 1868, the castle was square and substantial, lacking Gothic features, but instead providing a good example of the modern style, 'surmounted by a well-executed collosal [*sic*] lion, which gives an air of princely beauty to the whole building'. There was a conservatory 'full of choice and beautiful flowers' and a 'flowing lawn' at the front, while the densely wooded walks had been explored and praised by the philosopher David Hume.[9] The grounds were superb, but the Stephen sisters found Jack's mother cold, aware that she was not fond of young women and nor, apparently, was she overly fond of her son. They were relieved to return home on 1 October, when the 'dismal' visit came to an end, having spent 'one of the most acutely miserable' weeks of their lives.[10]

Later that month, Jack stayed in the Stephen family home at Hyde Park Gate while his own house in Victoria Grove was being prepared but, by this point, his dependence on them had turned into something more personal. In particular, he was drawn

to Vanessa, as despite being ten years younger than Stella, she was very similar in looks. Her sympathy, her consolation and her beauty seemed to offer him promise; the ghost of a chance to recapture the love and life he had enjoyed so briefly and then tragically lost. Vanessa could not remain as unmoved as she did in the face of Leslie's emotional outpourings. With her favourite brother Thoby absent at school, then at Cambridge, entering a world from which his sisters were excluded, her own feelings for Jack began to develop.

And yet such a relationship had no future. The marriage of a man to his sister-in-law would remain illegal in England until the passing of the Deceased Wife's Sister's Marriage Act in 1907. The artist William Holman Hunt, well known to the Stephen family, had been placed in exactly this predicament following the death of his first wife, Fanny Waugh, in childbirth in 1866. Wishing to marry her sister Edith, he was forced to leave England for Switzerland, where such unions were legal, although it caused a considerable breach with his family. The episode was dramatised in a novel entitled *Hannah* by the popular author Mrs Dinah Maria Craik, who had accompanied Edith abroad as her chaperone. 'No blood-relationship, no tie of old-association ... it is my own affair,' justified Hannah, who had been summoned to care for her dead sister's child, much as Leslie had relied on the support of Anny Thackeray. 'It is a man's law [that kept them apart],' replied her beloved, 'because God is on our side ...'[11] Hannah's lover admitted to her, 'You are a saint – I am only a man,' but the Stephen family 'Saint' was falling in love with the broken, passionate man who had appealed to her for love from the depths of his grief.

In April 1900, George Duckworth took Vanessa to Paris, where they stayed in the Hotel St Romain on the Rue de Roche. The city, poised in that moment at the very vanguard of the fine and applied arts, heralding the birth of Art Nouveau and Post-Impressionism,

with its cafés and bars, its new Metro system to be opened that July, its blazing electric lights, its opportunities for artists arriving from all across Europe, left Vanessa 'frantic with excitement'.[12] Picasso was to make his first visit that October, arriving from Spain at the age of nineteen, into a city full of 'fanfare' and 'tinsel',[13] seeking out the artists in Montparnasse and Montmartre; the world of Renoir's *Moulin de la Galette* and Lautrec's *Moulin Rouge*. It is highly unlikely that Vanessa was taken to such places, or to L'Enfer Cabaret, the Lapin Agile or the Cirque Medrano that influenced Picasso's early years in Paris. George would not have considered them suitable, and Virginia was only half-serious when she wrote warning him against visiting 'improper studios' because of Vanessa's 'artistic temperament,' which he might find 'difficult to manage,' given that 'she had volcanoes underneath her sedate manner'. At Cope's school, Vanessa had already discovered she was most at home in the 'grubby, shabby, dirty world of art students' and 'wanted nothing else in the way of society', as in their company, art was the only currency and she could 'think of nothing but shapes and colours and the absorbing difficulties of oil paint'.[14] This was to be her epiphany and her salvation during these difficult years: her first taste of freedom, her refreshing alternative to the stuffy world of late Victorian society. Yet there were young women of Vanessa's age and class making their mark alone in Paris.

Many women with artistic ambitions who wished to escape the family home met with resistance; crossing the channel was seen as little more than an opportunity to misbehave, a thinly veiled metaphor for the loss of virtue. Kathleen Bruce, a sculptor who visited the city in 1901, wrote 'To say that a lass perhaps not out of her teens had gone prancing off to Paris to study art was to say that she had gone irretrievably to hell.' Often, the parents' fears were proven. The lure of *fin de siècle* Paris for young English women

was that of employment, romance and artistic experience in a city where the classes could mingle in the streets and in bed; a city where Baudelaire's flâneur might ply an innocent with absinthe while the piano played away the hours in a cheap café.

Three such girls who arrived in Paris in search of adventure in 1898 were Slade school graduates, and 'stars of their generation'. Ida Nettleship, Gwen John and Gwen Salmond enrolled in the famous private Parisian academies, considering that a year or two at Julian's, the Beaux-Arts or Colarossi's was worth far more than South Kensington 'correctness'. Living above a café, they frequented whichever art schools they could afford, made their own clothes, shared paints and endured criticism that they lived and looked like prostitutes. In fact, their experimental bohemian lifestyles validated their parents' fears. Ida would marry the flamboyant Augustus John, having to share him with his many lovers, and dying soon after bearing her fifth son in six years, while her sister-in-law Gwen became the lover of the much older sculptor Auguste Rodin. Only Gwen Salmond made something of a conventional match, to the artist Matthew Smith, and bore him two sons, although he left her soon after, claiming she was stifling his career. While they embraced Parisian liberties, the city could only open the eyes of the younger Vanessa, who would have to wait several years before she enjoyed similar freedoms.

Vanessa's excitement with Paris was not too dampened by George's sense of the correct, as he steered her through the Louvre and other sights. The famous Exposition Universelle had opened that month, offering talking films, escalators and exhibitions from all round the world, with an Art Nouveau theme. Picasso had been assigned to cover it for a Barcelona journal and his fluid charcoal sketch of himself and his friends leaving the exhibition depicts a motley crew in large dark overcoats, accompanied by two ladies in furs and fashionable hats. Covering almost 300 acres and involving

fifty-eight countries, it was attended by over 50 million visitors in the six months of its opening. Also visiting the exposition that June was Oscar Wilde, who would dine at a little restaurant on the Rue Jacob before entering the exhibition through a gate surmounted by a huge Parisienne which reminded him of Sarah Bernhardt; he particularly enjoyed visiting the Café de l'Egypte, one of the many enclaves of foreign lands recreated within. Thomas Edison, who had been welcomed as a celebrity in the city during the 1889 exposition, sent his employees and their kinetoscope back to film the city's most beautiful locations in 1900. At their stand in the American pavilion, Wilde was recognised, and recited part of *The Ballad of Reading Gaol* into a phonograph. The surviving Edison footage shows scenes of the Place de l'Opera with its horse-drawn omnibuses, the Champs Élysées, the Seine, esplanades and places with fashionable walkers, the 'moving boardwalk', the glittering Palace of Electricity and Eiffel Tower, much the same as Vanessa would have seen them.

Perhaps the Paris trip was George's attempt to divert Vanessa from her love affair with Jack. Her half-brother had certainly noticed the change in her feelings towards the widower and, after attempting to appeal to Leslie, who had stated that it was Vanessa's responsibility to sort out, George turned to Virginia. In the summer of 1900, the Stephen family stayed at Fritham House, Lyndhurst, in Hampshire, and there, one evening, George took her aside in the garden and explained that 'people were saying Vanessa was in love with Jack,' and Jack was behaving selfishly, along with 'more emotion and some vague threat about its being against the law'.[15] He asked Virginia to speak to her sister, and make her 'give up seeing him alone'. Virginia apparently attempted this, but immediately Vanessa's bitter response, 'So you take their side too,' brought her to a realisation that she did not. Thoby's feelings about the matter are unclear, but when some of their Fisher aunts

were 'particularly vicious' about it, causing Vanessa to avoid them, he rebuked his sister for being rude. The affair dragged on: as late as 1903 Virginia was able to record 'Jack back tonight, so beloved Nessa has her cisterns full again.'

George's concern for his sisters' social positions drew out over an uneasy few years at Hyde Park Gate. With the conventional expectation that they should meet a 'suitable' young man from the upper classes and settle down as wives and mothers, he embarked upon a campaign to launch them in society that Vanessa and Virginia found excruciating. Having come out at the age of eighteen, shortly before Stella's death, Vanessa had already attended her first ball and dinner party, wearing the beautiful opal necklace that George had given her and a dress of silk from Harvey Nichols, and had been something of a success, dancing all night and being 'the envy of all the other fine ladies'.[16] On 29 June 1897, Virginia had recorded that both Duckworth brothers had accompanied Vanessa to Mrs Young's, at 65 South Audley Street, where she was to have two dresses made. Sarah Fullerton Monteith Young was an eminent court dressmaker who had been based on or near Grosvenor Square since 1876; until her retirement in 1907, she would equip many leading Victorian and Edwardian society ladies with artistic gowns for their debuts and weddings. Virginia referred to her as 'Sally Young', recalling the long satin dresses for which she charged fifteen guineas. In the end, because of Stella's death, Vanessa's dress was made of transparent black material over a white underskirt, sewn with tiny silver sequins: 'One that could be called mourning, but exquisitely pretty.'[17]

Beautiful as it may have been, Vanessa's dress became a symbol of the transformation that George, and a certain circle of society, expected the reluctant Vanessa to undergo. It signified more than a move from the closed world of girlhood into the public sphere of courtship and marriage; it was the representation of her struggle

to reject the values of the Duckworths and Fishers and replace their gods with hers, in personal relations, her emotions, career and art, and this struggle would not find resolution for several years to come. Though she 'felt all the thrill of putting on such a frock, [she] still came to dread the sight of it, so miserable were the many evenings [she] spent covered in the filmy black and white and sparkling sequins'.[18] Decked out with the fashionable accoutrements, George's gifts of fans, gloves, brooches and the carnation that always arrived shortly before their departure, she accompanied him to dances, dinner parties and weekends, as well as riding in Rotten Row early each morning and paying Sunday afternoon calls. At his side, Vanessa was introduced to the crowded drawing rooms of the 'stiff matrons' of 'political and official circles' in the hope of finding a husband. They graced the palace where the novelist Mrs Humphrey Ward tried 'to continue the George Eliot tradition', Lady Arthur Russell's parties and the home of Austen Chamberlain near Birmingham, where Vanessa was pleased to find pictures from the Royal Academy and to be able to discuss moths with Austen's half-brother Neville. After this visit to Moor Green, George informed her that although her 'frocks had been admired, [her] hair was not well done and [she] knew [she] had been only a qualified success.'[19] It proved to be a difficult experience for both Vanessa and George, with many scenes ending in frustration or tears on both sides, until she refused to co-operate anymore. Eager to fulfil his responsibilities and find an outlet for his own sexual urges, George uttered vague threats that he would have to solicit a whore if unable to mix in society, and turned his attention instead to Virginia.

In her diary for 1903, Virginia recorded her dislike at the social world into which George now whisked her. The dinners and dances seemed somehow unreal, she always felt 'the outsider where everyone else is intimate' and recognised that she had

not cultivated 'the social gift'. In *A Dance in Queen's Gate*, her portrayal of the weary 'pale phantoms' who are 'sucked in by the music' and possessed by it, transforming them into a 'diabolical ... twisting live serpent, writing in cold sweat and agony'[20] conveys her repulsion at the social tyranny. Painfully awkward, perhaps she also shied from the physical contact at being 'shoved well into a thick knot of human beings ... all pressing hard against each others' backs and fronts ... like flies struggling in a dish of sticky liquid'. There was no sight 'so ugly and depressing as a room full of people none of whom you know'.[21] Decked out in finery, her clothing made her feel 'artificial', conscious of breaking a set of rules she didn't understand and incurring George's displeasure. To be successful, she concluded, 'One wants the courage of a hero.'

At Hyde Park Gate, there was also the daily tyranny of the tea table, for which Vanessa and Virginia were expected to forsake art and writing in order to replenish the cups of visiting relatives who flocked to the house, stirred by sympathy for the motherless girls. Later, Virginia laid the blame for the 'suavity' of her early articles on her 'tea table training'. She could recall her younger self 'handing plates of buns to shy young men' and asking them whether they preferred cream and sugar.[22] Formal society manners did not come naturally to her or Vanessa, as she clarified; 'We learned it partly from memory ... it was imposed on us by the other side ... no one ever broke the convention ... it was like watching a game, no one ever broke the rules.' And yet, she could admit, years later, that the Victorian convention had its uses, 'for it is founded on restraint, sympathy, unselfishness, all civilised qualities. It is helpful in making something seemly and human out of raw odds and ends'.[23] So she and Vanessa continued to descend to the parlour, she in her blouse and skirt, Vanessa pulling off her blue painting smock, to ensure that Leslie and his guests received their cups of tea promptly at five. Their brothers were not sympathetic; perhaps the struggles

of young women to defy patriarchal convention was less real for them, operating as they did within that system. As Virginia wrote of their 'very close conspiracy', she and Vanessa were 'always battling for that which was always being interfered with, muffled up, snatched away'.[24] However, once darkness descended on the house, another battle began.

SIX

The Thickest Emotional Haze, 1898–1903

It's not catastrophes, murders, deaths, diseases, that age and kill us;
it's the way people look and laugh, and run up the steps of omnibuses.[1]

What happened between George Duckworth and his half-sisters in
their bedrooms at Hyde Park Gate has been the subject of intense
biographical debate. The question Virginia raised in her memoir,
'What kind of material was George made of?' has been answered
with theories that veer between painting him as a perpetrator
of sexual abuse and a boisterous rogue. It has been suggested
by some authors that Virginia might have 'over-exaggerated'
his behaviour, or enjoyed it, while others have concluded that
because she maintained 'friendly' or 'cheerful' relations with
him afterwards, it must mean he did not overstep the lines
of propriety. It has also been asserted, incredibly, that as 'all
girls have to have some experience of male sexuality', George's
attentions, however unwanted, were 'no worse than most'.[2] These
unsympathetic responses stand in stark contrast to the statement
of Quentin Bell, that 'a first experience of loving or being loved
may be enchanting, desolating, embarrassing or even boring; but

it should not be disgusting … [a] mawkish incestuous sexuality' that forever trapped Virginia in a 'posture of frozen and defensive panic'.

Abuse takes a range of forms, from the explicitly sexual, including bodily touching, to the blurring of appropriate relationship boundaries. There was definitely a physical aspect to George's demonstrations of affection, but his intentions and the exact way in which he touched his sisters remains unclear. His character appears to have been one of demonstration and sentiment, wrapped in a lack of self-awareness, 'the thickest emotional haze', which made an uncomfortable contrast with the Stephen girls' perception and natural reserve. Although his intentions may have been to comfort them, there is no doubt that for Virginia at least, and most probably Vanessa, George's behaviour had a significant and life-long impact. Even a cursory glance at psychologists' accounts of those who experienced a range of abuses within the family unit, from verbal to sexual,[3] makes clear that the dismissal or normalisation of Virginia's experiences is, at the very least, unhelpful. The fact that Virginia disliked George's attentions and found them inappropriate but was powerless to stop them is sufficient to indicate the severity of her distress. If the culture of the twenty-first century still makes it difficult for young women to recognise and admit they are suffering from abuse, seek help and be believed, then for a young dependent female in the late Victorian era it was far worse. However, there were occasions when the sisters sought help or confided in sympathetic friends. In this case, it is imperative that the accounts of Virginia and Vanessa are permitted to stand on their own merit and eclipse the kind of biographical interpretation that has drawn definite conclusions about what George did or did not do.

Both sisters participated in a private verbal belittling of George, which became harsher over time. In 1921, Virginia described him

in terms of a strange hybrid animal, with the eyes of a pig, leaping like a kid, the 'sprightly faun [who] had somehow been hobbled together with a timid and conventional old sheep.'[4] He was 'abnormally stupid', greedy and prone to paroxysms of weeping; a paragon of the Victorian Christian English gentleman, a saint and a sportsman: in short, the opposite of everything Virginia was, and the symbol of a regime she rejected. In arguments, he would 'seize you in his arms and cry out that he refused to argue with those he loved' and 'everything was drowned in kisses'. According to Virginia, 'as his passions increased and his desires became more vehement ... one felt like an unfortunate minnow shut up in the same tank with an unwieldy and turbulent whale.'[5] This reduction of George to a base creature was an important part of the process by which Virginia acknowledged what he had done and distanced herself from it. It stripped him of his seriousness, his male sexuality and, consequently, the threat that he posed: ridicule had been the sisters' early weapon against his influence, a protective shield of solidarity and a device to help explain the inexplicable.

So what exactly, did George do? Virginia's 1921 memoir concluded with a revelation from when she was a young woman, drifting off to sleep.

> The door opened; treading gingerly, someone entered. 'Who' I cried. 'Don't be frightened,' George whispered 'and don't turn on the light, oh beloved. Beloved' and he flung himself on my bed and took me in his arms. Yes, the old ladies of Kensington and Belgravia never knew that George Duckworth was not only father and mother, brother and sister to those poor Stephen girls; he was their lover also.[6]

The following year, in 1922, she described the situation again: 'Long past midnight ... there would be a tap at the door; the light would be turned out and George would fling himself on my bed,

cuddling and kissing and otherwise embracing me in order, as he told Dr Savage later, to comfort me for the fatal illness of my father.'[7] If this was the limit of his fumblings, it would appear that the doubly bereft George was not just offering consolation but hoping for it too.

Vanessa appears to have endured George's attentions too. On his death in 1934, Vanessa hired a car and drove to his funeral, only to arrive too late. Instead, she put a handful of garden flowers on his grave and retreated but, on reaching home, she took up her pen to record the past. Although her memoir does not survive, Virginia's response to it does, casting further light on the mixed emotions their half-brother elicited:

As a matter of fact I feel more affection for him now than I did 10 years ago. In fact I think he had a sort of half-insane quality – I can't quite make out what – about family and food and so on. But your memoir so flooded me with horror that I can't be pure minded on the subject. I hope to goodness somebody went to the service – I wish I had been able to.'[8]

Was the 'horror' that Virginia felt, on reading Vanessa's account, the resurgence of old memories, or in response to new revelations? The sisters had discussed George's behaviour as early as 1904, when Vanessa raised her concerns with Dr Savage, in the context of Virginia's second serious breakdown, implying that she at least considered George to be a contributing factor to her distress. In 1918, Vanessa confided in her cousin Fredegond Shove about George's behaviour, in response to which Fredegond wondered whether he was 'conscious' of the overtly sexual nature of his behaviour and Vanessa suspected he was not. This would support the interpretation that the abuse was not of the same nature as that which Gerald inflicted on Virginia, but more of a blurring of relationship boundaries.

It may be significant that three months before her suicide, Virginia attempted an analysis of George's character and left the memoir unfinished. The different manuscript versions show that she edited out certain phrases such as 'he dreamed and desired with great natural lust' and 'George's embraces, and the fact that my father let us read whatever we liked, had taught us all that could be known of sex in theory from very early days.'[9] It is significant that Virginia selected the term 'lover' to refer to George; 'The old ladies of Kensington and Belgravia never suspected that George was their lover.' The word's ambiguity allows for interpretations which describe behaviour as well as approach, painting George as a suitor, as well as the modern, literal one of a couple being lovers in the physical sense. Taking the word in the context of the beginning of the twentieth century rather than the end would lead to a more innocent reading. Yet in her memoir 'Am I a Snob?', written in the year of his death, Virginia referred to George as her 'seducing half-brother', which can hardly be ambiguous.

Virginia also sought other suitable confidantes, speaking first to her tutor and friend Janet Case in 1911. On hearing of George's 'malefactions', Case confessed an 'intense dislike of him', and offered her own memory of having witnessed him 'fondling' Virginia while she was studying Greek. Yet even Case was shocked by his nocturnal behaviour: 'When I got to the bedroom scenes, she dropped her lace and gasped ... by bedtime she said she was feeling quite sick.'[10] Another society friend, Elena Rathbone, confessed to disliking George in 1922, whereupon Virginia remarked that 'if she had known all she would have hated him', then imagined Elena spreading the news, followed by George's resulting social disgrace and suicide.[11]

Why was Virginia not more explicit in her descriptions? She left no doubt in her account of Gerald's molestation of her as a child, providing the detail that his hands went under

her clothing and touched her private parts. Yet she does not describe George's behaviour in similar terms; in fact, her phrases 'otherwise embracing', 'the bedroom scenes' and 'our doings' are uncharacteristically vague. There may have been a number of reasons for this. Firstly, it simply may be that George did not touch her unclothed body in an intimate way compared with Gerald's exploration of her genitals. Or, conversely, perhaps he did so in a way that was so intrusive that she did not wish to describe it. Secondly, she was condensing a series of incidents into a single anecdote, although the nature of George's attentions varied on specific occasions. Also, there was the credulity of her story to be considered. When Virginia addressed her abuse in letters or in conversation, she chose sympathetic women friends as her recipients, all of whom expressed a predisposition to dislike George. In private letters she repeatedly referred to him as her 'incestuous brother'. When she read her memoirs in the early 1920s, her audience were old friends, but a large number of them were men, who had encountered George in his public capacity. Perhaps Virginia was recalling the occasion when Vanessa's account of their father's histrionics had been dismissed by a cousin who had not found them compatible with his view of Sir Leslie Stephen. Even Leonard Woolf, writing in the 1960s, felt able to describe George as 'an extremely kind man and, I think, very fond of Vanessa and Virginia'.

There may have been further reasons why Virginia did not record events in more detail in the early 1920s. By this point, she was assessing the past from the platform of time, but that past had many layers. At forty, she had a different understanding of the complexities of character, emotion and perspective: time may have distanced her from the small child who was abused in the late 1880s at St Ives, but less so from George's intense demands. Distressing as it had been, Gerald's behaviour had

sprung from an adolescent curiosity and appears to have been a single incident. This places it in a different category from George's, which had been inflicted by an adult man upon her fully conscious adult self, in her own bedroom. The complex conflict of family affection may also have affected Virginia's declaration of 1921. As she later explained, George's behaviour did not mean that her feeling for him as a brother was entirely eradicated: in fact, the co-existence of love and loathing goes a long way to explain the unsatisfactory nature of her revelations. Whether she liked it or not, the Duckworth brothers were intimately connected with every aspect of her childhood, as two of the few remaining figures with memories of their mother and the early years of happiness. It is impossible to know, from her accounts, whether he was seeking the emotional comfort of caresses or if there was any sexual contact with either sister. According to Jack Hills, George remained a virgin until his marriage, at the age of thirty-six. Is it possible that he would not even recognise any identification of his behaviour as inappropriate? Virginia's ambiguity is inconclusive.

Yet some biographers have suggested that the revelation she made in 1921 to the Memoir Club was part of a conscious literary process, a quest to engage her audience. Of course, as a writer on the verge of revealing an intimate secret, a taboo of long-standing, Virginia would certainly have considered the effect of her words upon her friends and chosen them carefully. Yet perhaps the significance of her taking this step has been underestimated. George's abuse may have provided the finale to her piece, and she may well have revised and edited her words, as much from self-preservation as the artist's craft, but this does not invalidate her material. Her mortification at John Maynard Keynes's comment that his favourite piece of her writing was her 'memoir on George', and that she 'should pretend to write about real people and make it all up', reveals that her distress was more

the result of her friend's disbelief than the failure of her memoir on an artistic level. Rather than being exaggerated for effect, it is likely that the edited piece rejected a more detailed and explicit approach to George's antics, which Virginia decided it was not wise to take. She was aware that her listeners already thought her too harsh on her half-brother. As Quentin Bell relates, friends of the sisters were 'a little astonished at the unkind mockery, the downright virulence' with which they referred to the Duckworth brothers and some biographers have followed this lead, seeking to explain Virginia's account by equating George and Gerald with the high Victorianism the women felt compelled to reject. Certainly Vanessa and Virginia were rejecting both cultural and sexual repression, with good reason. The fact that Virginia brought up the subject at the club again in 1922 implies that its initial reception had fallen short of her hopes.

Virginia's account establishes that she was sexually abused by Gerald as a child at St Ives, on at least the single occasion that she recalled. When it comes to George's behaviour, though, her comments are sufficient to prove an uncomfortable level of emotional and physical intimacy, although they imply a lot more. Whether or not George engaged them in sexual acts, as some biographers have asserted, it was enough that he overstepped a boundary from fraternal concern into territory the sisters considered abusive. At the very least, the sexual frustration of his 'chaste' life led to a displacement of inappropriate affection. According to the classification of psychological counsellor Dr Dan B. Allender, the types of sexual abuse Virginia experienced are 'severe' in terms of Gerald's interference, while George's 'violation of the physical/sexual boundary' and his use of both sisters as a 'spouse surrogate' or intimate companion established a significant and persistent state of psychological abuse.[12] The correlation of these experiences with Virginia's mental health can only be matter for speculation.

While the demands of Leslie, Jack and George had to be endured, Vanessa and Virginia found satisfaction in developing their own talents as an artist and writer. In September 1901, Vanessa began attending the Royal Academy School at Burlington House on Piccadilly, as one of only twenty students admitted that year. Although it had been founded as early as 1769, the first woman artist had not been admitted until 1860, but the numbers had swelled by the time of Vanessa's arrival. For many of the girls' parents, though, it was still considered a finishing school before marriage, rather than the beginning of a real career. A catalogue surviving from an Academy exhibition that ran from January to March 1901 includes works by notable artists in the style the school favoured, such as Millais, J. M. W. Turner, Burne-Jones and Lord Leighton. The Academy though, was in transition. Traditional methods were favoured, with classes given in drawing from life and from the antique, and lessons on anatomy, perspective and composition. Genre painting and portraiture were still taught but, increasingly, the influence of the plein-air painters and naturalism was being felt, from the French school led by Jules Bastien-Lepage, which had also inspired the Impressionists. Taught by her mother's cousin Val Prinsep, as well as the feted society portraitist John Singer Sargent, Vanessa was encouraged to consider the effects of lighting and tone, as practised by Whistler and Monet. Vanessa's first taste of Monet and his circle came from a copy of Camille Mauclair's *The French Impressionists*, which was translated into English in 1903, and inspired her to attend one of art critic Frank Rutter's lectures at the Grafton Galleries. As Virginia wrote in the autumn of 1902, 'Nessa has Sargent at the Academy now' who was 'worth all the other teaching she's ever had. And she likes him – his voice – even his green eyes,' and especially the approving comments of her work, which made her fellow students jealous.[13]

One of the friends Vanessa made at the Royal Academy was

Margery Snowdon, to whom she wrote on several occasions in 1903 about art, artists and teachers. That March, she and George spent the weekend at Limnerslease, Guildford, the home of her parents' friend G. F. Watts. From there, she described Watts' current work, which was precise and traditional, where 'every leaf is cleanly painted ... no smearing ... as a protest against impressionism'.[14] Watts explained style to her in classical terms, with the harmony of movement and line, and rejected the error of 'modern art' as 'trying to make things too real', which Vanessa dutifully relayed, although she was in the process of forming her own ideas about artistic purpose and methods.[15] That autumn, she updated an absent Margery about Sargent's current teaching methods at the Academy, which were 'chiefly about tone' which was to be achieved by 'painting thickly'. However, she didn't find this instruction 'very clear' and her own attempts were criticised by her teacher as being 'too grey', while other students were 'squashed' for attempting effects 'regardless of truth'.[16]

In 1903, Virginia wrote an account in her diary of their visit to the Royal Academy's annual reception, a 'great and gloomy place' where they shed their cloaks 'in a kind of catacomb, damp, with stone arches'. She caricatured two kinds of women present as falling into either the 'society' or the 'artistic' camp. The former were 'exquisite in old lace and most refined evening gowns', knowing themselves to be the 'Queens of the gathering', while the latter wore 'amber beads and low evening collars', or the 'clinging Liberty silks, outlandish ornaments' and a 'strange dusky type of face'. Although the rooms were full, Virginia did not feel able to talk due to the 'public gallery feeling' and preferred to drift about, 'gazing at human pictures ... with snatches of desultory talk.'[17] Interestingly, she saw herself and Vanessa as removed from these social distinctions, as observers, almost flâneurs, anonymous, 'Of course there were too others like ourselves, of no particular

description,'[18] and at this time they were in a kind of social stasis, moving away from the society life they rejected, into a new artistic milieu.

In her diary, Virginia was also experimenting with different writing styles in order to convey truth. Back in 1899, the summer before Thoby started Cambridge, she had kept an experimental journal while the family were on holiday at Warboys Rectory in Cambridgeshire. The 'melting grey of sky, land and water' prompted her to picture herself as a ship-bound Norseman frozen into ice, shooting seals and walruses, 'a solitary creature dependent on winds and tides'. In the local churchyard of St Mary Magdalene, she sensed she was 'walking over some ancient dust forgotten and undistinguished from the hillocks of the field', and sat in the evening, amid the swooping bats, gazing up at the Pole star. She portrayed country life, with the harvesters in bonnets and aprons, heaping up the cut corn: a woman of seventy with 'white scanty locks and a wrinkled sun burnt wind scourged face' and a child of no more than four in a 'bright scarlet frock', trotting behind with 'a small armful of gleanings'. She included the history of the place, character sketches, bike rides and setting moth traps, garden parties and expeditions, until the beauty of the Fen country had completely won her over. It was a diary of impressions and sketches, focused on composition and language, rather than the more prosaic record of events that she had made two years previously. Self-conscious and mindful of an audience, certain phrases detach her from the experiences of the teenaged Virginia on holiday and align her with Virginia the author: 'Picture us uncomfortably seated on a towing path' and 'How can we describe the scene that followed?' and 'A showery day with wind and watery clouds is excellent material for a sunset.'

Inspired by Thoby's accounts of his lessons at Clifton, which were relayed to her while the pair marched up and down stairs,

Virginia began to study Greek and Latin in 1897 under the watchful eye of Dr George Warr. The classes were held at the Ladies' Department of King's College, London, although Virginia did not sit any formal examination. In 1899, she received private lessons from Clara Pater, sister of Walter Pater, and the following year from Janet Case, who had been educated at Girton College, Cambridge. Virginia was taught by Miss Case twice a week, and would spend three hours in the morning, from ten until one, preparing for the lesson which followed. Quickly it appeared that much of her previous learning needed to be undone and Miss Case returned her pupil to the rudiments of Greek grammar before beginning her translations afresh. Virginia and Vanessa were also both attending a range of lectures at King's College, London, and in 1902, undertook a course in book binding. Yet there was one friend from this period whose influence on Virginia would be more significant.

Violet Dickinson was a remarkable woman, seventeen years older than her young charge, who had previously been a background figure in Virginia's life. She had been a close friend of Stella Duckworth, first recorded in Virginia's diary as attending the fitting of her wedding dress at Mrs Young's on 2 April 1897. After Stella's death, she stepped into her shoes to care for the Stephen sisters; soon though, it was clear that a particular friendship had developed between her and Virginia. Philanthropic and generous, the niece of novelist Emily Eden and granddaughter of the Bishop of Bath and Wells, Violet had been Mayoress of Bath in 1899 and took particular interest in women with mental illness, paying visits to such cases in London hospitals. In the summer of 1902, she was thirty-seven and Virginia was twenty when Violet filled the role of mentor, teacher, friend and substitute mother. In their affectionate correspondence, Virginia referred to them as a pair of pumas, and signed herself as 'kangaroo', 'wallaby' 'sparrow' or 'sparroy',

different animal identities to those she used with Vanessa. She felt secure enough with Violet to beg her to 'put some affection into [her] letters, like sugar in otherwise rather bitter tea', and she felt possessive when Vanessa was the object of Violet's attention, 'filching' her from Virginia. Standing over six feet tall, Virginia could feel safe wrapped up in Violet's affection, as one surviving photograph shows. She visited the family in the summer of 1902 at Fritham House in the New Forest, which they had taken for a third consecutive year, where Virginia extolled her virtues in a sketch entitled 'Violet Dickinson at Fritham': a 'very high spirited, rather crazy, harem-scarem sort of person ... slightly ridiculous, warm hearted and calculated to make the success of any kind of party'.[19] With a London home in Manchester Square and a country house which she had designed and built herself at Burnham Wood, near Welwyn, Violet offered a friendship which was to provide an important outlet for Virginia during these difficult years. The heaviness and oppression of Leslie's personality coupled with their struggles for independence made this a turbulent period in the sisters' development.

Cambridge, 1899–1904

But now with these I finished
And burned my books and gone to bed
And bowed to Mephistopheles
I've done with all philosophies.[1]

For one member of the Stephen family, the Oriental gloom was about to be lifted. On 3 October 1899, Thoby Stephen entered Trinity College, Cambridge, as a nineteen-year-old undergraduate. In her 1922 novel *Jacob's Room*, Virginia described her eponymous hero, based on Thoby, through the eyes of a woman sharing his train carriage: 'Taking note of socks (loose), of tie (shabby), she once more reached his face. She dwelt upon his mouth. The lips were shut. The eyes bent down, as he was reading. All was firm but youthful, indifferent, unconscious.' Leslie recorded in his *Mausoleum Book* that he had seen Thoby off, presumably from King's Cross, after he had 'left Clifton on very good terms ... and distinguished himself chiefly as an essayist', adding that he had weighed 13 st. 8.5 lb after lunch.

Trinity College was one of twenty-three Cambridge colleges in

1899 (there are now thirty-one), and had been founded in 1546, when Henry VIII combined the existing colleges of King's Hall and Michaelhouse. The buildings dated from a mixture of eras, combining medieval, late Elizabethan and Victorian, like the yellow stone of 1860s Whewell's Court, where Thoby had his rooms. Although Leslie was an honorary fellow of the smaller Trinity Hall, the reputation of its larger neighbour preceded it, with recent alumni including Edward VII, prime ministers Arthur Balfour and Stanley Baldwin; authors Edmund Gosse, A. E. Housman and Erskine Childers, Egyptologist Lord Carnarvon and anthropologist Sir James Frazer. Yet despite its centuries of history and tradition, it was at Cambridge that Thoby's eyes would be opened. Along with a group of his contemporaries, he would begin to see his world clearer. Virginia's novel included the question, 'Is it fanciful to suppose the sky, washed into the crevices of King's College Chapel lighter, thinner, more sparkling than the sky elsewhere? Does Cambridge burn not only into the night, but into the day?'[2] Here, at the turn of the century, a group of young men would begin to see through the Victorian gloom, to reject the values of their parents' generation. Their iconoclasm was the crucible of the Bloomsbury group.

One of the best contemporary accounts of Cambridge through the eyes of the undergraduates in 1899 comes from *Sowing*, the first volume in the biography of Leonard Woolf. The third son of a large Jewish family from Kensington, a mere twenty-minute walk from Hyde Park Gate, Leonard had won an exhibition and partial scholarship to read Classics, which enabled him to enter Trinity on the same day as Thoby. It was 'terrible and terrifying, but also exhilaratingly exciting'. On that first day, when he 'walked through the Trinity Great Gate into Great Court on [his] way to the rooms at the top of a staircase in New Court ... [he] trod cautiously, with circumspection, with no exuberant hopes'. He knew no one and,

at first, was 'terribly lonely'. Then, however, after an exchange of words with a young man in the passage connecting the courts, 'everything changed ... I found to my astonishment that there were a number of people near and about me with whom I could enjoy the exciting and ... profound happiness of friendship'. His new friends were Thoby Stephen, Clive Bell, Lytton Strachey and Saxon Sydney-Turner.

Through Leonard's eyes, Thoby, known as 'The Goth', gave 'an impression of physical magnificence'. He was tall, broad-shouldered and well-built, although his small head was reminiscent of 'the way in which the small head is set upon the neck of a well-bred Arab horse'. His character, common sense and judgements were 'monolithic', reminiscent of Samuel Johnson, whose style he evoked in his own writing, which was rather eighteenth-century in its formality, while being flexible, lucid and natural.[3] According to Woolf, he had immense personal charm, 'partly physical, partly due to the unusual combination of sweetness of nature and affection with rugged intellect and a complete lack of sentimentality'. He loved literature and the outdoors, particularly walking, wildlife and bird watching: Leonard sometimes accompanied him roaming around the Cambridge countryside, when he followed what was almost 'a Stephen principle in walking, to avoid all roads and ignore the rights of property owners and the law of trespass'. It was a striking metaphor for their different backgrounds, which Woolf would later characterise as privilege versus cowardice.[4]

Leonard met the Stephen family on several occasions during their Cambridge years, finding them 'formidable and even alarming' to a 'nervous undergraduate', a 'young man like me'. The first encounter took place when Leslie was visiting for the weekend, a 'bearded and beautiful Victorian old gentleman of exquisite gentility and physical and mental distinction on whose face the sorrows of all the world had traced the indelible lines of noble

suffering'. A year or so later, when he saw Leslie again, old Mr Stephen was 'stone deaf' and communication was only possible by shouting into his ear trumpet. In spite of this, Leslie still conveyed his 'immense charm' and could 'see through our awkwardness and even grubbiness to our intelligence and was pleased by our respect and appreciation'. By the end of the meeting, they were 'all talking and laughing naturally', ear trumpet permitting. He found Vanessa and Virginia 'just as formidable and alarming as their father, perhaps even more so'. His first sight of them was in Thoby's rooms in the summer of 1900, when their beauty, offset by white dresses, parasols and large hats, 'literally took one's breath away'. Perhaps it was the occasion when they attended the Trinity May Ball, with their Fisher and Maitland cousins. On the surface, Vanessa and Virginia were the 'most Victorian of Victorian young ladies ... silent and ... demure', although the 'observant observer would have noticed at the back of the two Miss Stephens' eyes a look which would have warned him to be cautious, a look which belied the demureness, a look of great intelligence, hypercritical, sarcastic, satirical'. He thought that in their features, the Pattle 'saintly duck dying loveliness' was tempered by the 'more masculine' Stephen good looks. 'It was almost impossible for a man not to fall in love with them,' Leonard confessed, 'and I think that I did at once.'[5]

Nor was Leonard Woolf to be the Stephen girls' only conquest. Another undergraduate from the 1899 intake slotted less easily into the intellectual milieu gathering around Thoby. The red-haired, baby-faced Clive Bell had been raised in a typical 'hunting, shooting, fishing' county family in Wiltshire, more a 'blood'[6] than a thinker, whom Leonard first saw crossing Great Court 'in full hunting rig-out', including hunting horn and whip.[7] Yet thinking is exactly what Clive began to do, inspired by his love of poetry to break away from his 'wealthy philistine'[8] relatives and pursue

his passion for culture. Having attended Marlborough, he studied history and hung a Cezanne in his rooms. Also enrolled on the same course was Giles Lytton Strachey, who cut a striking figure with his long limbs, squeaky voice and Voltairean mind.[9] One of ten children born into a colonial family and raised in Lancaster Gate, overlooking Kensington Gardens from the north, it was Strachey's caustic comments to unsuspecting undergraduates which prompted Leonard to suggest that a notice be placed on the arm of his chair, reading, 'Be careful, this animal bites.' Another early friend was Saxon Sydney-Turner, a short, pale man whose bodily stillness and habitual silence concealed an immense intelligence. The son of a doctor from Brighton, he had attended Westminster School before enrolling on the classics course at Cambridge, impressing Leonard as 'an eccentric in the best English tradition' with 'an extraordinary supple and enigmatic mind'. Placing literature, argument and truth at the heart of their pursuits, these friends resigned themselves to not being popular among the college athletes and county set: the 'little men in waistcoats' as Thoby used to call them.[10]

Missing lectures and cricket matches alike, they shone instead in the Shakespeare Society. A surviving photograph shows nine young men in three-piece suits and straw boaters, with Thoby standing staring back at the camera, hands in pockets, while Lytton and Leonard sat with their legs neatly folded. Straining against even this group's limitations, they founded their own X Society, to read plays by other Elizabethan and Jacobean dramatists, then graduated to Ibsen and Shaw and found their message to be of 'tremendous importance'. Sixty years later, Woolf recalled Shaw as one of the 'leaders in the revolutionary movement of our youth' and one of the primary tenets of Bloomsbury emerged at this time from his work: the need for absolute candour. Woolf cited the playwright's words, that

idealism, which is only a flattering name for romance in politics and novels, is as obnoxious to me as romance in ethics or religion ... I can no longer be satisfied with fictitious morals and fictitious good conduct ... I do not see moral chaos and anarchy as the alternative to romantic convention and I am not going to pretend I do merely to please the people who are convinced that the world is only held together by the force of unanimous, strenuous, eloquent, trumped-tongued lying.

Along with Thomas Hardy, whose controversial novel *Tess of the D'Urbervilles* deeply impressed Woolf, the young men considered Shaw and Ibsen to be their leaders, the causes of change, 'so much involved in this struggle of ideas and ideals'.[11]

The Cambridge experience of Thoby and his friends, this early embryonic version of Bloomsbury, was essentially social. As Leonard admitted, they rarely ventured out of their colleges, and then only to purchase books. After the X Society had met at 8.30, they moved on to Clive's rooms for the Midnight Society, where literature was read aloud, pipes were smoked and topics strayed into the unusual. Thoby was also a member of the Sunday Essay Society, which discussed questions relating to religion, and attended the regular Thursday evenings of philosophy don J. M. E. McTaggart, a follower of Hegel's theories and an idealist who was, like Thoby, an alumnus of Clifton. There were reading parties, where they devoured and discussed the novels of Henry James, Flaubert and Dostoevsky, of Fielding, Richardson, Austen and the Brontës at remote country pubs. Walking in the Trinity cloisters at night, listening to nightingales singing over the Backs,[12] they chanted Swinburne with passion. They sat up until the early hours, passing the time in debate, reading, games or silence: on one occasion Saxon was the object of the 'method', a rigorous process of pseudo-Freudian questioning developed and administered by

Lytton and Leonard, intended to expose the true soul of the interviewee. Their usually taciturn victim was finally permitted to stagger off to bed at five in the morning.

In a character sketch of Thoby, decades later, Virginia described the importance of his friendships. When he came home for the holidays, he would tell her stories about his companions, which went on and on, as 'he had a great power for admiring his friends, for liking them'. He could 'enjoy their gifts to the full ... was always amused by them, admired them, saw a great deal in them, and yet I think he felt himself in his own way their equal'.[13] She recognised Thoby's powerful mind, so different from her own, as he 'mastered' things rather than guessed at them, or felt them intuitively, as she did. His essays showed great intelligence but he was 'not precocious'; he held his own, with a 'stock of his own power' and 'dominated his friends in his own way'. He had a blend of 'mastery and sensibility, of friendliness and composure' and yet from under his reservation, which would not allow 'a word of feeling' to escape, 'there would creep out a curious sympathy, a pride in us'. On his return to Hyde Park Gate during the holidays, he would be 'amused, surprised', even 'questioning' towards Virginia, a shell-less little creature ensconced in her bedroom, reading Greek while he was 'writing ... for a prize at Trinity'. He had 'consumed' Shakespeare and they argued heatedly about books, when she rejected his 'sweeping statement' that everything was contained in the author's plays. In 1901, she wrote to him about the characters in *Cymbeline*, complaining about their abstractness, comparing Jonson and Marlowe, and complaining, 'Just as I feel in the mood to talk about these things, you go and plant yourself in Cambridge.'[14] She pictured him sitting in the corner, a pipe in his mouth, with the unperturbed look of one who 'knew his place ... relishing his inheritance and his part in life, aware of his competence, scenting the battle: already in

anticipation, a law maker, proud of being a man and playing his part among Shakespeare's men'.[15] Thoby's family nickname, the Goth, suggested something monolithic, or 'Napoleonic', as one of his aunts called him; later characterised as Jacob, or Percival,[16] his blend of intelligence, physical attractions, confidence, bodily ease and common sense drew this circle of Cambridge friends to his side, although lack of other documentation leaves him rather a shadowy, elusive figure in their colourful midst.

While friendship took precedence over academic pursuits, establishing the lifelong connections of the future Bloomsbury group, certain figures loomed large as gods to the students. Recording his time as an undergraduate, philosopher Bertrand Russell met G. E. Moore, then a fellow of Trinity and advocate of common sense over idealism, whom Russell and many others considered to be the fulfilment of their ideal of genius. He had 'a look almost of inspiration, and with an intellect as deeply passionate as Spinoza's. He had a kind of exquisite purity. I have never but once succeeded in making him tell a lie, [and] that was by a subterfuge.'[17] Leonard described Moore's mind as 'an extraordinarily powerful instrument; it was Socratic, analytic ... He had a passion for truth, but not for all or any truths, only for important truths.' He could not tolerate 'anything but truth, common sense and reality' and had a genius for seeing 'what was important ... he pursued the most relevant and ignored the irrelevant with amazing tenacity'.[18] In 1899, Moore was still only twenty-seven, but it was a significant enough age gap for Thoby's circle to revere his maturity and absolute candour. His oft-repeated statement, 'I simply don't understand what he means,' became a mantra for the younger men, even infiltrating the Stephen home, where Virginia grew irritated by Thoby's insistence that she clarify her meaning exactly. In 1903, Moore published *Principia Ethica*, which became something of a bible for the Bloomsburys, providing

them with a structure for living in what seemed like an otherwise meaningless world.

These beliefs were crystallised in Cambridge's most elusive society. The Apostles, or Cambridge Conversazione Society, had been founded in 1820, evolving into a discussion group in which members took turns presenting topics to a select audience gathered in their room on a Saturday evening. The numbers were limited to an apostolic twelve, and Moore and Russell were already established members when Lytton was elected in February 1902, signed the book and swore the oath, or 'curse'. He became secretary that October and probably proposed the two new 'embryos' (potential members), Leonard and Saxon, who were admitted soon after, although Clive was considered unsuitable and Leonard's wish to admit Thoby was rejected amid concerns that he would be bored by the club.[19] Other members who had graduated became 'angels' and returned for annual dinners or attended talks when they were in the city: one surviving list of attendees from a meeting at the Royal Palace Hotel, Kensington, included civil servant and patron Eddie Marsh, artist and critic Roger Fry, journalist Desmond MacCarthy, classicist J. T. Sheppard, critic C. P. Sanger, poet R. C. Trevelyan and economist John Maynard Keynes. There was a tone of irreverence, absurdity, extravagance and even ribaldry: Leonard explained that they were serious about what they considered 'serious in the universe or in man and his life', but felt no obligation to be solemn, and that there were 'practically no questions or situations in which intelligent laughter may not be healthily catalytic'.[20] In 1902, the society debated the question 'Why laugh?' while early in 1903, Leonard was moderator for a debate in which Lytton, Saxon and others explored the topic 'What is style?' In 1904, the topic of 'Eggs or omelettes?' followed the usual Apostolic line of using an apparently simplistic dichotomy to conceal a more serious subject

for debate. Topics debated by Roger Fry in the 1880s included 'Ought we to be hermaphrodite?', 'Shall we wear top hats?' and 'Shall we sit on the safety valve?'

It is interesting that Leslie never considered sending Virginia to university. Vanessa's artistic ambition determined the route of her education, but Virginia's intense study of Greek and wide reading among history and literature would have been solid preparation her for the 'Little Go', the entrance examination to Cambridge, and any deficiencies in mathematics or Latin might have been rectified with the aid of a tutor. Two of Lytton Strachey's sisters were to attend university, Pernel at Newnham College, of which she became principal in 1923, and Marjorie at Royal Holloway in 1902, then at Somerville College, Oxford. Just like the men, their Cambridge sisters established their own societies, including the Friday Reading Club, to which Pernel was invited, a Sharp Practice Society for music and a Sunday Society for discussion. In addition, Leslie's niece Katherine Stephen overcame her parents' resistance to work as the secretary to Newnham's vice-principal in 1886, before filling the vice-principal position herself between 1911 and 1920. Certainly this connection could have been of assistance to Virginia, had the possibility of her attendance at Cambridge been raised at Hyde Park Gate. Yet it was never considered a viable path for her. Julia, certainly, had opposed the women's suffrage movement and Virginia recognised that had Leslie lived, she would never have become a writer. For a woman, a university career was seen as incompatible with marriage, of which Julia had been the embodiment, frequently acting as matchmaker among her young friends. Perhaps Virginia's frail health was taken into account, although it seems more likely that the Stephens were less forward-thinking when it came to the education of women than the outspoken feminist Jane Strachey.

Virginia fought to be part of Thoby's experiences at school,

first at Clifton when they discussed Greek and Shakespeare, but especially after he had gone up to Cambridge. She wrote to him early in November, just a month after his arrival, apologising for using a 'cartload of goatisms' (her sayings) and maligning Christopher Marlowe, whose work she had since been reading and enjoying more than she thought she would. Her letter strikes a balance between having a light-hearted and affectionate tone and being a serious academic enquiry, about characterisation and the nature of Elizabethan drama, perfectly illustrating her position as an outsider of the education system and exposing just how suitable she would have been as a student with her intelligence, wider reading and enquiring mind. 'What a dotard you must think me,' she offers Thoby, as a mask for her gender and culturally perceived inabilities, even as she admits being compelled to write and offer her thoughts.[21]

It was an invigorating time for the young men of Trinity College, coinciding with a period of immense social change. According to Leonard, they sensed they were living 'in an era of incipient revolt' and were 'mortally involved' in the rejection of a 'social system and code of conduct and morality', which he labelled as bourgeois Victorianism. This was defined as the struggle for freedom of speech and freedom of thought, of common sense and reason in the face of a 'religious and moral code of cant and hypocrisy'. They rejected 'traditional wisdom' and the authority of experts in favour of truth, beauty, works of art, friendship and love. Everything was new, anything was possible and they had big ambitions: Leonard, Thoby, Lytton and Saxon all wanted to be writers, and that victory or defeat in the battle to forge a new world depended 'to some small extent upon what we did, said or wrote ... We were in the van of the builders of a new society which should be free, rational, civilised ... It was all tremendously exciting.'[22] Yet the significant death that acted as the catalyst for the birth of Bloomsbury was

not so much the eighty-one-year-old Queen Victoria, who passed away at Osborne House on the Isle of Wight on 22 January 1901, but the end of Leslie Stephen, who died at Hyde Park Gate on 22 February 1904.

Part II

THE NEW EDWARDIANS

Freedom, 1904–1906

The drawing room had greatly changed its character ... the Sargent-Furse age was over. The age of Augustus John was dawning ... The door opened and the long and sinister figure of Mr Lytton Strachey stood on the threshold.[1]

Leslie's funeral took place at Golders Green on 24 February, after which his ashes were scattered on Julia's grave in Highgate. Even more consequential than the loss of her mother, his death was perhaps the most significant event of Virginia's life, allowing her and her siblings to step out of the Victorian shadows and into the artistic and moral clarity of Edwardian modernism. She would later assert that without his death there would have been no Virginia Woolf, no novels, no authorship. Yet, while the event opened the door of the 'cage' of Hyde Park Gate, it was also to imprison Virginia within the confines of intense grief and guilt over the loss of a father to whom she had grown particularly close.

The young Stephens immediately escaped the Victorian gloom of Hyde Park Gate for the bracing cliffs and seascapes of Manorbier in Wales. Situated on the dramatic Pembrokeshire Coast and

overlooked by a Norman Castle, the four took a house in the town, near the picturesque church. Virginia walked by the sea and wrote long letters, while Vanessa painted Thoby seated in the window, and the view beyond. The freedom and the fresh air were exhilarating, but Virginia was riddled with regret for the recent past and full of doubts about their future. Leslie's slow decline and the constant visits of well-meaning relations had made 'the waiting ... intolerable',[2] but the closeness of his children had been a reassurance at the end; 'It comforts me to think that you are all so fond of each other that when I am gone you will be the better able to do without me', he stated. However, although his children were close in many ways, when it came to confiding in each other about their grief, they were still bound by a very Victorian reserve and stiff upper lip approach. As Virginia confessed shortly before his death, 'We are the sanest family in London and talk and laugh as though nothing were happening ... We should never get on without this kind of thing.'[3]

Yet the memory of her father's final years gnawed at Virginia. Writing to Violet, she confessed her fear that she 'never did enough for him all those years ... if he had only lived, we could have been so happy ... if one could only tell him how one cared, as I dreamt I did last night'.[4] As in 1895, one of the most difficult aspects for Virginia was the inability to communicate this directly – 'It's so hard to talk, even to one's own brothers and sisters' – especially when her mood did not chime with theirs. Vanessa was revelling in her new-found freedom, 'her happiness in being delivered from the care and the ill-temper of her father was shockingly evident', and Virginia was shortly to describe Thoby and Adrian's antics as 'rampant', with Thoby roaming over the hills watching birds and chasing foxes.[5] She was relieved, though, when George's visit to them in Wales came to an end and he returned to London, proposing an Easter visit to Venice. Vanessa was keen to see

the city's art and architecture but Virginia was left dreading the holiday and 'our joint household', her life under the same roof as the Duckworth brothers, which she believed would follow.

That April, they headed to the Grand Hotel, Venice. It was situated on the Grand Canal, where gondolas bobbed, from which musicians sang and paper lanterns hung, opposite the Santa Margarita church. After two nights in temporary accommodation they secured rooms on the top floor, overlooking the sloping rooftops and distant Dolomite mountains. The nineteen-year-old American Marjorie Van Wickle had stayed there the previous September when visiting with friends and a female chaperone, and described the 'quaint stone bridges' and 'soft-tinted houses' with their 'vine-covered balconies'. She could hardly believe in the 'fairy-tale' she was witnessing, just as the Stephens were 'in a state of childlike astonishment and joy', scarcely able to 'believe that the place was real'.[6] Like Lucy Honeychurch in E. M. Forster's 1908 *A Room with a View*, Marjorie gravitated like most tourists to St Mark's Square, where she dined at Florian's, took tea at Caffè Quadri and shopped for linen at Jesurum's.[7] As Forster wrote, Venice made Lucy 'peculiarly restive', making her wish to do something of which 'her well-wishers would disapprove'. Her act of rebellion was the purchase of some art postcards, including Botticelli's *Birth of Venus*, but as her tastes were innocent, Catholic, she extended 'uncritical approval to every well-known name'.[8] In 1904, Vanessa's responses were similar, although like Lucy she was hovering on the verge of an artistic awakening, a realisation about form, composition and colour, so that she would never really embrace the old masters so naively again.

Vanessa would have followed in the footsteps of other young women like Marjorie and the fictional Lucy on their Grand Tours, visiting the Galleria dell'Accademia to see the works of Bellini, Titian, Carpaccio and others. As she wrote to Margery

Snowdon, there were 'heaps' of paintings to be seen and they divided their time between galleries in the morning and churches in the afternoon. She found the Venetians had 'much more idea of decoration and seem to think nothing of personal character' but the use of colour on a grand scale, particularly the swathes of gold, was 'simply gorgeous'.[9] Thoby was struck by Tintoretto, comparing his layers and symbolism to Shakespeare in a letter to Clive Bell, and although Vanessa found him to be 'splendid' and 'great', she was not impressed by his 'dull' portraits.[10] Virginia, though, was starting to feel like 'a bird in a cage' and became critical of Italy, writing to her friend Emma Vaughan that 'there never was a beastlier nation than this in its railways, its streets, its shops, its beggars and many of its habits ... where is a decent woman to look sometimes?'[11]

From Venice, they travelled to Florence, where they were the guests of the Rasponi family at their home, the Villa Font'allerta in the hills. The Rasponis' daughter, the recently married Rezia Corsini, her brother Nerino and cousin Guido were friends of George Duckworth and had previously encountered the Stephens in the New Forest and at Cambridge. Vanessa painted an incomplete portrait of Rezia during their stay, but Virginia was less than impressed by their hostess, Countess Angelica, an old friend of American novelist Edith Wharton: 'a stout, decisive woman, broad, almost squat featured, her cheek dark red and scarred by a dog's bite ... she watches and springs but calculations go on forever in the brain'.[12] The Stephens also paid a visit to the fifteenth-century Villa Palmerino, the home of Violet Paget, writer of supernatural stories and Pater-inspired cultural essays under the pen name of Vernon Lee. Then in her late forties, Lee was an advocate of women's rights and a lesbian who frequently dressed as a boy. Vanessa described her as 'rather ugly but very clever looking' and was impressed by the 1881 Sargent portrait of her *à*

la garçonne, which hung in her home. After a sojourn at the Palace Hotel, where Violet Dickinson joined them, the party headed to Siena and Genoa, before moving on to Paris on 1 May.

Clive Bell was also in Paris at the time, under the auspices of researching a dissertation in order to win a Cambridge scholarship, although he was spending most of his time in raptures at the paintings he discovered in the Louvre. Since January he had been staying in a pension run by a Madame B, just behind the Trocadero, but in April he moved to rooms in the Hôtel de La Haute Loire, on the junction of the Boulevard Montparnasse and Boulevard Raspail. Thoby stayed there with him, while the women found rooms in the Hotel de Quai d'Orsay. Clive now became the Stephens' enthusiastic guide, introducing them to his friend and fellow Trinity alumnus Gerald Kelly and conducting them around the Salon, taking them to visit Rodin's studio and introducing them to café society, specifically the Chat Blanc, where they sat drinking and smoking until the early hours. Behaving like Bohemians, breaking these boundaries of polite society, particularly in the knowledge that George objected to women smoking, was the heady first step towards realising their newly found freedom.

Arriving home at Hyde Park Gate in mid-May, the strain finally took its toll on Virginia. Her grief, 'natural enough', was compounded by a 'profound irritation' that arose from the letters of condolence, the visiting relatives and obituaries that 'missed the point' of Leslie.[13] Even if she had felt able to communicate her feelings, the stoicism of her siblings, 'as merry as grigs all day long', isolated her within the family, and she turned instead to Janet Case and Violet for support. She collapsed the day after their return. Again, as with her symptoms in 1895, we should hesitate before labelling Virginia as 'ill' or 'mad', or equating her with other sufferers of conditions that have certain labels. Her breakdown was her own, specific to her unique circumstances and

mind. Just as her presentation of her abuse, Virginia's own words should be considered as the primary evidence for her experience, without being interpreted or corrected. However, as Virginia wrote no letters during the period of this illness, from May to the start of September 1904, her references to it are retrospective.

Virginia's mental health shattered dramatically on 10 May. She launched into a long verbal attack against Vanessa, who summoned Dr Savage to observe her physical symptoms. This was also the point at which she confided in him regarding the details of George's behaviour. It was agreed that Virginia would best recover outside London, and Violet offered to care for her at Burnham Wood. There, she refused to eat, experienced terrible headaches which may have been prompted by prescribed sleeping draughts, and developed scarlet fever. However, biographer Panthea Reid[14] suggests that the fever was in fact a cover, invented by Thoby, to cover the uncomfortable antagonism Virginia displayed towards Vanessa, whom she was now refusing to see. The root of this animosity is likely to have been Vanessa's response to Leslie's death, or Virginia's guilt that she had formed an alliance with her sister against their father. Violet hired three nurses, but Virginia saw them, too, as persecutors and became violent, attempting to throw herself out of a window. This can hardly have been a serious suicide attempt, as the room was situated on the ground floor; it was more likely an act of desperation, symbolic of her frustration and sense of incarceration. She believed she heard the birds outside singing in Greek and King Edward VII uttering profanities among the azaleas outside. Virginia's biographer Hermione Lee suggests that the large doses of veronal and chloral hydrate she would have been given may have themselves created these auditory hallucinations.

This breakdown also featured the complex relationship with food that Virginia was to experience throughout her life. Her

early diaries are full of the enjoyment of the treats of strawberries, cake and ice cream, to the extent that it became something of a family joke in *Hyde Park Gate News*, and a healthy appetite was considered correlative with well-being. However, Virginia also considered that controlling her intake of food, or denying herself meals altogether, was one method of retaining control over her sanity. During her breakdown of 1904, she attributed the voices she heard to 'overeating' and attempted to starve herself to silence them. Recognised as an anorexic by her great niece, Emma Woolf, Virginia certainly had difficulties eating and her weight would later soar from eight stone to twelve when she was compelled to follow an invalid's diet. However, it is unclear whether this was a constant part of her health, indicative of a preoccupation with her body, or if it was one of a set of more general physical symptoms, the palpitations, rapid pulse, headaches and fatigues that accompanied the occasional decline of her mental health.

By September, she was permitted to join the remaining Stephens on holiday at the Manor House, Teversal, in Nottinghamshire, accompanied by Nurse Traill, where she studied a little Greek with Thoby. Considered to be the prototype of D. H. Lawrence's Wragby Hall from *Lady Chatterley's Lover*, the Manor House had been built in the fifteenth century and altered in the eighteenth, although it had been remodelled again as late as 1896. Set in substantial grounds, it was close enough for Virginia to visit Hardwick Hall and Chatsworth, and they were visited there by Violet and Clive Bell, whom Vanessa had summoned by letter. They walked before breakfast, studied in the morning, played tennis or went for a walk, and followed this with more tennis and walking after tea. Apparently she and Vanessa were 'very harmonious together' and 'very happy together', and she did not intend 'to have any more disgusting scenes over food'. Writing to Violet, Virginia was delighted to have been delivered 'safe and

sound from the miseries of the last six months' and found that life was an 'exquisite joy every minute', although she would emerge 'less selfish and cocksure than when I went in and with greater understanding of the troubles of others'.[15]

On 10 September, George married Margaret Herbert, the family from whom Manor House had been leased. Virginia was not considered well enough to attend and Thoby was also absent, so Vanessa and Adrian set out for Pixton Park in Somerset, as they 'were expected to'. As Vanessa recorded, being George's bridesmaid was 'the last of [her] social duties', but having negotiated the change of train at Bristol, they discovered that their luggage had gone missing. Arriving at 'the grandest house party ever seen', amid earls and countesses they received a scolding before George located the luggage later in the day, so Vanessa was able to wear the eighteenth-century lady ensemble, complete with blue sash and tumbling curls.[16] Their first child would arrive the following year, with Virginia describing to Violet in July 1905 that she had seen it take its bottle, 'looking more like a Christian now he can eat'.[17]

In the winter months preceding Leslie's death, the decision had been taken for the Stephens to sell the gloomy house in Hyde Park Gate with all its associations and move to a Georgian terraced house in the less reputable but cheaper neighbourhood of Bloomsbury. Vanessa oversaw the move to 46 Gordon Square that October, while Virginia was staying with her Aunt Caroline Emelia Stephen at Cambridge, then with the Vaughan family at Giggleswick Hall, in Yorkshire. It was light and airy, clear from clutter, with a view across the trees in the square: she sold the old furniture and bought everything new, had it all freshly painted white and hung with family portraits. Vanessa aimed for a contemporary aesthetic style, with a red carpet in the dining room, Indian shawls draped over chairs and green and white chintzes. There was an L-shaped sitting room on the first floor and Vanessa and Virginia had a

study, with Thoby, who had just begun reading for the bar, settled on the ground floor. Virginia's was equipped with a new sofa and desk, ready for her return. It was exhilarating for Vanessa, occupying and arranging her own space, in her own style, 'to have come to these white walls, large windows opening onto trees and lawns, to have one's own rooms, be master of one's own time'.[18] Dr Savage was concerned that Virginia should not return to London too soon, but the sisters overruled him and when Virginia arrived that November, she found the house 'the most beautiful, the most exciting, the most romantic place in the world'.[19] It was essential for her to return, she wrote to Violet, as 'London means my own home, and books, and pictures, and music, from all of which I have been parted since February now'.[20] For the first time, paradoxically significant in preserving her freedom, Virginia had a lock on her bedroom door.

Having graduated from Cambridge, Thoby's friends also began to visit. Leonard Woolf had a 'farewell dinner' at Gordon Square before departing for Sri Lanka, then known as Ceylon, where he embarked on a seven-year career in the Colonial Civil Service. Shortly after he left, Lytton wrote to him of having visited the Stephens and finding Virginia 'rather wonderful – quite witty, full of things to say and absolutely out of rapport with reality'. He may have identified something of Virginia's recovering mental fragility in this observation, as well as the strain placed on the 'wan-looking' Vanessa, to whom the task fell of keeping her 'mad brothers and sister in control'.[21] By this point, Virginia had agreed to write a memoir of Leslie for her cousin Frederic Maitland's biography, resumed her diary and announced the end of her 'horrible long illness'. Clive and Saxon were also frequent visitors, as were a number of other Cambridge graduates, including Hilton Young and Theodore Llewelyn-Davies. By mid-March, Thoby was hosting a regular Thursday night 'at home', where discussion

and silence reigned in equal measure, relieved by cocoa and buns. These evenings were later identified by those involved as the genesis of what came to be known as the Bloomsbury Group. Virginia recorded in her diary for 16 March that Gerald and Saxon arrived after dinner, 'the first of our Thursday Evenings', while the following evening, nine guests arrived and stayed until one.[22] As Virginia observed, many of the evenings were spent in silence, or the occasional chuckle 'over a Latin joke': she wanted the approval of these strange young men who did not seem 'robust enough to feel very much', but found greater emotional satisfaction and ease in the company of her women friends – Violet, her cousin Emma Vaughan and Madge Symmonds, the wife of Emma's brother, author of the 1893 novel *Days Spent on a Doge's Farm*. In comparison with Thoby's Cambridge friends, Virginia initially decided 'women are my line and not these inanimate creatures'. She was unimpressed by the dramatic melancholy of *Euphrosyne*, a collection of poetry published by Strachey, Bell, Woolf, Sydney-Turner and others in 1905, but quickly began to adjust to their company, listening 'intently to each step and half-step in argument', planning to 'sharpen and launch [her] own little dart', and experiencing 'joy ... when one's contribution was accepted'.

The events of 1904 had disrupted Vanessa's studies at the Royal Academy. When her request to return that autumn, to make up for lost time, was refused, she enrolled instead in the Slade School of Art in Gower Street. Its teachers favoured the French emphasis on sketching, producing swift, clear and accurate lines in a succession of realistic sketches. All students began in the Antique room, where 'casts of Classical and Renaissance sculpture were scattered everywhere, around the walls, on plinths, on trestle-tables or simply lying on the floor; heads, busts, torsos, complete figures; here and there an odd foot. Among these and various overhanging plants, the students worked, most of them seated astride wooden

donkeys.'[23] Since 1892, the most formidable of the teachers was former surgeon Henry Tonks, whose exacting standards masked his real dedication to serious students of art. According to Slade alumni Augustus John, students were allowed only paper, charcoal and a 'chunk of bread for rubbing out',[24] and Tonks was known to throw erasers out of the window in a rage if he saw his rules being broken. His reputation was still fearsome by the time of Gwen Darwin's arrival in 1908 and his criticism was direct; 'After staring at a piece of work with his heavy lidded-eyes, he could demolish it with a pithy phrase,'[25] such as 'What is it? Horrible! Is it an insect?'[26] Gwen's contemporary Paul Nash summed up the teacher's influence; 'Tonks was the Slade and the Slade was Tonks,' and some students took up the chant, 'I am the Lord thy God, thou shalt have no other Tonks but me.'[27] Despite his fearsome exterior, their teacher was committed to the equal education of his female students once they had proved their skill and intentions, firing them with his belief that 'in art, nothing short of the best would do and everything must be sacrificed to achieve it'.[28] Vanessa did not appreciate his methods, though, and chose not to return to the Slade after the Christmas holiday of 1904. The following spring, Vanessa's portrait of Nelly, Lady Robert Cecil, was exhibited at the New Gallery, London. Virginia set out to see it on the morning of 27 April and, to her great relief, found it listed in the catalogue, and hung 'fairly in the gallery'; she returned in the afternoon with Vanessa and Adrian.[29] Her verdict on the rest of the paintings was that, apart from the Sargents, they were 'not a striking lot'.

However, something very striking was to happen in the English art world in the winter of 1904/5, although it would not receive the attention it deserved. At the Grafton Galleries, the Parisian art dealer Paul Durand-Ruel exhibited over 300 paintings by the French Impressionists, including Cezanne, Degas, Manet, Monet, Renoir, Pissaro, Sisley, Mary Cassatt and Berthe Morisot.

Photographs from the exhibition show Renoir's *The Dancer*, *La Femme au Chat*, *La Grenouillère*, *Luncheon of the Boating Party* and *La Loge*, Degas' *La Tasse de Chocolat*, *Women Ironing*, *Woman Ironing*, *Horse Race Before the Start* and *La Source* hanging on the walls. By the time the exhibition opened in January, most of these works were already thirty years old. As art critic Elizabeth Robins Pennell commented after visiting, the British public had 'got used to seeing their work, and is therefore no longer scandalised, much as it may still disapprove'. When the critic Frank Rutter attempted to set up a fund to purchase a Degas for the nation, he met with some resistance and a work by the far more traditional landscape painter Boudin was purchased instead. The more radical work that was being done across the Channel, from pointillism, synaestheticism, symbolism and the explosive colours of the Fauves that would cause a riot that autumn, would not hit the unsuspecting British public for another five years. And although they were still under the spell of the Impressionists in 1905, it would be Bloomsbury who would provide the wake-up call.

That autumn, Vanessa founded the Friday Club, a group that would come together weekly for the discussion of art and to arrange exhibitions. She hoped to emulate the kind of café society they had briefly enjoyed in Paris and 'eradicate politeness', allowing people to feel at ease to call each other 'prigs and adulators quite happily' in a small group, emulating the emotional and artistic honesty that was developing in Thoby's Thursday at-homes. In September, she sought rooms to rent, asking the advice of Clive Bell, who attempted to impress her by addressing the group and submitting two works of his own to their launch exhibition that November. Among the group's members in these early years were Saxon Sydney-Turner, Pernel and Marjorie Strachey, and Vanessa's friends from the Royal Academy, Margery Snowdon,

Mary Creighton and Sylvia Millman. New friends also arrived from her brief stint at the Slade; Welsh landscape artist J. D. Innes, who painted in a bold Impressionist style and strong colours, the talented but tragic John Currie, who had escaped a job painting ceramics in the Staffordshire Potteries, and the former Slade School star Edna Clarke Hall. There was another newcomer too, an Australian painter named Henry Lamb, who had abandoned his medical studies and family in Manchester for London. He had met Lytton at a party soon after his arrival in the summer of 1905, and was soon to enrol in the Chelsea art school run by Augustus John and William Orpen. Vanessa was ruthless in rejecting the work of friends that was not up to her standard and discovered something of a 'genius for organisation'. As Virginia recorded, their discussions captured the current division in modern art as England was opening up to the influence of the Parisian vanguard: 'One half of the committee shriek Whistler and French Impressionists and the other are stalwart British.'[30] Meanwhile, Virginia experienced some success of her own, publishing her first review in the *Guardian*, of W. D. Howell's novel *The Son of Royal Langbrith*.

In the summer of 1905, the four Stephens returned to St Ives. For Vanessa and Virginia, it was their first visit since the final summer of 1894, before Julia's death, and was recorded by Virginia as an occasion of great poignancy and nostalgia. From the 'feeling of enchantment' when they boarded the Great Western train, the 'wizard' to transport them 'into another age', she could almost believe that their corner of Cornwall 'had slept under some enchanter's spell since we last set eyes on it'. Perhaps, she hoped, by returning to the scene of their childhood happiness, they might 'recover something tangible' of their memories. Arriving at dusk, they made their way up the old path to Talland House, through the gate and peeped through the escallonia hedge, looking back

through the vista of years as if there was 'a film between us and the reality'. It was just as if they had left it that morning, but there they stopped, knowing that the spell would be broken if they went any further, for 'the lights were not our lights, the voices were the voices of strangers' and they were 'ghosts in the shade of the hedge'.[31]

From their base at Trevose View, a Victorian villa in Carbis Bay, the family followed the old paths to Tren Crom, sailed in the bay, met old friends who remembered them fondly, watched the annual regatta and the pilchard fleet, and visited all the old landmarks.[32] Vanessa painted the view from her bedroom window, forming her own new style of painting like Whistler, 'only he used many more layers than I should because he painted very thinly ... but the important point, which I believe I haven't realised before, is that he didn't put the right colour on at once', but built up to it from a monochrome.[33] On the eve of their departure, 4 October, Virginia sat bathed in the gleam of the lighthouse, acknowledging that 'writing is a divine art'. She would reuse the symbol two decades later in her most famous novel about the return of her fictional autobiographical family to their holiday home.

During this flourishing of their artistic and adult freedom, both Stephen sisters had attracted suitors. The Greek scholar and poet Walter Headlam was over twenty years older than Virginia and had been a frequent visitor to Talland House during the summers of her youth. Following Leslie's death he began a flirtation with her that involved their shared literary interests and teas in London and Cambridge, but although Virginia enjoyed his company, she did not really take his advances seriously, such as they were. Shy and eccentric, he appears never to have made a formal declaration, and the friendship had cooled somewhat by 1906. Thoby's Cambridge friend Clive Bell, though, was another matter entirely. Erudite and confident, with his shock of red-gold hair and experience with

women in comparison with his Trinity peers, he set his sights on Vanessa. In July, Clive invited her to dine in a room he had filled with red roses, but when he proposed the following month, she refused. After a year, he asked again, and was again rejected. Her letter to him of 30 July 1906 is an attempt to speak openly and honestly about affairs of the heart because, as she wrote, 'the fact is I trust you so entirely' and more was 'to be gained' by being direct than resorting to 'frigid politeness'. She knew him 'too well to make pretence' and she said, '[I] must talk to you naturally and freely.' Her concept of what marriage should be required 'something more' than her current feelings. If, she explained, 'marriage were only a question of being very good friends and of caring for things in the same way', she would accept him, as she liked him 'much better than [...] anyone else'.[34] Although it was a rejection, her words were enough to allow Clive to entertain hope.

In the autumn of 1906, the Stephen siblings departed on a trip to Greece. Thoby and Adrian went first, travelling on horseback, and in September, Vanessa and Virginia, accompanied by Violet, set out to meet them. Vanessa began to feel unwell almost at once and required supplies of medicine, smelling salts and champagne as well as the attendance of foreign doctors. She was forced to halt at a hotel in Corinth, suffering from appendicitis, stress and depression, while the men went on to Delphi. Eventually, Vanessa was able to continue to Constantinople, although she had to be carried on to the Orient Express, which was to carry them home. At home, within days, Thoby and Violet both became ill with malaria. Also ill and forced to take to her bed, Vanessa summoned Clive, writing, 'I am quite sure that a visit from you would do me a lot of good ... I hope you won't find me either sentimental or too proper.'[35] Then, although he appeared to be recovering well under the watchful eyes of the family doctors, Thoby's condition worsened. He underwent an operation on 17 November, but died

three days later, at the age of twenty-six. Within forty-eight hours, Clive proposed to Vanessa for the third time and was accepted.

The shock among Thoby's family and friends was profound. Virginia continued to write to the unwell Violet maintaining the pretence that he was on the mend, until Violet read a reference to his death in connection with the publication of Maitland's *Life of Leslie Stephen*, and realised the truth. Lytton, who idolised Thoby, also read the announcement in *The Times*, writing to Keynes that 'the loss is too great, and seems to have taken what is best from life'. Lytton also wrote to inform Leonard Woolf, who was still in Ceylon, of the news, although 'to break it to you is almost beyond my force. You must prepare for something terrible. You will never see the Goth again. He died yesterday.' The letter did not arrive until 12 December, when Leonard replied that he was 'overwhelmed, crushed ... he was an anchor. He was above everyone in his nobility.'[36] On hearing the news, Apostle Walter Lamb cited the final lines of *Hamlet*: 'For he was likely, had he been put on, to have proved most royal.'

NINE

Love Triangles, 1907–1910

No stories are told; No insinuations are made. The hillside is bare; the group of women is silent; the little boy stands in the sea saying nothing.[1]

Vanessa and Clive were married on 7 February 1907, at St Pancras Registry Office. Absorbed in the first flush of love, they talked about art for seven or eight hours a day, walked along the street arm in arm and established a new intimacy that left Virginia out in the cold. Along with Adrian, she left Gordon Square and set up home at 29 Fitzroy Square, feeling abandoned and puzzled. Far from agreeing with her sister that her new husband was wonderful, she again found Vanessa's buoyancy in the face of tragedy to be tactless, even callous. As with the deaths of Julia, Stella and Leslie, Vanessa's method of handling grief was to throw herself enthusiastically into life, in contrast with Virginia's reflections and regrets. Vanessa embraced Clive's experience and sensuality, receiving guests as they lay in bed together, basking 'like an old seal on a rock' and enthusiastically discussing the joys of sex. It drove a further wedge between the sisters.

Nor was Virginia convinced of the bridegroom's merit. Clive paled in Virginia's eyes in comparison with their lost brother: 'When I think of father and Thoby and then see that funny little creature twitching his pink skin and jerking out his little spasm of laughter, I wonder what odd freak there is in Nessa's eyesight.'[2] Virginia nicknamed him 'paraqueet' and was inclined to believe 'no one can be worthy' of the sister to whom she had been so close and she would need 'all [her] sweetness to gild Nessa's happiness'. In another letter she took the initiative to understand Clive better, asking him, 'Write a description of yourself – your features, your gifts, your prospects, your parents.'

Like the disguised Viola in *Twelfth Night*, Clive might have replied to Virginia's question about his parentage thus: it is 'above my fortunes but my state is well, I am a gentleman'. There was no doubt about his status and wealth, but the Bell family fortune had been a recent acquisition, deriving from Clive's father and the family coal mines in Wiltshire and Wales. In 1883, William Heward Bell had bought Cleeve House, a large Victorian Property in Seend, Wiltshire, situated between Bath and Marlborough. He had redesigned much of the house in the 1890s and on her first visit, late in 1906, Virginia found it stuffed with hunting trophies and weapons, with the conversation dominated by sport. For years she was haunted by the image of a horse's hoof which had been turned into an inkwell. With his passion for culture, Clive was something of an oddity among the Bells, who were a typical county family with little feeling for art and literature. Virginia felt ill at ease at Seend, losing her temper on her first visit in December 1906, storming out of the house at lunchtime only to return that evening.[3] She did not get to see her sister alone, and had to accept the changes: 'This is all over ... and Clive is a new part of her, which I must learn to accept.' The old family friend Henry James, a veteran of St Ives holidays, was also critical of

Vanessa's choice, wincing to find her 'boisterously in love' when he visited bringing wedding gifts, along with an atmosphere of the 'hungry futurity of youth', and Vanessa 'turning her back' on her family ghosts.[4] Leonard wrote to Lytton that he had 'half expected the news' and he was 'too weary to mind the mockery of it all'.[5] Other friends objected to the location of Virginia's new home: if Gordon Square had been disreputable enough, Fitzroy Square was unthinkable to Beatrice Thynne, who begged Virginia not to move into that neighbourhood, while even Violet expressed doubts. Having sought the advice of the police, though, Virginia and Adrian occupied their new home in March, for the cost of £120,[6] while Vanessa and Clive were on honeymoon at the Hotel du Quai Voltaire, in Paris.

By the time of the marriage, Virginia was beginning to warm to Clive, if only for Vanessa's sake. Her affectionate letter, written the day before the wedding, presented a playful picture of him as a red ape, continuing the family tradition of taking animal nicknames and characteristics. Signed by 'Billy', the goat, although reputing to be from three apes and a wombat, she laid her devotion at Vanessa's feet, and commended the marriage. Casting herself, in the plural, in the role of pets with Vanessa as their mistress, she wrote charmingly about relinquishing her sister:

We have been your humble beasts since we first left our isles ... and during that time we have wooed you and sung many songs of winter and summer and autumn in the hope that, thus enchanted, you would condescend one day to marry us. But as we no longer expect this honour, we entreat that you keep us still for your lovers ... and in that capacity we promise to abide well content always adoring you now as before.[7]

'Billy' had made a study of the ape Clive, concluding that his

fur was 'of fine quality, red and golden at the tips, with an undergrowth of soft down, excellent for winter. We find him clean, merry and sagacious, a wasteful eater and fond of fossils.[8] To Clive, Virginia wrote in a very different tone, about reviews, telegrams and Gibbon, in an attempt to impress and understand her new brother-in-law: 'Shall I argue that a mind that knows not Gibbon knows not morality or shall I affirm that bad English and respectability are twin sisters ... for it will ramify if I mistake not through all the limbs of my soul and clasp the very judgement seat of God.' Yet, when it came to Vanessa, the same letter became playful again when conveying the admiration she and Clive shared:

> I am almost inclined to let her name stand alone on the page. It contains all the beauty of the sky, and the melancholy of the sea, and the laughter of the dolphins in its circumference, first in the mystic Van, spread like a mirror of grey glass to Heaven, next in the swishing tail of its successive esses and finally in the grave pause and suspension of the ultimate A breathing peace like the respiration of Earth itself.[9]

Virginia might have felt excluded from her sister's new relationship, but that did not prevent her and Adrian from joining the Bells in Paris. The pair also rented a house at Playden in Sussex that September, while the Bells were staying in Watchbell Street in nearby Rye. While Clive was out walking, Virginia was able to talk to her sister about their old favourite topics of 'art and life', which, although they were now mixed with 'marriage and motherhood', remained Vanessa's preoccupation. Virginia was relieved to find her sister return to her former conclusion that 'art is the only thing; the lasting thing, though the others are splendid'.[10] While near Rye, they visited their old family friend, Henry James, at Lamb House, and were visited in turn by Saxon Sydney-Turner and Walter

Lamb, elder brother of Henry. Virginia found the young men dull, confessing to Violet, '[They remained] so disinterested that I see how I shall spend my days a virgin, an Aunt, an authoress,' in contrast with Vanessa's newly found sexuality. She passed the days writing a memoir of Vanessa for her future children and preparing to teach at Morley College that autumn.

The following year Virginia's correspondence with Clive indicates a shift in their relationship. In February 1908, Vanessa had given birth to her first child, a son named Julian, and within weeks Virginia was imploring Clive to kiss Vanessa for her and inform her 'how fond I am of her husband'. After this, their friendship escalated in warmth, with damaging results. As Vanessa was increasingly occupied with her baby, to the exclusion of both her sister and husband, who complained that he no longer slept with her, an uncomfortable flirtation developed between the pair. Clive resented being displaced, either unable or refusing to hold his son, and Virginia questioned what her role was in their marriage: 'With Vanessa bumbling about the world, and making each thorn blossom, what room is there for me?' During a joint holiday in St Ives in the last two weeks of April, Virginia confided in Clive about her feelings, which she confirmed in letters to Lytton and Violet: 'A child is the very devil, calling out ... the very worst and least explicable passions of the parents – and the Aunts.' She doubted that she should 'ever have a baby. Its voice is too terrible, a senseless scream, like an ill-omened cat.'[11] To escape the noise, she and Clive began to take long walks, also seeking an outlet for their frustration in Vanessa's absorption with Julian, but companionship soon spilled over into a full-blown flirtation.

In a letter from early May 1908, Virginia makes the change in mood clear: 'Though we did not kiss (I was willing and offered once ...) I think we achieved the heights, as you put it.' Clive replied that he had wanted 'nothing in the world but to kiss' her but

misread her feelings. In turn, Virginia admitted that his gallantry in pursuing her departing train in order to deliver a book had brought a 'tear to [her] eye and a blush to [her] cheek'. Over the following year Clive continued to pursue Virginia, and she responded with warmth but uncertainty, still able to discern that his 'mind is of a peculiarly prosaic and literal type',[12] drawn to the intimacy he could offer but resisting the final surrender of a full-blown affair. Her reactions were also in retaliation; Clive was an engaging and useful enough companion but ultimately, he was not the object of her affection. That was always Vanessa. The pseudo-affair was Virginia's compensation, her weapon and self-inflicted wound, for the distance that now existed between her and her sister. The very close conspiracy had been broken and Virginia was jealous, resentful and excluded, and consciously or not, she sought to inflict a similar wound in return. She was successful.

Vanessa was deeply hurt by Virginia and Clive's betrayal. Suspecting the nature of their friendship had changed, she asked to see her sister's letters to Clive, which he refused to produce, later writing to Virginia that she should 'blush for the havoc' she had caused in the Bell household.[13] In response, Vanessa withdrew, making her letters colder and more formal, as Virginia effused in the attempt to regain her affection; she also 'curbed' Virginia's attempts to initiate private talk.[14] Even Lytton attempted to intervene, having grown closer to the Stephen sisters in the wake of Thoby's death, using his pseudonym of Vane Hatherley to advise Eleanor Hadyng (Virginia) against getting involved with James (Clive). Privately, Lytton expressed his outrage to Leonard 'that that little canary-coloured creature we knew in New Court should have achieved that – the two most beautiful and wittiest women in England.'[15] Yet Virginia was not in love with Clive, describing him to Vanessa by letter as 'an exquisite, fastidious little chipmonk [*sic*] with the liveliest affections and the most tender instincts',

but denying the suggestion of a mutual friend that he might be classed as a genius.[16] She did not give in to his attempts to seduce her. Virginia would later regret this unhappy episode, this 'knife-turning' that marked an irrecoverable distance between the sisters. When it came to her future love affairs, Vanessa would be far more circumspect.

Disappointed, Clive found consolation with a Mrs Raven-Hill, a neighbour from Seend, who had been his lover before his marriage. Although he remained flirtatious, his relationship with Virginia found a more solid footing as she realised he might provide valuable advice when it came to her literary endeavours. As early as summer 1908, when the work was still in its planning stages, she sent him sections of *Melymbrosia*, which was to become *The Voyage Out*, thrilled to receive his praise and compliments and reflecting on his criticisms of her 'unfortunate work'. She started with her heroine's name: 'I may as well ask you what you think of a Spanish name for the lady ... Her father touched at many ports and sailors like sentimental names.' Aiming at a radical approach to form and style, she confided her ambitions to 're-form the novel and capture multitudes of things at present fugitive, enclose the whole and shape infinite strange shapes'.[17] Clive was direct and honest that October, responding, 'In spite of the immaturity, crudity even, and some places jagged like saws that make my sensitive parts feel very much what the Christian martyrs must have felt, I believe this first novel will become a work that counts.' He suggested she did not overuse the words 'solid' and 'block' but that the presentation of ideas was an 'immense improvement on all [her] other descriptive writing'.[18] By the following February, he felt the book was taking off, with most of the problems confined to volume one. Clive thought that the heroine's daydreams 'flood the mind with an exquisitely delicate sense' but that some of the conversations and letters were stiff and needed revision. He felt

Virginia had given more 'humanity' to the work at the expense of the supernatural or magic, which he 'thought as beautiful as anything that has been written these hundred years' and that with more work, it might become wonderful. He was 'stunned and amazed by [her] insight, though ... [he] had always believed in it'.[19] Virginia found his response valuable, as he had 'laid his finger on spots already suspected by her'. The same year, Virginia tried to establish a similar correspondence with Lytton, asking him about *Lord Pettigrew*, a novel he had begun but abandoned after four chapters. Her teasing comment that he should confine his genius to one department, instead of dancing all over the departments of literature, showed the very real literary connection they shared. Clive, though, saw Lytton as a rival for her affection and, for a while, the friendship between the two men became frosty. In the coming years, Clive's fears would prove to be far from groundless.

In December 1907, Clive and Vanessa had established the Play Reading Club at Gordon Square which, along with the Friday Club, continued the friendships of Thoby's Thursday at homes. Old Cambridge favourites like Lytton, Sydney-Turner, Harry Norton, C. P. Sanger and the newly married Desmond MacCarthy were welcomed, as well as Lytton's younger brother James and older sister Marjorie, appreciated for her 'astonishing gifts as a music hall artiste'. There were also a few new friends, including the shy King's Apostle E. M. Forster, author of the 1908 *Room with a View*, whose unprepossessing appearance led Lytton to nickname him the 'Taupe', or mole. They came to rehearse and read a range of plays, starting with Vanbrugh's *The Relapse* and progressing to Swinburne, Spenser, Defoe and Milton. These evenings were lively, with ribald jokes and puns, as well as the proximity and familiarity bred by performance, during which Lytton uttered the famous question 'semen?' on noticing a stain on Vanessa's dress, after which the final barriers to openness were broken down.

As Vanessa wrote of Lytton, 'His great honesty of mind and remorseless poking fun at any sham forced others to be honest too and showed a world in which one need no longer be afraid of saying what one thought.'[20] 'What did we talk about?' she asked, in *Notes on Bloomsbury*, 'the only true answer can be anything that came into our heads.'[21]

One of the other newcomers was Lytton's cousin and erstwhile lover, Duncan Grant. Born in Scotland in 1885, he had spent his early years in India and Burma, was schooled at Rugby, where he had met Rupert Brooke, then progressed to St Paul's in London. Encouraged by his aunt, Lady Strachey, to pursue his artistic ambitions, he had avoided following the same army career as his father; he attended the Westminster School of Art and visited Italy and France, spending some time at Jacques-Emile Blanche's Parisian school, La Palette. Blanche was director between 1902 and 1911, advocating a style that blended the best of Manet with Sargent and producing his own iconic portraits of Proust, Beardsley and Sargent himself. Early in his career, Duncan had produced the convincing study *The Kitchen* with its sympathetic shades of yellow and grey in the Whistlerian mode, but he was not yet an avant-garde artist. Although he was Paris in 1905–06, he had missed the important exhibitions of the Fauves at the Salon d'Automne and Matisse's work at the Druet Gallery, as well as the mood of experimentation in Montmartre which gave birth to Picasso's *Demoiselles d'Avignon*. Lytton wrote urging him to visit Durand-Ruel's house but Duncan preferred instead to copy the bucolic scenes of old masters in the Louvre and did not go immediately. While Paris was rushing to embrace modernism around him, Duncan's early tastes lay more in the eighteenth century. The following spring Lytton wrote to the Bells, Virginia and Adrian, who were heading to Paris, asking them to visit Duncan, whom they met on the Louvre's Salon Court. The

admiration was mutual. 'What a quartet,' he wrote, 'I seem to like them all so much,' while Clive declared him 'clever and amusing, wonderfully lively and good looking.'[22]

In 1908, Vanessa exhibited pictures at the first Allied Artists' Exhibition at the Albert Hall. It was the idea of *Sunday Times* critic Frank Rutter, who intended to provide a platform for artists to show up to five works to the public without requiring them to submit to the Academy-style process of rejection. Around 4,000 items were submitted, including 175 works by Russian avant-guardists Maria Tenisheva, Nicholas Rerikh and Ivan Bilibin. Duncan would also later exhibit with the group, offering *Lemon Gatherers*, which Vanessa bought for £10, with the unqualified praise that Duncan was 'certainly one of the most interesting of the new painters'. Clive, who received the painting as a gift, added in the *Nation* that Duncan was 'blessed with adorable gifts and a powerful intellect ... if he has the strength to realise his conceptions and the courage to disdain popularity,' he should 'become what we have been awaiting so long, an English painter at the front rank of European Art'. Clive also wrote glowingly about Vanessa's 'very personal gifts ... a large simplicity of style ... something oddly sympathetic ... the peculiar significance to her of certain forms and relations of forms comes through and gives to her work an air of intimacy that you will get from nothing else in this exhibition'.[23]

Vanessa's own style and concept of art was evolving rapidly. Virginia commissioned Henry Lamb to draw her sister, and the two artists' conversation addressed the use of colour, with Lamb avoiding using black altogether. She was moving towards a new, colour-based approach, although her handling of paint in her current portrait of Marjorie Strachey was more traditional. It may have been during these visits that Clive Bell also sat to Henry Lamb, who produced a slightly shifty-eyed version of the young man, with his hair curling on his neck. In 1909, Vanessa's elegant

Icelandic Poppies was praised by Sickert at the second annual Allied Artists Exhibition. The critic Watney found that the work retained its form while achieving a 'unity of tone', and its striking design and use of shadows represent an important step in her development.[24] The same year Vanessa found time to fuse life and art, completing a handful of images of Julian as a baby and a portrait of Saxon Sydney-Turner in profile, sitting at the piano. The marriage of her Whistlerian background with the new art may also be felt on her *Apples* or *46 Gordon Square*, with its thick brushstrokes, off-centre focus and Cezanne influenced subject.

Duncan had returned to London permanently in 1907, moving in with his parents in Hampstead, close to the Belsize Park house where the Strachey family had relocated. That November, he invited the Bells and Virginia to dine in Fellows Road, after which he admitted to Lytton that he had 'enjoyed [his] dinner party very much indeed' and that he 'might manage to like being married to Virginia – but not to Clive.'[25] In these early days, Virginia described their new friend as a 'queer faun-like creature, hitching his clothes up, blinking his eyes, stumbling oddly over the long words in his sentences', although his beauty and effortless guile seemed to exude a charm that won him general admiration. Totally impoverished, he relied upon the goodwill of friends to feed and clothe him and once ruined a pair of trousers by jumping into the Cam to save a child who had been swept into the river by the rope of a punt.[26] Predominantly homosexual, he had been engaged in an affair with his cousin Lytton, whom he had left for the Apostle John Maynard Keynes, before falling in love with James Strachey, who was in turn enamoured of Rupert Brooke, after which Duncan became enamoured of Cambridge scientist Arthur Hobhouse. It was a complicated emotional tangle, peppered by brief flirtations with women, which often left Duncan uncertain and unhappy. By 1907, he was involved again with Keynes.

The eldest son of a Cambridge economist, the 'sensual, affectionate, volatile and optimistic'[27] Keynes had graduated in 1904, with first-class honours in mathematics, before entering the civil service as a clerk in the India Office in 1906. He soon tired of this, and returned to Cambridge to work in the field of economics and probability theory, but the Stephens' sympathy for Lytton's broken heart meant that they may not have welcomed Keynes with open arms at first. The economist was largely absent, spending much time in Cambridge after being awarded a fellowship at King's College, but he and Duncan jointly rented rooms at 21 Fitzroy Square from 1909. From that point onwards, Keynes moved into the heart of Bloomsbury, where he would remain until the end of his life. Duncan, though, was a favourite from the start, seeing them frequently during the absence of his lover. Around this time, the Fitzroy three posed for a formal studio portrait, with Duncan and Virginia standing behind a seated Adrian, in positions that echo a family group. With their parents dead, the Stephen siblings were forging their own sense of family from among the friends who shared their values.

To distract Virginia from her flirtation with Clive, Vanessa and others became keen that she should find a husband of her own. The sudden death of Walter Headlam at the age of forty-two in June 1908 removed him from the scene, although by this point his friendship with Virginia had cooled. Through the end of that year, Vanessa hoped to see a match develop between Virginia and Lytton and, despite his evident homosexuality, Lytton responded by entering into a wooing of Virginia that was based on their mutual passions, compatible characters and intellectual connection. Such a move was not considered as unrealistic, even as unfair, as it might today. With homosexuality remaining illegal in England until 1967 and the recent case of Oscar Wilde casting a long shadow over Lytton's Cambridge years, marriages were sometimes

made by bisexual and gay men during this period in an attempt to conform to social expectation. Equally, the sexuality of a number of Bloomsbury members was to prove fluid, with Duncan Grant fathering a daughter, Lytton living with artist Dora Carrington, who conducted relationships with members of both sexes, as did Virginia's friends and fellow authors Katherine Mansfield and Rupert Brooke, and as did Virginia herself, with the married Vita Sackville-West. Keynes would go on to marry in later life, as did Adrian Stephen, David Garnett and many of the other men whose homosexual experiences began in their public school years. The members of the group whose sexuality remained constant were fewer in comparison with those who experimented and experienced heterosexual as well as same-sex love.

Lytton's marriage to Virginia was considered a suitable practical solution to both their unwedded states, providing each with the social status and independence they craved and the freedom to pursue their own lives, with the support of a sympathetic partner. Ultimately, they both would achieve this, when Virginia married Leonard and Lytton set up home with Carrington. It may have been an attempt to rescue Virginia from Clive, but it was also grounded in genuine affection. To confuse the issue, Lytton confessed to have felt the stirrings of a sexual attraction to Vanessa and later, towards Katherine Mansfield. As early as August 1908, Vanessa was asking her sister whether or not Lytton had proposed, but by the end of the year, Virginia confirmed, 'I am not in love with him, nor is there any sign that he is in love with me.'[28] In fact, Lytton was already writing to Leonard Woolf, suggesting that Woolf would be a far more suitable husband for her. 'Do you think Virginia would have me?' Woolf wrote in reply, early in February 1909, 'she is I imagine supreme ... wire to me if she accepts. I'll take the next boat home.'[29] Yet it was Lytton who proposed to Virginia and was accepted. As he wrote to Woolf, 'As I did it, I saw that it would

be death if she accepted me,' and was relieved the following day when 'she declared she was not in love with me' and they agreed not to marry. 'She's an astounding woman,' Lytton enthused, 'and I'm the only man in the universe who would have refused her; even I sometimes have my doubts. If you came and proposed, she'd accept,' he urged Woolf, 'you would be great enough and you'd have the immense advantage of physical desire.'[30] Confused by Lytton's double role in the proceedings, Leonard did not reply and Virginia would have to wait another two years for his proposal. Lytton's attempts to match-make would also alienate Clive Bell, whose possessive jealousy over Virginia, as a hangover from their former flirtation, would lead him to ban Lytton from his house for a brief period.

Yet the awkward engagement did little to diminish their mutual respect. There was an undeniable connection between Virginia and Lytton that would remain throughout their lives. A week after the incident, Lytton wrote to his sister Dorothy that after his beloved Duncan, 'the two people I see and like most are two women ... Vanessa and Virginia with neither of whom I'm in love'.[31] When scientist and editor Hilton Young asked Virginia to marry him in a punt on the Cam, he was refused and told that the only man she might marry was Lytton. That October, when she visited Lytton, who was staying at Pythagoras House in Cambridge, Virginia was able to write, 'We were very intimate and easy and I have no doubts of his charm.'[32] Virginia was in Cornwall the following February, when Lytton was a guest of the Bells for a 'dream of a week' in Gordon Square, where he enjoyed dignity, repose and medical consolations. It would take until the end of 1910 before Vanessa gave up hope for the match. By that time, there was a change in the air, both in art, and in their private lives.

TEN

Post-Impressionism, 1910–1911

The Post-Impressionists are in the company of the Great Rebels of the World.[1]

In 1910, a chance encounter would lead to what would be the most significant art exhibition to be held before the First World War. Out of the depths of an English winter, the vivid reds, greens and yellows of Cezanne, Van Gogh and Matisse would burst like an explosion into the restrained tonality of the Edwardian art scene. They would be loathed and derided, admired and praised in equal measure, but they would change the nation's concept of beauty forever. Once the English public had seen Van Gogh's *Sunflowers* and Manet's *A Bar at the Folies-Bergère*, their iconic status was established. Their informal style and rejection of the traditional rules also flew in the face of artistic training, suggesting that art was accessible to more than just the educated elite and that 'skill was subordinate to the direct expression of feeling'.[2]

Standing on the station platform at Cambridge that January, Vanessa and Clive recognised art critic Roger Fry, who was also waiting for the London train. In fact, they had already met

briefly in their overlapping social world and Roger's reputation at Cambridge, the Slade and London University preceded him. Then aged forty-three, Fry was a tall, lean man, with grey hair parted in the centre, a man of extraordinary vitality, receptiveness and great honesty who 'never minded admitting he had been wrong and changing his mind if only he could come a little nearer the truth'.[3] He had an open-mindedness that made him 'not only one of the most delightful companions but one of the most remarkable men of his age'. He always listened to opinions 'attentively and sympathetically ... and always conceived it possible that he might be completely wrong'.[4] His biographer, Virginia, would describe him as giving 'the impression of a man with a great weight of experience behind him ... worn and seasoned, ascetic yet tough'.[5]

Like the Bells, Roger had become convinced that the avant-garde was the only way forward in art. Also like them, it had taken him a while to get there. He had earned a double first in Natural Sciences at Cambridge and joined the Apostles before beginning to lecture at the Slade. Initially a devotee of the Renaissance and Italian art, his first book had been on Bellini and, in 1903, he helped found the *Burlington Magazine*, where his articles highlight his increasing interest in modern French art. Three years later, he accepted the position of curator of paintings at New York's Metropolitan Museum of Art, but the timing proved to be wrong for him. Committed to the job, his move across the Atlantic was mirrored by a dramatic shift in his artistic allegiance which replaced his Anglo-American vision with a desire to reconnect with France. First impressed by Cezanne's work at an International Society exhibition of 1906, he had progressed to admiring Gauguin, Denis and Signac as offering an 'expressive alternative to the Impressionists', although he found it difficult to accept their use of bright colours, admitting that a work by Moreau 'must be possessed of a quite astonishing artistic intelligence ... yet for the

present, I do not quite see it'. His own 1909 one-man show at the Carfax Gallery presented a typically English palette of browns, blues and greys, criticised by *The Times* for its colours – 'A land of everlasting twilight would be a dreary place' – and the *Morning Post* for inaccessibility – 'People will have to be under its influence for a time to appreciate its beauty.' His increasing focus on Europe, as well as differences of opinion with his boss, J. Pierpont Morgan, led to his dismissal from the Metropolitan.

Fry had returned to England as an advocate of modern French art, to the painful situation of having to watch his wife's mental health unravelling. Having married Fry in 1896, the artist Helen Coombe had borne him two children but, in 1910, just as the country house Fry had designed and built for her recovery was completed, her condition worsened. When he met the Bells on Cambridge station platform, Roger's life was at something of a crossroads. Sitting opposite him, listening to the men talk, Vanessa found him 'intensely alive but quiet' and of 'astonishing beauty'.[6] After this, he was invited to speak at the Friday Club, entertained the Bells at home at Durbins, near Guildford, and enlisted Clive to sit on his committee for a new exhibition of French art. While they planned a revolution in the art world, though, other dramatic changes were taking place in Edwardian England.

That winter, Virginia had volunteered to help the Women's Suffrage movement and spent hours addressing envelopes, although she found the whole experience something like an H. G. Wells novel. His *Ann Veronica*, the story of an emancipated 'new' woman, had caused a storm the previous autumn, with its championing of the Suffrage, rejection of patriarchy and thinly veiled use of Wells' own love life. In spite of her belief in women's rights, Virginia was only involved in the Suffrage campaign in a small way, although she heard much about its aims from her friends who were active in its promotion. Philippa Strachey was secretary of the London

Society for Women's Suffrage in collusion with her sisters Pernel and Marjorie, and Virginia also knew Mary Berenson's daughters Rachel, or Ray Costelloe, who would marry Oliver Strachey and Karin Costelloe, who would become the wife of Adrian Stephen in 1914. There was also Mary's sister Alys Pearsall Smith, who was then married to the Cambridge mathematician and philosopher Bertrand Russell. Virginia might have helped address envelopes, but it was Duncan Grant who collected signatures on behalf of the Suffrage movement during the election of 1910, and who designed the poster 'Handicapped' of a suffragette rowing to Westminster against the tide for the Artists' Suffrage League.

In February 1910, Virginia, Adrian and Duncan Grant took part in what has come to be known as the Dreadnought Hoax. At the last minute, they had been drafted into the latest scheme of notorious prankster Horace de Vere Cole; professional costumers arrived at Fitzroy Square before breakfast to apply black face make-up, turbans, beards, false lips and clothing to transform Virginia and Duncan into the retinue of the Emperor of Abyssinia. It was a repeat of a similar scam in which Adrian had joined Cole five years earlier, when they were Cambridge undergraduates, to pose as the Sultan of Zanzibar. His taste for public hoaxes undiminished, Cole informed the First Lord of the Admiralty that the delegation was coming, then conducted his group to the HMS *Dreadnought* at Weymouth, where they were treated as honoured guests and spoke in a babble of 'bunga-bunga' and pigeon English. Adrian took the role of translator. Cole later leaked the story to the press, being reported as far afield as Tasmania, New Zealand and Singapore, but in spite of the wrath of her cousin, Admiral William Fisher, Virginia escaped her name being made public. The nature of the hoax, widely distasteful to modern sensibilities, was very much a product of the sheltered colonial Edwardian world with its institutionalised view of the races. Vanessa, Clive and

Lytton objected, but this was due more to their fears for Virginia's good name and mental health rather than their concerns about the nature of their costumes and performance. Their fears were not unfounded either, as the following March Virginia did slide into another depression.

With Vanessa pregnant again and Virginia experiencing doubts about her novel, a holiday at Studland Bay, in Dorset, was arranged that spring. When this did not seem to work, they followed it by staying at the Moat House, Blean, near Canterbury, a sprawling eighteenth-century property on the edge of Rough Common. Photographs taken from this period, of the group on Studland beach and in the garden at Blean, show Virginia looking ill-at-ease, perched beside Clive or Julian, staring side-long into the camera. In several, it looks as if the photographer is resented, something of an intrusion. She sits beside Clive in a bathing costume on the dunes, each echoing the other's body language, slightly turned to the side, with the right knee up. Outside the Moat House, she, Clive and Julian have the appearance of a family group, with the new parents intent on their child. It is notable that Vanessa is absent from these images, probably behind the camera, although this highlights the greater distance that the flirtation had caused. Vanessa left early, returning to London to make arrangements for her confinement, leaving her husband and sister-in-law behind.

But Vanessa was not only making arrangements for herself. Knowing that she would not be able to care for Virginia during the coming months, she contacted a nursing home in Twickenham, run by a Mrs Jean Thomas. Dr Savage had advised Vanessa that a drastic solution was required, as they had 'tried half measures long enough', and recommended a modified version of the popular S. Weir Mitchell 'rest cure'. Vanessa, though, was anxious that her sister did not think she had instigated the regime, writing from Gordon Square to Clive that she hoped Virginia wouldn't 'be in a

fearful state about it' and that it had come entirely from Savage, because of 'how serious he thought it'.[7] Virginia went straight from Canterbury to be cared for at 'Burley' in July. On 19 August, Vanessa delivered her second son, whom she would later name Quentin. Distanced from her family, friends and London, Virginia took her seclusion personally. She threatened half seriously to throw herself out of a window in a similar incident to that of 1904, and addressed Vanessa as a 'dark devil', in the belief that some 'great conspiracy [was] going on behind [her] back'. She wrote that she was most in want of 'intelligent conversation' rather than the 'silent prayer' she was being offered by her nurses and the 'brightest spots' of her incarceration were Clive's visits. The particular combination of religion and reverence for the royal family was at odds with Virginia's rejection of Victorian values, as well as the ugliness of the house and 'all the eating and drinking and being shut up in the dark'.[8] In mid-August, Virginia was finally released into the sunshine as she and her nurse Jean Thomas headed to Cornwall for a walking holiday.

Although Vanessa and Virginia were out of the way, momentum for Roger's Post-Impressionist exhibition was building. Then, just as his plans were beginning to form, he was beaten to it. In June that year, curator Henry D. Roberts and journalist Robert Dell launched a show at the Public Gallery in Brighton, including works by Monet, Matisse, Degas, Gauguin and Cezanne. A review in *The Times*, attributed to Fry, explained that the works sought to capture a mental image rather than a 'direct impression of a real scene', although many of the other responses were hostile. James Strachey attended the exhibition, writing to Rupert Brooke in mid-August, 'If you've got any moral sense you'll go to look at it. The pointellistes [*sic*] are of course out of date. But there's a whole roomful of symbolists – Gauguin, Matisse, Derain – My God! The Colours!'

Yet the exhibition's influence did not spread. Brighton might sometimes be referred to as 'London by the Sea', but the crucial difference was that it was not London, and did not enjoy the same audience, reach or critical response. For the purposes of launching the artists in England, the scale of the response was provincial rather than national. As the introduction to the exhibition catalogue for the Grafton Galleries show acknowledged, 'The works of the Post-Impressionists are hardly known in England. The exhibition organised by Mr Robert Dell at Brighton last year has been our only chance of seeing them.' However, such works had been on show in London before, as only five years before the Grafton had hosted over 300 works by Cezanne, Degas, Renoir, Manet and others, sponsored by the French dealer Durand-Ruel. The Post-Impressionists had also been displayed at other locations in the city in 1906 and 1908, when they had been denounced in the *Burlington* magazine as 'infantile' and 'trivial', to which Fry had replied to defend their work. For some reason, the circumstances had not favoured these earlier exhibitions and the Post-Impressionist artists had failed to make an impact in London so far. That was soon to change.

In September, Fry enlisted the help of Robert Dell and Desmond MacCarthy on a trip to France to select pictures for a new exhibition. Dell took them to visit the Parisian various dealers who had been instrumental in launching the careers of the new artists; Vollard, Druet, Kahnweiler, Sagot and Bernheim-Jeune. In one afternoon alone, they chose around fifty pictures. In Meaux, they found Van Gogh's *The Postman*, a 'wonderfully hideous, alive and disconcerting' portrait, which MacCarthy expected would 'send people to the turnstile clamouring for their money back'.[9] From there, MacCarthy went on to Munich and Amsterdam, where Van Gogh's sister-in-law offered him several more images, including *Irises*, *Sunflowers* and *View of Arles*. In October, Clive joined Fry

and MacCarthy when they returned to Paris in the company of London socialite and patron, Ottoline Morrell, who had helped found the Contemporary Art Society. She was a striking figure, with her theatrical dress sense, imposing features and vibrant red hair, and had hosted her own salon at 44 Bedford Square. Roger was also involved in a brief affair with her at this point, being a frequent visitor at Peppard, her house in the country, and wrote that she was 'quite splendid ... I am preparing for a huge campaign of outraged British Philistinism'.[10] Occupied at home with her new baby and the toddler Julian, Vanessa could only express her interest in their trip from afar, wondering to Clive whether he would 'come across a new genius in Paris and even perhaps invest in one of his works'. Returning home with only weeks to go before the exhibition was due to open, Fry spread out the pictures they had acquired on chairs. They were 'bold, bright, impudent almost' in comparison with a G. F. Watts portrait hanging on the wall behind. He believed, as Virginia wrote, 'that it was quite easy to make the transition from Watts to Picasso; there was no break, only a continuation. They were only pushing things a little further.'[11]

At first, Fry found it difficult to decide on a name for the exhibition because of the wide range of artistic styles. Eventually, under pressure from the media, he chose 'Manet and the Post-Impressionists' to cover the 228 catalogued items, of which twenty-one were Cezannes, twenty-two Van Goghs, forty-six Gauguins, a few Vlamincks, Derains and Frieszs and twenty-two Matisses, covering painting, drawing and sculpture. They were a riot of colour. Having recently hosted the International Society of Sculptors, Painters and Gravers, the United Arts Club and the Women's International Art Club, the Grafton Galleries sang with the lemon yellow of Cezanne's *Les Maisons Jaunes*, the vivid orange of Matisse's *Girl with Green Eyes* and the gold *Cornfield* languishing under Van Gogh's bright blue sky.

The exhibition opened for a private view on Saturday 5 November. Straight away it alienated a number of Fry's patrons. Sir Charles Holroyd, director of the National Gallery, asked that his name be removed from publicity on seeing the paintings, and the Duchess of Rutland wrote to MacCarthy that she was 'horrified' at being associated with the exhibition. A slightly less extreme reaction came from Charles Holmes, Slade Professor at Oxford, whose lukewarm guide went on sale at the exhibition, vaguely praising Cezanne and granting 'in the arts, I am inclined to think that a stimulus of any kind is healthy'. Chasing a sensational headline, critic Robert Ross misidentified 'a wide-spread plot to destroy the whole fabric of European painting', while another commented that 'the exhibition is either an extremely bad joke or a swindle'. At the Slade, Professor Frederick Brown broke off his longstanding friendship with Fry, and his colleague Henry Tonks warned his students to stay away from the Grafton Galleries for fear of contamination. Tonks also produced an unflattering cartoon of Fry and Bell entitled *The Unknown God*, in which Fry presents a dead cat to an unimpressed audience. The anonymous critic of *Connoisseur* regretted that 'men of talent ... should waste their lives in spoiling good acres of canvas when they would have been better employed in stone breaking for the roads'. The critic of the *Daily Telegraph* threw down his catalogue and stamped on it, while the *Pall Mall Gazette* described the exhibition as the 'output of a lunatic asylum'.[12] Two days later, Fry took his wife, Helen, to the Retreat, an asylum in York, where she would remain for the rest of her life.

The public were admitted to the show on 8 November. Londoners were let loose with howls of derision upon works that a century later would be recognised and loved worldwide. The spectacle of art was treated much like any of the entertainment shows to be visited at Olympia or Alexandra Palace: 'The British public will

flock to the new sensation and laugh, marvel or rage' for their amusement. Their behaviour was not unlike that of the stalls at a music hall. One critic used the analogy of dogs and music, 'It makes them howl but they can't keep away.' He had overheard the paintings described as 'nightmares' and the 'ceaseless hee-haw' of laughter, while the *Observer* described 'the majority of the pictures ... are not things to live with'. The *Illustrated London News* tried to capture the range of public responses in cartoons, labelled, 'Some who point the finger of scorn, some who are in blank amazement or stifle the loud guffaw; some who are angry; some who sleep.'[13] The *Bystander* magazine produced its own satirical sketches, centred around a distorted version of Van Gogh's *Postman*. Fry was denounced as an anarchist.

Yet there were also positive responses. While some still persisted in seeing these new works as 'post-savages ... apaches of art' whose work belongs 'on the pavement', according to one letter sent into the *New Age* magazine, reactions did mellow after the initial weeks. By January 1911, the *Daily Graphic* was able to report, 'The general attitude was one of admiration and of regret that an exhibition which has furnished so much food for discussion must close.' Critic V. H. Mottram attended the exhibition 'as unbiased as anyone could ... owing to the newspapers' and expecting to 'be made to laugh', which he did, 'at the stupidity of the comments made in my presence by the other visitors'. Douglas Fox Pitt reminded readers that 'all art movements have grown out of difference' and the inability to see the beauty in Cezanne indicated 'a defective aesthetic sense'.[14] Lytton and James Strachey attended the exhibition on 11 November, and James described it to Rupert Brooke as 'simply superb'.

The public's reaction had not been a surprise. With artistic tastes dictated by the Royal Academy and favouring the representational and heroic, Fry, Bell and MacCarthy had predicted that the

bold work of artists like Van Gogh, Gauguin and Cezanne was not instantly accepted. Pictures that appeared to be simplistic, immediate and rule-breaking tapped into a wider sense of social discord. Teaching in London's art schools had favoured the 'draw for seven years – learn anatomy and chemistry and the use of the stump' approach derided by Vanessa Bell. Once the Post-Impressionists had been exhibited, the message was spreading that an expensive education and social connections were not necessary in order to paint. What was needed instead was passion and creativity. This cut to the heart of the class divide. As Fry explained in *Vision and Design*, his 'crime' had been to

> strike at vested emotional interests ... it was felt that one could only appreciate Amico di Sandro when one had acquired a certain considerable mass of erudition and given a great deal of time and attention, but to admire a Matisse required only a certain sensibility. One could feel fairly sure that one's maid could not rival one in the former case, but might by a mere haphazard gift of Providence surpass one in the second.

The exhibition was revolutionary in changing public perceptions of what constituted art and who might produce it, as 'social rather than an aesthetic prejudice'. As Virginia later wrote, 'On or around December 1910, human character changed.'

ELEVEN

The Opposite Sex, 1911–1912

The excitement and challenge of life.[1]

The year 1911 began with one of the riotous Bloomsbury parties that would go down in the popular imagination as the epitome of bohemianism. With James and Marjorie Strachey, Vanessa helped raise funds for Women's Suffrage by organising a Friday Club dance at Crosby Hall in Chelsea. Post-Impressionism was in the air, with its exotic freedoms, iconoclasm and bright colours. In response, the costumes were wild. James, Clive, Vanessa, Virginia, Adrian, Duncan and Roger were inspired to dress as figures from Gauguin's pictures, as 'Negrès Enflammés',[2] appearing 'incredibly beautiful and very naked with a few brilliant clothes'. The scene was described by the eighteen-year-old David Garnett, who had been surprised to have received an invitation: towering over them all, Adrian wore 'long oriental robes' and 'the very tall hat of a Persian Magus', and had 'hollow lantern jaws … a slightly bewildered air of astonished amusement' and 'extraordinarily innocent eyes'. A 'tall, slim' woman 'with flowing draperies and long hair … a striking beauty, mysterious and lovely' was Virginia,

while James Strachey's costume was decorated by Roger and Duncan, with the image of a Post-Impressionist rocking horse, inspired by a design from Nijinsky's Scheherazade, although it was chiefly grease paint from the hips upward with full Turkish trousers, worn low enough to reveal his navel. On his head 'was a black astrakhan wig and round his neck a big gold or silver-gilt necklace in the form of a cobra with jewelled eyes.'[3] Roger made up his face to look like the face of the seated figure, the "awful creature" in the painting *Esprit de Mal*. They all danced properly and beautifully, instead of ... absurd waltzes and things.'[4]

With this renewed spirit of freedom, a significant transition was taking place within the Bells' marriage. Fractured by Clive and Virginia's flirtation, and Clive's defection to Mrs Raven-Hill, it had remained companionate, with the lives of both centred on their household and children, as well as their shared passion for art. However, the past four years had proved to be full of heartache for Vanessa and by the time of the Friday Club dance, the marriage was resolving into a friendship, a 'masterpiece of tact' to accommodate the needs of both.[5] Committed to G. E. Moore's concept of friendship and civilised human relations, it would become what Roger called an 'almost ideal family based as it is on adultery and mutual forebearance, rather a triumph of reasonableness over the conventions'. Through her life, Vanessa remained able to keep her husband and lovers close and even allow Clive's amours into the family circle, although sometimes on a tight-lipped sufferance.

The Bells were still sleeping together, though, and Vanessa was pregnant for a third time when they arranged to travel to Turkey with Harry Norton and Roger in April 1911. To Clive, the trip seemed ominous from the start, although his fears were misplaced, focussing not on his expectant wife but on Virginia, who he was certain would be snapped up by an amorous suitor in his absence. It was Vanessa who caused concern though, falling ill as they

set out, feeling faint at Dover and having to rest. Clive tried to persuade her to return home, but she refused to give up the trip. From Dover, they took the boat to Constantinople then travelled on to Broussa, the old Ottoman capital. There, overlooked by the mountains, they stayed at the Hotel d'Anatolie, known for its garden and good wine, and run by a Madam Brotte, who charged fifteen francs a night for a room. 'Roger seems to be business-like and capable; haggles with the waiters and officials and tried to write Turkish,' Vanessa wrote to Virginia, in contrast to 'Clive [who] looks after me like an old granny.' Yet she was enthused with a sense of escape, leaving her restrictions and obligations behind in England: 'nothing gives me the same sense of complete irresponsibility and freedom'[6] than leaving behind familiar shores. As the artists in the group, Roger and Vanessa were frequently thrown together, seeking suitable locations to paint in the hills, at the colourful bazaar and on boat trips, during which time Vanessa found herself increasingly impressed by Roger's energy and compassion.[7] She realised that 'under his possibly ascetic exterior there were hidden immense depths of passion and emotion', but was aware of the suffering he had recently endured, nursing Helen and being forced to reconcile himself to life without her.

It must have seemed highly symbolic for the state of her marriage when Vanessa lost her little French engagement ring down a well, making her more distressed than she could understand, 'as if something obscure but terrible had happened'. Soon after this, still in Broussa, she miscarried and suffered a complete breakdown. Conditions in the town were primitive. While Clive worried and grew frustrated, unable to cope with the demands of the sickroom, it was Roger who stepped in and nursed Vanessa back to health, sitting by her bedside at night and convincing her she would get well. He seemed to 'know exactly what [she] wanted, physically and mentally'[8] and brought her back colourful silks from the

bazaar, sketches and treats. By the time Virginia arrived on the Orient Express to carry her sister home, fearful of a repeat of the tragedy of 1906, Vanessa and Roger had fallen in love.

At first, the relationship was kept secret from Clive. In June, Vanessa was writing that she was glad to receive a letter from Roger and kept it to herself, 'although it was very discreet'.[9] Back in England, it quickly developed into a passionate sexual affair. Vanessa visited Durbins but clashed with Fry's formidable spinster sister Joan, so rented a nearby cottage to be close to Roger. 'You have given me something quite new and very large and beautiful,' she wrote to him, and 'I begin to try and draw you ... I know the shape of all of you pretty well now, even your hands ... almost as well as you know mine ... perhaps I have felt them more intimately.'[10] It was 'tantalising' to talk to him on the phone 'and not be able to see' him and she teased him with the thought that someone else besides him had kissed her toes: 'It was done with almost but not quite as much pleasure ... as you showed.' 'I want you and I love you,' she wrote, wishing he could be there 'all today and tonight.' Having lived through years of heartache with Helen, Roger was happier than he had ever been and would always consider Vanessa to be the love of his life.

Understandably, Vanessa was protective of their newfound happiness. She warned Roger to keep their secret: 'Talking of discretion, do be careful ... what you ever tell Virginia,' and urged him not to leave letters lying about. Unable to fully trust her sister after her entanglement with Clive, Vanessa discovered that Virginia had leaked several secrets to Duncan and Adrian, including one about a fling Roger had with Ottoline, not just as 'a general sketch but ... every detail'. Falling ill again in July, Vanessa explained Roger's presence in the house to the absent Clive as necessary, 'because I felt I couldn't be alone so long'.[11] In September, they all took a holiday to Studland Bay, while Roger rented a house nearby with his children. With Clive unsympathetic towards the

practicalities of babies and childrearing, Vanessa found that she was able to share her deep maternal feelings with Roger, connecting as parents as well as artists and lovers. Vanessa was uncomfortable when Virginia joined them in Dorset, as she appeared to have guessed the secret and insisted on referring in her letters to Vanessa and Roger as a pair. Vanessa feared her sister was intent on making mischief by hinting to Clive about the relationship, and she wrote to Roger, 'We must give her no possible excuse for being able to say anything as she's really too dangerous.'[12] While both Clive and Vanessa agreed they should be free to 'have whatever friendships [they] like[d]', Clive did not always 'live up to his principles'.[13] When Virginia did arrive at Studland, she behaved herself, being more 'amiable and amusing' than expected, although Lytton observed that she was 'shrivelled up inside'. By October, the cat may have been out of the bag, as Vanessa was able to write to Clive and jokingly refer to him as her 'legitimate male'.

In October 1911, the Bells visited Paris, where the work of the cubists was sending ripples through the artistic community. Since the vibrant colours of the Fauves had caused a riot at the 1905 Salon d'Automne, Picasso and his friends Georges Braque and Juan Gris had adopted a different approach, playing with dimension and form to create images that were opened, dissected and presented from a number of angles simultaneously. Under the influence of the African masks he had seen at a 1906 Trocodero exhibition, Picasso had produced his startling *Demoiselles d'Avignon*, although it had not yet been seen outside his circle of friends. Since then, he had progressed through the initial stages of analytical cubism in 1909–10, reducing shapes to simple forms, and had begun a new style of synthetic cubism using collage that would become increasingly three-dimensional. His innovations were already being imitated by a group of Salon cubists, ensuring that the new style was becoming familiar in Montmartre and beyond. Vanessa

wrote to Virginia from the Café Napolitain: 'We're in a huge state of excitement having just bought a Picasso for £4. I wonder how you'll like it. It's 'cubist' and very beautiful colour, a small still life.'[14] The work was the 1908 *Pots et Citron*, a Cezanne-style confection of blue, white and brown planes around three central ellipses, surrounded by black cloisonné line, which remained in the family until the 1960s. In the company of Roger and Duncan, the Bells scoured the Salon d'Automne 'looking for young geniuses' for a proposed Second Post-Impressionist Exhibition.

Back at home in Fitzroy Square, Virginia started thinking seriously about marriage as the milestone of her thirtieth birthday loomed. That summer she had written that all her 'devils came out ... hairy black ones. To be 29 and unmarried – to be a failure – childless – insane too, no writer.'[15] Yet after the mistaken engagement to Lytton, she despaired of finding a man with whom she would share a similar connection, without the complications of Lytton's sexuality. In July, she received an invitation to walk in Richmond Park from Walter Lamb, brother of Lytton's friend Henry. Only three weeks older than Virginia, the Australian-born Cambridge classicist Walter had been described by Thoby as a 'Greek boy in a vineyard', although Virginia noticed that he was already balding. He remained a member of the Friday Club and had joined the Bells on holiday at Rye in 1907 and Studland in 1909, although Virginia had found him to be a rather awkward, unforthcoming companion, writing about 'the memory – alas it fades – of conversations with Walter Lamb'. Still, he persisted, misreading the signs, lying with her under the trees to confess his admiration while she felt the conversation became 'increasingly strained'. Knowing that she did not love him, there was never any question of Virginia accepting his proposal, and she sought refuge in listing her faults. What is significant in their conversation though, is Walter's question about heterosexuality and starting

a family: 'Do you want to have children and love in the normal way?'[16] Virginia replied that she did. Over the coming years this was to prove a central question.

There was fresh excitement to be found in London in the summer of 1911 with the arrival of Diaghilev's Ballets Russes. Although this was to be the beginning of a fruitful personal and artistic connection with Bloomsbury, including the introduction of Keynes to his future wife, London responded to the avant-garde ballet with as much ridicule as it had to Post-Impressionism. Opera-goers in Covent Garden were used to the harmonies of Verdi, Rossini and Puccini, sung by 'first-rate singers' to make a profit, as one critic of 1911 complained: 'It were idle to pretend that Covent Garden is primarily concerned with opera as an art.'[17] Yet the change had already begun. In December 1910, the opera *Salome*, based on Wilde's play, had been performed for the first time since being banned for its sexual themes. People began to queue for tickets at six-thirty in the morning and the opening performance sold out in eighty minutes. Vanessa attended with Adrian, finding it 'exciting in places ... and horrid in others'. One reviewer thought the audience divided into those prudes 'who will raise an outcry at every gesture of Salome' and the prurient, 'who will insist on each revolting detail as an instance of courage',[18] while Lytton declared that the audience contained everyone he knew in Europe. Bloomsbury and their friends flocked to Covent Garden to see the Russian dancers in *Scheherazade*, impressed by its bold iconoclasm, colours, design and beauty.

Writing in *The New Age* magazine, Huntly Carter explained exactly why the performance can be allied more with the achievements of the Post-Impressionist exhibition of 1910–11 rather than as a continuation of the operatic tradition:

To begin with, the arrangement of the music material by Rimsky-Korsakov is especially designed to create an extraordinary atmosphere

of Eastern voluptuousness and to call forth the harmonious and expressive dancing and decorations. The introduction is full of the jagged lines and colours of departing Persian warriors. This changes to a sound like the throbbing of loosened hearts ... then suddenly it tears apart the rich flowing lines and gorgeous sensuous colours to plunge us into the terror of a coming storm ... the lines colours and movements change ... Two amazing tableau curtains were introduced ... the composition of the music and the curtain was completely harmonious ... the spasmodic, jagged, conflicting passages of the one being repeated in the feverish, resisting lines and intensely dramatic colours of the other ... The primary condition for the new form of ballet is that the public shall regard it as an organism, as an entire work of art, not merely as an evening's entertainment.[19]

In July 1911, Duncan Grant and Rupert Brooke were both impressed by Nijinsky dancing in *Scheherazade*, returning several times to watch him. Duncan would encounter the dancer at Ottoline Morrell's Thursday salon the following year, when Nijinsky and the Russian costume and set designer Leon Bakst observed him one twilight playing tennis in the square outside. 'Duncan ... of course became at once their pet,' Ottoline wrote, 'I saw Nijinsky looking him all over,' and Duncan was equally fascinated, longing in vain to design a ballet for the dancer. As William Plomer wrote,

> Nijinsky, seeing the ballet
> of tennis players in white
> darting between the tall, theatrical
> and sepia-mottled columns of the vaulting trees,
> threw out a dancer's arm, and called
> in a faun's warm voice
> 'Ah, quell décor.'[20]

Nijinksy may well have been inspired to create the 1912 ballet *Jeux* by this meeting, set to music by Debussy and Bakst's scenes of 'dreaming garden trees' that echoed Bedford Square. The very geography and fabric of Bloomsbury entered their art while also proving a canvas for it. In the same year, Duncan may well have been thinking of this meeting when he executed a huge mural of tennis players on the walls of Adrian's rooms in Brunswick Square. According to David Garnett, it was in a drawing room that stretched across the whole front of the first floor, painted on the west wall opposite the fireplace. The image was Post-Impressionist in style, with one large woman in the foreground reduced to a triangle of yellow skirt. On the floor below, a room with a round end, occupied by Duncan and Keynes, there was a continuous street scene 'in which the centre of dramatic interest was a fallen cab horse with the driver of the hansom still perched precariously aloft, though the cab was tilted forward with the shafts touching the pavement'.[21] This had been painted by Duncan, working with his friend, the Kensington-educated artist Frederick Etchells. Garnett saw the work evolve as a regular visitor to Adrian's rooms, attending his poker parties along with his friends the Olivier sisters, Saxon, Keynes, his fellow economist Gerald Shove and the Costelloe sisters Karin and Ray. While Adrian was still in love with Duncan in 1911, he would marry Karin in 1914, while Shove would marry the Stephen's cousin, Fredegond Maitland, in 1915.

New friendships had also begun to develop for Virginia, as she reconnected with one of the little boys who had played cricket on the lawn of Talland House. Rupert Brooke had been five or six that summer at St Ives, but after an education at Hillbrow and Rugby, where he had known Duncan Grant, he had proceeded to Cambridge. There he became the protégé of Walter Headlam, under whom he stage-managed a performance of Milton's *Comus* in 1908. Lytton had fallen in love with Rupert in 1908, writing to

Virginia of a beautiful young graduate 'with a romantic name ... pink cheeks and bright yellow hair', unaware that he would stir memories of her past. Virginia and Rupert met again and had tea in February 1909, while he was visiting Cambridge with James Strachey and Duncan, although the friendship did not really take off for another two years. In the meantime, Brooke discovered two photographs from a childhood holiday in Cornwall; '1893 perhaps of me, Dick [his brother], Adrian, Vanessa, Virginia, Thoby, Leslie ... all very sporting and odd. Virginia and Vanessa are incredibly old in it; a little gawky, Virginia very fat-faced.'[22] Rupert was initially drawn closer to the Bloomsbury circle through his friendships with Duncan, who was his regular confidant, and James, who was in love with him, and with whom Rupert attended Diaghilev's ballet in July 1911.

Virginia and Rupert reconnected, making a visit to London Zoo with Desmond MacCarthy, and Rupert was amused that his old friend proved liberal enough to 'gloat' over a seal with an erection.[23] That July, he encountered her again at a performance of *Le Spectre de la Rose*, after which James Strachey wrote to Rupert that Virginia 'fairly "went it" over you – thought your poems must be so good, as you had such a wonderful grasp of things'.[24] Perhaps this was what prompted Brooke to invite her to stay at the Old Vicarage in Grantchester outside Cambridge, whose lilacs and chestnut trees overhanging the river Rupert would recreate in the poem of the same name. 'The Old Vicarage' was a place where bare feet trod through the long grass and the gods of nature bathed, hares played in golden May fields, the breeze sobbed in the trees and the poet asked whether there was still honey for tea. Brooke would compose the poem nostalgically in 1912 in Germany, recalling the happier days of the previous summer.

Virginia now found herself among the Cambridge set that she and Vanessa had christened the 'neopagans' for their outdoor

lifestyle, liberalism and vegetarianism. She already knew Rupert's lover Ka Cox, 'one of the younger Newnhamites ... a bright, intelligent, nice creature'[25] as well as the artist Gwen Darwin, granddaughter of the scientist, and her new husband Jacques Raverat, whose wedding she had attended that May. Also present were the diplomat and lecturer Sydney Waterlow and Frances, Gwen's sister, who had been married to her fellow poet Francis Cornford. Waterlow already knew Virginia from the Studland Bay holiday of 1909 and had dined with her and the Bells in December 1910, where he characterised the sisters as 'Vanessa icy, cynical, artistic, Virginia much more emotional, and interested in life rather than beauty'.[26]

Having heard of Rupert's reputation for beauty and poetry, Virginia packed her manuscript of *Melymbrosia* in August 1911 and took the train to Cambridge. The next few days were spent out in the fresh air, reading poetry and daringly bathing naked in Byron's Pool, which was quite a liberating step for Virginia, especially when she witnessed Brooke's party trick of emerging from the pool with an erection. However, there was little hint of romance – she and Rupert slept at opposite ends of the house – and she was aware of his various love affairs, including the occasions when he had bedded Arthur Hobhouse.

When Virginia returned to Firle, Rupert came with her and from there they headed to Clifford Bridge on Dartmoor, where a group of fellow neopagans were camping in a joint venture known as 'Bloomsbury under Canvas'. Among them were Maynard and Geoffrey Keynes, James Strachey, Justin Brooke and the beautiful Olivier sisters, with Lytton and G. E. Moore staying at nearby Becky House. With them was Leonard Woolf, who had returned home on leave from Ceylon in June, and, holed up against the vagaries of the weather, Lytton had embarked on writing his first book, *Landmarks in French Literature*, which would come out in

1912. Inspired by their schooling at the forward-thinking Bedales, a co-educative school focusing on the liberal arts and healthy outdoor living, the neopagans cooked over an open fire and slept under the stars. 'Camp Life suits me very well,' wrote Keynes to his father, 'the hard ground, a morning bathe, the absence of flesh food, and no chairs, don't make one nearly so ill as one would suppose.' It was too much for James Strachey though, who spent a single night sleeping under a bush before retiring to the comfort of Becky House. By the end of the camp tempers were a little frayed, and the volatile Rupert, unable to choose between Ka Cox and Noel Olivier, lost his temper and wandered off to sit and cry alone on the hillside.[27] There was to be no romance between Rupert and Virginia, but the friendship continued, and they attended a performance of *Die Walküre* together that October, with Adrian and Leonard.

Having left Ceylon on leave, Leonard Woolf had little intention of returning. His mind was now set on making Virginia his wife, as Lytton had suggested in 1909. He had probably first seen her again in July, when dining with the Bells in Gordon Square, and found that the two prim Edwardian sisters he recalled from 1904 were now confident, liberated and outspoken women, pursuing the lives of their choosing in the face of social expectations. Surnames had been dropped and everyone was on intimate, first-name terms, kissing instead of shaking hands and sharing the sort of personal details that had been taboo when Leonard left for Ceylon. He felt at home at once. 'It was this feeling of greater intimacy and feeling, of the sweeping away of formalities and barriers, which I found so new and so exhilarating ... To have called a (sexual) spade a spade in the presence of a Miss Strachey or a Miss Stephen would seven years before have been unimaginable ... for the first time I found a circle in which complete freedom of thought and speech' was extended to both sexes.[28] And Leonard found this exposure to

the female minds of Bloomsbury to be enlightening, enchanting. As he admitted, 'I have always been greatly attracted by the undiluted female mind, as well as by the female body' ... they were 'gentler, more sensitive, more civilised' than men.[29] In particular, though, he recalled Lytton's words and found his praise of Virginia's mind to have been no exaggeration. Bloomsbury also accepted Leonard, as an Apostle, a critical thinker and a friend of the much-missed Thoby. After the July dinner, Virginia wrote and invited Leonard to stay with her for the weekend at Asheham House, but he was already committed elsewhere and unable to accept until September, after the neopagan camping trip.

In the autumn of 1911, with the lease of 29 Fitzroy Square coming to an end, Virginia and Adrian took the controversial decision to rent a larger house and share it with friends. That October they occupied 38 Brunswick Square, with Maynard Keynes and Duncan Grant sharing the ground floor, Adrian on the first floor and Virginia above him. The top floor was offered to Leonard Woolf. When George Duckworth protested about the immorality of Virginia sharing with men, she considered teasing him that at least it was near the foundling hospital. According to the Scheme of the House, written up for Leonard by Virginia that December, meals were supplied by Sophie the cook and the housemaid Maud at 9 a.m., 1 p.m. and 8 p.m., with tea at 4.30, for which the inhabitants would sign up each day by initialling the kitchen Instruction Tablet. These were left on trays in the hall, for the 'inmates' to carry up to their rooms, consume the meal and return at once.[30] Leonard moved into his rooms on 4 December, paying a rent of thirty-five shillings a week, with an empty bookcase to grace the newly painted walls.

Virginia was also looking for a place in the country. During her illness of 1910, it had been suggested that she rent a country house to provide her with a retreat when London life became too intense.

In early 1911 she signed a year-long lease on a new red-brick villa in the Sussex village of Firle, which she named Little Talland House and painted in Post-Impressionist colours, staining the floors 'the colour of the Atlantic in a storm', and invited friends to stay. In the last weekend of November 1911, she entertained Vanessa, Roger and Sydney Waterlow, who was recently separated from his wife. Although technically still married, Waterlow had long admired Virginia and when his decree nisi was granted on the final day of the visit, he hoped to make her his second wife. Two days later, in London, he proposed. Virginia had no intention of accepting, though, and had perhaps heard stories about his most recent love affair, begun two days after leaving the family home. She gave him a gentle but definite rejection and he returned to Cambridge the following day 'in despair'.

Before the year-long lease expired on Little Talland House, Virginia discovered the eighteenth-century Asham, or Asheham House, while walking with Leonard on the South Downs. Set along the Lewes–Seaford road, among trees near the village of Beddingham, it seemed an ideal country retreat, although its ancient plumbing and primitive fittings needed considerable work to make it habitable. Leonard described it as an 'extraordinarily romantic looking house' with views across the fields and Ouse valley. It was built in an L-shape, with a 'flat, plain, serene yellow-washed' front and French windows opening on to a terrace. Leonard, who was always deeply affected by the 'personality' of his homes, admitted that he had 'never known a house which had such a strong character ... romantic, gentle, melancholy, lovely ... as if one were living underwater in the depths of the sea behind the thick, rough glass ... a sea of green trees, green grass, green air.' Once, he slept outside and woke early to 'a tremendous chorus as if every thrush and blackbird in England had started to sing' with the 'uncut grass towering over [his] head, the rose

leaves above the grass and the elms above the rose leaves.'[31] In the autumn, the hollow was full of mushrooms, and they once saw a vixen and her cubs playing on the grass. Virginia was also convinced it was haunted and made it the subject of her story 'A Haunted House', which begins 'Whatever hour you woke, there was a door shutting ... wandering through the house, opening the windows, whispering not to wake us, the ghostly couple seek their joy.' Early in 1912, she held two house-warming parties, the first falling, ironically, on the 'coldest day for forty years'. It was a disaster, with birds having found their way into the house, bottoms falling out of the grates and the pipes frozen. A second party, held a week later, was more of a success, although Virginia was exhausted afterwards and took to her bed for a week, with a 'touch of my usual disease, in the head you know'. There may have been more behind her retreat.

In early January, Leonard travelled down to Frome, in Somerset, to stay with friends. He had grown increasingly close to Virginia in the last six months, reaching the decision that he had fallen in love with her and wanted to make her his wife. On 11 January, he travelled up to Brunswick Square by train for a brief visit, after having warned Virginia of his arrival by letter. The urgency of his words, insisting that he must speak with her, may have led her to suspect the reason for his actions. He did propose to her on that day, two weeks before the significant thirtieth birthday that seemed to mark a rite of passage in Virginia's mind. The romantic took a prosaic turn, though, when they were interrupted by the arrival of Walter Lamb, and the atheist Leonard joked that Lamb's arrival almost proved the existence of a God. Returning to Frome without an answer, he wrote expressing his uncertainty about whether she might be able to love him, and promising to be ruled by her. A second letter, composed the following day, made his feelings clearer:

I see the risk in marrying anyone and certainly me. I am selfish, jealous, cruel, lustful, a liar and probably worse still. I had said over and over again to myself that I would never marry anyone because of this, mostly because, I think, I felt I could never control these things with a woman who was inferior and would gradually enfuriate [sic] me by her inferiority and submission ... You may be vain, an egoist, untruthful, as you say, but they are nothing compared to your other qualities; magnificence, intelligence, wit, beauty, directness. After all, too, we like one another, we like the same kinds of things and people, we are both intelligent and above all it is realities which we understand and which are important to us.[32]

Virginia replied that for the moment, she wished to 'go on as before' and that she should be free. On 12 February, Leonard took her to meet his family at Putney, but the meeting between Virginia and Marie Woolf did not go well and Marie would air the grievance that her son had been 'stolen' away from her. At the end of February, she returned briefly to Jean Thomas's nursing home in Twickenham and, understanding that her mental state was volatile and his presence might influence her, Leonard agreed not to contact her. Vanessa, though, was one of the few people in whom Virginia had confided, and wrote to Woolf, saying how glad she would be if they married, as 'You're the only person I know whom I can imagine as her husband.'[33]

Leonard, 1912–1913

When the lights of health go down, the undiscovered countries ... are then disclosed.[1]

Virginia and Leonard were married on 10 August 1912. His was the only proposal she had taken seriously and the timing was right. She had shed her childish 'tremendous, absurd, ideal of marriage' as well as her dislike of the 'safeness and sobriety' of young married couples: 'Now I only ask for someone to make me vehement, and then I'll marry him!'[2] As Vanessa had confessed to Leonard, there was no other man of her acquaintance who was suitable husband material for Virginia: she was bored by Walter Lamb and never saw Hilton Young, Rupert Brooke or Sydney Waterlow as viable alternatives. Lytton was still 'charming and amenable', but in a letter to Molly MacCarthy, Virginia admitted she wouldn't 'float into a bloodless alliance with Lytton, though he is in some ways perfect as a friend, only he's a female friend.'[3] Yet there was one other man whose dark good looks had caught her eye. During her flirtation with the neopagans, Virginia had admired the French artist Jacques Raverat; he had daunted and

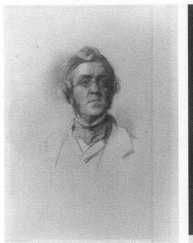
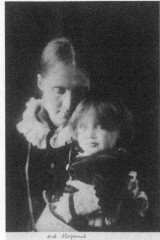

Left: 1. William Thackeray, the novelist who died in 1863. Four years later, his friend and great admirer Leslie Stephen married Thackeray's daughter, Harriet Minna, known as 'Minnie'. She would bear him one daughter before dying in 1875. (Library of Congress)

Right: 2. Julia Stephen and Virginia around 1883. Julia had already borne Leslie two children before deciding that they would have no more children. Whatever contraceptive method they employed was not a success, though, as Julia went on to bear Virginia in 1882 and Adrian in 1883. (Mortimer Rare Book Room, Smith College Library)

3. Lake Lucerne, the romantic location where Herbert Duckworth proposed to Julia Jackson. The marriage was happy but short-lived, leaving the widowed Julia to raise three children in Hyde Park Gate. Her neighbour was Leslie Stephen, whom she comforted after he lost his own wife, Harriet. (Library of Congress)

Left: 4. J. R. Lowell, the American poet who became Virginia's godfather in 1882 and wrote a poem as a gift to her. (Library of Congress)

Right: 5. William Holman Hunt, the Pre-Raphaelite painter who had been a close friend and admirer of Julia Stephen. He left the country in order to marry his sister-in-law, at a time when such matches were illegal. (Library of Congress)

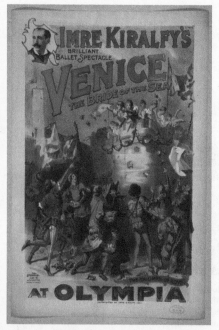

6. Kiralfy's *Venice: the Bride of the Sea*, a spectacular entertainment held at Olympia, to which Virginia and her siblings were taken in 1892 by George and Stella Duckworth. (Library of Congress)

7. Kensington Gardens. The Stephen children walked in the gardens near their home once or twice a day, along routes that took them past the flowers and pond, where they sailed boats. (Library of Congress)

8. Brighton, the home of the Stephen children's maternal grandmother Maria Jackson, where they visited her in 1885 and returned on holiday in 1896 and 1897. (Library of Congress)

9. Park Lane and Hyde Park. A scene close to their home, which the Stephens would have seen daily, taken in around 1900. (Leonard Bentley)

Left: 10. Tea in Kensington Gardens, a popular place for smart society to meet during the Stephen children's childhood. (Library of Congress)

Right: 11. The National Gallery and Trafalgar Square. The gallery was a frequent destination of the Stephen sisters in the 1890s, where they appreciated the works of Turner and the old Italian and Dutch masters. Vanessa had not yet come under the influence of the Post-Impressionists. (Library of Congress)

12. Paris, Exposition Universelle, 1900. Vanessa was taken to Paris in April by George Duckworth, which was her first taste of the city she would come to love. Picasso also visited the exhibition, with its displays of art, technology and different cultures, before its closure that autumn. (Library of Congress)

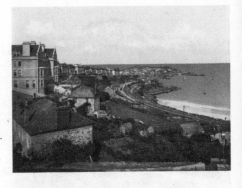

13. St Ives, Porthminster Bay. The Stephen children spent their childhood summers staying in Talland House, overlooking the bay – playing on the sand, tramping across the hills, catching moths in the garden and playing cricket. In 1895, after a new hotel partially obscured their view and Julia had died, Leslie sold the lease. The Stephens returned to gaze at the house in nostalgia in 1905. (Library of Congress)

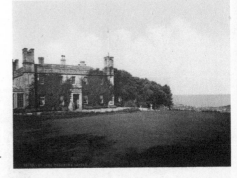

14. Tregenna Castle Hotel, St Ives. The overflow of guests to Talland House, including novelist Henry James, were housed in the nearby castle-style Tregenna Hotel. (Library of Congress)

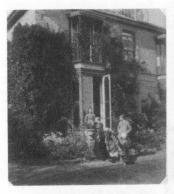

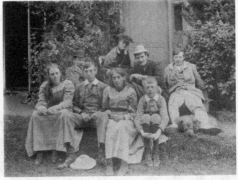

Left: 15. Family group on the steps of Talland House, St Ives, outside the French windows, taken around 1892. Vanessa stands on the top step and Julia just below her, with Adrian at her side. Virginia is bending to stroke the dog and Thoby stands behind her. (Mortimer Rare Book Room, Smith College Library)

Right: 16. Family group at St Ives. Julia is seated at the back and before her (left to right) are seated their guests, Horatio Brown, George Duckworth and Gerald Duckworth. In front of them (left to right) are Vanessa, Thoby, Virginia and Adrian. Taken in around 1892, probably in the garden of Talland House. (Mortimer Rare Book Room, Smith College Library)

17. Slade School of Art, Gower Street, London. In 1904, after the disruption of Leslie's death, Vanessa could not re-enrol at the Royal Academy so she went for a term to the Slade, which had trained such artists as Augustus John, his sister Gwen John and William Orpen. Vanessa did not enjoy the teaching of Professor Tonks and did not return for the new term in January 1905. (Anthony Lloyd)

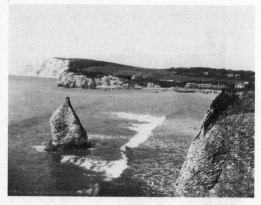

18. Freshwater Bay, Isle of Wight. Virginia's great aunt, the photographer Julia Margaret Cameron, lived at Dimbola Lodge overlooking Freshwater Bay. Julia was a frequent guest there in the 1860s, when she sat for her iconic photograph, and the Stephen family stayed there thirty years later, the summer after her death. (Library of Congress)

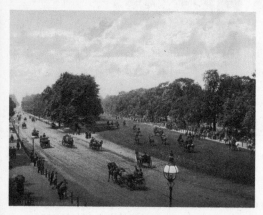

19. Rotten Row, Hyde Park. The haunt of the fashionable Kensington elite, George Duckworth insisted that Vanessa accompany him driving and riding in Rotten Row. He purchased an Arab mare for her to ride, every morning before breakfast, down Ladies' Mile. (Library of Congress)

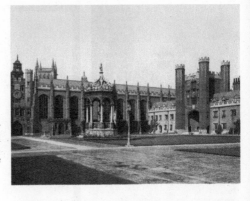

20. Trinity College, Cambridge. In the autumn of 1899, Thoby Stephen, Clive Bell, Leonard Woolf and Lytton Strachey went up to Cambridge and their discussion clubs, founded on the principles of free speech and emotional honesty, proved to be the foundation of Bloomsbury ideals. (Library of Congress)

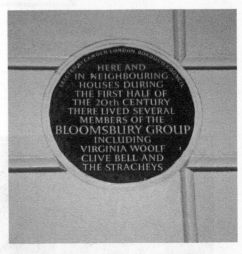

21. Plaque in Gordon Square. In 1904, the Stephen siblings left their family home in Hyde Park Gate in Kensington and moved to the less-reputable district of Bloomsbury. The location represented considerable freedom in running and decorating their own home, but also on a personal level. It was here, at Thoby's Thursday evenings, that the first meetings of the group took place. Vanessa and Clive continued to live at No. 46 after their marriage and Keynes lived there after 1917; James and Alix Strachey lived at No. 41, Vanessa and Clive occupied No. 50 at different times and Lytton lived at No. 51. (Amy Licence)

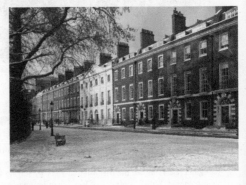

22. Bedford Square, Bloomsbury; No. 44 was the London home of society hostess Ottoline Morrell, who became an important friend and patron, as well as having a brief affair with Roger Fry. (Steve Cadman)

Left: 23. Paul Cezanne, whose work deeply affected Roger Fry through the first decade of the twentieth century. His liberation of form influenced the Post-Impressionist painting of Fry, Grant and Vanessa Bell, and underpinned Clive's theory of significant form. This statue to him stands in Aix-en-Provence. (Louise Carter)

Right: 24. Street scene in Sri Lanka, now Ceylon, in around 1900. In 1904, after graduating from Cambridge, Leonard Woolf accepted a position as a cadet in the Ceylon Civil Service, in Jaffna, Kandy, and then administrating the district of Hambantota. He returned on a year's leave in 1911 but decided to stay in order to marry Virginia. (Library of Congress)

25. Rupert Brooke, poet and neopagan, who had been the protégé of Walter Headlam at Cambridge. The Stephens had played cricket with Rupert and his brother in St Ives and Virginia re-established the friendship in 1911 by staying with Rupert at The Old Vicarage, Grantchester. With a complicated love life of his own, he was never a serious suitor for her hand. (Louise Carter)

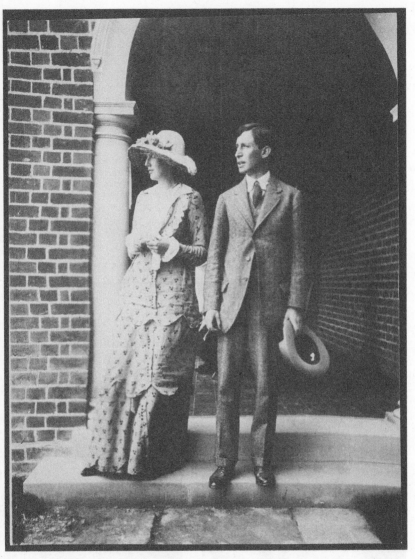

26. Leonard and Virginia, in a photograph taken soon after their engagement in 1912, at the home of George Duckworth, Dalingridge Place, near East Grinstead, Sussex. (Mortimer Rare Book Room, Smith College Library)

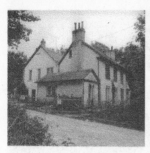

Left: 27. Asheham, or Asham, House, photographed in 1994 shortly before it was pulled down. The Woolfs leased the eighteenth-century house at Beddingham, Sussex, between 1912 and 1919 but its plumbing was ancient and life there was fairly primitive. They spent their wedding night there and Virginia was certain it was haunted, describing it in her short story *The Haunted House*. (East Sussex Record Office)

Middle: 28. Asheham interior. One of the rooms in the house, as it was in 1994. (East Sussex Record Office)

Right: 29. Asheham bathroom, 1994. (East Sussex Record Office)

 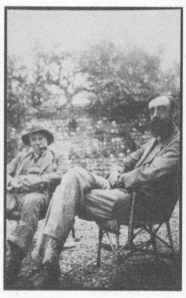

Left: 30. Clifford's Inn off Fleet Street. When the Woolfs returned from their honeymoon in October 1912, they moved into No. 13 Clifford's Inn. The building they knew was demolished in 1934. (Peter Dixon)

Right: 31. Clive Bell and Lytton Strachey. (Mortimer Rare Book Room, Smith College Library)

Left: 32. The side of Charleston Farmhouse opening on to the walled garden, showing the new studio that was added in the 1920s. (Amy Licence)

Right: 33. Charleston's walled garden, frequently painted by Vanessa, where friends were entertained and children played. (Amy Licence)

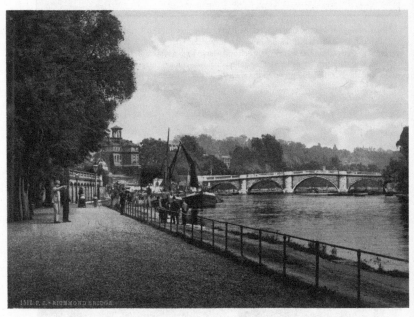

34. Richmond Bridge around 1900, a short distance from Hogarth House and the Green. The river proved a popular walk for Virginia, along past the bridge and into Richmond Park. (Library of Congress)

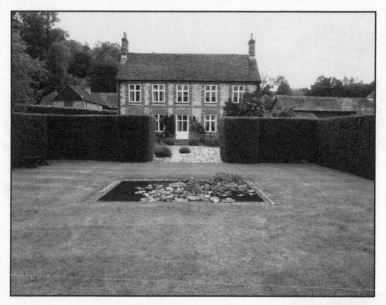

35. Garsington Manor, outside Oxford, home to society hostess Ottoline Morrell and her husband, the Liberal MP Philip Morrell. During the First World War, it was a haven for conscientious objectors such as Clive Bell and Mark Gertler, who came to live and work on the land. It was known for its lavish hospitality, exquisite colour schemes and peacocks strutting among the grounds, and provided the scene for many Bloomsbury parties. (Stuart Chalmers)

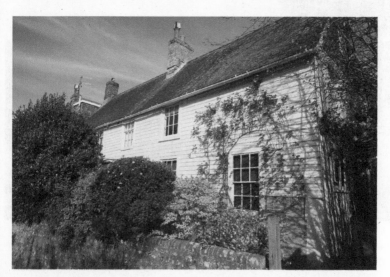

36. Monk's House, Rodmell, Sussex. The Woolfs bought the house at auction in 1919, along with some of its furnishings, and loved its rambling, abundant garden, views of the church and views over the countryside. It is now owned by the National Trust. (Amy Licence)

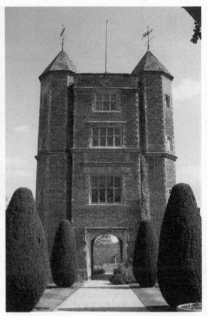

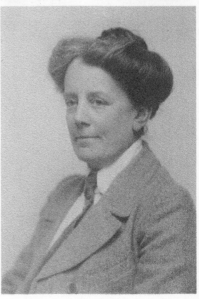

Above left: 37. Lydia Lopokova as a young woman, taken around 1915. Ten years later, she married John Maynard Keynes, having caught his eye while dancing the role of the lilac fairy in Tchaikovsky's *Sleeping Beauty* at the Alhambra. (Library of Congress)

Above right: 38. Sissinghurst Castle, Kent. In 1930, Vita Sackville-West and Harold Nicolson lived in the remainder of the medieval and Tudor palace with their two sons. Virginia was a frequent guest. Vita's study in the tower remains, preserved with her books and desk, as it had been left. The garden they created here is one of the most famous in England. (Amy Licence)

Right: 39. Ethel Smyth. Virginia attracted the friendship of the older composer and suffragette in the late '20s. Ethel fell in love but Virginia only wanted friendship, and the pair remained friends until the end of Virginia's life. (Library of Congress)

Left: 40. Plaque to Mark Gertler on his childhood home in Elder Street, Spitalfields, London. Jewish Slade-educated artist Gertler had long been on the periphery of the Bloomsbury Group, having befriended Lytton in an attempt to woo Carrington, then lost her to him. A few months before the outbreak of war, Gertler dined with the Woolfs to discuss Fry's work, but he gassed himself in his London studio in June 1939. (Amy Licence)

Right: 41. War was declared on 3 September 1939, but it had been brewing for a number of years. (Library of Congress)

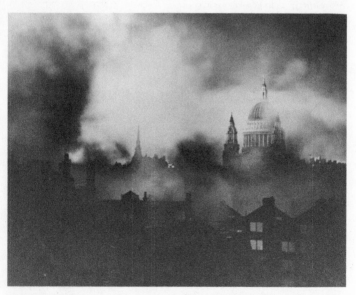

42. Bombardment of London, 1940. After a period of 'phoney war', the Blitz began over London in September 1940, with considerable damage to property and loss of life. For Virginia, whose previous homes in Tavistock Square and Mecklenberg Square would be hit, the destruction of the city she had loved since childhood was difficult to bear. (Library of Congress)

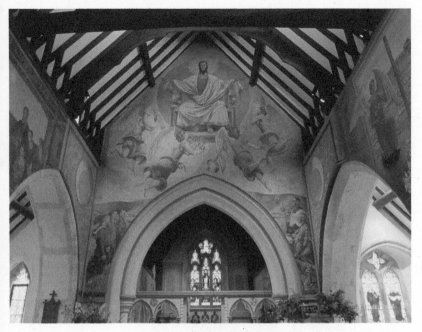

43. In 1940 to 1942, Duncan and Vanessa decorated the inside of Berwick church, including the walls, rood screen, pulpit and wooden panels. The images depict a range of biblical scenes including the nativity, the seasons and rural life. (Amy Licence)

Left: 44. Three young men in the mural at Berwick, overlooking the nativity, modelled on John Higgens, son of Grace, the Charleston cook, and Bill and Ray West, sons of the gardener. (Amy Licence)

Right: 45. Berwick church nativity, modelled on (left to right) Duncan Grant, Angelica Bell, Quentin Bell and Chattie Salaman. (Amy Licence)

Left: 46. Bust of Virginia in the garden at Monk's House. Virginia's ashes were originally buried under the elm named after her, but when it was blown down in a storm, this bust and quotation were erected as her memorial. (Wolf Gang)

Right: 47. Church of St Michael and All Angels, Berwick, Sussex, ten miles to the south-east of Charleston farmhouse. (Amy Licence)

Left: 48. Vanessa Bell's grave in the churchyard of St Peter's at Firle. She died at Charleston in 1961. (Amy Licence)

Middle: 49. Bust to Leonard Woolf in the garden at Monk's House. (Amy Licence)

Right: 50. Grave of Duncan Grant, d. 1978, beside that of Vanessa Bell at St Peter's, Firle. (Amy Licence)

impressed her with his 'quick easy way ... as if he had solved the problems of life'.[4] She may have wanted him 'to admire' her, but Jacques' affections were already engaged, and Virginia wrote to congratulate him on hearing that he had proposed to Gwen Darwin: 'My congratulations are very warm. As I said, I have heard so much of you, that I can congratulate her too.' In April 1911, she attended their wedding. With his long nose, thin face and sensitive eyes, Leonard bore more than a striking resemblance to the man who Virginia had admired.

In the middle of her deliberations, as she emerged from the Retreat, Virginia received a surprising letter from Rupert Brooke. The friendship had cooled a little in since the summer of 1911, but Rupert's own mental health was fragile and he recognised the connection this gave him with Virginia, appealing to her in March 1912, 'I feel drawn to you, in this robust hard world. What tormented and crucified figures we literary people are! God! How I hate the healthy unimaginative hard shelled dilettanti.' Undoubtedly the pair shared a mental fragility and literary ability, but Rupert was too unstable in comparison with Leonard's solidity and strength. Brooke had already turned against Bloomsbury and his former friends by the summer of 1912, responding with bitterness and dismissal when he heard about the engagement, writing to James Strachey that 'the sullen, surly Clive Bell reminds me that Virginia has married into the Society ... No doubt you've got a heap of funny stories about it. I thought the little man'd get her. Directly he began saying he was the only man who'd had a woman she knew and telling tales about prostitutes – oh you should have seen the love light dance and dawn in her eyes.'[5] When he saw Virginia, shortly after her marriage, he 'felt infinitely removed from her'. Five years later, Virginia would recall Rupert as being 'jealous, moody and ill-balanced'[6] although she declined to add this to her review of Edward Marsh's *Memoir* of the poet.

Virginia and Leonard had come to an understanding over an epistolary airing of defects. Four days after having resigned his position in Ceylon, he wrote that he was 'cold and reserved to other people', and didn't 'feel affection very easily' but that he desired her physically and wanted her to love him. 'I wouldn't have you marry me,' he wrote 'much as I love you, if I thought it would bring you any unhappiness,' but he hoped to be 'mind to mind and soul to soul' with his ideal wife. Virginia could see the advantages of accepting; she could be quite happy with him and 'he [would] give [her] companionship, children and a busy life,' but she sometimes felt 'angry at the strength of [his] desire'. She vacillated between wanting everything: 'love, children, adventure, intimacy, work', and physical coldness, feeling 'no more than a rock' when he kissed her. One of her fears was that 'the sexual side of it' would come between them. She wanted the intimacy of married life, with affection, kisses and caresses, but feared the actual act of intercourse. Another was her instability, as she could 'pass from hot to cold in an instant, without any reason', and a third concern was Leonard's Jewishness, which was alien to her and made him 'seem so foreign'. Such attitudes were common among all classes of Edwardian society, as an extension of the imperial system that had allowed Leonard to treat 'darkies' like children in Ceylon. What Virginia wanted was 'a marriage that is a tremendous living thing, always alive, always hot, not dead and easy in parts as most marriages are. Perhaps we shall get it,' she wrote, 'then how splendid!'[7]

On 3 May, Leonard and Virginia attended the second day of the inquiry into the sinking of the *Titanic*, which was held at the London Scottish Drill Hall in Buckingham Gate. The supposedly unsinkable ship had been lost on the night of 14–15 April after striking an iceberg, and the pair would have heard the first examination being conducted with survivors and witnesses. Four

days later, they attended a concert together and Virginia handed over the complete manuscript of *Melymbrosia* for Leonard to read. Replaced as Virginia's literary confidant, Clive was struggling to accept he had been replaced in Virginia's affections and Vanessa wrote to Roger that Leonard was 'more resented than you are'. According to Vanessa, Clive refused to 'see much of the couple and I think resents me [Vanessa] doing so,' which led to a 'tremendous' quarrel in the Bell household[8] and created a temporary coldness between the sisters. Virginia was now alienated from her closest family and under an increasing sense of obligation to Leonard, whose resignation from the Colonial Civil Service had been accepted on 7 May. Three weeks later, Leonard and Virginia lunched together and talked, during which she finally told him that she loved him. Then, they took a boat on the river at Maidenhead and dined nearby, during which time she agreed to become his wife.

To her cousin Madge Vaughan, Virginia explained that Leonard was a Jew, that he was thirty-one and that he had spent seven years 'governing natives, inventing ploughs, shooting tigers'. She felt happy and complete, 'even though it does seem a fearful chance, my having found any man who gives me what Leonard does.'[9] To Violet, she confessed that her 'penniless Jew' made her 'more happy than anyone ever said was possible' and insisted that her old friend should like him.[10] Leonard, she said, thought her writing 'the best part of her'.[11] Her letter to Janet Case contained a hopeful vision of the future: 'I shall never be ill again,' she vainly hoped, 'because with Leonard I get no chance.'[12] To Lytton, she sent a telegram, saying simply, 'Ha! Ha!' and signed by them both. An often-reproduced photograph of the couple during their engagement, with Virginia wearing a tiered cotton dress and floral hat, standing elbow to elbow beside the suited Leonard, was taken during a visit to George Duckworth's home at Dalingridge. The wedding took place between 'Mongoose' and 'Mandril' on

10 August at 12.15 p.m. amid a thunderstorm. It was the same location that Vanessa had married Clive in, St Pancras Registry Office, and Vanessa was a witness, along with George Duckworth. Roger, Duncan, Saxon and others were invited but Marie Woolf was not. Nor did Clive attend, although he hosted a celebratory lunch for the couple afterwards at Gordon Square. Then, as Mr and Mrs Woolf, they headed to Asheham for the night.

Virginia had been correct when she predicted that sex was to be their biggest problem. Although she had stated clearly that she wanted children, and agreed with Walter Lamb that she wanted a 'normal', or heterosexual, love life, the practice was rather different from the theory, and Virginia and Leonard's attempts at intimacy proved disastrous. Leonard had lived a sexually active life in Ceylon, visiting prostitutes, conducting affairs, sharing his home with a mistress and almost falling in love with the daughter of a tea planter. His letters had made his sexuality and expectations clear and, according to Brooke, he had confided in Virginia about his visits to prostitutes. In letters to Lytton in 1909, he had commented that virginity was a 'ghastly complication' and Lytton replied that Virginia was aptly named. It is impossible to know what happened on the wedding night at Asheham, or during the few days they spent at the Plough Inn, Holford, in Somerset. After that they set off touring through France, Spain and Italy, and by the time they had reached Saragossa in Aragon, Leonard had made an effort to make love to Virginia and failed.

Although Virginia felt able to write to Ka Cox that she had lost her virginity and found 'the climax immensely exaggerated', it is likely that the marriage had been consummated incompletely. Leonard's later description of the occasion suggests that the attempt had been abandoned without success: 'When on their honeymoon he had tried to make love to her, she had got into such a violent state of excitement that he had had to stop, knowing as he did that

these states were a prelude to her attacks of madness.'[13] Virginia would confess in 1926 that her sex life with Leonard had been 'a terrible failure and was abandoned quite soon', and her lover Vita would add that she 'dislikes the possessiveness and love of domination in men. In fact she dislikes the quality of masculinity'. Virginia expressed anger towards Leonard as a result of their honeymoon encounter, although it isn't clear whether this was because he had attempted sex or because he had failed: 'Except for a sustained good humour (Leonard shan't see this) due to the fact that every twinge of anger is at once visited upon my husband, I might still be Miss Stephen.'[14] Vanessa wrote to enquire whether Virginia was 'a promising pupil', and suggesting that Vanessa herself was bad at sex, and that Leonard might like to give her 'a few lessons'. There was a double-edge to this teasing, with Clive's affection for Virginia and jealousy of Leonard still strong enough for him to write that he loved Virginia very much. That December, when they asked Vanessa for advice, she told them that she had always felt Virginia 'never had understood or sympathised with sexual passion in men'. Quentin Bell suggests that they connected Virginia's distraught responses to her experiences with George and Gerald Duckworth, although he admits that while 'George certainly left Virginia with a deep aversion to lust … perhaps he did no more than inflame a deeper wound and confirm Virginia in her disposition to shrink from the crudities of sex'. Bell suggests this may have been due to 'congenital disposition'.

The possibility that Virginia's problems might be psychological, and her symptoms psychosomatic, was not pursued fully. Freudianism was a fairly new concept in England in 1912, but if anyone was well placed to grasp its significance for Virginia, it was Leonard, who would review Freud's *Psychopathology in Every Day Life* for the *New English Weekly* in 1914, and James Strachey, who would become a disciple and translator of Freud.

She did see at least one psychologist during this period, but the medical consensus was one of agitated nerves. Virginia always rejected what she called 'Freudian fiction' and only read Freud's full works shortly before her death, although she continued to explore the nature of the unconscious in her novels. To modern Freudian psychoanalyst Alma Bond, the cause of Virginia's distress seems clear: 'If one were to read only Virginia's diaries and the words of her family (i.e. Bell, that marrying Leonard was the wisest decision she was to make in her lifetime), one might be inclined to wonder why, during the honeymoon of this "happiest of marriages," the bride would suffer the most severe breakdown of her life.'[15]

During the remainder of the honeymoon, the Woolfs maintained the safe, 'day-time' life of companionship, seeing the sights, talking, reading and writing. Virginia completed *Melymbrosia* and Leonard also finished his first novel, *The Village in the Jungle*, and began a second, which would become *The Wise Virgins*. Into it he poured all the disappointments that he was unable to show to Virginia, and she would not see the novel until 1915. Their last stop was Venice, where Virginia was displaying the usual warning signs of headaches, exhaustion and refusal to eat. She required a week in bed being nursed by Leonard before they returned home. In October, they moved into rather crowded, unsatisfactory rooms at 13 Clifford's Inn and divided their time between there, eating their meals at the Cock Inn and weekends at Asheham. There was also an uncomfortable quarrel between the Bells and Woolfs, which broke out when Lytton showed Leonard a number of letters that Clive had written him, in one of which Clive admitted that he intended to have an affair with Virginia once she had recovered. Confronted by a furious Leonard, Clive insisted the comment had been a joke, but a breach had opened up in the heart of Bloomsbury and the former closeness between the sisters was further damaged by these leaked secrets and tangled emotions.

The timing of Virginia's illness, coming immediately after the sexually disastrous honeymoon, is suggestive. The distress she was suffering was not necessarily a resurgence of a past condition, or illness, but a response to the recent pressures of Leonard's sexuality and the strictures of married life. 'I was already troubled and apprehensive when we returned from our honeymoon,' Leonard wrote in his autobiography, as Virginia's symptoms became more serious through the first half of 1913. He accepted the notion that she was 'mad' and responded to the symptoms rather than the causes of her illness, often consulting doctors without her knowledge, administering drugs and making decisions for her. This initiated a shift in their marital identities, from husband and wife to patient and carer, insane and sane. Authority was firmly placed in Leonard's hands, while Virginia's only recourse was to react, to embrace the irrational, and to fall ill. Finally relieved of her responsibility for Virginia's welfare, Vanessa was grateful for Leonard's stoicism during her spells of illness, but even she was often frustrated by his inflexibility of mind. Soon, he would take an even more important decision into his hands.

Closely allied with the Woolfs' sexual difficulties was the question of whether Virginia would able to conceive, bear and raise children. It was understood that women who suffered from depression might experience worse symptoms as a result of hormonal changes, but the exact nature of Virginia's illness was uncertain, with the family doctor, Savage, diagnosing the 'modern' complaint of neurasthenia. Already losing credibility by this time, the term referred to a weakness or debility of the entire nervous system, which was seen as the result of exhaustion and displacement caused by urbanisation. It was considered a particularly female complaint, with sufferers exhibiting symptoms of dizziness, faintness and fatigue, and being treated by the rest cures that Savage recommended for Virginia. However, motherhood was not

considered detrimental to neurasthenics. It was certainly advised against for depressives who might pass on the condition, but not neurasthenics. Leonard, though, had his doubts. Concerned that the experience would trigger further bouts of emotional instability, he sought advice from a number of doctors until he found those that confirmed his view. Savage 'brushed [his] doubts aside' and declared that motherhood would settle Virginia, an opinion with which Jean Thomas and Dr Maurice Wright agreed. Dr Maurice Craig, however, who was then treating Vanessa for depression, strongly advised against it on the grounds of heredity. Leonard had gained the impression of Dr Savage as more of a 'man of the world' than a nerve specialist, so he chose to disregard his advice in favour of Craig and a second doctor, T. B. Hyslop. After further discussion with Leonard, Jean Thomas, the nursing home owner, also changed her mind and pronounced against Virginia experiencing motherhood.

It is interesting that Leonard chose to consult T. B. Hyslop about Virginia's health, beyond the fact that he sought confirmation of Craig's view that she should not have children. Hyslop was a self-declared enemy of the essential values of Bloomsbury, opposing what he saw as 'unhealthy and insane degenerate art' and preferring representational works, which were true to nature. In 1911, he denounced the Post-Impressionist exhibition in a lecture and article titled 'Post-Illusionism and Art in the Insane', in which Hyslop stated that the works at the Grafton Galleries had been created by madmen. 'Degenerates,' he wrote, 'often turn their unhealthy impulses towards art and not only do they sometimes attain to an extraordinary degree of prominence but they may also be followed by enthusiastic admirers who herald them as creators of new eras of art.'[16] In 1912, Hyslop went so far as to suggest that 'necessary eugenic measures, designed to weed out mental defectives, were being hampered by soft-hearted attitudes'.[17] That

October, as the Woolfs had returned from honeymoon, Hyslop had published a list of proposed changes to the Mental Deficiency Bill, claiming that the vital energy of the British Empire was under threat from such individuals. He had singled out 'the new breed of intellectual women' who wanted to do 'mental work like writing' to be sapping imperial energy. As women's mission, in his eyes, was to 'breed as many children as possible ... the departure of a woman from her natural state to an artificial one involves a brain struggle which is deleterious to the virility of the race.'[18]

This was not so far removed from the general public lack of sympathy, where the terms 'imbecile' and 'idiot' were interchangeable, including the brutal remarks Virginia confided to her diary in 1915 about witnessing a line of 'imbeciles' who 'should certainly be killed'. Clearly, there was no empathetic link made between her own 'madness' and this state of imbecility, although this may have been defensive, as a result of how close she would come to incarceration in the intervening years. Virginia seemed to want a child though, although she had shied away from the practicalities of being an aunt. In October 1912, she wrote to Violet after having discovered a cradle in one of the rooms at Clifford's Inn, thinking of 'my lost virginity and the probable fruits of it ... My baby shall sleep in the cradle'. As late as April 1913, she was still persisting in her hope that she would bear a child, writing to Violet, 'We aren't going to have a baby, but we want to have one and six months in the country or so is said to be necessary first.' Either Leonard had not told her that he agreed with the medical opinions against her motherhood, or she had rejected his view.

Later, writing with the hindsight of the 1960s, Leonard would write that he remained unconvinced that any of the doctors he consulted 'knew the cause of, except superficially, the nature of the disease which they called neurasthenia. It was a name, a label

... which covered a multitude of sins, symptoms or miseries' and they could only treat the symptoms by insisting that Virginia lead a 'quiet, vegetative life, eating well, going to bed early, and not tiring herself mentally or physically'.[19] He was certain that when Virginia became ill, she crossed a line 'when she passed from what can be rightly called sanity to insanity'. On one side was a 'kind of mental balance, a psychological coherence between intellect and emotion, an awareness and acceptance of the outside world and a rational reaction to it.' On the other, he saw a 'violent emotional instability and oscillation, a sudden change in a large number of intellectual assumptions ... a refusal to admit or accept facts in the outside world'[20] When Virginia was well, he explained, she could 'recognise that she had been mad, that she had lived for weeks or months in a nightmare world of frenzy, despair, violence'.[21] 'When we married,' he admitted, 'I had no clear knowledge or understanding of all this but I had become extremely uneasy about Virginia's health.' In time, he would begin to recognise the signs of imminent collapse; the refusal to eat, the headaches, the inability to sleep, and the point at which he must insist that she rested. Initially, though, this was not easy to harmonise with the absorption with which Virginia focused on her work.

Between December and the following March, Virginia was busy rewriting and typing up a final draft of *Melymbrosia*, under its new title of *The Voyage Out*. Having applied herself with 'tortuous intensity' to it since 1907, it was an 'excruciating effort' for her to accept that the work was complete. Finally, on 9 March, Leonard carried it to the publishers Duckworth and Co., founded by Gerald in 1898, where it was read enthusiastically by Edward Garnett. It was accepted for publication on 12 April 1913. In May and June, Virginia corrected the proofs, reflecting on the same process for her penultimate novel in 1936, 'I have never suffered, since *The Voyage Out*, such acute despair on re-reading ... never

been so near to the precipice to my own feeling since 1913.'[22]
The nature of the novel made her all the more sensitive to critical
responses. She was struggling to find a voice that was uniquely
hers and a way of representing consciousness and the experience
of life that felt authentic, instead of the emphasis on 'things' that
she found in the popular novels of writers like Arnold Bennett. By
experimenting with association, perspective and dream narrative,
Virginia was taking a literary risk in pursuit of a fresh, modern
form for the novel that relied on the sort of subjective approach
that paralleled the vision of the Post-Impressionists. Although still
a more traditional novel than her later works, and quite clearly a
'first novel' in its unevenness, *The Voyage Out* was a literary debut
that marked Virginia as a writer worth watching.

There was also a deeply personal element to the text. The
story of Rachel Vinrace, embarking on a journey on board
ship to South America, records a rite of passage, an awakening
and self-discovery that had distinct autobiographical parallels.
Accompanied by characters inspired by Vanessa (Helen Ambrose),
Clive (Terence Hewet) and Lytton (St John Hirst), Rachel steers
her way through the world of adult sexuality, is oppressed by
the weight of masculinity, finds liberation and clarity through
discussion and is awakened by an adulterous kiss. She accepts
a proposal of marriage from the Clive character, but admits to
herself that marriage makes women 'renounce ... the real things
... of life'. Contemplating her future, Rachel states, 'I've cared
for heaps of people, but not to marry them ... I suppose I'm too
fastidious. All my life I've wanted somebody I could look up to,
somebody great and big and splendid. Most men are so small.'
However, the tragic conclusion of this flowering was her descent
into delirium and tragic death. Her demise was symbolic of the
death of Virginia's life as she had known it; the answer to her
suffering, the resolution of her fears.

As the date of publication loomed, Virginia herself was spiralling into illness again, refusing to eat, not sleeping and suffering from headaches. Dr Savage suggested she undergo a rest cure at Twickenham again, but this did not seem to cure her. 'It is the novel which has broken her up,' wrote Jean Thomas to Violet; she 'thought everyone would jeer at her. Then they did the wrong thing and teased her about it ... the marriage brought more good than anything else till the collapse came from the book ... it might have come to such a delicate brilliant brain after such an effort.' While her health improved slightly, a more worrying trait developed, in which Virginia began to express resentment towards Leonard, saying she did not trust him and wanted to separate.[23] Deeply upset by this, Leonard wrote to try and discover the cause, insisting, 'You can't doubt my love for you ... take on your mongoose in service for another year and if you'll only let him grovel before you and kiss your toes, he'll be happy.'[24] With characteristic steadfastness, he insisted, 'I won't believe you even if you tell me those dreadful things again ... in a week we shall be looking back at these days as a nightmare that is over ... life will begin again.' Virginia left the Retreat on 11 August, in time to celebrate their first wedding anniversary. Savage suggested they return to the Plough Inn, where they had spent a few days after their marriage. Possibly associated with the failure of their sex life, the location was not beneficial to Virginia, who became acutely anxious and experienced 'delusions', including the belief that people were laughing at her. Convinced that her body was monstrous, demanding food simply in order to excrete it, she refused to eat and Leonard summoned Ka Cox for support.

Returning to London, the Woolfs stayed at Brunswick Square while Leonard consulted a new doctor, Henry Head. While he and Vanessa were absent, Virginia found Leonard's unlocked drugs case and took an overdose of 100 grains of veronal. Summoned back by

Ka Cox, who found Virginia in a deep sleep, Leonard immediately
called Geoffrey Keynes, who was then a qualified doctor working
at St Bartholomew's Hospital. Using a stomach pump, Keynes and
Head worked through the night to save Virginia's life. For a while
it was unclear whether she would survive and in the early hours of
the morning, they feared that she was dying. By dawn, however,
she was out of danger.

Omega, 1913–1914

The artist is the man who creates, not only for need, but for joy.[1]

The Second Post-Impressionist Exhibition opened at the Grafton Galleries on 5 October 1912, with the intention of highlighting the most recent developments in France, England and Russia. Cezanne, Picasso, Gauguin, Bonnard and other established masters were included, and Roger set up his easel to paint the entire room that was devoted to Matisse. He also had the assistance of the Russian mosaicist Boris Anrep, a friend of Henry Lamb, who sourced a number of works from his homeland including those of Natalia Goncharova and Mikhail Larionov. In addition, Fry invited contemporary British artists to exhibit, including Frederick and Jessie Etchells, Stanley Spencer, Spencer Gore, Wyndham Lewis and Eric Gill, many of whom were members of the Camden Town Group, which met in Sickert's studio from 1911. Leonard was appointed as secretary, to assist with the hanging of the paintings and to field off the public's comments: 'Every now and then some well-groomed, red-faced gentleman, oozing the undercut of the best beef and the most succulent of chops, carrying his top hat

and grey suede gloves, would come up to my table and abuse the pictures and me with the greatest rudeness.' Duncan and Vanessa selected several works each to contribute: in fact, Duncan designed the iconic poster for the show, featuring a society lady in shock at the pictures, based on an idea by Vanessa. The poster played with the concept of audience disapproval, capturing this response in a Post-Impressionist style which made the visitor's reactions part of the art itself, essentially a performance played out in the galleries.

Duncan exhibited six works: portraits of Roger Fry's daughter Pamela, artist Henry Doucet and Ka Cox, as well as *The Dancers*, *The Countess* and *The Queen of Sheba*. A significant shift was visible in his style since the staging of the previous exhibition, undoubtedly due to the influence of Europe and Post-Impressionism. Prior to that, he had adopted an Impressionistic but very English style in the richly coloured portrait of Lytton Strachey reading *Crime and Punishment* and the sombre, solid *Lemon Gatherers* of 1909–10, which had been inspired by Sicilian dancers appearing at the Shaftesbury Theatre. However, there was a marked difference between these and *Dancers*, which Duncan had painted in 1911 after meeting Matisse in his studio. Exhibited in Paris in April 1912, *Dancers* was also a graceful tribute to the bright colours and solid forms of Cezanne, Van Gogh and Gauguin. Similarly fluid and light works from this time included *Footballers* and *Bathers*, where Duncan captured movement and form amid increasingly abstract settings; the water of *Bathers* is reduced to a series of wavy parallel lines and the sky is touched with a mottled effect, often known as Duncan's 'leopard spot' style. He experimented further with pointillism in 1912, when Lytton and Pippa Strachey posed for the *Queen of Sheba*, perhaps influenced by Carl Goldmark's opera of that name, which premiered in London in the winter of 1911. In the week before the opening of the Second Post-Impressionist Exhibition, Duncan had met Picasso in his Parisian studio. It is

possible that he had seen works there such as the *Demoiselles d'Avignon*, which had not been publicly displayed, but similar harsh geometric lines, crude shading and mask-like faces would show up in Grant's 1913 works, such as *The Tub*.

Vanessa's art from this period shows the definite influence of Cezanne's theory that all shapes could be reduced to the cone, sphere and cylinder. Most striking are her paintings on Studland beach with its dramatic blocks of colour, the solid mass of blue sky behind the white bathing tent and the simple forms of figures. Her faceless portraits of the Etchells siblings, Virginia in a deckchair and Virginia seated in an armchair remain personal and identifiable, but convey more power for being simplified; it is their significant form, their humanity and timelessness that emerges, rather than distracting details. She also experimented with looser portraits of Virginia and a pointillist picture of Roger in profile. Increasingly, though, as 1913 progressed and they worked side by side, Vanessa came to admire Duncan's work more and more: 'His are so gay and lively, mine rather dull and stupid ... and then Duncan's colour – it's long since I've been so depressed by working with him.'²

Although the critical response to the Second Post-Impressionist Exhibition was not as extreme as it had been two years before, the show still met with mixed reviews. Of the Bloomsbury artists, it was Duncan's more traditional scene, the historical *Queen of Sheba*, that was most praised at the exhibition, while Vanessa's *Asheham* was dismissed by critic P. G. Konody as Post-Impressionist linoleum; he also thought her *Nosegay* looked as if it were cut from paper. Konody thought the English work derivative, declaring, 'There is no eccentricity, no affectation, no mannerism in French that does not find a ready echo in English Post-Impressionist art,' and rejected their use of colour as dull. Rupert Brooke's review in the *Cambridge Magazine* focused in

particular on Matisse's work, which he called 'clean, lovely and inhuman as a douche of cold water', although he dismissed Picasso as a minor artist in comparison. Brooke praised Stanley Spencer's *John Donne arriving in Heaven* and Wyndham Lewis's *Timon of Athens*, but found Duncan Grant's 'genius to be an elusive sprite'.[3] Two other significant visitors were the collector and author Gertrude Stein and her lover Alice B. Toklas, visiting London from Paris. Stein was close to Picasso and Duncan's meeting with her encouraged his interest in the painter, whose influence of North African art would show in Grant's 1913 *Head of Eve* and *The Tub*. By the end of the exhibition, Roger was already enthusing about a new project, which was to fuse the artificial divide between the fine and decorative arts. He had been approached by publishers Chatto and Windus to produce a book about Post-Impressionism, but in order to follow this new vision passed the project to Clive, who began to draft the book that would be published in February 1914 as *Art*.

Art proved to be a defining book for the Bloomsbury aesthetic. Moving on from Cezanne's theories of shape, Clive identified 'significant form' as the most crucial element of a work of art, the relation of line, form and colour, which evinced a specific artistic response independent of other meanings or associations. It was simply what best pleased the eye. This was a necessary identification when it came to the defence of the increasingly abstract direction in which the works of Vanessa and Duncan were moving. Clive also attempted to draw a historical thread between a wide range of different works that had proved successful: 'What quality is common to ... the windows at Chartres, Mexican sculpture, a Persian bowl, Chinese carpets, Giotto's frescoes at Padua, and the masterpieces of Poussin, Piero della Francesca and Cezanne? Only one answer seems possible – significant form.' Great art remained so, he argued, because 'the feelings that it awakens are independent

of time and place'. Clive's attempt to draw comparisons across time and varying mediums was ambitious and inclusive, although it did not address the symbolism and alternative meanings of works of art. However, it did create an important stepping stone in art criticism that would smooth the way towards more extreme forms of abstract and conceptual art.

In the meantime, Roger turned his attentions to the applied arts. Concerned by the poverty in which some of his friends lived, he wished to set up a workshop to support individual artists and apply the techniques of fine art to everyday life. His model was the Wiener Werkstatte, which had been established in 1903 and employed hundreds of artists to produce ceramics, silks, textiles, furniture, jewellery, leather work and enamels, bearing the company's striking black-and-white double 'W' logo. Founded by Secessionist artist Kolomon Moser and his architect friend Josef Hoffman, the workshops had expanded from an initial handful of rooms to occupy three floors of a building, before expanding from Vienna to Karlsbad in 1909. The idea was to create exquisite objects, each consciously designed, even down to the last teaspoon, following the motto 'Better to work ten days on one product than to manufacture ten products in one day.' Fry had also been impressed by the girls' school established in 1912 by Parisian designer Paul Poiret at the Atelier Martine. There, the pupils' creativity and spontaneity was encouraged without criticism, as they produced designs for textiles, wallpapers, carpets and ceramics. Late in 1912, Fry's prospectus attracted a swathe of investors, including George Bernard Shaw, and by the following April, he had raised enough money to lease 33 Fitzroy Square. The Omega Workshops were registered as a company on 14 May 1913, with Roger, Duncan and Vanessa as directors. The official public opening was on 8 July.

No. 33 Fitzroy Square had previously been a private residence,

with the typical large fireplaces and domestic arrangements of late Edwardian living. Under Fry's guidance it underwent a transformation. The ground floor was divided into two showrooms. A surviving newspaper cutting from the *Daily Mail* reveals a space that was filled with decorated screens and wooden chairs, leading through the 'Adam and Eve' curtains to a second room where a table stands before a mural. An image of the studios on the floor above captures Roger leaning over paper spread out on a table, dipping his brush into a pot of water or paint, with a female artist in the same pose in front of him. Winifred Gill looks on, flanked by papers pinned to the wall. Two workshops occupied the first floor, where artists were encouraged to drop in and create designs for no more than three half-days a week, so as not to interfere with their own work. Everything was sold anonymously, stamped with the distinctive Greek letter omega, so they could stand on aesthetic merit rather than the artist's name. Collections of these designs were on permanent display in portfolios and clients were encouraged to browse and choose the decoration to be applied to an object, or to purchase finished products. Items were intended to be used, with furniture and Delft pottery bought in from outside to be decorated, but they were primarily *objets d'art* for an elite audience, and Fry refused to sand down finished products to give them a more even finish. This was, as Roger wrote in the catalogue, 'in the belief that the public has at last seen through the humbug of the machine-made imitation of works of art'. Instead, his vision was to 'satisfy practical necessities in a workmanlike manner, but not to flatter by the pretentious elegance of the machine-made article,' striving instead to 'keep the spontaneous freshness of primitive or peasant work while satisfying the needs and expressing the feelings of modern cultivated man'.[4]

Among the first artists to work for the Omega were Wyndham Lewis, Frederick Etchells, Edward Wadsworth, Cuthbert Hamilton,

Spencer Gore, Roald Kristian and Nina Hamnett. Others would join later, including Mark Gertler, Paul Nash, David Bomberg, William Roberts and Henri Gaudier-Brzeska, while Winifred Gill, Barbara Hiles and Gladys Hines helped with the day-to-day running of the place. Fry wrote to his friend Goldie Dickinson that 'the artists are delightful people but ever so impractical … delightful, vague, impossible Englishmen that they are. But I think I can manage them and it's very exciting.'[5] The artworks began to sell. One of the company's strengths was its social connections, and soon clients like Ottoline Morrell, Syrie Maugham, the wives of the Belgian and German ambassadors and Lady Cunard were purchasing Omega items. There were painted silk scarves, embroidered panels worked by Vanessa or Duncan's mother, hand-knotted carpets, painted tiles and lampshades, toys, bead necklaces, fans, bags, parasols, lamps, trays and fabrics such as to cover chairs, beds and sofas. An opening dinner was held at Gordon Square in July, after which Vanessa said, 'We should all get drunk and dance and kiss. Orders would flow in and the aristocrats would feel sure they were really in the thick of things.'[6]

The workshops had not been running for long when dissent broke out among the artists. As part of the *Daily Mail's* Ideal Home Exhibition for October 1913, the paper approached the Omega to commission the decoration of a display room. This was prompted by the *Mail's* admiration of murals in the nightclub the Cave of the Golden Calf, a draper's basement in Heddon Street, which had been executed in May 1912 by Lewis, Gore and Charles Ginner under the influence of the Ballets Russes. According to Lewis's biographer, the Ideal Home request was made for a 'suitable futurist artist',[7] and was intended for the Golden Calf artists, but Fry took the commission for the Omega and asked him to do some mantelpiece carvings instead of the wall paintings he'd hoped for. From Roger's perspective, the assignment

was given to the workshop under its aegis of anonymity and the work was distributed accordingly. Lewis's anger took him by surprise. Yet Lewis went further than merely arguing his case and resigning from the workshops, taking three other artists with him. He prepared a round robin letter, denouncing Fry and his vision, which he condemned as nepotistic, lacking vigour and masculinity. 'The idol is still prettiness,' Lewis wrote, 'this family party of strayed and dissenting aesthetes, however, were compelled to call in as much modern talent as they could find, to do the rough and masculine work without which they knew their efforts would not rise above the level of a pleasant tea party, or command more attention.' This letter was signed by Lewis, Etchells, Wadsworth and Hamilton and sent to prospective patrons, the press and other interested parties. Lewis may also have had an axe to grind after the first Post-Impressionist Exhibition, when the contributing artists' commission was initially placed too high, then reduced, to which Lewis 'protested violently' and 'never forgave'.[8] Fry was out of the country at the time, but friends advised him to take legal action for libel. No action was taken though, as Fry preferred not to give Lewis the publicity that the occasion would generate, nor to answer what he considered to be unsubstantiated claims. He was philosophical about Lewis' revolt, writing to his mother that the venture 'arouses an immense amount of interest but also bitter opposition … I'm always a little surprised at the vehemence and the personal antagonism that it stirs up.'

The Omega's reputation proved not to have been damaged. At the end of the year, an exhibition was held in Fitzroy Square which included a model bedroom and nursery with panels painted by Vanessa in a pseudo-Indian and -African style, a ceiling by Winifred Gill and jointed wooden toys made by Roger. The following spring, the Omega was commissioned to decorate three rooms in the Hyde Park Gardens home of Lady Hamilton, which included stone pots

by Henri Gaudier-Brzeska, a mosaic by Vanessa and stained glass panels by Roger, and were followed by requests to design rooms for Henry Harris in Bloomsbury, a dining room for Ethel Sands in Chelsea and the interior of the Cadena Café in Westbourne Grove. That year, Omega also exhibited work in Liverpool and Oxford, contributed eighty-five pieces to the Whitechapel Exhibition of the Twentieth Century and sent work to the Allied Artists' Exhibition at Holland Park.

Through the early dramas and successes of the Omega, Virginia was slowly regaining her strength. Ensconced in George's imposing Sussex home of Dalingridge, she was cared for by Leonard and four nurses, initially using physical force to resist their attempts to feed her and make her rest. Finally, in November 1913, after the usually slender Virginia had put on an additional stone in weight, they left for Asheham, although Virginia still had a nurse in her room all night until the following February. At that point their new doctor, Sydney Belfrage, wrote to Leonard that 'the time has come to place reliance on your wife's self-control' and hoped that Virginia 'recognised fully the enormous importance of ordering her life in the most careful and thorough fashion', with regular habits, 'the hours of rest, immutability of meal times and of going to bed'. She should spend her mornings quietly and 'be in bed no less than ten hours out of the twenty-four'.[9] Leonard accepted this advice and began a strict regime with Virginia on mealtimes and bedtimes that seems almost to echo his experiences in the rigid social structure of Ceylon. Virginia admitted to Ka Cox that it was 'the only discipline she'd ever had in her life'.[10] Yet in terms of his art, Leonard was about to take a risk that threatened his wife's delicate mental balance.

The previous October, while Virginia was in the midst of illness, the novel that Leonard had begun on their honeymoon was published as *The Wise Virgins*. It was an attack upon the snobbish

attitudes of a suburban family, a rejection and thinly veiled caricature of his mother and siblings through the eyes of a young Jewish anti-hero coming of age, a sort of savage, self-loathing bildungsroman. Unsurprisingly, it offended Leonard's family. His sister Bella responded to a first draft of the manuscript with a nine-page letter condemning it as 'an unpardonable attack on the Woolf family and their Putney neighbours', Marie Woolf thought that the 'reading of [it] had given her more pain than evidently [Leonard] intended', and that publication would result in 'a serious break between us', while his brother Philip thought that the portrait of their mother was very accurate. However, Philip also commented that the family may not be the work's right audience, so Leonard sent the work to Lytton at the end of December 1913. Despite his private conviction that fiction was not Leonard's forte, not 'his right assiette', Lytton's reply was 'splendid and very encouraging'.

However, *The Wise Virgins* was also an intimate and damning account of the failure of their marriage, especially poignant as it was written during the honeymoon days when Leonard was attempting to make love to Virginia. It relates a young Jew's attraction to a cold, bloodless bluestocking, and his subsequent marriage to a simpler, more 'physical' girl. Virginia was thinly characterised as 'Camilla', the 'dreamy' and sexually inadequate young woman with whom the Leonard figure, Harry, fails to connect. Instead, he sates his lust on the willing Gwen, a woman of instinct rather than intellect, who Leonard later admitted was modelled on at least one of his amours from Ceylon. While the novel's conclusion is deeply unsatisfactory, with Gwen and Harry forced into marriage after succumbing to a night of illicit passion, it is, nevertheless, the conclusion that the author chose. Just as Leonard's family recognised and were hurt by the portraits of themselves, it would not be possible for Virginia to read the novel and fail to recognise

that Leonard had rejected her fictional self in favour of giving his autobiographical protagonist a marriage that offered him physical fulfilment. Vanessa certainly noticed. Portrayed as Camilla's more sympathetic sister Katherine, she felt 'the superficial things are copied so exactly ... it's almost impossible not to think that the character does to some extent convey your idea of the person'.[11] Adrian read a draft and was furious, proposing to send Leonard a £70 bill for damages.[12] The publication of *The Voyage Out* had been rescheduled for March 2015 to allow Virginia to recover, but that February she suffered a major breakdown. Leonard maintained that it was due to the approaching release of her own work, but there is also the likelihood that it was the result of Virginia having read *The Wise Virgins* two weeks before.

On 31 January, while Leonard was out, Virginia sat down and read *The Wise Virgins* from start to finish. She recorded in her diary that it was very much a 'writer's book' and that reading it had made her 'very happy', although these comments may have been made for Leonard's eyes. A few weeks later, when sitting in bed, Virginia had a vision of her mother, the symbol of the angel in the house, attempted to speak to her and became agitated. Leonard wrote to Jack Hills on 7 March, expressing his regret that 'Virginia is again seriously ill'. They had relocated to Richmond, he told Jack, living in rooms overlooking the Green while preparations were being made to their new home, Hogarth House, on Paradise Road. Virginia had seemed happy there, Leonard wrote, until she experienced a headache and took to her bed. On 25 March Virginia returned to the Retreat, to be cared for by Jean Thomas, but left after only a week, spending her first night at Hogarth House on 1 April. When Leonard wrote to Violet at the end of April, her health had deteriorated again and was 'worse than [he] had ever seen her before'. The indications of mania were inherent in his comment that she hadn't 'had a minute's sleep in the last sixty

hours'. Even Vanessa described her as 'incoherent' and related to Clive how she had attacked one of her nurses.[13]

By July, Virginia appeared to be improving, eating and sleeping, but as Leonard wrote to Violet, 'the only thing is that she suddenly turned very violently against me ... and although it is a little better lately, she is still very opposed'.[14] In fact, this had been building for weeks. In May, she had been so violent that the question had arisen for having her incarcerated in an asylum; Vanessa wrote to Roger that she thought 'it might be inevitable' and that Leonard 'could do nothing as she is very angry with him right now'.[15] In a diagnosis that sounds depressingly like Dr T. J. Hyslop, Vanessa believed that Virginia had 'worn her brains out' and, like Helen Fry, would never recover her wits. Violet felt that Vanessa had washed her hands of her sister, a belief that could only have alienated Virginia further, convinced as she was that Vanessa despised her over her intimacy with Clive. As Leonard explained in his autobiography, it was then the custom for anyone attempting suicide to be certified by a magistrate, and then committed to an asylum or nursing home. He even went to visit a couple of institutions recommended by Dr Head and Dr Savage; 'dreadful gloomy places enclosed by high walls, dismal trees and despair' and returned to inform them that he was 'prepared to do anything required by them if they would agree to her not being certified'.[16] At this point, he undertook the complete care of her, physically and mentally, even though she was currently behaving towards him with great hostility. It would become his life's work.

On 10 May, Leonard recorded in his diary that Virginia was angry with him and Vanessa confirmed that this was still the case in June: 'She won't see Leonard at all and has taken against all men. She says the most malicious and cutting things she can think of to everyone and they are so clever that they always hurt.' Could this have been a revolt against Leonard's masculinity, as a husband

with sexual expectations, as a writer whose work had exposed and rejected her, or as a carer whose inflexibility threatened Virginia's autonomy? She may well have resented the power he had over her pain, being the one to choose when to administer sleeping draughts or pain relief; he would occasionally administer a tranquilliser with her food, and on other occasions he refused to give her any form of medication, under his own authority rather than that of a doctor. There may be a correlation between this infrequent medication and her swings between being 'very reasonable and at times very violent and difficult'. Later, Virginia would embrace periods of illness as an enforced respite from the world that bought her thinking time, as well as the comparative freedom, the 'childish outspokenness' resulting from it. But she knew a hawk from a handsaw; like Hamlet, it was during her periods of irrationality that Virginia spoke most sense. She was voicing her inner fears and resentment when she attacked Leonard: resentment against his power, inflexibility and sexuality; her 'mad' persona actually gave expression to her true self, her sane self. These were the desires she dared not voice in periods of calm, when she was behaving herself in the way that her family, her doctors and society expected. This links to the constant theme running through Virginia's life since 1895, of the discrepancy between what she felt and what she was supposed to feel, and how she should behave as a result of both. By September, they were able to go to Asheham and Virginia was quietly resting, reading and making jam. These descriptions strongly suggest that far from the cause of her mania and antipathy to Leonard being addressed, she had simply submitted.

FOURTEEN

Pacifism, 1914–1918

Last night I dreamt that I had gone to Hell
I seemed to know the milieu pretty well.[1]

War had been declared on 4 August 1914, but at first its ripples were scarcely felt in Bloomsbury. Virginia and Leonard were at Asheham on that day, and although they observed troops marshalling, they soon escaped on holiday to Northumberland for five weeks. Vanessa and Clive were visiting the Bells at Seend, where the news struck Clive with despair, but Vanessa was more pragmatic, writing to Roger that in the countryside 'one is able to a large extent to forget the war'. Only a few weeks later, though, she was writing that 'even the sort of thing one vaguely hoped for the children may be spoiled'. Duncan Grant headed down to Asheham and began work on a large mural, but he was more concerned about the arrival of Adrian Stephen in the wake of their affair ending, especially as Adrian was accompanied by his future wife, Karin Costelloe. 'I feel sure one ought to give way to depression,' Duncan wrote to Lytton, who shared his ideological objections to the war, 'one ought to plunge into the horror ... everything

one cares about is done for.'² 'So far as I can make out,' Lytton himself declared, 'there isn't the slightest enthusiasm for the war ... but I think there will be a change when the casualties begin.'³ From Cambridge, Maynard Keynes helped raise funds to help send their friend, poet Ferenc Békassy, home to Hungary before travel became impossible. Ottoline Morrell's husband Philip put an end to his promising political career by speaking out against the war in the Commons and being unanimously shouted down.

On the day itself, the hostilities were announced to diners at the Café Royal by a waiter. Augustus John turned to David Bomberg and said that 'this news of the outbreak of war is going to be bad for art'. John was being uncharacteristically understated. Recent Slade graduate Mark Gertler was painting down in Hastings when the news broke. 'The war is indeed terrible, but how ludicrous!' he wrote to fellow artist Dora Carrington. 'If it continues much longer, the working classes will starve. My own father's little workshop is closed!' He advocated that in the circumstances, the only thing for artists to do was to continue to work.⁴ Nina Hamnett was in Paris that summer and heard tell of a mob storming a German firm and killing those inside: 'There was pandemonium ... we had two weeks in which to get papers and register ourselves.' By early September, the German forces took Claye, only ten miles from the French capital, the birthplace of Post-Impressionism and spiritual home of Bloomsbury since 1910.

With so much of its ethos of freedom, friendship and civilisation based on the writings of G. E. Moore, Bloomsbury's approach to the war was always going to be one of horror and distance. It was in sharp contrast to the young men of the Vorticist and Futurist movements who had quarrelled with Roger twelve months before. Embracing masculinity, machine and conflict, Wyndham Lewis, Henri Gaudier-Brzeska and their friends enlisted and headed off to the trenches of northern France. In the summer of 1914, which

was brimming with artistic promise, it was widely believed that the war would be over by Christmas. Keynes was sure that they were 'bound to win, and in great style too, having at the last moment applied all our brains and all our wealth to the problem'.[5]

However, as 1915 arrived with little sign of the conflict ceasing, it became increasingly difficult to remain detached from events across the Channel. On clear days, the guns in France could be heard booming by walkers on the South Downs. That January Leonard and Virginia were visited by Leonard's brothers Cecil and Philip, who were both 'sick to death of soldiering' and told stories 'of military stupidity which pass belief. They found a man guilty of desertion the other day and sentenced him and then discovered that the man did not exist.'[6] In Paris, Slade graduate Gwen John witnessed lines of blind men shuffling along, each with their hand on the shoulder of the one in front, and at Gare Montparnasse, luggage and cattle trains were 'loaded with frightened people'. She read the graphic reports of the First Battle of Ypres in December 1914, which brought home the 'awful cost of trench warfare'.[7] Visiting recovering soldiers at Cambridge, Keynes saw the effects of shell shock and the terrible wounds inflicted in bayonet charges. He wrote to Lytton that November, 'It is utterly unbearable to see day by day the youths going away first to boredom and discomfort and then to slaughter. Five of this college who are undergraduates … are already killed.'[8] Keynes's skills meant he was in demand at home and, as advisor to Chancellor of the Exchequer, he was privy to inside information about the deepening crisis and the horrors of trench warfare.

In February, Roger Fry travelled to France in search of his friend, the young Omega artist Henri Doucet, and found him briefly on the front line before being arrested as a spy. Doucet was killed on 5 March. That April, Rupert Brooke died from blood poisoning on his way to Gallipoli and Henri Gaudier-Brzeska was killed in

fighting at Neuville-Saint-Vaast in June. Békassy, the young poet Keynes had helped, was also killed that month. Hearing of these losses, Lytton wrote that 'the meaningless of Fate is intolerable; it's all muddle and futility. After all the pother [*sic*] of those years of living, to effect – simply nothing.' Clive Bell's response was to write and publish the pamphlet *Peace at Once*, arguing for negotiations to be opened with Germany, but the copies were seized by the police and destroyed. James Strachey left his position at *The Spectator* over disagreements with his cousin, the editor St Loe Strachey, about the war: like Clive, James felt that a peace should be negotiated at once. Apostles and Bloomsbury friends Harry Norton and C. P. Sanger collaborated on the 1915 book *England's Guarantee to Belgium and Luxembourg*, criticising the legal and diplomatic basis of Britain's involvement in a war that 'overwhelmed' Sanger with 'the horror of the whole thing'.

Increasingly, Vanessa began to long for a life in the quiet of the countryside. In April 1915, the Bells, Duncan and David Garnett went to stay at Eleanor, the Sussex home of Mary Hutchinson, with whom Clive had begun an affair. Vanessa loved the peace and quiet, with 'no front door bells and no telephones and no one unexpectedly to dinner ... how nice it would be to live in the country'. She longed for privacy at a point when her private life was about to become more complicated. Over the past two years, Vanessa had felt a deep sympathy develop between her and Duncan and, despite his homosexuality, her feelings for him had eclipsed those she had previously held for Roger. She had restrained her emotions while Duncan was involved with Adrian but, since their relationship ended, Duncan had grown closer to Garnett, who was known to the group as Bunny. Roger was deeply hurt by Vanessa's rejection and, while he remained a beloved friend, would always mourn the loss of their relationship and the woman he claimed to have loved more than any other. At some point in 1915, Duncan

and Vanessa's friendship developed into a sexual affair. That August, she escaped again to The Grange in Bosham, Sussex, with Duncan and Maynard, and began to think seriously about finding a country property of her own, where they could sit out the war. With fears that conscription would be introduced riding high, a farm would provide the conscientious objectors of Bloomsbury an opportunity to engage in alternative service.

Many artists had already found a haven at the Oxfordshire home of Lady Ottoline Morrell. Purchased by Ottoline and her husband, the Liberal MP Philip, Garsington Manor had been transformed into a riot of exotic pinks, sea green, pearly dove-grey, Venetian red and gold lacquer. It had been draped in silks, and had a fish pond, flower gardens and clipped yew trees. Virginia described a house party there in 1917: 'People strewn about in a sealingwax coloured room ... Philip tremendously encased in the best leather; Ottoline as usual, velvet and pearls; 2 pug dogs. Lytton semi-recumbent in a vast chair. Too many nick nacks for real beauty, too many scents and silks and a warm air which was a little heavy. Droves of people moved about from room to room all Sunday ... after tea I had perhaps an hour over a log fire with Ottoline.'⁹ Virginia's hostess was just as exotic as her surroundings, as her semi-serious description to Vanessa relates: 'I felt as if I'd suddenly got into the sea and heard the mermaids fluting on their rocks ... red-gold hair in masses, cheeks as soft as cushions with a lovely deep crimson on the crest of them ... a body shaped more after my notion of a mermaid's than I've ever seen: not a wrinkle, or blemish, swelling but smooth ... She didn't seem so much of a fool as I'd been led to think.' For her generosity, which ultimately forced Ottoline to have to sell Garsington, she was often made a figure of fun by her writer friends, featuring in novels by D. H. Lawrence and Aldous Huxley.

'By 1915, life in London had been entirely changed by the

war,' Ottoline wrote in her diary, 'in the constant procession of ambulances going to hospitals one saw tortured, maimed human bodies lying. At least in the country there would be an escape from this.'[10] In the summer months, writers, philosophers and artists slept on the roof, bathed naked and danced on the terrace. Ottoline's noble intention was 'to make this place into a harbour, a refuge in the storm, where those who haven't been swept away could come and renew themselves and go forth strengthened'.[11] Among the frequent visitors were Slade graduates Mark Gertler and Dora Carrington, D. H. Lawrence, Aldous Huxley, Siegfried Sassoon, Katherine Mansfield, Herbert Asquith, T. S. Eliot and Ottoline's lover, Bertrand Russell. In August 1915, Ottoline described Duncan as flitting 'to and fro like a winged elf, sympathetic and charming in body and heart ... his hand when he paints seems guided by a magic impulse that ... makes it sing with beauty' and saw Vanessa's character as 'a broad river, not worried or sensitive to passers-by' and 'very much married' to Duncan. Clive was a 'sipper, the taster, the professional connoisseur of life', lacking in depth or passion, whose sensuality 'of which he is so proud, is stimulated almost entirely by vanity', while Duncan's lover David 'Bunny' Garnett was 'an odd rather loutish figure' with an expressionless face and overflowing, affectionate heart.

In August 1915, Ottoline recorded that Lytton visited Garsington with Vanessa and Duncan and stayed on, spending 'most of his summer here ... lying out on the lawn or writing in a quiet room his book on *Eminent Victorians* ... an adorable companion ... a wonderfully sympathetic friend and his rectitude of mind is enchanting'. It was partly at Garsington that the love triangle of Lytton, Gertler and Carrington was played out. The son of Polish Jews from the East End, Gertler had achieved a place at the Slade purely on talent, although he constantly felt a social awkwardness at being out of his accustomed milieu. He had been in love with his

blonde-haired fellow student Dora Carrington for several years, but she was keen to keep their relationship platonic. In 1914, Gertler had turned for advice to Lytton, who became his informal mentor, suggesting how the young artist might improve his mind and win the object of his affections. However, at the end of 1915, Lytton and Carrington were fellow guests at a weekend party at Asheham and, while walking on the Downs, Lytton was drawn to the androgynous bisexual Dora and attempted to kiss her. That night, as an act of revenge, she crept into his bedroom with a pair of scissors, with the intention of cutting off his beard. Instead, Strachey awoke and Dora fell in love. For the time being, Gertler remained none the wiser, writing to Carrington, 'I was surprised to hear that you had stayed with the Clive Bells. I am glad however that you managed to enjoy it.'[12] With Strachey and Carrington growing closer and developing what would become a lifelong relationship, and the unaware Gertler still urging her to submit to his advances, the situation became an emotional time bomb.

By the autumn of 1916, Lytton and Carrington had decided to set up home together in the country, with Lytton taking a sort of quasi-paternal role towards the young woman who was beginning to adore him. When her brother Teddy was killed in the war, early in 1917, it was Lytton she turned to for support, not Gertler, who continued to pester her for sex. By the autumn, Carrington had found The Mill House in the village of Tidmarsh, near Pangbourne in Berkshire, and they moved in at the end of the year. Lytton settled down to a quiet routine in an attempt to complete *Eminent Victorians*, his four-part book that would revolutionise the art of biography and challenge the assumptions of previous generations. Having tried and failed to distance herself from Gertler, Carrington denied the rumours he was hearing about their plans right up until the moment that the artist waited outside a Bloomsbury party in a jealous rage and attacked Lytton. Although his private life was

beset by problems, more pressing concerns were threatening to destabilise Lytton's world.

When the Military Service Act was introduced on 5 January 1916 and enforced two months later, Clive joined other pacifists, like Gertler, staying in one of the estate's outbuildings to engage in 'farm work' and avoid conscription. Philip Morrell ran a pig farm and they cut hedges, hoed ditches and kept poultry among the stalking peacocks that roamed the grounds. As a Quaker, Roger was exempt from service and Leonard was relieved to be rejected as medically unfit, with tremors in his hands that prevented him from handling a rifle. In 1916, he wrote the book *International Government* from a pamphlet commissioned by the Fabian Society, which contained a scheme for the regulation and prevention of future wars, ideas that later contributed to the founding of the League of Nations. When Lytton, Duncan and Bunny refused to fight on the grounds of conscientious objection, Philip Morrell represented them at the national tribunals that had been established to investigate individual cases. Lytton had joined the No Conscription Fellowship and the National Council Against Conscription, helping draft articles for their leaflets, but it did him little good. One such work of his had been withdrawn as seditious immediately after publication, but not before a copy had reached the *Morning Post*, causing a furore. Early in 1916, he applied for absolute exemption on the grounds of poor health and conscience, anticipating that he would be required to take up some administrative or clerical role.

On 7 March 1916 Lytton appeared at the Hampstead Tribunal, represented by Philip Morrell, and stated that his objection was based on moral principles, denouncing the 'whole system by which it is sought to settle international disputes by force [as] profoundly evil'. When asked how he would respond if he saw a German soldier attempting to rape his sister he famously stated that he would attempt to 'come between them'. The court was not

sympathetic and the next two years were full of anxiety as his case was under consideration. In March 1918, he was summoned to appear for a second time and before a medical board, before finally being declared unfit for all forms of military service. Duncan and Bunny faced a tribunal at Blything in Suffolk, where they had moved in anticipation of this event, to undertake work on a farm. Despite being defended by Philip, Adrian and Keynes, their case was considered suspicious and they also had to appeal again to avoid a prison sentence. Finally, in May 1916, both were given an exemption from fighting on condition that they engage in work of 'national importance'. Other members of their circle who opposed the war and conscription were not so fortunate.

Ottoline's lover, the Cambridge philosopher Bertrand Russell, had been outspoken about his dislike of the war from 1914, in publications such as *The Nation,* urging the formation of a Stop the War Party. In 1916, he was dismissed from Cambridge for anti-war activities and sentenced to two months in jail, or a £100 fine, for printing 'statements likely to prejudice the recruiting discipline of His Majesty's Forces'. Russell was put on trial for a second time in the winter of 1917 at Bow Street Magistrates' Court as a result of an article he had written for *The Tribunal,* a weekly magazine supporting the abolition of conscription, and given a sentence of six months' imprisonment in Brixton Jail. Other friends found themselves roles assisting with casualties. Henry Lamb had enrolled as an assistant at Guy's Hospital in the first autumn of the war, but commissioned in 1916 as a lieutenant in the Royal Army Medical Corps to serve in Palestine and France, where he would be badly gassed. Even the gentle E. M. Forster worked as a volunteer orderly in Red Cross hospitals in Egypt in 1916–17. A number of the Vorticists who had enlisted in 1914 and seen active service were given the role of official war artist.

London was becoming dangerous. That year Nina Hamnett

recorded the first Zeppelin raid, which took place while she was dining at Clifford's Inn: there was a strange whizzing sound, followed by 'a terrific crash ... and in the sky was a thing that looked like a golden pencil'. At nearby Chancery Lane the street was flooded, as a bomb had hit a water main, and the Strand 'was several inches deep in broken glass'.[13] Virginia's diaries written at Asheham record the constant tension of waiting for raids on clear, cloudless nights: 'aeroplanes over the house early, which may mean another raid ... heard guns over London and saw lights last night ... clouded after tea. Heard firing.' Eventually, a huge bomb did fall in Piccadilly, blowing out the windows of a department store, although soon after, as Virginia noted, business continued as usual. Fortunately Mudie's was untouched, so she did not have to forego selecting new library books.

In October 1917, the Woolfs had a 'horrid shock' when Leonard was called up. He had been given an exemption the previous June on the evidence of letters submitted by the family doctors, in addition to the fact that the removal of Leonard as Virginia's primary carer would have a detrimental effect upon her health. Although she was certain they had nothing to fear, on account of the tremor in his hands, Virginia recorded 'the nuisance – waiting a week, examination at 8.30 at Kingston – visits to Craig and Wright for certificates – is considerable'.[14] Waiting outside to hear the news while Leonard met with the doctors, Virginia disliked the feel of Kingston Barracks, 'a disagreeable impression of control and senseless determination'. Undergoing examination, Leonard had been 'a good deal insulted: the doctors referred to him as "the chap with the senile tremor" through a curtain'. However, after half an hour, all was over. 'We are safe again and so they say for ever,' Virginia recorded. That November, they returned to receive the papers that declared Leonard 'permanently and totally disabled'. Their relief was short-lived, though, as only weeks later, they heard

that Leonard's brother Cecil had been killed in action and his other brother Philip was wounded. 'The wounded one is in hospital in London and is going on very well,' Leonard was able to say two weeks later, 'but it is rather appalling for him as the two had been absolutely inseparable since they were children.'

There was comfort to be had in old friends, with Lytton visiting on 9 December, and proving as sympathetic a character as he had ever been.

He is one of the most supple of our friends; I don't mean passionate or masterful or original, but the person whose mind seems softest to impressions, least starched by any formality or impediment. There is his great gift of expression of course, never [to me] at its best in writing; but making him in some respects the most sympathetic and understanding friend to talk to. Moreover he has become, or now shows it more fully, curiously gentle, sweet tempered, considerate; and if one adds his peculiar flavour of mind, his wit and infinite intelligence … he is a figure not to be replaced by any other combination.

The following March, *Eminent Victorians*, the lives of Cardinal Manning, Florence Nightingale, Thomas Arnold and General Gordon, was published to critical acclaim. Reading it in his cell at Brixton Prison, Bertrand Russell found it 'brilliant, delicious, exquisitely civilised' and when he laughed out loud, a warder came to remind him that a prison was a place of punishment. G. M. Trevelyan wrote to tell Lytton he had 'a real historical sense which few professional historians have and hardly any literary people who dabble in history … not only historical sense but judgement'. 'I can't tell you how I like the book,' said Walter Raleigh, 'every word!'[15] Later, Edmund Wilson wrote critically of the work that it had 'punctured' something for good, but this was exactly Strachey's intention, to destroy the pretensions of Victorian morality.

In the midst of national crisis, the Bloomsbury group considered their primary responsibility was towards friendship and art. Yet the world in which they produced that art, and subsequently its audience, was changing irrevocably. Leonard always considered that *The Wise Virgins* had been killed by the war, receiving little positive critical attention due to is timing. In March 1915, *The Voyage Out* received mixed praise, with comparisons made between Woolf's narrative and a 'Tolstoyan appearance of reality. Everyone seems solid ... a separate existence in fact, outside the pages of the book. Even the final catastrophe, which from the purely artistic point of view might be held to overbalance the work emotionally, may be justified on the grounds of its overwhelming reality.'[16] Lytton had already identified this influence, as well as stating that Shakespeare would not have been ashamed of her characters, with the handling of detail being quite 'divine'. Most of all, as he was writing his iconoclastic *Eminent Victorians*, he admired Virginia's rejection of Victorian values: 'I love too, the reigning feeling throughout – perhaps the most important part of any book – the secular sense of it all – 18th century in its absence of folly, but with colour and amusement of modern life as well. Oh it's very very unvictorian.'[17] Virginia was delighted, replying that he almost gave her courage to read it, which she hadn't since its publication. Another reviewer in *The Nation* praised the novel's insight but felt the author was too 'passionately intent upon vivisection', inviting Virginia to try again with a second novel but wondering whether it would have many readers. This was balanced by the warmth of Allan Monkhouse's response in the *Manchester Guardian*, who recognised that 'beauty and significance come with Rachel's illness and death' and were written with 'delicacy and imagination'. He believed that 'a writer with such perceptions should be capable of great things'. It was a 'remarkable' first novel that showed 'not merely promise, but accomplishment'. E. M. Forster's review

appeared in the *Daily News and Leader*, pleasing Virginia greatly with its comment that 'here is a book that achieves unity as surely as *Wuthering Heights,* though by a different path'. Forster continued, 'While written by a woman and presumably from a woman's point of view, soars straight out of local questionings into the intellectual day,' but he made the observation, which Virginia would take seriously, that her characters were not vivid enough. The *Times Literary Supplement* found it modern, feminine and illogical.

The Omega Workshops continued to trade through the war years, although the ranks of its young artists were depleted. In January 1915, Virginia popped in to buy a shawl and was back again in November 1917 to buy an apricot-coloured coat, as if little had intervened in almost three years. Yet in 1917, Roger was conducting 'three chattering Frenchwomen' around the showrooms in the semi-dark, with the paintings being glimpsed through the dusk, and the building often had to be evacuated for the threat of air raids. With the employees and clientele increasingly female, a new line of Omega dresses were created and designed by Vanessa; a portrait of Nina Hamnett painted by Roger in 1917 depicts her in one such dress of black, yellow and green checks. One exhibition held at the workshop contained dresses, coats, cloaks, parasols, hats, artificial flowers and waistcoats, but Virginia felt that the colours which Adrian's wife adopted were too bright: 'Karin's clothes almost wrenched my eyes from the sockets – a skirt barred with reds and yellows of the vilest kind and a pea green blouse on top.'[18] A portrait of Vanessa by Duncan from 1917 shows her wearing a homemade dress in patterned scarlet.

During the early part of the war, Duncan and Vanessa favoured an increasingly non-figurative style, veering towards a two-dimensional concept of cubism in works such as Vanessa's yellow, pink and blue *Abstract*. This broke down her subject

matter into simple rectangles, an extension of the significant form she had been highlighting in her Studland Bay paintings. Of the two still lifes she and Duncan produced, both of the corner of the mantelpiece in Gordon Square, it was Vanessa whose shapes and colour underwent the greatest simplification, while Duncan's 1915 *Interior at Gordon Square* broached the gap between an impressionistic domestic scene and complete abstraction. Their portraits from the same year continued the theme of simplification of form, with Vanessa painting Helen Maitland and Mary Hutchinson in a simple, monolithic and perhaps unsympathetic style. There are also their wildly different interpretations of David Garnett: Grant portrayed his lover as a massive physical force, with pouting mouth, sultry eyes and blue shadows playing across his muscular build. Vanessa, however, depicts her rival as little more than a child, with a sallow chest, unresolved teenage features and a bright pink nose. The unresolved nature of their love triangle could not be clearer: Duncan remained in love with Bunny while Vanessa tolerated and even encouraged the much younger man in order to keep Duncan close.

The years of 1910 to 1915 marked the most experimental and abstract period of both artists' work, but then things began to change. The three women in Vanessa's 1916 *Conversation* continued the preoccupation with form, under the influence of Matisse and Picasso, but Duncan's *Vanessa Bell Writing* presents a more lyrical approach that seems to blend Fauvism and cubism, with bright colours daubed over darker ones, with the lines of the sketch still visible in a way that suggests movement. By 1918, their interiors, still lifes and portraits had moved away from abstraction towards a more intuitive personal style, achieved through the fusion of a number of Post-Impressionist influences. While both remained distinct in their approach, with Duncan's colours usually the richer, their subject depiction was never again as non-figurative

as in the first years of the war. This development, along with their contrasting styles, becomes clear when comparing Vanessa's gentle, feminine *The Tub* of 1917 with Duncan's angular, confrontational, Picassoesque *The Tub* of 1913.

The Woolfs also ventured into publishing. Settled into their new home at Hogarth House, Leonard felt it would be good for Virginia to have a practical occupation to take her mind off work, so after taking some uninspiring lessons in typesetting, they resolved to teach themselves and purchased a printing press for £19. The going was slow initially, but there was pleasure to be had in the typesetting and in choosing unusual papers for the binding: Japanese prints, brilliant patterns from Czechoslovakia and marbled paper from Roger's daughter Pamela, who was in Paris. As Virginia admitted, 'I see that real printing will devour one's life,' but their first publication, a joint volume of Virginia's 'The Mark on the Wall' and Leonard's 'The Three Jews', appeared that summer and was well received. Only 134 copies were produced, illustrated with woodcuts by Carrington, who received 15s for her work. The second manuscript they accepted was Katherine Mansfield's *Prelude*, and they later contracted another printer to help them publish works by T. S. Eliot, Vita Sackville-West, E. M. Forster, Julia Strachey, Laurens van der Post, Christopher Isherwood and Maxim Gorky. At the end of the war, Harriet Weaver of *The Egoist* hoped to interest them in publishing a new novel by Irish writer James Joyce. She deposited the unfinished manuscript of *Ulysses*, wrapped in brown paper, at Hogarth House when she came to tea, and the Woolfs read this 'remarkable piece of dynamite' and decided they would publish it, if they could find a printer to help. However, all their enquiries met with rejection, and they were informed that 'no respectable printer would have anything to do with it, for the publisher and printer of it would certainly be prosecuted'. Virginia was also at work on her next

novel. From late in 1916 or early 1917, she was gathering ideas for the plot and characters of what would become *Night and Day*. It grew gradually: the idea had germinated at Wissett, been discussed with Vanessa at Easter 1917 and appeared for the first time in her diary on 13 November. By the following March she had completed 100,000 words.

In early 1916, Duncan, Bunny and Vanessa moved to Wissett Lodge in Suffolk, the former home of one his aunts who had recently died. Situated about half a mile from the village among six acres of fields and orchards, the large, half-timbered lodge was ideal and they set about taming the rambling roses in the garden. Yet they had already discovered what was to become their permanent home, Charleston Farmhouse, set at the bottom of Firle Beacon, with the Downs rising and swelling behind, sheltering them from the Channel. Leonard and Virginia had stayed at Wissett in June 1916, with Virginia feeling that it 'seems to lull asleep all ambition'. She wrote to urge Vanessa to return to Sussex: 'I wish you'd leave Wissett and take Charleston ... it has a charming garden, with a pond and fruit trees and vegetables, all now rather wild, but you could make it lovely. The house is very nice with large rooms ... and four miles from us so you wouldn't be badgered by us.' In September, Vanessa visited Sussex and immediately fell in love with the rambling farmhouse, which had once been a guesthouse, and signed the lease. Along with Duncan, Bunny and her two sons, now aged eight and six, she took up residence in October. Almost at once, despite the poor plumbing and overgrown garden, the artists began to decorate their new home in the unique style that visitors to the Sussex house can still see today.

Virginia gives us a glimpse of Vanessa's life and work at Charleston on 2 November 1917, as well as the inevitable comparison between the sisters' art that had been a theme since childhood:

Duncan painted a table and Vanessa copied a Giotto. I unpacked all my bits of gossip. They are very large in effect, these painters; very little self-conscious; they have smooth broad spaces in their minds where I am all prickles and promontories ... Few people have a more vigorous grasp or a more direct pounce than Nessa. Two little boys with very active minds keep her in exercise. I like the feeling that she gives of a whole nature in use ... living practically, not an amateur ... I expect this is the effect of children and responsibility.[19]

When peace finally came, on 11 November 1918, members of the Bloomsbury Group were scattered around the country. In London, Roger Fry continued to paint, apparently unaware of any change, while Bunny hurried up to join a huge party which had taken over the streets of Piccadilly, along with Nina Hamnett, Aldous Huxley, Carrington and Diaghilev. Far from the raucous celebrations detailed in some memoirs, Virginia and Leonard found Armistice Day to be an empty, desolate time. They were at Hogarth House when the guns went off: 'The rooks wheeled round and were for a moment the symbolic look of creatures performing some ceremony, partly of thanksgiving, partly of valediction over the grave.' Then they 'drifted to Trafalgar Square' where a 'thin, fine, cold rain fell remorselessly upon' the figures carrying sodden flags or wandering 'aimlessly in the rain and mud with no means of celebrating peace or expressing our emotions of relief and joy'.[20] At Charleston, Vanessa was almost eight months pregnant with Duncan's child. At two o'clock in the morning on Christmas Day 1918, she gave birth to a daughter, whom she named Angelica.

Part III

A RADIANT MATURITY

Post-War, 1919–1921

And still to live, and still to sow, and reap
Still rises once again the Evening Star.[1]

Night and Day was published by Duckworth in October 1919 and dedicated to Vanessa, but to Vanessa alone: Virginia could find no quotation of suitable profundity or beauty worthy to 'stand by' her name. The most conventional of all Virginia's novels, *Night and Day* follows the lives of four main characters in order to explore themes of love and marriage in the recent past. It was an era Katherine Mansfield thought had been 'lost forever', surging out of the pre-war darkness like a huge ship,[2] yet Virginia had deliberately resurrected the pre-war years that many of her contemporaries felt were anachronistic. She was shaking off her demons. In weaving together the threads of past and present with a paradoxical nostalgia and defiance, she was grappling with a far more subtle relationship with her parents' generation than had been presented even in Lytton's *Eminent Victorians*.

The novel's heroine, Katharine, idealises her parents, feeling herself bathed 'in the light of sixty years ago' or a 'pleasant dreamy

state in which she seemed to be the companion of those giant men' when 'the insignificant present moment was put to shame'. Contrast is provided by Katharine's suitor, Ralph Denham, who voices the modernist ethic: 'I hate great men. The worship of greatness in the nineteenth century seems to me to explain the worthlessness of that generation.' Yet Virginia reconciles these two in the engagement of Katharine and Ralph; Katharine's rejection of the mediocre and sycophantic William, and Ralph's lack of sincere feeling towards the suffragette Mary allows Katharine to recognise herself as both a creature of her time and a product of the past. She need not hero-worship her ancestors, nor completely reject them; she must 'join the present on to this past', just as Virginia was coming to terms with life as a wife over whom the shadows of the past and parental expectation still stretched. On 5 May, she wrote in her diary, 'The day mother died twenty something years ago. The smell of wreaths in the hall is always in the first flowers still; without remembering the day I was thinking of her, as I often do.'[3] It was a theme she would return to in almost every other novel she would write.

The novel's 'first fruits' came from Clive, who pronounced it as 'no doubt a work of the highest genius'. Not everyone agreed. In the *Piccadilly Review*, Ford Madox Ford found it a 'passionless' description of the lives of a certain Edwardian milieu, but picked up on Virginia's Shakespeare parallel; it was a 'moral-less but very entertaining book which is all ado about nothing'.[4] The *Times Literary Supplement* appreciated the delineation of character type: 'It shows an apprehension of values which is rarely found, even in days like these when fiction is commonly supposed to be troubled with too much thinking,' and the story was so exciting that 'to read it is to pass through a keen emotional experience.'[5] W. L. George in the *English Review* disagreed, finding the work characterised by pity and disdain, with 'excessive prominence

given to minor emotions'.[6] Katherine Mansfield, who had met
Virginia at Garsington, wrote in the *Athenaeum* that she found
it 'extremely cultivated, distinguished and brilliant, but above
all – deliberate', and compared it to a modern-day Jane Austen,
even though she felt it lacked Austen's 'potency' and dismissed its
focus as backward-looking.[7] With a tentative friendship growing
between the two writers, she concealed her real views that
the book was a 'lie in the soul', full of intellectual snobbery
and an attempt to pretend 'the war has never been'.[8] In turn,
Virginia kept her feelings about Katherine, her 'queer balance of
interest, amusement and annoyance', to herself, and their strange
'quicksand' intimacy shuffled on until Katherine's early death from
tuberculosis in 1922.[9] Virginia regretted the loss and admitted that
she had been the only living writer whose work she had envied.

A second Bloomsbury book, which came out in the autumn of
1919, was also concerned with the relation of past and present,
but Maynard Keynes's *Economic Consequences of the Peace*
was to anticipate darker days that lay in the future. In late
1918 Keynes was asked to represent the British Treasury at the
Versailles Conference, which met in Paris from 19 January to seek
a solution that would prevent future conflict, and resulted in the
formation of the League of Nations. Delegates from twenty-seven
nations attended but the main decision-making was dominated by
Britain, France, Italy and the USA. Keynes was critical of the harsh
reparations imposed on Germany and argued for a far more lenient
approach, with the forgiveness of war debts, as Europe could not
prosper without a fair, equable system: 'Who can say how much
is endurable or in what direction men will seek at last to escape
from their misfortunes?'[10] His focus was on recovery, rather than
punishment, and he was concerned that the treaty did not honour
the terms of the Armistice. However, his arguments were rejected
by Woodrow Wilson and Georges Clemenceau, who Keynes felt

'had a chance of taking a large, or at least a humane view of the world but unhesitatingly refused it,' offering the 'abhorrent and detestable' policy of a 'backwards-looking old man, blind ... to the threshold of a new age.'[11] Finding the peace terms intolerable, Keynes resigned his position and returned to England. He wrote *Economic Consequences of the Peace* over a period of two months that summer while staying at Charleston.

By 1919, the lease on Asheham House was coming to an end and the Woolfs realised with reluctance that they would be forced to move. After Virginia made the impulse purchase of the Round House in Lewes, she realised its size and location alone made it unsuitable, so they began to look around for another property in the area. On 1 July they purchased Monk's House in Rodmell, set at the bottom of a winding lane, with a huge rambling garden and views over an orchard and churchyard, which gave Virginia a 'profound pleasure'. There was 'an infinity of fruit-bearing trees, the plums crowded so as to weigh the tips of the branches down; unexpected flowers sprouted among cabbages. There were well kept rows of peas, artichokes, potatoes; raspberry bushes had pale little pyramids of fruit.' It was not large in comparison with Asheham, comprising two stories of small, low-ceilinged rooms and lacking a bath and hot water, so all cooking was done on a gas stove, and the 'convenience' was 'an earth closet, discreetly but ineffectively hidden in a grove of cherry laurels in the middle of the garden'.[12] But Monk's House was pretty and the more they saw it, the less they were inclined to fault it. It was 'an unpretending house, long and low, a house of many doors ... with the store of old fashioned chairs and tables, glass and furniture with which every inch of room space is crowded'.[13] With the space cleared and their own belongings moved in, Leonard and Virginia moved in on 1 September. Vanessa and Duncan came to tea; they strolled in the garden after dark and listened to the church bells ringing. Despite

'all the difficulties, advantages and disadvantages of the place', Virginia wrote, 'I think the upshot is wholly favourable,' adding a week later that 'I think perhaps nine people out of ten never get a day in the year of such happiness as I have almost constantly'.[14]

Earlier in the year, Virginia had been reflecting on her friendships. An appendix to her 1919 diary gives a good overview of what she considered to be Bloomsbury by that point and how her circle had evolved since the primary movers had first met at Cambridge:

There's Lytton, Desmond, Saxon; they belong to the Cambridge stage of life, very intellectual, cut free from Hyde Park Gate, connected with Thoby ... Ka and Duncan for example, both came rather later; they belong to Fitzroy days, the Oliviers and all that set are stamped as the time of Brunswick Square. Clive I put a little aside; later still there are the cropheads, Alix,[15] Carrington, Barbara,[16] Nick,[17] Bunny ... I have not placed Ottoline or Roger and again there are Katherine and Murry[18] and the latest of all Hope Mirrlees,[19] who recalls Pernel and Pippa and outlying figures such as Ray. Gertler I must omit ... Eliot I liked on the strength of one visit ... Well, I cherish a considerable friendship for each of them; the worst of it is how seldom we meet ... months pass without a sight of them ... But when we do meet there is nothing to complain of. Lytton is said to be more tolerant and less witty; Desmond, they say, needs a glass of wine; Saxon has his rhematiz [*sic*] and his hopeless love.[20] Lytton is again famous these last six months ... I like Carrington though. She had increased his benignity. O yes, if he were to walk in this moment we should talk about books and life and our intimate feelings as freely as we ever did and with the same sense of having hoarded a great deal peculiarly fit for the other.

Already in 1919, the question emerged of 'Bloomsbury' as a definable group to whom London 'society' might react. Virginia had

already used the term in her diary, back in 1914, but on this later occasion, it was almost a defensive name, a term that might result in raised eyebrows or disapproval. No doubt this was the result of a number of factors, including the hype in the popular press about the Post-Impressionist Exhibition, the exclusive market catered to by the Omega galleries and the rumpus kicked up by Wyndham Lewis, who was nothing if not a tenacious adversary. Over dinner at the Isola Bella Restaurant in 1919, Clive attempted to convince Virginia, Vanessa, Duncan and others that they, along with Roger and Lytton, were 'the most hated people in London; superficial, haughty and giving ourselves airs – that, I think, is the verdict against the ladies'.[21] Clive had been talking to T. S. Eliot, whom Virginia had liked upon meeting, but appeared to have expressed some secret dislike of her to Clive. This was again, perhaps, the result of Lewis's breach, as Eliot was convinced of the genius of the works of Lewis and his fellow Vorticist Ezra Pound. The day after the dinner, Mary Hutchinson telephoned Virginia to apologise, claiming Clive had misunderstood and that Eliot had 'only abused Bloomsbury in general',[22] rather than Virginia specifically. Virginia, though, was guarded from that point onwards in her dealings with Eliot, but the general charges of cliquism and snobbery were to reappear against a general concept of 'Bloomsbury' in the years to come, as the fame of its members spread.

One of the milestones in this fame was Duncan Grant's first solo exhibition, which was held at the Paterson-Carfax Gallery on Bond Street. Thirty-one pictures were included, ranging from still lifes and farm scenes depicting the countryside around Charleston to imaginative subjects and portraits. The private view was followed by a lunch party at the Café Royal, which was attended by Virginia and Adrian, Lytton, Maynard, Pippa Strachey and Duncan's mother among others. Lytton paid the not inconsiderable £60 for *Juggler and Tightrope Walker*, and Virginia was given a watercolour as a

gift. She found Duncan's work 'so lovely, so delicious, so easy to adore'.[23] However, Duncan's gleeful distortions of the human form drew criticism from the *Daily Telegraph*, on the grounds that he was being deliberately sensational and provocative, such as in the large *Venus and Adonis*, which foreshadowed Picasso's monolithic female nudes of the 1920s and '30s. Roger answered the accusation by agreeing that some artists might sacrifice all to shock, but that Duncan's 'transparent sincerity and simplicity' proved him to be an exception.[24] Roger did feel, though, that the colours of Duncan's new work were pale in comparison with the brilliance of his former pieces: he felt that some of the pieces were a little lifeless as a result and some critics agreed, wondering whether Duncan's talent had already peaked. The gallery's sales told another story, with twenty-four paintings raising £855. Ottoline attended and 'undulated and eulogised', while Clive stated unashamedly that 'Duncan Grant is, in my opinion, the best English painter alive … [his] ancestors are Piero della Francesca, Gainsborough and the Elizabethan poets, something fantastic and whimsical and at the same time intensely lyrical.'[25] While the influences on Duncan were certainly Renoir and Matisse, Clive's comments established a sense of continuity between modern art and the old masters, a central and constant tenet of Bloomsbury style.

It was at this point, in the aftermath of the war, that Bloomsbury group members felt the past move more sharply into focus beside the uncertainties of modern life. In March 1920, Desmond's wife Molly founded the Memoir Club, in which participants were invited to read papers and were free to say anything they liked, which would ultimately contribute to individual autobiographies. The original thirteen members, which Leonard dubbed 'Old Bloomsbury', were Desmond and Molly, Vanessa and Duncan, Virginia and Leonard, Lytton, Saxon, Maynard, Roger, E. M. Forster and Sydney Waterlow, with Bunny joining shortly afterwards. The

club produced some important biographical pieces, including the papers where Virginia exposed George Duckworth's abuse, but Molly's other intention was to prompt Desmond to write the novel that all his friends felt him capable of, casting him in the role of successor to Henry James. With conversation his metier, Desmond never did write a novel, although the club continued to meet until 1964. Seven people read at the first meeting, and Virginia wryly commented, 'Lord knows what I didn't read into their reading ... I doubt anyone will *say* the interesting things but they can't prevent their coming out.'[26] Although Virginia had not been troubled by the mixed reviews about *Night and Day*, she was anxious about the reception of her first memoir, fearing that her piece was 'egotistical sentimental trash' that created 'an uncomfortable sort of boredom on the part of the males'.[27] In the event, when she did read in early December, she believed she had been 'fearfully brilliant',[28] but it is significant that this was the audience for which she composed her account of George Duckworth's abuse.

A number of marriages took place in the years immediately following the war among friends connected to Bloomsbury. Ka Cox had been intimately involved with Rupert Brooke, either miscarrying or aborting his child before the war, and grieved his loss in 1915. Three years later she married the artist Will Arnold-Forster and bore his son, Mark, on 14 April 1920. Virginia saw the announcement in *The Times* and 'felt slightly envious all day in consequence'.[29] The same year another of Brooke's devotees, James Strachey, married Alix Sargeant-Florence, an American graduate of the Slade and Newnham College, Cambridge. Together, they decided to become psychoanalysts and moved to Vienna to learn from Freud. Their translations of his works remain the standard English version. On 31 March 1921, Bunny Garnett surprised everyone by marrying Rachel, or Ray, Marshall, a shy, dark-haired girl who had studied book illustration and was linked to the

Stracheys by marriage. Although Duncan and Bunny's relationship had suffered various infidelities and trials, Duncan was shocked when Bunny tried to insist that the marriage need not affect their affair. 'It's a ridiculous argument that there is no difference between a liaison and a legal marriage,' he wrote to Bunny, 'this is an event in your life, however much you pretend it isn't … You needn't mind hurting my feelings any more, that's done with.'[30] For a while, Duncan refused to see Bunny alone. Meanwhile, another Bloomsbury love triangle had resulted in marriage in 1921, but this was as a deliberate attempt to resolve emotional difficulties and preserve a way of life.

That year, Lytton had cemented the success of *Eminent Victorians* by following it with *Queen Victoria*, which he dedicated to Virginia, as, he said, 'You're more unlike Old Vic than anyone in the world.'[31] She read the book, finding it 'an incredible gem, and a masterpiece of prose' and felt her 'jealousy twinged'.[32] The proceeds set him up for life, and Virginia recorded that he was as 'mellow as a pear', but this was only on the surface. Lytton's home with Carrington at Tidmarsh had expanded to include a third member, Ralph Partridge, a Cambridge friend of her brother who was working as an apprentice to the Woolfs at the Hogarth Press. Carrington remained devoted to Lytton, but was fond of Partridge, who fell madly in love with her and, encouraged by Virginia, urged marriage. In turn, Lytton was filled with a patriarchal love for Carrington, while desiring the heterosexual Partridge and becoming fearful that he would fly the nest. In 1921, Carrington agreed to marry Ralph in spite of the importance to her of independence and privacy, and the fact that she did not want children. 'One cannot be a female creator of works of art and have children,' she wrote to her friend Gerald Brennan, 'my real reason however, is that I dislike merging into a person … I hate those little self-centred worlds which married people live in.'[33] She

accepted Ralph in order to keep Lytton and all three departed on honeymoon to Venice.

1921 was also the year in which Maynard Keynes fell in love with his future wife. Diaghilev had staged *The Sleeping Beauty* at the Alhambra Theatre, with music by Tchaikovsky and scenes by Bakst, drawing a wide audience from among the Bloomsbury milieu and London society. From his first visit, Keynes's attention was captured by the Russian ballerina dancing the role of the Lilac Fairy. She was the daughter of a serf from St Petersburg who had become the star of the Imperial Ballet School. This was not Lydia Lopokova's English debut, though. She had already caused a stir back in 1918, dancing in Massine's *The Good Humoured Ladies*, after which Ottoline had taken Duncan and Bunny backstage to meet her, an occasion on which all three had been quite charmed by her. Lydia was already married to the Italian business manager of the Ballets Russes, Randolfo Barrocchi, but it had not proved a success, least of all due to the fact that Barrocchi proved to be a bigamist, leaving Lydia free to conduct an affair with the composer Stravinsky. She and Keynes fell in love in London and married on 4 August 1925. After some misgivings, Duncan agreed to be the best man, turning up at St Pancras Registry Office in a borrowed suit but without the ring.

Virginia and Vanessa were initially uncertain about Lydia's influence on Keynes, and the integration of a wildly different character into their close personal circle. 'I can foresee only too well,' Virginia wrote, 'Lydia stout, charming, exacting; Maynard in the cabinet [and] ... being a simple man, not analytic as we are, would sink beyond recall long before he realised his state. Then he would awake, to find three children and his life entirely and forever controlled.'[34] After Maynard leased Tilton, a farmhouse half a mile down the lane from Charleston, Vanessa realised that the Keyneses were as concerned to preserve their privacy as she

was hers, and the marriage proved happy, although to their regret it was childless. The sisters could never rid themselves of the sense that Lydia was an outsider, which was, perhaps, inevitable given their shared history and closeness, but there were happy times at Charleston and Tilton. Duncan even painted two portraits of Lydia in the 1920s and designed the sets for her ballets. The members of the Bloomsbury Group were moving on.

Art and Life, 1919–1924

We Georgians have our work cut out for us.[1]

As new doors opened, old ones closed. After a few years of struggling, Roger made the decision in 1919 to shut the Omega Workshop for good. Its coloured curtains and Duncan's blue lily sign were taken down, the vibrant screens were folded and the huge caryatids that stood either side of the entrance were dismantled. The departure of Vanessa and Duncan for the country in 1916 meant they had spent increasingly less time in the gallery and, in spite of prestigious commissions to decorate the homes of Lalla Vandervelde in Chelsea and Arthur Ruck in Berkeley Street, finances had become problematic. The venture 'threatens to die but does not die ... there is no more future', Roger had written despondently to Vanessa, who attempted to convince him of the desirability of closure.[2] Yet Roger clung to the idea, reluctant to admit defeat, much in the same way he hoped to retain Vanessa's affections. Visiting him in 1916, shortly before he turned fifty, Virginia found Roger 'rather melancholy,' talking 'about old age and the horrors of loneliness'.[3] Soon afterwards, he launched the

Omega Club, which met weekly in Fitzroy Square and attracted such figures as George Bernard Shaw, W. B. Yeats and Arnold Bennett, along with Clive and Lytton, to drink, talk and watch performances of Duncan's giant puppets. Yet, in spite of this and several exhibitions of varying success, Roger was finally ready to end the venture by February 1919, writing with some bitterness to Vanessa that he was 'simply tired out with all the cares of the Omega'. He had been forced to take on everything during the illness of staff and had 'surpassed [himself] in ingenuity',[4] but a final show that March proved a fiasco. A closing sale was held in June.

Roger was in reflective mood, therefore, when he published a collection of his essays under the title *Vision and Design* in 1920. Written over a period of twenty years, they covered topics as diverse as Florentine Art, African Sculpture, William Blake, Aubrey Beardsley, Claude, Giotto, El Greco and, of course, the Post-Impressionists. Considering his lengthy support of artists such as Cezanne, Roger realised that 'what [he] had hoped for as a possible event for some future century had already occurred ... that art had begun to recover once more the language of design and to explore its so long neglected possibilities'.[5] His pre-war efforts were vindicated by a Matisse exhibition that was held in London that autumn.

On a personal level, Roger had had a series of short affairs through the war years, including one with Omega artist Nina Hamnett, and in 1923 with Josette Coatmellec, a highly strung consumptive who shot herself following their disagreement over an African mask. This deeply affected him; he designed her tombstone and attended the funeral in Le Havre, declaring he was cursed and would never be happy again. Roger then sought refuge in the colourful south, at Toulouse and St Tropez, throwing himself into his painting and celebrating the warm colours that filled him with

a 'new sense of power and ease'. The loss of Vanessa and birth of Angelica had also hurt him, as he had once held out hopes that Vanessa would bear his child. The war years and early twenties proved to be a dark time in his personal life. It was not until 1924 that he finally found happiness, with Helen Maitland Anrep, whom he met at a party held in Vanessa's studio. Helen's marriage to the Russian mosaicist Boris was already unhappy but had become uncomfortable after he expected her to live *à trois* with a young Russian girl. After the party, when Boris accused her of giving Fry too much attention, she left their Hampstead home and travelled to Fry's studio, beginning their long-term affair. Roger also changed locations. In 1919, with his children at school, he sold Durbins and moved to a beautiful large house in Dalmeny Avenue, in Holloway, moving out of the centre of Bloomsbury, where he no longer felt he belonged.

The workshop might be closed but the style of the Omega continued to flourish inside the homes of the Bloomsbury Group and their friends. In the 1920s, as well as covering every available surface at Charleston, Duncan and Vanessa decorated Keynes's sitting room at Gordon Square and his rooms at Cambridge, as well as an interior for Adrian and Karin in 1922, for Leonard and Virginia in 1924, and Clive's rooms in 1926. Interiors were also decorated by the pair for Mary Hutchinson, Angus Davidson, Raymond Mortimer, Ethel Sands and others, with their designs fusing to such a degree that some were no longer clearly distinguishable as being by either Duncan or Vanessa. From practice together at Charleston, they had developed a Bloomsbury 'house style', a 'distinctive calligraphy' which was featured alongside that of Le Corbusier in the 1929 book *The New Interior Decoration* by Raymond Mortimer and Dorothy Todd. As Virginia recorded in her biography of Roger, the Post-Impressionist shades had gone but 'some of the things he made still remain; a painted table, a

witty chair, a dinner service, a bowl or two of that turquoise blue ... and if by chance one of those broad deep plates is broken, or an accident befalls a blue dish, all the shops in London may be searched in vain for its fellow'.[6]

Recovering after the birth of Angelica, Vanessa was concerned about the baby's weight and the primitive conditions at Charleston. Only a small group of intimates were informed that the baby had been fathered by Duncan; otherwise their family and acquaintances were allowed to assume that she was Clive's. In the meantime, Duncan had ended his sexual relationship with Vanessa, and despite her pain, the pair continued to live and work together, recognised by all as artistic partners. However, there were those who disliked the bohemian lifestyle of Charleston and felt it their duty to say so, or imply so through omission. The Stephens' cousin Madge Vaughan, now the wife of a headmaster, decided against her plan to rent Charleston for three weeks in Easter 1919, on account of the immoral lives of its inhabitants. 'As for the gossip about me,' Vanessa replied furiously, 'it seems to me almost incredibly impertinent of you to ask me to satisfy your curiosity about it ... I am absolutely indifferent to anything the world may say about me, my husband or my children.' She followed this with a softer letter, apologising for her anger, but adding that neither she or Clive 'think much of the world's will or opinion, or that a "conventional home" is necessarily a happy or good one ... my married life has not been full of restraints but on the contrary, full of ease, freedom and complete confidence'.[7] Although there had been moments of difficulty, the Bells' marriage had resolved into a committed partnership that allowed each the scope to pursue individual interests in a way that was remarkably experimental and open for the times.

Soon Vanessa was ready to return to the world. Emerging from the country, she took over part of the lease of Adrian and Karin's

house at 50 Gordon Square, making galleries, parties, shops, theatres, museums and friends more accessible. Julian started school at Owen's in Islington in the autumn of 1919 and Quentin had a governess, but with Angelica still a baby, Vanessa was finding it increasingly difficult to get good staff to help in the nursery and kitchen. The subject of one of her first Memoir Club papers was her maid Mary, who was committed to an asylum following a long and distressing descent into mania, during which she invented a string of tragic accidents that had apparently afflicted her family. Vanessa was sympathetic, but Mary's departure proved a relief; it also meant that she was able to engage a new woman, Grace Germany, who would remain with the family for the remainder of her working life.

In comparison with 1910–14, Bloomsbury art after the war retreated from the precipice of the vanguard. The experimental, Post-Impressionist style of Vanessa's work had returned to more traditional methods and subjects that were more reflective of her surroundings and the national mood. Something about the conflict had made the pre-war iconoclasm seem irrelevant, indulgent in the face of the grim reality which now dominated the canvases of those who had been at the front. Bodies, mud, craters, broken trees and searchlights captured a sense of muddy despair that paralleled the stories of those in the trenches. As Virginia noted on the eve of war years later, 'Art is the first luxury to be discarded in times of stress.' Collectively, the Bloomsbury artists were committed to pacifism, so they went unrepresented in the work of the official war artists, which seemed to capture or shape the public interest at the time. Bomberg, Nevinson and Lewis employed the harsh, geometric and machine-like style of Vorticism to effect a very modern disunity and chaos of conflict, and although their fellow Slade artists Stanley Spencer and brothers Paul and John Nash painted in a more lyrical English style, their influences were different from those that had

affected Vanessa, Roger and Duncan from 1910 to 1914. Even the powerful work of older artists, such as Orpen and Sargent, whose large, iconic painting *Gassed* has a traditional and immediate appeal, captured emotions at variance with the view outside the window at Charleston, or a still life of flowers. Other pacifist painters did create their own powerful comments on the conflict, such as Mark Gertler's nightmarish *The Merry Go Round* of 1916, but Duncan and Vanessa's warm colourful portraits and interiors were an assertion of their focus on family, friendship and love. During such a period of turmoil, this sense of the importance of civilised living represented a vital continuity, a personal distancing from a war that was not their choice and would pass, returning the world to the timeless values that really mattered. It was deliberate art of pacifism, but whereas before the war Bloomsbury had been at the vanguard of English Post-Impressionism, those experiments and influences were now swept away in a changing tide of conflict. Increasingly it became clear that the old world was not going to return and that a new artistic direction needed to be sought.

Letters from Clive and Roger in Paris made Vanessa long to go abroad again. In the spring of 1920, she headed off for a painting holiday to Italy with Duncan and Keynes. They stayed in Rome at the Hotel Russie, where she felt uncomfortable with the atmosphere created by the crowd of 'contessas, marchesas, principessas and duchesses'. From there, they headed off on a five-day tour of the countryside before hiring a studio in the Via Murgutta, where Vanessa produced still lifes and street scenes in a solid, realistic style. The vast array of beautiful flowers available astonished them: 'One can buy masses of arum lilies, irises, roses, pansies and marigolds for a few francs on the steps of the Piazza di Spanga,' she wrote, and adorned the studio with them. On the way back, they stopped over in Paris, dining with Derain, Satie, Segonzac and Braque and attending a private view of the latest

Picassos. Vanessa's affectionate letters to Roger describe their visit; meeting Clive, who was staying up until five each morning talking to Derain, and who was negotiating a 'complicated' private life between a rather sad-looking Mary Hutchinson and Juana, a Chilean beauty whose arrival in Paris caused problems. They also met the poet Andre Salmon, saw a show of Dutch art, admired Delacroix and visited the Louvre, Courbet's studio and an exhibition of nudes at Bernheim's gallery. In her absence, Roger kept an eye on her children, for which she gratefully wrote, 'I feel safe with you at hand as I know you would do anything that was necessary and would let me know ... I don't think I know anyone else I should feel so safe with.'[8]

Vanessa came home renewed, with new work and fresh ideas and vigour. That November, she and Duncan held a joint exhibition with fellow artist Robert Lotiron at the Independent Gallery. The *New Age*'s regular art critic, R. A. Stephens, was lukewarm about Duncan's work, suggesting his ideas were 'inferior to his capacity' and that his approach should be 'larger'; his *Cowshed* was 'rendered with economy' and in his *The Window Sill*, 'the idea is merely clever but the treatment is large'.[9] When it came to Vanessa's work, he was more appreciative, finding her *Tidmarsh* to be 'skilful to the point of intuition' while *The Mantlepiece* was a 'witty drawing, full of judicious violence'.[10] Although it usually tended to be Duncan whose work attracted more attention for its colour and composition, Stephens' preference for Vanessa's style would endure, describing her the following March as one of the 'best of our women painters'.

In the winter of 1921, Vanessa took her family and Duncan down to the south of France, where Roger was painting. After a long train journey to St Tropez, they settled in at La Maison Blanche, their holiday home set on the hills with wonderful views across the bay. Owned by Rose Vildrac, wife of an art dealer, its

walls were hung with the canvases of Derain, Friesz and Vlaminck, whose vivid colours seemed to spill into the countryside and infuse their life in the sun. 'There are vineyards all around,' Vanessa wrote to Clive, 'we are high up ... the sea is very blue and today the weather is perfect ... it's a most sympathetic place with everything very simple ... It's delicious to be in the south, one forgets how nice it is, all the colours and the light and space and everything looking so baked through.'[11] They painted all day, from October until January, capturing the vibrant oranges, blues and purples in such works as Vanessa's *Interior with a Table*, reawakening the spark that had been fused by their contact with the Post-Impressionists and beginning their life-long love affair with the south of France.

The following spring, with Julian commencing as a boarder at Leighton Park, Quentin now at preparatory school in Peterborough and Angelica still in the care of a nurse, Vanessa and Duncan went back to Paris. They visited Segonzac in his studio, met Zadkine and Kisling, and attended the Salon des Indépendants, where they admired very little except the Derains. On her return, Vanessa had her first solo exhibition at the Independent Gallery, exhibiting twenty-seven paintings which sold well but attracted no reviews. The gallery also hosted an exhibition of modern British and French painting, at which Roger and Duncan exhibited, with Roger's *Water Carrier* praised for its seventeenth-century style and Duncan's *Still Life* singled out as the best work in the show.

Just as Vanessa, Duncan and Roger had gone through a process of forging a new style, Virginia was undergoing a transition from a figurative narrative into something more impressionistic. She had explored new styles in a series of short stories, but by 1921 she was working on a new novel, her most experimental so far, which would become *Jacob's Room*. It is clear from her letter to Katherine Mansfield that February that she had been working on it for about a year, finding that it was 'always chopping and changing from one

level to another'.[12] What she wanted to do, she confided, was to 'change the consciousness, and so to break up the awful stodge,' so that there wasn't 'just all realism any more, only thoughts and feelings, no cups and tables.'[13] As the novel progressed, she began to feel that at last she had found her voice.

Then, a stinging, anonymous review of the Hogarth Press's newly released *Monday or Tuesday* was published in the *New Age*. This was something of a sore point: it was a collection of eight of Virginia's stories, published that year alongside woodcuts by Vanessa, which the Woolfs' apprentice had sent out in a state of imperfection. Of the title story, the critic declared that Virginia had 'tried to do in words what can only be done in music or painting', while a 'miserable woman on a train inspired her to concoct "An Unwritten Novel"' and the 'Mark on the Wall' was the result of her refusal to get up and notice that it was, in fact, a snail. 'None of Mrs Woolf's work can be called written,' continued the critic, 'she tumbles out words and ideas in the hope that they will convey some impression ... [she] has a disorderly mind and does not know how to write. She gushes drivel and ... her idea of honour is unmistakeably feminine.'[14] In some ways, this comment displays a clumsy recognition of Virginia's new method; her attempt to find a sort of Post-Impressionism in words, which she also explored in the short story 'Blue and Green', her attempt to evoke the reality of colour through the use of signifiers. It was a bold and radical move, exploring and overlapping the boundaries of different media, although the critic misunderstood the precision and clarity of her conscious 'disorderliness' in attempting to forge a new, modern way of recording life to parallel the achievements of artists like Cezanne and Matisse. In spite of this, the stories clearly did make a mark and Virginia did not suffer any sort of crisis as a result. Always acutely conscious of criticism, she assessed her feelings rationally in her diary; 'I'm not nearly as pleased as I was

depressed and yet in a state of security; fate cannot touch me; the reviewers may snap and the sales decrease. What I had feared was that I was dismissed as negligible.'[15] There was little question of that. With her next book, she was to really find her own voice and the confidence to withstand the critical views of those who failed to understand her aims and achievement. She might be writing for 'half a dozen instead of 1,500' but she was producing 'something which I want to write; my own point of view'.[16]

Jacob's Room represented a leap forward in Virginia's style, a voyage into modernism. It was published by the Hogarth Press on 26 October 1922, with a woodcut cover designed by Vanessa. Drawing on her memories of Thoby, Virginia created an innovative fictional biography with an absent protagonist, a vacuum at the heart of the text. Jacob Flanders is a construct of fragments from the perspective of others, through their interactions with him or through significant moments and objects like his discarded boots or creaking armchairs: his life is comprised of a series of impressions or memories, an elegy to loss. Like Thoby, Jacob spent childhood summers at St Ives, proceeded to Cambridge, then London and visited Greece before dying in the war. It was a deeply personal book, a moving tribute to the brother whose presence was felt less keenly with every passing year, whose personality is fleetingly felt, as if the text is inhabited by a ghost. Its modernism was not just conveyed through narrative style and structure, but in its attempt to make sense out of the senselessness of early death, in the forces of chaos lurking beneath the surface of life and the reality of discontinuity. The question Jacob's mother poses at the end, of what she is to do with his old shoes, remains as challenging to her as to the reader, when the guillotine abruptly falls on a misleadingly but consciously random and directionless narrative.

Perhaps it was because Virginia found the writing of *Jacob's Room* cathartic that she was less troubled by the critical responses

when the work was published: 'The reviews have said more against me than for me on the whole. It's so odd how little I mind and odd how little I care much that Clive thinks it's a masterpiece.'[17] It was for her as powerful a memorial book as Leslie's *Mausoleum Book* had been, only without the stifling presence of a maudlin author saturating every line. Faithful as ever, Lytton found the book 'astonishing' and claimed he 'occasionally almost screamed with joy at the writing', while Desmond called her 'a marvel and a puzzle'.[18] The *Times Literary Supplement* lamented the very insubstantiality of the characters, which so contributed to the novel's poignancy, finding Virginia's technique did not 'create persons and characters as we secretly desire to know them'.[19] Virginia found the review 'tepid' but 'flattering enough'.[20] Similarly, Arnold Bennett, whose novels Virginia considered to be the antithesis of hers, commented in *Cassell's Weekly* that the 'characters do not vitally survive in the mind because the author has been obsessed by details of originality and cleverness'.[21] Rebecca West, writing in the *New Statesman*, considered the novel a failure because its characters were simplified types, but that taken 'as a portfolio' it was 'indubitably precious' as a series of still lifes.[22] W. L. Courtney would admit in *The Daily Telegraph* that as a modern novel, 'we do not quite understand what the authoress is driving at,' as instead of a 'straightforward narrative dealing with certain characters ... we have a perfectly different art form.' Yet he, like West, identified a pictorial aspect of the text: 'In her instinct for the nuances of character, in the keen discernment of those small, unessential things which go to the making of life, she scores again and again. Her theory of art ought, I suppose, to be called impressionist.' He also opted for a musical analogy: 'In its tense, syncopated movements, its staccato impulsiveness, do you not discern the influence of Jazz?'[23] The *Yorkshire Post* compared her to James Joyce. Virginia was circumspect: 'I expect to be neglected

and sneered at ... either I am a great writer or a nincompoop.'[24] By 7 November, she felt she was 'through the splash ... Yet the private praise has been the most whole hearted I've yet had.'[25]

In the meantime, the private life of one of her closest friends was unravelling. Despite his efforts to keep the peace, Lytton's ménage at Tidmarsh had become increasingly complex. Having witnessed his close relationship with Carrington develop, Virginia and Leonard had advised their apprentice Ralph Partridge to propose to her, and now found themselves embroiled again as the hasty marriage began to fragment. From the start it was an unconventional match, with Carrington admitting she did not feel about Ralph as 'other wives' did about their husbands,[26] and that it was a convenience to preserve their way of life with Lytton. Soon Carrington discovered that Ralph had been unfaithful, most recently with the married artist Valentine Dobrée, whom Carrington had also admired. Just to confuse the circle further, Valentine had conducted an affair with Carrington's former lover Mark Gertler, who had been suicidal when hearing of Carrington's marriage. As a result, Carrington felt justified in allowing her own flirtation with the writer Gerald Brenan to become more physical, although she took pains to keep it a secret. However, Ralph did not agree. He could not tolerate the same sexual freedom in his wife that he allowed himself, especially when it happened to be with his best friend. With Ralph working three days a week at the Hogarth Press, the drama of this complicated sexual intrigue spilled over into the Woolf's house. Gerald and Ralph met at Hogarth House[27] for an explosive discussion in which Ralph demanded to know the details of his wife's love affair and considered leaving her permanently. Ralph's existing relationship with the Woolfs was already strained, and becoming 'slightly worn with Ralph's outpourings'.[28] Virginia and Leonard both disliked the double standard they witnessed in the behaviour of their apprentice. In her diary, Virginia balanced

his 'lumpishness, grumpiness, slovenliness and stupidity' against his 'niceness, strength, fundamental amiability and connections'.[29]

By the end of 1922, as the Partridge marriage limped on, Ralph finally stopped working at the Hogarth Press, although Virginia promised Carrington that 'all friendships remained intact'.[30] In 1924 Lytton, Carrington and Ralph relocated to Ham Spray, a nineteenth-century farmhouse on the edge of the Wiltshire village of Ham, surrounded by fields. The property cost Lytton and Ralph £2,000, but they believed 'there was no view more beautiful, more inexhaustible, and no house more loveable than Ham Spray'.[31] There, their strange *mésalliance* would continue until Ralph met Frances Marshall in 1923, a 'black-haired beauty, a beautiful Princess that lives in Birrell and Garnett's bookshop',[32] for whom he would finally leave Carrington.

The Woolfs had found Carrington's new love, Gerald Brenan, more sympathetic than Ralph. In April 1923, they travelled to Spain to stay with him at his remote village of Yegen, set high on the rugged mountaintops that were perpetually covered in snow. They arrived on two mules, after riding solidly for twelve hours a day, to find Brenan living alone among 3,000 books, olive groves, almond, pomegranate and orange trees. After nine days as Brenan's guest, Virginia and Leonard journeyed back through Spain and on to Paris. The trip, according to Leonard, was 'an immense success' and Virginia had coped with the travelling 'remarkably well',[33] especially in comparison with the strain that she usually experienced.

Through the 1920s, Virginia remained well, in spite of the various trials of writing and publishing books, varying critical responses to her work and the mixed fortunes of the Hogarth Press. It seemed that the long period of ill health she had experienced during 1912 to 1915 was firmly behind her and that, with Leonard's help, she had established a regime of work and rest that maintained her

equilibrium. Perhaps it was this stretch of stability that allowed Virginia the opportunity to explore some of her personal demons – mental illness and her family memories – which would shape her two most significant fictional works. 'I want to give life and death, sanity and insanity; I want to criticise the social system and show it at work, at its most intense,' she confided to her diary in June 1923.

Ghosts, 1924–1927

Green in nature is one thing, green in literature another.[1]

In 1922, Virginia had been saddened to hear of the death of her old friend Kitty Lushington, whose marriage to Leo Maxse had been encouraged by Julia on the seat by the greenhouse, the 'love corner' at Talland House. Their fictional counterparts, Paul Rayley and Minta Doyle, repeat the process in *To The Lighthouse*, rushing up to dinner from the beach, where Mrs Ramsay realises that 'it must have happened' to this 'golden-reddish girl, with something flying, something a little wild, a little harum-scarum' about her, 'some lustre, some richness' in her 'large brown eyes'. Yet Kitty had grown up to become a society hostess, charismatic, 'pretty, seductive and smart',[2] who had chaperoned Vanessa during her youth and had been one of the final visitors at Leslie Stephen's deathbed. Later, she had reacted against the Stephens' move to Bloomsbury, willing them to attract suitable South Kensington husbands, and Virginia found her brittle, 'tinselly', unsympathetic and discouraging about her writing and her friends, so they increasingly saw less of each other. In October 1922, as

Virginia was beginning to plan a new novel, she learned that Kitty had died after falling over the banisters at her home in Cromwell Road, at the age of fifty-five. The loss of her 'radiant personality' was a 'shock to the many who rejoiced in her friendship', read her obituary in *The Times*, as the result of a terrible accident.

Four days after her death Virginia reminisced that she hadn't seen Kitty properly since 1908,[3] and recalled her 'white hair, pink cheeks, how she sat upright, her voice with its characteristic tones, her green-blue floor which she painted with her own hands, her earrings, her gaiety, yet melancholy, her smartness, her tears which stayed on her cheek. Not that I ever felt at my ease with her.'[4] Virginia did not attend the funeral, which was held at Holy Trinity Church, Brompton, on 11 October. 'Now Kitty is buried and mourned by half the grandees in London and here I am thinking of my book,' she wrote in her diary. 'Kitty fell, very mysteriously, over some banisters,' and Virginia pictured her asking if she would ever walk again and saying to the doctor that she would never forgive herself for her carelessness. 'How did it happen?' Virginia mused. 'Someone presumably knows.'[5] She suspected suicide.

The first appearance of *Mrs Dalloway* comes in Virginia's diary entry for 16 August 1922, when she was 'laboriously dredging her mind' and bringing up 'light buckets'.[6] A week later, she had left her eponymous character in Bond Street to muse that it was the anniversary of the day in 1897 when 'Jack came to Hindhead and was accepted by Stella in the moonlit garden'.[7] By the day of Kitty's funeral the story had 'branched into a book … a study of insanity and suicide: the world seen by the sane and the insane side by side'. In June 1923, she felt the book contained almost 'too many ideas' and found that 'the mad part tries me so much, makes my mind squint so badly that I can hardly face spending the next weeks at it'.[8] The novel's structure, the 'design', was 'so queer and so masterful' that she was always 'having to wrench [her]

substance to fit it'. She foresaw that it was going to be 'the devil of a struggle' and although she wanted to 'write away and away at it, very quick and fierce', she suspected that in three weeks' time, she would be all 'dried up'.[9] It was not until the following May that she proposed to dedicate four months to completing it, followed by a break of three months, before revising it in January 1925 with a view to publication by the Hogarth Press in the early summer. *Mrs Dalloway* was completed on 9 October 1924 and did indeed come out, as Virginia had predicted, on 14 May 1925.

The novel developed two existing short stories, 'Mrs Dalloway in Bond Street' and the unfinished 'The Prime Minister', setting the narratives of society hostess Clarissa Dalloway, modelled on Kitty, alongside that of the trenches survivor Septimus Warren-Smith. The working title of *The Hours* was a conscious structural comparison to *Ulysses*; Woolf's action also took place over the period of a single day, although the past was very much a palpable presence for her characters. While Clarissa prepared for a party and recalled past love affairs with her imminent guests, Septimus's unravelling mental health projected him towards a tragic conclusion. Like Virginia, he experienced hallucinations, and in order to avoid being sectioned, jumped out of a window to his death. In April 1924, when she finished writing the 'doctor chapter', the 'usual depressions' briefly assailed her and that September she was 'dreading the madness rather'.[10] The parallels with Virginia's experiences are clear, although her 'explanation' of his war service made this depiction of 'madness' more accessible to a general readership; it became something with a universally recognisable cause and effect, just four years after the war's end. Thus she was able to depict her own experiences, the reactions of the 'sane' and the medical profession, at a fictional remove.

As an extension of Virginia's experiences and a significant step towards modernism, *Mrs Dalloway* is concerned with the inability

to communicate. Developing the impressionistic style of narration and characterisation of *Jacob's Room*, Virginia imported the varying strains of discourse that she had experienced during her 'madness', which were frequently unable to overlap, being divided by a common language. Although her characters might be united by the external world, such as the movement of an aeroplane across the sky or a quotation in a bookshop window, they could only give voice to their interior monologues in a subjective and exclusive way. Dr William Bradshaw espouses a language of patriarchy, proportion and denial: 'Health we must have; and health is proportion; so that when a man comes into your room and says he is Christ (a common delusion) and has a message, as they mostly have, and threatens, as they often do, to kill himself, you invoke proportion; rest in bed; rest in solitude, silence and rest, rest without friends, without books, without messages; six months' rest until a man who went in weighing seven stone six comes out weighing twelve.'[11] These were the ineffectual steps Virginia herself had been advised to take towards the resolution of her complex and delicate state of mind. The satire she directed at the patriarchal medical profession is clear.

Virginia's initial plan was that Clarissa Dalloway, at the age of fifty-two, would also commit suicide, but she abandoned this during the writing. Instead, Mrs Dalloway reflects on her past relationships through the crucial summer when she chose to marry her husband Richard instead of Peter Walsh, wondering to what extent true happiness is possible and affirming her existence through the small, colourful details of buying flowers. The old friends she recalls, once so significant, have aged and changed. The society party she plans, with its successful middle-aged guests, represents the world which Septimus fought to preserve, from which he is now alienated and to which he has become a source of embarrassment, as we see through the eyes of his wife Rezia.

Virginia wove the threads of past and present, the themes of class, time and love, happiness and compromise, madness and sanity in an interior monologue, or stream of consciousness. The question of who was the first author to use, or to perfect, this method, is an arguable one. The term had originated in the context of psychology through Henry James' brother William in 1890, but it resurfaced in a 1915 review by May Sinclair, of Dorothy Richardson's novel *Pointed Roofs*. Virginia had read it by 1923, but she had also already read part of the unfinished manuscript of *Ulysses*, and T. S. Eliot's poem 'The Love Song of J. Alfred Prufrock'. In her 1919 essay 'On Modern Fiction', Virginia had written that on a single day, 'the mind receives a myriad impressions – trivial, fantastic, evanescent or engraved with the sharpest steel', and it was the job of a writer to give 'fictive life' to such subjective impressions.

One of the novel's first reviewers identified the Post-Impressionist influence, with Richard Hughes in the *Saturday Review of Literature* noting the sense of vividness and 'creative faculty of form which differs from what is ordinarily called construction'. While Cezanne made this a visual form, of 'synthesis, relation, rhythm', Hughes noted that Virginia used a mental pattern, 'created behind the eye of the reader, composed directly of mental processes, ideas, sensory evocation' and that her novel was memorable for the 'coherent and processional form' that transcended its vividness.[12] The *Times Literary Supplement* connected her style with that of Joyce, adding that if Virginia had 'suggested the simultaneousness of life' in *Jacob's Room*, 'here she paints not only this but its stream-like continuity'.[13] Gerald Bullet compared the novel favourably to the latest Jamesian-style release by Edith Wharton: it captured an 'incessant flux ... the sensation of seeing and feeling the very stream of life ... an inversion of the ordinary method of narration' where 'the life of the mind is more significant than the movement of the body'. The picture did not lack definition, but

it lacked stability in comparison with more conventional writing, and Bullet felt this 'insubstantiality, this exhilarating deluge of impressions' might unsettle some readers.[14] P. C. Kennedy in *The New Statesman* likened the work to 'the ghostly world of Mr Bertrand Russell's philosophy, in which there are lots of sensations but no one to have them' and that despite problems, it was an 'intellectual triumph'.[15] E. M. Forster thought it her masterpiece, an 'exquisite and superbly constructed' book, while Lytton disliked it, feeling it did not 'ring solid' and that she had not yet 'mastered [her] method'.[16]

In 1924, the Woolfs decided they wished to live more centrally and sold Hogarth House in order to move to 52 Tavistock Square. On 9 January, Virginia wrote that she had bought a ten-year lease and the house was theirs: 'basement and the billiards room, with the rock garden on top and the view of the square in front and the desolated buildings behind and Southampton Row and the whole of London – London thou art a jewel of jewels – music, talk, friendship, city views, books, publishing, something central and inescapable, all this is now within my reach'.[17] She was sorry to leave Hogarth House, where they had begun the press, where 'that strange offspring grew and throve', but that she had also 'had some very curious visions [at Hogarth] lying in bed, mad, and seeing the sunlight quivering like gold water on the wall. I've heard the voices of the dead here. And felt, through it all, exquisitely happy'.[18] The move to London represented a return to health as much as a return to society. Vanessa and Duncan were commissioned to decorate the property, including some large painted panels at the 'outrageous extravagance' of £25, which, although being later destroyed in an air raid, were captured in photographs taken in the 1930s by Gisèle Freund. Installed in the third-floor sitting room, the panels were also featured in the November 1924 edition of *Vogue*, with their typical pink, beige and grey urns, cross-hatching and swirls.

Leaving Hogarth House, Virginia imagined the next inhabitant, Saxon's mother, occupying her room: 'Old Mrs Turner will lie in my room now and die there, it is predicted, in two years' time, among her china, her linen and her great flowering wall papers, her father's bureau and several enormous wardrobes.'[19] The Woolfs moved into Tavistock Square on 15 March, where they had the top two floors above a solicitor's practice. The Hogarth Press was set up in the basement and one of the first books they published there was Freud's *Collected Papers*. Virginia loved their new home: 'Oh the convenience of this place! And the loveliness too! We walk home from theatres, through the entrails of London.'[20] Life was moving on after the darkness of her illness and the war years; the glowing shop fronts, Donne's church, the park, the buses, the Strand: all delighted her.

At Charleston, life was harmoniously chaotic, filled with art, friends and flowers. Yet although they worked and lived together and shared a daughter, Vanessa still feared that one day she would lose Duncan, so she did not complain about his affairs with men, as she had not with Bunny. In 1924, when Duncan became close to the handsome sculptor Stephen 'Tommy' Tomlin, her tone to him wavered between that of a mother and a confidante, wanting to know 'how the affairs of [his] heart progress'[21] but half-joking that he might be staying up too late without her knowing. In 1926, Duncan would start an affair with the young aristocrat and writer Edward Sackville-West, whose *The Apology for Arthur Rimbaud* was published by the Hogarth Press the following year. As it happened, Vanessa's love was central to Duncan's being. Although he was not 'in love' with her, he needed the stability she provided, revered her and did not want to risk losing her. As he would later explain to her, for him, 'the main difference between a male love affair and a female one' was that 'with a man one is really alone without being lonely, with a female that is never

so because one never knows and it is always interesting, what a female is thinking'.[22]

When they renewed a fourteen-year lease on Charleston and added a studio to the back of the house, their domestic future seemed even more secure. After visiting them there, Virginia wrote that she had never seen two people 'humming with heat and happiness like sunflowers on a hot day more than those two'.[23] Each year, they continued to develop Charleston, working on the garden, decorating new surfaces and walls, adorning everyday items, sewing curtains and refreshing designs, which all contributed to the sense of lived-in shabby-chic that professed something of a chaotic but organic home and workspace. Friends old and new visited to enjoy their peculiar blend of 'very plain living and high thinking', where naked children roamed the garden in the summer months, put on plays or messed about on boats on the pond. Vanessa and Duncan's creative partnership continued to flourish as they visited Paris again, followed by Venice, Ravenna and Padua in search of Cezannes, mosaics and Giottos. Stephen Tomlin would remain in the Bloomsbury orbit, marrying Lytton's niece Julia and sculpting Lytton, Duncan and Virginia. Eddy Sackville-West would also continue to be a friend of Duncan's but it was his cousin, Vita, who would leave a greater mark on the productions of the Bloomsbury Group.

Having published four novels and considerably more in the way of essays, short stories, criticism and reviews, Virginia was now unquestionably an established writer. It is worth pausing here to glimpse her at work described by Leonard in his autobiography, as he admitted he had 'never known anyone work with more intense, more indefatigable concentration than Virginia' writing a novel. 'The novel became part of her and she herself was absorbed into the novel.' Because she was not to overtire herself, she was only allowed to write between ten in the morning and one, sitting back

in an arm chair with a board on her knees, to which an inkwell was attached. She wrote on large sheets which had been bound especially for her, usually with some pretty paper as a cover. In the afternoon, she would type up what she had written, but 'all day long, when she was walking through London streets or on the Sussex Downs ... the book would be moving subconsciously in her mind ... It was this intense absorption which made writing so exhausting mentally for her.' For relief, she would alternate between writing fiction and reviewing, but 'the difficulty with Virginia was to find any play sufficiently absorbing to take her mind off her work'.[24] Perhaps the confirmation of Virginia's status is nowhere illustrated as clearly as the invitation she received in 1924 to lecture at Cambridge on 'character in modern fiction', a powerful indictment of the journey she had taken from being the sister of undergraduates, not permitted to walk on the lawn.

Virginia and Leonard continued to see old friends in 1924. Saxon dined with them at Hogarth House in January and was discussing taking over the lease; Virginia recorded that he was reading Plato and was now a 'distinguished man'. They also saw Adrian and Karin, but Virginia judged that Karin wasn't happy and indeed, the pair were having difficulties. Their elder daughter, Ann, then aged eight, stayed at Monk's House in September, and Virginia was fascinated to see that she lived in a world of her own, 'happy because she's going to have cocoa tonight and go blackberrying tomorrow ... the walls of her mind all hung round with such bright vivid things'.[25] In 1925, Adrian and Karin moved into a former inn, the isolated King's Head, at Landermere in Essex, with its view over the mudflats and estuary, where they took guests sailing; in 1926, they qualified with medical degrees and began to train as psychoanalysts. Roger also remained a significant friend. At various points through the year, Virginia recorded seeing him 'and his pictures', seeing Roger 'wild eyed and staring', presiding

over a London Group dinner in Wardour Street, where she gave a speech, and dining at the Etoile in June. He was still supportive of the Charleston artists and had written *Living Painters; Duncan Grant*, which was published by the Hogarth Press in 1923. The following August, Virginia saw him at Vanessa's house, 'lean, brown and truculent'.[26] Two years later, Roger wrote in *Vogue* in praise of Vanessa's art, where 'sentimental honesty' was deeply engrained, along with 'reticence and frankness'. Other visitors to Monk's House in 1924 were Keynes and Lydia. Maynard 'is grown very thick and opulent but I like him for his innocency', Virginia wrote, but, engrossed in her characters for *Mrs Dalloway*, accidentally referred to Lydia as Rezia, and noticed that she left with crumbs sticking to her face.[27]

On 9 May the Woolfs stayed with Lytton at Tidmarsh, and he dined with them in October. 'Oh I was right to be in love with him 12 or 15 years ago,' Virginia confided to her diary. 'It is an exquisite symphony his nature when all the violins get playing as they did the other night; so deep, so fantastic.' They talked of 'his writing and I think now he will write another book … of the school of Proust … then of Maynard' and other old friends. That November, they visited him at his new home, Ham Spray 'on a wet misty' day, walked with Carrington and found the other guests, Lytton's love Philip Ritchie and Roger Senhouse, 'a little simple minded'.[28] In 1925, Lytton's play *A Son of Heaven* was staged at the Scala Theatre to raise money for the London and National Society for Women's Service, of which Pippa Strachey was secretary. Set at the time of the Boxer Rebellion of 1900 and based at the Imperial Palace in Peking, its sets and costumes were designed by Duncan and Vanessa in a palette that seems to have been their favourite of the mid-1920s: pink, orange, green, beige and grey, with the hand-painted costumes drawing on Omega designs. That year they also decorated the Strachey family's new home at 51 Gordon

Square in blue, beige and brown, Clive's flat next door, Raymond Mortimer's flat in Gordon Place, Mary Hutchinson's new house in Regent's Park and Angus Davidson's home.

Virginia also saw T. S. Eliot on a few occasions in 1924. That year the Hogarth Press published *The Four Quartets* and Eliot had also turned to Leonard for advice regarding his wife's mental health, but although Virginia was fond of him, she still had reservations. There is no doubt that she could be critical in her private diaries, although she never intended them to be read and, as Leonard later commented, not all her observations were correct. In 1924, she wrote that there was something 'sinister and pedagogic', something vain and schoolmasterish, 'something hole and cornerish, biting in the back, suspicious, elaborate, uneasy' in Eliot's character that put her on edge when they attended the theatre together or met at Garsington. She had no sympathy for his wife Vivienne either, who had made her 'almost vomit, so scented, so powdered, so egotistical, so morbid, so weakly'. She also saw Sydney Waterlow 'and was monolithic on purpose' as she 'feared gushing and depths', and an eager E. M. Forster, who was taking piano lessons and had just finished *A Passage to India*; 'He is much excited, on the boil about it.' Virginia also reported in her diary that Desmond MacCarthy fell down the stairs at Mary Hutchinson's and was very brave when he broke his knee cap. Clive was still in a relationship with Mary and they visited Monk's House that September. The Woolfs held a party in November, to which Duncan and Vanessa came, along with Siegfried Sassoon and Nancy Cunard. Later that month, they attended a party held by Mary Hutchinson to celebrate moving house from Hammersmith to Regent's Park, where the 'upper classes', including Duff Cooper and Lady Diana Cooper, 'pretended to be clever', and Clive recalled his roots, becoming 'very loud, familiar and dashing at once'. Lytton sat 'in his own green shade' and Vanessa wore her

'old red brown dress' which she made herself, without a care 'of what people say, which triumphs over all the tubular cropheads'.[29] The move back to London made friends more accessible and the Woolfs would divide their time between Tavistock Square and Monk's House for the next fifteen years.

By May 1925, Virginia already had the title and concept for her next book, *To the Lighthouse*. It would prove to be a voyage into the past, a rediscovery of the delightful summers spent overlooking St Ives Bay, with the children playing cricket on the lawn and hunting moths at night, the garden flowers, the boats bobbing on the waves and the frustrations and illusions of childhood, set alongside its intense moments of joy. The centre of the book was to be a portrait of her father 'sitting in a boat, reciting We perished, each alone, while he crushes a dying mackerel'.[30] She wanted the 'sea ... to be heard all through it' and contemplated a synonym for the unsuitable word 'novel', considering that she might call it an elegy instead. Leonard thought it might be a 'psychological poem'. In February 1926, she recorded, 'Never have I written so easily, imagined so profusely,' twenty times more quickly than ever; the novel was blowing her about 'like an old flag', and that 'what fruit hangs in my soul is to be reached there'.[31] On Saturday 17 April, she completed the first part of the novel and began the second part the very next day. Writing at speed, she raced her way through, concerned about how to bring together her characters at the end, believing it to be 'more subtle and more human' than *Jacob's Room*. She was 'making some use of symbolism' and went in 'dread of sentimentality', before writing the last page on 16 September.

The finished work was a wonderful evocation of family life at St Ives, with Virginia's parents, friends and guests portrayed on holiday on the Isle of Skye, dominated by the view of the lighthouse. Vanessa recognised the depiction at once, writing to Virginia from her holiday home at Cassis:

You have given a portrait of mother which is more like her to me than anything I could have raised from the dead. You have made one feel the extraordinary beauty of her character ... it was like meeting her again with oneself grown up and on equal terms and it seems to me the most astonishing feat of creation to have been able to see her in such a way. You have given father too I think as clearly ... you seem to me to be a supreme artist and it is so shattering to find oneself face to face with those two again that I can hardly consider anything else ... I am excited and thrilled and taken into another world as one only is by a great work of art.[32]

The portraits of Leslie and Julia Stephen dominate the work. Mr Ramsay, with his hard-beaked, crystalline search for the truth at any cost, his recognition of his own limitations and self-dramatising need for validation, is the opposite of his long-suffering, deep-feeling wife, who is driven to heal and bring people together. 'She has haunted me,' Virginia wrote of her mother in 1927, 'but then so did that old wretch my father ... I was more like him than her I think, and therefore more critical, but he was an adorable man, and somehow, tremendous.'[33] Ramsay's character has a touching balance of lofty pronouncements as he crashes about the garden, pondering, posturing, performing, balanced with a childishness, an insecurity that needs constant soothing by his wife. On a simple level, he embodies the life of the mind, while she is sympathy, understanding and pure love: 'He found talking much easier than she did' but 'she found herself very beautiful.' At their worst, he is a bully and she, a martyr, just as the Stephen parents could be.

The Ramsay children, Prue, Andrew, Jasper, Rose, Nancy, Roger, Camilla and James, are derived from the Duckworth-Stephen siblings, with Virginia as the young Cam, mischievous and energetic, her hair and manners wild. Mrs Ramsay's friend Lily Briscoe struggles as a single woman and an artist to be taken

seriously, to counter the claim that 'women can't write, women can't paint,' and finally reaches her artistic potential by revisiting the house and recapturing the ghost of her mentor by embracing a more abstract form of art. As a novel whose main protagonist is an artist, the book was of particular interest to Vanessa, who was uncertain about the validity of words as symbols: 'Your theories of art are very interesting ... the mere words gold or yellow or grey mean nothing to me unless I can see the exact quality of colour but I suppose if you do it well you convey that.'[34] It was a method Virginia had already explored in the short story 'Blue and Green'. Again, this underpinned a wider concern with communication, from James's inarticulate rage against his father's inflexibility at the start of the novel, through to Lily's recognition that 'one could say nothing to nobody. The urgency of the moment always missed its mark. Words fluttered sideways and struck the object inches too low.' Understanding is reached through reflection and the passage of time, through observation and moments of illumination, from basic human interaction, rather than discussion or overt personal connections.

Structured around two visits to the house, ten years apart, the novel echoes Virginia's own return to St Ives a decade after her mother's death, almost as if time had stood still while it had also irrevocably advanced. These are bridged by a central section, 'Time Passes', in which the vital events of war, life and death take place in parenthesis, mere moments in history beside the still lifes of interiors, where insects and dust gather untouched by man. These scenes parallel the domestic subject matter painted by Vanessa and Duncan during the war years: the focus on the personal and intimate paradoxically establishes a universal concept of time through the use of familiar objects which transcends the boundaries of individual mortality: 'The very stone one kicks with one's boot will outlast Shakespeare.' In 'Time Passes', the spotlight falls on a

jug and basin, a bowl of red and yellow dahlias, a flap of hanging wallpaper, the folds of a shawl gradually loosening. The focus is on life as a collective experience, more powerful and poignant than death, which cannot dim the memories of Mrs Ramsay in the mind of her protégé Lily, or in the greater consciousness. Virginia's answer to the questions of life and death is that people remain. 'Even the prying of the wind, and the soft nose of the clammy sea airs, rubbing, snuffling, iterating, and reiterating their questions – "Will you fade? Will you perish?" – scarcely disturbed the peace, the indifference, the air of pure integrity, as if the question they asked scarcely needed that they should answer: we remain.' When Lily considered what the meaning of life was, she realised, 'The great revelation perhaps never did come. Instead there were little daily miracles, illuminations, matches struck unexpectedly in the dark.'

Virginia and Leonard had spent a month abroad, visiting Paris, Naples and Rome then staying with Duncan and the Bells at Cassis, before returning to face the reviewers. The book had 'its own motion', claimed the *Times Literary Supplement* on 5 May 1927, a 'soft stir and light of perceptions, meeting or crossing, of the gestures and attitudes, the feelings and thoughts of people, of instants in which these are radiant or absurd, have the burden of sadness or of the inexplicable. It is a reflective book, with an ironical or wistful questioning of life and reality.'[35] In the *New York Times*, Louis Kronenberger felt the final section of the book struck a minor note; 'with Mrs Ramsay's death, things fall apart, get beyond correlation' and 'life seems drifting', but praised the central part of 'Time Passes', where 'the great beauty of these eighteen pages of prose carries in it an emotional and ironical undertone that is superior to anything else that the first-class technician, the expert stylist, the deft student of human life in Mrs Woolf ever has done'.[36] Poet Rachel Taylor observed in a lyrical review published

in the *Spectator* that 'nothing happens and everything happens ... there are secret flames in flowers ... subtle sensations are caught here that are elusive as a fragrance or a flavour'.[37] Unsurprisingly, Virginia's old adversary Arnold Bennett felt that the novel did not work and that the style of sentences was 'tryingly monotonous', although he grudgingly admitted that the novel 'has stuff in it strong enough to withstand quite a lot of adverse criticism'.[38] The American novelist and poet Conrad Aitken, writing in *Dial*, saw Virginia as being as 'modern, as radical' as Joyce; 'a highly self-conscious examiner of consciousness, a bold and original experimenter with the technique of novel writing', although she also 'breathed the same air of gentility, of sequestration, of tradition, of life and people' as Jane Austen, while Jean-Jacques Mayoux in the Parisian *Revue Anglo-Americaine* compared her 'internal rhythm' to that of Proust.[39] Lytton found it 'a marvellous and exquisite arabesque' and supposed there was 'some symbolism about the lighthouse' but, as he had commented about *The Voyage Out*, he was disappointed that there was a 'lack of copulation'.

Three weeks after it came out, *To the Lighthouse* had sold 2,200 copies and was being reprinted. 'I think,' wrote Virginia in her diary on 6 June, 'I am now almost an established figure, as a writer. They don't laugh at me any longer. Soon they will take me for granted. Possibly I shall be a celebrated writer. Anyhow, The Lighthouse [*sic*] is much more nearly a success, in the usual sense of the word, than any other book of mine.'[40] Virginia's artistic confidence was also grounded in a new, personal happiness. She had fallen in love.

Vita, 1927–1930

A poetic masterpiece of the first rank.[1]

In 1927, in a frenzy of passion, Virginia began to write 'the longest and most charming love letter in literature' to her new friend Vita Sackville-West. In it, according to Vita's younger son Nigel Nicolson, she 'explores Vita', as the character Orlando, 'weaves her in and out of the centuries, tosses her from one sex to the other, plays with her, dresses her in furs, lace and emeralds, teases her, flirts with her, drops a veil of mist around her':

> Orlando stood now in the midst of the yellow body of an heraldic leopard ... the shapely legs, the handsome body, and the well-set shoulders were all of them decorated with various tints of heraldic light ... Orlando's face, as he threw the window open was lit solely by the sun itself. A more candid sullen face it would be impossible to find. Happy the mother who bears, happier still the biographer who records the life of such a one ... from deed to deed, from glory to glory, from office to office he must go ... the red of the cheeks was covered in peach down; the down on the lips was only

a little thicker than the down on the cheeks. The lips themselves were short and slightly drawn back over teeth of an exquisite and almond whiteness. Nothing disturbed the arrowy nose in its short, tense flight; the hair was dark, the ears small and fitted closely to the head ... he had eyes like drenched violets, so large that the water seemed to have brimmed in them and widened them; and a brow like the swelling of a marble dome pressed between the two blank medallions which were his temples. Directly we glance at eyes and forehead, thus do we rhapsodise.[2]

Vita and Virginia had first met in December 1922, at a party hosted by Clive. Ten years older than the heavy-lidded aristocrat, Virginia's reputation preceded her, as Clive had already given Vita a copy of *Jacob's Room* to read, which she had found interesting but bewildering. Vita was then thirty. Born and raised at the fairytale palace of Knole in Kent, once home to archbishops and famously boasting 365 rooms, she had been married at twenty-one to the diplomat Harold Nicolson and borne two sons. This had not prevented her from conducting affairs with women, notably Rosamund Grosvenor and Violet Trefusis, the latter of whom she had eloped with to Paris, where she roamed the streets dressed as 'Julian'. She was also a prolific writer and, on her meeting with Virginia, had recently published her fifth collection of poetry, *Orchard and Vineyard*, and her third novel, *The Heir*. A few weeks after the party, Virginia was invited to visit Vita at her London home in Ebury Street. The same night Vita wrote a description of her guest to Harold:

> She is utterly unaffected: there are no outward adornments – she dresses quite atrociously. At first you think she is plain; then a sort of spiritual beauty imposes itself upon you, and you find a fascination in watching her. She was smarter last night; that is to say

the woollen orange stockings were replaced by yellow silk ones, but she still wore the pumps. She is both detached and human, silent till she wants to say something and then says it supremely well. She is quite old (forty). I've rarely taken such a fancy to anyone and I think she likes me ... Darling, I have quite lost my heart.[3]

On 10 January 1923, Vita dined with Virginia at Hogarth House. It was only their third meeting but she told Harold, 'Oh dear, how much I love that woman.' Virginia's affection was slower to develop and the relationship stalled as their social lives took them in different directions. They saw each other on a handful of occasions that year and the next, although Vita's first stay at Monk's House in September 1924 was a qualified success, with Virginia feeling that her guest eclipsed her surroundings. From that point through to the summer of 1925, the friendship gradually grew closer. Suddenly Vita began to appear in Virginia's diary and letters, with a vitality and poetry that foreshadowed the character Virginia would weave around her, with the 'body and brain of a Greek God ... divinely lovely, a little touseled, [sic] in a velvet jacket,' a 'high aristocrat' whose 'real claim to consideration is ... her legs. Oh they are exquisite, running like slender pillars up into her trunk, which is that of a breastless cuirassier, but all about her is virginal, savage, patrician ... if I were she I would simply stride, with eleven elk hounds behind me, through my ancestral woods.'[4] She was 'like a willow tree, so dashing on her long white legs with a crimson bow ... I like the complete arrogance and unreality of [her] mind, for instance buying silk dressing gowns casually for £5 and then lunching off cream curd ... the whole thing is very splendid and voluptuous and absurd. Also she has a heart of gold.'[5] To Vita, in mid-1925, she wrote that she had a 'perfectly romantic and no doubt untrue vision of you ... stamping out the hops in a great vat in Kent, stark naked, brown as a satyr, and

very beautiful. Don't tell me this is all illusion', and, 'I'm going to live the life of a badger, nocturnal, secretive, no dinings out, or gallivantings, but alone in my burrow at the back. And you will come and see me there – please say you will.'[6]

In November 1925, Harold had departed for a diplomatic position in Teheran, leaving Vita alone. Virginia sensed that a critical point had been reached in their flirtation, writing, 'If I do not see her now, I shall not, ever; for the moment of intimacy will be gone.'[7] The long-awaited invitation came, and Virginia stayed at Long Barn for three nights from Wednesday 17 December until the Saturday, when Leonard came to collect her. Virginia never spoke about what happened during her stay, but according to Vita, the relationship did become physical, although she was afraid of unbalancing Virginia's mental health and tactfully stated that their connection was based more in affection and companionship. 'I just miss you in a quite simple desperate human way,' Vita wrote after she had left, and Virginia replied, 'I have been dull: I have missed you, I do miss you, I shall miss you ... I'm not cold, not a humbug, not weakly, not sentimental. What I am, I want you to tell me. Write, dearest Vita, the letters you make up in the train. I will answer everything.'[8] A year later, with Vita already conducting other affairs, Virginia wrote, 'But don't you see, donkey West, that you'll be tired of me one of these days' and 'There's nothing I wouldn't do for you, dearest Honey ... why do I think of you so incessantly?'[9] Vita's letter of praise on the publication of *To the Lighthouse* touched Virginia, especially taking 'some sentimental delight' that she had liked Mrs Ramsay.

The question of Virginia's sexuality is raised by her relations with Vita. Describing their physical encounters to Harold as 'making love', is it clear that Vita and Virginia shared a bed on at least a couple of occasions and were physically intimate. Coupled with her extreme reactions to Leonard's attempts to make love

to her on their honeymoon, it has been suggested that Virginia's sexual orientation was predominantly lesbian. When she confided in Vanessa about her nights of 'passion' with Vita, her sister calmly asked 'but do you really like going to bed with women?'[10] Since the 1905 Thursday evenings in Gordon Square, the homosexual affairs of Lytton, Keynes and others had been a frequent topic of discussion, but sexual practices between women featured far less openly. In August 1928, the homosexual E. M. Forster stayed at Monk's House and, prompted by the recent publication of Radclyffe Hall's lesbian novel *The Well of Loneliness*, admitted that he found 'Sapphism disgusting; partly from convention, partly because he disliked that women should be independent of men' and believed that Dr Head could convert them. When Leonard asked him if he wished to be converted, Forster replied with a definite negative. Reviewing Hall's book in the *Nation*, Leonard stated it was no great work of art, but it was not pornographic and wrote to T. S. Eliot that it would be 'monstrous to suppress it'. Even Forster agreed that censorship was unwarranted, but that November, the novel was prosecuted on the grounds of indecency and the judge ruled that all copies should be destroyed. It is interesting, though, that Virginia did not confide in Leonard about her passion for Vita, who sent her intimate letters concealed in more innocent ones, designed to be shown to Leonard. Perhaps she was concerned not to hurt his feelings and, if he suspected, he was more concerned that the liaison did not unbalance her health.

Labelling Virginia as a lesbian is too simplistic. She never had another affair with a woman, unlike Vita and Carrington, and her attraction to Leonard, despite their intimate problems, is undeniable. She attracted devotion from the composer and predominantly lesbian Ethel Smyth, and despite feeling that it was rather like 'being caught by a giant crab', the pair maintained a platonic relationship. Virginia's sexuality was a

complex construct of childhood experiences, social convention and natural impulses. She liked female company, writing that 'I like their unconventionality. I like their completeness. I like their anonymity,' and that female friendships were 'so secret and private compared with relations with men.' Her admission that 'women alone stir my imagination' and her aim at an androgynous state of mind might bring us closer to the truth in interpreting her sexuality as a fluid, all-embracing approach to both genders, complicated by early abuses and her dislike of patriarchy. It seems unhelpful to attempt to define and categorise her feelings, instead of simply accepting that she fell in love with the qualities she admired in a person, rather than with their gender. Virginia was passionate about a select few friends, as Vita wrote in 1941: she 'wasn't all cool intellect by any means. She had the warmest and deepest and most human of affection for those she loved. They were few perhaps, and she applied alarmingly high standards, but her love and humanity were real, once they were given.'[11] It was that very outpouring of love for Vita that would lead Virginia to compose her most charming and whimsical work.

In October 1927, the seeds of *Orlando* were first planted in Virginia's mind: 'A biography beginning in the year 1500 and continuing to the present day, called *Orlando*: Vita only with a change about from one sex to another.' She wrote to her lover that just the act of writing the title 'flooded' her body 'with rapture and [her] brain with ideas … suppose Orlando turns out to be Vita …'[12] Six weeks later she was writing the 'main backbone of my autumn', rushing 'pell mell from ten to one … so quick I can't get it typed before lunch … Today I began the third chapter.' Begun 'as a joke', but now 'too long for a joke and too frivolous for a serious book',[13] the novel was finished on 22 March 1928. It was a fantasia of a piece, a celebration, a rush of love, wish-fulfilment and a most delightful play with history, a gleeful rejection of the boundaries of

time and gender. It was Proustian in its conviction that the way to recover lost time was through its immortalisation in a work of art: both in capturing the historic past and the women's more recent relationship. As Virginia made clear in the novel's preface, it was inspired by Defoe and Sterne, and although she also cited Emily Brontë, Walter Scott, Sir Thomas Browne, De Quincey, Pater and Macaulay, in its treatment and picaresque roguishness *Orlando* was pure eighteenth century, a nod to Shandyism with the exploits of Moll Flanders.

Born as a man, a lover of Queen Elizabeth, Orlando travels through time, falling in love with a Russian princess based on Violet Trefusis, through the great Frost Fair of 1608, to converse with Jacobean poets and dramatists, to become Charles II's ambassador to Constantinople, where he falls asleep and awakes as a woman. Escaping with the help of gypsies, she rejects an archduke, accepts a sea captain, wins the property battle that Vita herself lost when unable to inherit her childhood home of Knole, publishes a book and wins a prize, as Vita herself did in 1928, being awarded the Hawthornden Prize in 1927 for her narrative poem *The Land*. Leonard took *Orlando* 'more seriously than [she] had expected' and found it more interesting than *To the Lighthouse*, very original, 'with more attachment to life and larger'.[14] In late September 1928, Virginia and Vita spent a week together in France. Eleven days after their return, *Orlando* was published.

The critics' responses were mixed. Desmond MacCarthy hailed it as 'beautiful and original' in the *Sunday Times*, 'a wonderful phantasmagoria ... garnered from past epochs' where 'the chariot of romance is driven full tilt from beginning to end'. The *New York Times* described Virginia's approach as 'an application to writing of the Einstein theory of relativity' that faced squarely 'one of the most puzzling technical and aesthetic problems that

confront contemporary novelists'.[15] Conrad Aitken picked out
the spoof element, the *jeu d'esprit* of the work, but the magic
of the book escaped Arnold Bennett, who was confused by the
inclusion of photographs of Vita as Orlando and 'failed to perceive
any genuine originality' in Virginia's writing.[16] Helen MacAfee,
publishing in the *Yale Review*, found it a book 'rich in humanity,
a spirited prose epic of intellectual adventure', in which readers
might find 'a whole philosophy of creative literature, a subtle
speculation upon personality and recorded time'.[17] The novelist
Storm Jameson found *Orlando*'s style to be 'just, flexible and
lovely'. For her, the book 'resembled a tapestry of which every
detail is carefully contrived ... the folds of a gown and the feathers
in a young man's cap. It deals with space and time ... what we see
is a process, the very chemistry of thought and action' although
ultimately, she felt it was detached and lacked humanity.[18]

In the New York *Bookman*, Raymond Mortimer reviewed
Orlando alongside Lytton's latest work *Elizabeth and Essex*, as
two innovatory books in their respective fields. Both writers, he
argued, 'are firebrands: she has revolutionised fiction and he,
biography ... The old biographers left out too much, the novelists
put in too much. Mrs Woolf and Mr Strachey have each set a new
norm.' In attempting to find the common ground between their
work, Mortimer admitted that 'in style they are a world apart
but in mind the authors have this mysterious quality in common
which we do not find in Wells or Bennett or Lawrence. It has
some relation to a voice that is never too loud, a scepticism that
remains polite, a learning that is never paraded and a disregard,
that never becomes insulting, for the public taste. It is a quality
of inherited culture. Genius and taste can only come to terms by
something approaching a miracle. In these two writers this miracle
is accomplished.'[19]

In late 1925, Lytton had originally intended to write about a

number of love affairs in one book – those of Elizabeth and Essex, Voltaire and Madame du Châtelet, Byron and Augusta Leigh, Robert and Elizabeth Barrett Browning, Verlaine and Rimbaud – but the first couple absorbed him to such a degree that he dedicated the entire book to them. For the first year of writing, though, he was unsure about the project's future and found it a struggle. Fortunately, domestic matters no longer distracted him, as the Ham Spray ménage had finally been resolved, with Ralph spending the week in London with Frances Marshall and the weekends in the country with Lytton and Carrington. In September 1927 Lytton was deeply upset by the premature death of one of his young friends, Philip Ritchie, and found consolation in visits from Oxford graduate and translator Roger Senhouse, who became his lover. The same month, he visited Charleston and found Vanessa 'very superb', Clive nice, 'as he invariably is when not feeling the need to show off', and their elder son Julian about to go up to King's College, Cambridge.

The late 1920s produced something of a flurry of Bloomsbury books, after the appearance of *Orlando* and *Elizabeth and Essex* in 1928. Clive wrote *Landmarks in Nineteenth Century Painting*, a study of Impressionism, in 1927, followed by a study of Proust and *Civilisation* in 1928. The latter work, arguing in favour of a leisured class in order to maintain civilisation, did little to help Bloomsbury from critics who saw it as elitist. Leonard published *Essays on History, Literature and Politics* and *Imperialism and Civilisation*, which questioned the intellectual foundation of the British Empire and advocated the pacific role of the League of Nations, founded in 1920. Roger published books on Cezanne and Matisse, on whom he lectured at the Royal Academy. In 1929, Virginia also brought out the series of essays based on lectures she had given at Cambridge, with the now iconic title *A Room of One's Own*. It explored questions of women's education, the history of

women writers and their status as outsiders, as well as the gulf between their experiences and their idealisation in patriarchal literature, such as Coventry Patmore's *Angel in the House*, a familiar domestic martyr Virginia advocated killing off. This was a direct rejection of the values embodied by her anti-suffrage, pro-marriage mother, a different facet of Virginia's exploration of the past that had resulted in the portrait of Mrs Ramsay. *A Room of One's Own* engaged with the debate raised in Clive's *Civilisation* by asserting that in order to write, a woman must have 'a room of her own and five hundred a year', just enough to live on and maintain two servants without needing to work, but Arnold Bennett was among the first critics to point out that 'long and formidable novels' had been written in rooms without locks on the door, at an income of less than fifty pounds.[20] While Bennett denied that it was a feminist tract, Vita's review qualified that Virginia was 'too sensible to be a thorough-going feminist' as she rejected the opposing notion of 'masculinism' and advocated a sort of androgyny in writing that united the best qualities of the male and female brain.[21] When Vanessa spent Christmas with Clive's very traditional family at Seend, pouring out the tea, 'eating thin bread and butter' and 'listening to accounts of Women's Institutes', she left *A Room of One's Own* lying about 'and they just remember my relationship in time to prevent indiscreet remarks'.[22]

Virginia and Vanessa's relationship was still close, but a degree of distance had pervaded it by the late 1920s, partly as a result of their different lives and Vanessa's absorption in art and motherhood. When staying at Charleston and Monk's House, they often walked the four miles across the Downs to visit, and occasions like birthdays were spent together. Increasingly, Vanessa was spending more time at her house La Bergère, in Cassis, and her emotional centre was Duncan and her family, while Virginia's was Leonard. In 1928, Vanessa wrote to Leonard from France,

complaining of how little she heard from her sister and 'was beginning to feel rather badly treated', although Leonard's recent letter had reminded her of the 'character and charm' of 'Old Bloomsbury' and she urged him to consider buying a house near Cassis. A few days later she was writing to Virginia asking her to 'egg your husband on to write to me', and describing their visit to Marseilles.[23] The following year, Vanessa and her son Quentin, Duncan, Virginia and Leonard visited Berlin, but the holiday proved awkward. Harold Nicolson was working in the English embassy, accompanied by Vita and their sons, and there were tensions between him and Leonard, as well as Vanessa finding the Woolfs difficult to 'rub along with'; eating in the hotel instead of dining out and walking miles to avoid taking a cab so that practical questions, as well as ideological differences over a film they all went to see, were the cause of quarrels. Vanessa felt that the Nicolsons were 'an unnecessary importation' into the group and was relieved when the time came for her, Duncan and Quentin to move on to Vienna, where they met Roger. That spring, they returned to Cassis, which suited them much better, and Virginia's impression of Vanessa there was one of 'overpowering supremacy'.

In November 1929, Vanessa and Duncan decorated the dining room of Lady Dorothy Wellesley, a lover of Vita's, using large Italianate landscapes, curved glass lights, octagonal mirrors, silk curtains decorated with sequins and their own furniture and carpets, predominantly in grey and picked out with pale shades of blue, green and purple, which was much praised in *Studio* magazine. Just weeks later, Vanessa held a solo show at the Cooling Galleries, with Duncan designing the exhibition poster and Virginia writing an essay for the catalogue. 'I really seem to have become something of a best seller,'[24] she wrote to Duncan on 7 February, having sold twelve pictures after a review appeared of the exhibition in *The Times*. 'This coming to herself of Mrs Bell is something to make

a song about,' wrote Charles Marriott, 'she has always been a delightful colourist, with a fluent style, but her pictures hitherto have been just a little priggish.'[25] The show made Vanessa a very respectable £200, with Keynes buying some large nudes, and drew praise from John Piper in the *Nation and Athenaeum*.

That summer, though, Vanessa and Maynard fell out over a landscape exhibition he was helping run for the London Artists' Association, when deciding which works should be included. The tensions in their friendship that had arisen over the arrival of Lydia had never fully been resolved. Now, Vanessa argued in favour of a thematic selection while Keynes wanted to be more inclusive towards all the artists, hoping that 'considerations of equity or equal treatment ought not to be too much sacrificed to the best possible appearance of the room' and that there should be 'no sort of discrimination or difference of treatment between the somewhat homogenous group of older original members ... and the ... much less homogenous group of younger members'.[26] Roger and Vanessa both threatened to resign, with the latter grumbling that 'Maynard interferes with things he knows nothing about' and 'Roger takes command where he ought not to ... I suppose we shall always have rows.' Maynard was called away to Cambridge just before the show, but a further problem arose over the payment of Duncan's salary. When Lydia shook her fist across the street at Duncan and Vanessa, relations between Charleston and Tilton hit an all-time low.

A further cause of unhappiness had arisen for Vanessa too, when Duncan fell deeply in love with the Russian-Jewish artist George Bergen. Vanessa deeply disliked him. Writing to his former love Bunny, Duncan described the time as a 'turmoil of love, anxiety, terror and sadness and happiness ... doubts about love – others' love to oneself are terrible ... and why does Nessa not believe I love her as much as I ever did? ... My love for George gives me more power to love her instead of less ... the truth is, I want them

both. I want too much I suppose ... I cannot help thinking that if Vanessa could see into my soul at such moments she would see that everything is alright.'[27] As usual, the monolithic Vanessa kept her pain to herself and, from the outside, life at Charleston still appeared as harmonious as ever. Virginia believed that 'nothing can be now destructive of that easy relationship'; Angelica described her mother as 'the magnetic centre of all our thoughts and activities' and Roger grudgingly admired her 'ideal family', her 'triumph of reasonableness over the conventions'. As an extension of her role as the family matriarch, the centre of home life, Vanessa began work on a large ambitious picture entitled *The Nursery*, an evocation of childhood, featuring a mother, nurse and two children standing among toys. Just as Virginia had in *To the Lighthouse*, Vanessa was reconstructing an earlier time, when her children were younger and life was more simple. 'It seems to me,' she wrote to Virginia, that if she could make it work, 'it would have some sort of analogous meaning to what you've done ... painting a floor covered with toys and keeping them all in relation to each other and the figures and the space of the floor and the light on it means something of the same sort that you seem to me to mean.'[28]

Roger considered *The Nursery* to be the best thing Vanessa had ever done, writing that it was 'all extraordinarily gay and bright and something like a Fra Angelico', while Vanessa herself called it 'an absurd great picture ... gigantic ... a monster'.[29] A black-and-white photograph of the picture remains, but the original was either misplaced or destroyed, perhaps by fire in 1940. Duncan's affair with George Bergen dragged on all through the painting of the work, which Vanessa did not complete until 1932. She was relieved when George finally returned to New York the following September, after keeping Duncan on tenterhooks for months. Duncan drove down to Southampton to wave him off, and found he was not the only one of George's lovers on the quayside.

Straws to Cling to, 1931–1937

Come pain, feed on me. Bury your fangs in my flesh. Tear me asunder.[1]

'There was the moment of the puddle in the path,' wrote Virginia in 1939, returning in her memory to the Kensington Gardens of her youth, where boats floated and sank under the surface of ponds, where they skated in icy weather and sat on the grass to eat Fry's chocolate and read *Tit-Bits*. 'There was the moment of the puddle in the path; when for no reason I could discover, everything became unreal,' one of two 'moments of being' she always remembered.[2] It had also appeared thirteen years earlier in her diary, when she was musing on the nature of life, which was 'soberly and accurately, the oddest affair; has in it the essence of reality. I used to feel this as a child – couldn't step across a puddle once I remember, for thinking, how strange – what am I? etc.'[3] She suspected this memory might be 'the impulse behind another book' and soon the image did enter her newest novel, with the character Rhoda being unable to cross the puddle: 'In the middle lay the puddle, cadaverous, awful, lay the grey puddle in the courtyard, when, holding an envelope in my hand, I carried a message. I

came to the puddle. I could not cross it. Identity failed me.'⁴ The puddle had become her metaphor for the realisation of the present moment, existential crisis and the inability to deliver the message, to communicate.

Virginia had been inspired to write by a letter from Vanessa in Cassis, which described a number of large moths circling her lamp at night. In the same way, Virginia constructed a narrative of a number of individuals circling central questions, figures around a will o' the wisp of inspiration; bright stars she could not reach.⁵ She was writing *The Waves* under the working title *The Moths* by 1929; there was 'something there' but she found it hard going and could not grasp it firmly. By early November she had written sixty-six pages and had concluded the first part by the end of the month. The following March, she was still finding it 'a difficult book', going in 'fits and starts' as she attempted to give the 'essentials' of a person's character in a 'very few strokes'.⁶ She recognised that she was pushing her form further than she had in previous books, writing to a rhythm not a plot, punctuated by the swell of the tides that surfaced between each chapter. It was a play-poem, a colloquy of six voices, connected by simile and simultaneity, following them from childhood through to maturity, in an attempt to construct existence through individual consciousnesses that overlapped. Bernard, Louis, Neville, Jinny, Susan and Rhoda speak directly to the reader in a stream-of-consciousness technique that creates a constant refrain of 'I ...' and 'I am', as they come to terms with their identities and, although the seascapes stretch from early morning until night, what after all is 'one little night?', as Virginia asked in *To the Lighthouse*, making the single day a metaphor for the overlapping passage of lifetimes.

It has been suggested that the six main characters of *The Waves*, along with their friend Percival, who never appears in person, are depictions of Virginia's friends. There may be some elements of

Desmond MacCarthy and E. M. Forster in Bernard, with his vivid imagination and desire to write, and something of Lytton and Keynes in Neville's rhapsodic devotion to young men. It might be that Louis' Australian identity and need to conform in order to feel accepted and succeed owes something to T. S. Eliot's Americanism, and shares his intelligence and aloofness. Jinny's focus on the material body, on socialising and being loved, could suggest some aspects of Mary Hutchinson, and the monolithic, deep-feeling Susan's retreat to the countryside and absorption in maternity may draw on elements of Vanessa that her sister observed. The distant Percival, absent in the same way as Jacob, adored and missed by his friends after his premature death, evokes Thoby Stephen, as Virginia confessed to Vanessa, hoping she did not find the portrayal too sentimental. Likewise, Rhoda's existential depression and self-effacement echo known incidents in the life of the author.

And yet, they are more than that. 'I did mean,' Virginia explained, 'that in some vague way we are the same person and not separate people. The six characters were supposed to be one.'[7] In their own way, each is a facet of the author, with Bernard's symbol of a fin in the water appearing in Virginia's diary, Jinny revelling in the same delight of food and physicality as the author as a young child, Louis' nationality and Neville's sexuality serving as barriers between society and self and Susan as the projection of a path Virginia chose not to take. At the end of the novel, Bernard sums up life as being 'the happy concatenation of one event following the other', but the symbolism in *The Waves* transcends the literal world to capture the continuity of shared consciousness through an impressionistic and experimental modernism. As Earl Daniels would comment in the *Saturday Review of Literature*, 'Whereas the Psalmist turned outward to God and queried, "What is man that Thou art mindful of him?" Mrs Woolf's characters turn to that inward self and question, "What then is this I, and for

what does it count?" ... *The Waves* is a novel of first importance; one of the few which have come in our own day with so much as a small chance to survive the vigorous test of time.'[8] Completing the novel was an exhilarating but anxious process, as it tapped so deeply into Virginia's states of mind, past and present: 'Having reeled across the last ten pages with some moments of such intensity and intoxication that I seemed to stumble after my own voice, or almost after some sort of speaker (as when I was mad) I was almost afraid, remembering the voices that used to fly ahead.'[9] Leonard described it as an 'emotional and imaginative volcanic eruption', but felt that the book was a masterpiece.[10] Virginia was so relieved she was 'like a girl with an engagement ring'.

The Waves was published by the Hogarth Press on 8 October 1931. Vanessa wrote that she was deeply moved by it; 'it's quite as real an experience as having a baby ... the feelings you describe on what I must take to be Thoby's (Percival's) death ... it's only because of your art that I'm so moved. I think you make one's human feelings into something less personal – if you wouldn't think me foolish I should say that you have found the "lullaby capable of singing him to rest."'[11] Virginia felt an 'amazing relief' on getting her sister's letter: 'I always feel I'm writing more for you than anybody ... And Lord – what I owe to you!'[12] She was also pleased to receive warm praise from Ethel Smyth, Vita, Roger's Cambridge friend Goldie Dickinson, E. M. Forster, the new Hogarth Press assistant John Lehmann and even George Duckworth, who found *The Waves* 'plain sailing and common sense'.[13] The reviews were largely positive, seeing the book as 'a piece of subtle, penetrating magic', a 'glittering rain of impressions and reactions', a 'series of rhapsodies' and with L. P. Hartley describing a 'pointillist picture alive with golden notes' in which 'never were so many moments of vision, so many flashes of arrowy insight, gathered together between the covers of a novel'.[14] Harold Nicolson stated in *Action*

that there was a 'note in this book which has never yet been heard in European literature'.[15] The negative tones were sounded by Frank Swinnerton in the *Evening Review*, who felt it to be too amorphous with characters as receptive sensationalists, and the *San Francisco Chronicle*, which warned readers that 'most people are going to find (the novel) extremely difficult reading'.[16]

Virginia was still a little bemused about how she should react to criticism. It was partly an extension of the questioning of her youth, when she wondered what to feel in certain social expectations, but the reflections on critical comments in her diary were largely positive:

What ought I to feel and say when Miss B devotes an article in Scrutiny to attacking me? She is young, Cambridge, ardent. And she says I'm a very bad writer. Now I think the thing to do is to note the pith of what is said ... then to use the little kick of energy which opposition supplies to be more vigorously oneself ... With my odd mixture of rashness and modesty ... I very soon recover from praise and blame ... the most important thing is not to think very much about oneself ... on no account to retaliate by going to the other extreme.[17]

Virginia did engage with the comments of one critic, who happened to also be a friend. The novelist Hugh Walpole, very much of the Henry James and Arnold Bennett school of writing, felt that *The Waves* was 'unreal', a word Virginia had recently applied to Walpole's novel *Judith Paris*, which also came out in 1931. 'I'm very much interested about unreality and the Waves – we must discuss it,' she wrote to him in November, also admitting she was tired of 'being caged with Aldous, Joyce and Lawrence. Can't we exchange cages for a lark? How horrified all the professors would be.'[18] To her surprise though, the book sold better than any of her

others and, setting aside the views of friends, 'opinions good and bad, seem to me increasingly futile and beside the mark'.[19] It was a state of confidence that would not last.

On 10 December, Virginia wrote to Lytton, the 'bearded serpent' from Tavistock Square. She had dreamed about him, sitting across the aisle from her at a play and, turning, they 'both went into fits of laughter' and it had seemed to her 'more vivid than real life'. She had heard that he was off to Malaya soon and asked him to 'come and see your old and attached friend'[20] when he was back in London. However, as it transpired, she would never see Lytton again.

Lytton had been busy that autumn, returning from a trip to France and Germany, visiting old friends and making new ones, yet when he dined with Clive in Gordon Square he felt off colour and left early. By December he was confined to bed 'in an enfeebled semi-miserable condition' and soon was unable to eat or read. Four days after writing, Virginia had been informed of his condition and told Carrington she was 'so unhappy' to hear of his illness, asking to be kept informed and echoing the offer she also made to Pernel Strachey; 'We are at your service, any moment, day or night.'[21] The doctors had initially diagnosed an ulcerated colon, but soon it became clear that Lytton was dying. Vanessa and Clive, Virginia and Leonard drove over to Ham Spray, but Lytton was too unwell to see them. His strength failed just before Christmas but then he rallied enough to allow Virginia to imagine 'a future with my old serpent to talk to ... I sobbed on Christmas Eve ... we have lived through every grade of feeling – how strong, how deep, more than I guessed, though the cavern of horror is well known to me.'[22] In mid-January, she added that he went on 'now better, now not so well' so she could hope it was 'not the end'[23] and, five days later, the letter she wrote to Carrington about Ham Spray being 'the loveliest place in England'[24] was the last Lytton

was able to read for himself. 'I should mind it to the end of my days if he died,' Virginia told Vita, 'it is like having the globe of the future perpetually smashed.'[25] Lytton died of stomach cancer on 21 January 1932.

Lytton was cremated at Golders Green, in the presence of James Strachey and Saxon Sydney-Turner. It all happened so quickly, without the opportunity for many of his friends to say goodbye. 'No service, no farewell,' complained Maynard, 'no mark to say "this is over".' Virginia agreed: 'I don't know where his ashes are buried ... there is no commemoration ... except when we meet and talk, or in the usual ways, alone at night, walking along the streets.'[26] There were also serious concerns about Carrington, once the 'wild moorland pony with the piercing blue eyes and bell of gold hair, in whom the lights seemed to have gone out'. Although the Ralph and Frances situation had been resolved, Carrington's personal life had remained complicated. She had affairs with Henrietta Bingham and Stephen Tomlin in the 1920s, the latter of which ended when Stephen married Julia Strachey, and her latest amour, Bernard 'Beakus' Penrose, had wanted her to make a full commitment to him, although she declined and underwent a termination when she found she was pregnant. Her life was centred on Lytton and, two days before his death, she had attempted suicide, only to be rescued by Ralph. She quoted David Hume in her diary, 'Why should I prolong a miserable existence ... I believe that no man ever threw away life when it was worth keeping.' Virginia wrote to her on several occasions, praising and thanking her for the happiness she had brought Lytton – 'I could never give him what you did ... before he knew you, he was so depressed and restless – and all that changed when you had Tidmarsh' – and urging her to live: 'It is more for you to live than for anyone, because he loved you so ... something of the best part of his life still goes on ... I know all day long, whatever I'm doing,

what you're suffering.'[27] Virginia and Leonard drove over to Ham
Spray for lunch on 10 March. 'I held her hands,' Virginia wrote
in her diary, 'her wrists seemed very small. She seemed helpless,
deserted, like some small animal left.' They stood side by side
in Lytton's study and looked out of the window and Carrington
agreed to come and visit them next week. As they drove away,
Virginia felt that it was 'terrible leaving her alone ... without
anybody in the house'.[28] That night, Carrington telephoned Ralph
to say that she felt more cheerful. Early the following morning,
under the guise of a tragic accident, she donned Lytton's purple
dressing gown and shot herself. She was thirty-eight.

Despite the appalling shock and sense of loss, the days continued
to pass and spring arrived. Virginia went to visit Vita at her
new home of Sissinghurst Castle in Kent, originally a medieval
manor house with Tudor additions, of which only a tower and
one range survived. 'It's rather a lovely rose-red,' wrote Virginia,
'with moat, drawbridge ... greyhound, ghost, bowling green and,
I daresay, buried treasure.'[29] She also saw James and Alix, who as
Lytton's executors had found 'masses of poems and plays, mostly
unfinished, and box upon box of letters'. In April, the Woolfs went
to Greece with Roger and his sister Margery, by train and boat via
Venice, and barely stopped talking all the way, 'as sweet as nuts and
soft as silk'. Virginia dressed 'like and elderly yak in a white pelt
constrained by a girdle' and Roger 'oozed knowledge'.[30] They dined
in a restaurant where Roger had eaten with his wife Helen thirty-six
years before, and drove around Brindisi in search of a dome, played
chess, observed Easter in Athens, visited Byzantine relics, temples,
terraces covered with olives and wild flowers, heard nightingales,
picked scarlet anemones and caught fleas. Virginia wrote letters
home from the Hotel Majestic, in rhapsodies about the beauty of
Greece in May, although the ghosts must have returned to her of
her previous visit in 1906 with her sister and brothers.

By way of relief after *The Waves*, Virginia was writing a light-hearted biography of Flush, the Victorian poet Elizabeth Barrett-Browning's dog. Drawing on two poems written about her pet as well as the poet's letters, she created an impressionistic biography of the woman as well as the animal, with the familiar themes of communication and language barriers being resolved by the use of imagery and symbolism. The book was published in October 1933 and was seen for what it was, entirely beautiful, but 'a necessary pause ... not a tour de force'. There was no response from her old adversary, Arnold Bennett, who had died in 1931, but it did elicit a response from Wyndham Lewis. Never one to forget a grudge, Lewis was the self-styled 'enemy' of writers whose work he perceived as 'fluid' or 'internal', and in whom Virginia believed she had found the perfect antithesis of Keats. In *Men Without Art* he set up an imaginary confrontation between 'the orthodox idealist' Woolf and the 'big beefy brute Bennett', drawing out the 'incompatibility of the eternal feminine ... and the rough footballing "he" principle – the eternal masculine' and criticising the arrangement of a 'sort of bogus "time" to take the place of the real "time"', which he saw as 'the so-called Bloomsbury technique, both in the field of writing and painting ... much to the disadvantage of any vigorous manifestation in the arts ... it is a myopic humanity'.[31] It was the poet Stephen Spender who rose to Virginia's defence in the *Spectator*, regretting that 'Mr Lewis's habit of successfully tying people in knots' was compromised by his failure to make 'his own criticism as rigid as one might expect from a writer with such high standards of taste and such contempt for both the taste and the work of others', as it was distressing to find Lewis curling round and making knots 'as fantastic as any of his victims'. In Spender's opinion, Lewis failed to hit at Virginia, Forster or anything else 'he labels Bloomsbury'.[32] Lewis's comment about spending 'fifteen years [subsisting in this]

suffocating atmosphere' indicate the true root of his antipathy, springing from the unresolved Omega feuds that had all but been forgotten in other quarters.

Yet Lewis's response was part of a wider critical approach towards the concept of 'Bloomsbury' as an elite group, which saw Virginia's art as 'the art of a governing class' which, coupled with her advocacy of £500 a year for a woman writer, neglected the 'ignorance, dirt, vulgarity and want' which could burst the bubble of her 'serene and lovely world'.³³ The perception of Bloomsbury and its 'members' as an ivory-tower elite slowly began to gather force. In *The Intelligentsia of Great Britain*, Dmitri Mirsky, or Prince Mirsky, a teacher of Russian Literature at London University, described the group as brilliant young Cambridge men 'who combined political radicalism with an interest in the most intriguing abstract problems, and further an extremely refined taste produced by study of English poetry and French painting'. Among the members, whom he knew personally, he listed Lytton and Maynard, Virginia, Roger and Clive, as well as Bertrand Russell, and defined their approach as 'a mixture of philosophic rationalism, aestheticism, and a cult of the individuality' [*sic*]. Yet he saw them as bourgeois, with their liberalism a 'thin-skinned humanism for enlightened and sensitive members of the capitalist class'. The atmosphere, he stated, was 'extremely aristocratic', living amid books and moving in the best circles, 'avoiding extremes and abnormalities'. Mirsky was wide of the mark in naming Katherine Mansfield's husband, John Middleton Murry, as the 'chief propagandist of Bloomsbury', and wider still when he stated that the group's influence had 'passed far beyond its confines'.³⁴ Having welcomed Mirsky into their home, Leonard felt he had the 'baleful smile of the shark or crocodile' but found him 'unusually courteous and even gentle ... highly intelligent, cultivated, devoted to the arts' and attempted to persuade him not

to return to Communist Russia in 1931. Virginia feared 'some day they will put a bullet in his head', and, indeed, he was arrested in the Great Purge of 1937 and died in a labour camp two years later.

In March 1934, Vanessa held a one-woman show at Lefevre Gallery in King Street, opened in 1926 by two of the foremost dealers in avant-garde art; it had already held shows of work by Seurat, Matisse, Degas, Modigliani and Picasso. Vanessa submitted about thirty-five paintings 'laid out like corpses' in a downstairs room, mostly scenes in and around Charleston, still lifes and five portraits. Vanessa wrote to Roger, who was in Italy, asking him to return before her show ended; 'It's your duty to considering that you are really responsible for me as a painter.'[35] The show proved a commercial success, with Vanessa receiving £500. Soon afterwards, on a brief stop in England before heading back to France, Roger visited Vanessa and her family at Charleston. The news that George Duckworth had died at Dalingridge House in April 1934 brought a mix of emotions to the surface for Virginia and Vanessa which had never been resolved. Complicated by their shared parentage and past, his over-effusive emotion and unwanted advances, his insistence on social standards and his repressed sexuality had been a formative influence on them as young women. Vanessa drove over to East Grinstead to pay her respects but arrived after the funeral. Virginia did not attend. No doubt the death of George was a milestone, but it paled in comparison with the blow that would follow later that year.

Vanessa was at Monk's House with Virginia and Leonard on 9 September when the news came that Roger had died. Two days earlier he had slipped on a rug and injured his hip, then been transferred to the Royal Free Hospital in Hampstead. The move may have been too much for him too soon, as his heart then failed. It was a devastating blow, unexpected and all the worse for the sense that his care had been mishandled. Vanessa took it

badly, howling in her bedroom, not able 'to get near anyone' and feeling faint. The next day she wrote to Helen Anrep, asking to see her, as she 'felt nearer Roger' when she was with her.[36] She attended the funeral service at Golders Green on 13 September, at which passages from Fry's *Transformations* were read, along with Milton and Spinoza, and music by Frescobaldi and Bach: 'It was so much what Roger would have chosen ... why should one want more than that people like him and music like Bach's and such incredible loveliness as one sees all round one should exist and that one should know them.' A week later she wondered 'will one ever lose the habit of thinking one can tell him things?'[37] Eight months later, in Rome, Vanessa reread Roger's letters to her, some of the earlier ones being 'rather painful to me to read', although later 'everything gets so easy and happy ... that one forgets the misery and sees that it was worthwhile'.[38] By this point Virginia had already sketched out the idea of writing a biography of Roger, and set herself the task of reading through all his correspondence to seize this 'splendid, difficult chance'. *Roger Fry: A Biography* was finally published in 1940.

Increasingly, talk was turning to the political situation in Europe, to the rise of Germany and the situation in Spain, the rise of fascism in Britain as well as the atrocities committed by Stalin in Russia. In 1935, Virginia and Leonard had sought advice from a neighbour who worked in the foreign office before driving through Germany to meet Vanessa in Italy, whose reassuring response was perhaps too dismissive given that the official government line was to warn British Jews not to visit the country. Having recently completed his anti-fascist book *Quack Quack*, Leonard wanted to see the political situation for himself. They were advised to avoid any Nazi rallies and the 'mad dog' Hitler, especially as Leonard's Jewish appearance would have attracted unwanted attention, but as it happened they were driving through the Rhine valley just at

the moment when a large public reception for Hermann Goring was being held. They could not have escaped seeing the placards and banners that were held aloft in the streets daubed with the ominous messages that Jews were the enemy. Following Hitler's appointment as Chancellor in 1933, Jewish shops and businesses had been boycotted and attacked and increasingly draconian laws were passed to limit their activities.

The Woolfs' visit was ill-timed. The spring and summer of 1935 saw a series of violent anti-Semitic attacks that marked a significant rise in the level of hostility, preceding the Nazi's Nuremberg rally of that September, during which the Nazi party renounced the restrictions made against it at Versailles in 1919, as Keynes had foreseen. A law was passed forbidding marriages or relationships between Jews and non-Jews, and it also excluded Jews from being part of the Reich, thus stripping them of their German citizenship. Leonard was lucky that *Quack Quack* would not appear in print until that June, when he was safely home in England. The Woolfs' ticket out of what might have become a potentially explosive situation took the form of Leonard's small pet monkey Mitz, who drew such admiration from the crowds that the identity of its owner was overlooked, allowing the Woolfs to drive away to freedom. What they had witnessed that day stayed with them though their lives. Over the coming years, other novelists would reflect the anti-Jewish persecution in books such as Katherine Burdekin's trilogy culminating with *Swastika Night* and Phyllis Bottome's *This Mortal Storm*, both published in 1937. By this point, Virginia was keeping a scrapbook of cuttings about the political, economic and social climate and had started writing down her thoughts, in a form that would later become an anti-war tract, *Three Guineas*.

Having predicted the implication of such harsh reparations being imposed on Germany in 1919, Keynes was also deeply concerned

about the rise of the Nazi party. During the depression of the 1930s, he had published *The Means to Prosperity* (1934), which suggested ways of tackling the rising figures of unemployment, and *The General Theory of Employment, Interest and Money* (1936). His advice was considered by the British government and adopted in Sweden and Germany: he also met with the newly elected President Roosevelt. However, he was particularly concerned, as were the rest of Bloomsbury, by the rise of the Nazi party with its restrictions on personal freedom, the 'threat to culture and intellectual liberty' and the implications of Germany's occupation of the Rhineland in 1936. Almost twenty years after his initial advice had been overlooked, he was unable to take the stand he wanted, especially given his deteriorating health. In 1937 he suffered a heart attack and was forced to retire to Tilton and live a quieter life.

In 1936, after years of oppression, violence, injustice and upheaval, the long-anticipated civil war broke out in Spain. Vanessa's elder son Julian, who had been teaching English in China's Wuhan University, returned to England in March 1937 and soon declared his intention to go and fight in support of the Republic movement. His Cambridge friend John, the son of neopagans Francis and Frances Cornford, had been killed in action the previous December, at the age of twenty-one. The combined persuasion of Vanessa and Virginia made him to agree not to take part in combat, but instead he would drive an ambulance: in spite of this, both women had a premonition that he would be killed. The older members of Bloomsbury, who had lived through the First World War, remained predominantly pacifist, although as the 1930s advanced many grudgingly admitted that there were worse things than war, abuses that it was worth fighting to prevent. Clive's assertion that a 'Nazi Europe would be … heaven on earth compared with Europe at war'[39] and Bertrand Russell's extreme form of pacifism were increasingly seen as 'complete insanity'

leaving little option but to 'submit to Hitler'[40] by those who understood the Nazi agenda. A farewell dinner was held for Julian at Charleston on 5 June and he left the following day.

Writing to him at the end of June, and praising some of his work, Virginia felt that 'old Bloomsbury, though fast dying, is still our bulwark against the tawny flood. So come back and drive your stake in, before we are overwhelmed.'[41] Privately, she was angered by his decision, for the anxiety it caused Vanessa, writing that she supposed 'it's a fever in the blood of the younger generation which we can't possibly understand'.[42] Finally receiving a letter almost three weeks after Julian had written it, Vanessa admitted she could not conceal her fear and asked him to write to her whenever he could. In July, the Republicans initiated the Battle of Brunete fifteen miles south of Madrid. The fighting lasted three weeks, during which Julian was struck by shrapnel while acting as a stretcher bearer. He was taken to the Escorial hospital and died on 18 July 1937. The news reached England two days later.

Angelica was at a dance class when Duncan appeared and took her home to Fitzroy Street, where Vanessa had completely broken down. She was lying 'in an unreal state' when Virginia arrived, and 'hearing her voice going on and on keeping life going' when 'otherwise it would have stopped'. To Virginia, it was an 'atmosphere of deep grey waters and I flopping like a dilapidated fish on top', and she wondered 'how can she [Vanessa] ever right herself'[43] when she and Julian had been so close: 'The future without Julian is cut off, lopped, deformed.' Later Vanessa would admit to Vita, 'I cannot say how Virginia has helped me. Perhaps some day, not now, you will be able to tell her it's true.' The following week, they moved Vanessa down to Charleston and Virginia remained at her side. She would never recover from the loss of her firstborn, with whom she had shared an unparalleled bond, but slowly, with Virginia's help, she began to come back to life.

TWENTY

Darkening Skies, 1937–1941

There was a star riding through clouds one night and I said to the star
'consume me'.[1]

The last novel Virginia saw through to publication was *The Years*.
A surprisingly conventional family story spanning fifty years, it
focuses on the domestic and social details of women's lives against
the constants of time, the seasons and the weather. Through the
lives of the Pargiter family, Virginia tried to give a broad panorama
of society, fusing individuals into 'one vast many-sided group', a
collective that transcended individual existence. The book had
taken five years to write and the process had been agony: 'How
you'll hate my new novel,' she wrote to Vita as early as 1932.[2]
Two years later, she told Ethel Smyth that it would be hopelessly
bad, 'verbose, foolish, all about hollow reeds'.[3] Virginia considered
the novel a failure, and if Leonard had not prevented her, by lying
about the work's merit, she would have 'tossed it in the bin'. In
April 1936 the strain of correcting the proofs made her collapse at
Monk's House, leading to an illness of several dismal months. She
knew she had 'never been so near the precipice to my own feeling

since 1913'[4] and was relieved that November, when she edited it down from 700 pages to 420. The theme was 'too ambitious', she felt, the characters too 'muted' and she 'muffed the proportions' through illness and 'sheer incompetence'.[5] And the terrible process of editing lay ahead, almost unbearable: 'The horror is that tomorrow, after this one windy day of respite ... I must begin at the beginning and go through ... pages of cold proof. Why, oh why? Never again, never again.'[6]

As publication day approached, Virginia was anxious and unwell. Some of the recent attacks in print had clearly hit their mark. Looking at the pile of review copies, she could anticipate the critics' laughter at 'the long drawn twaddle of a prim prudish bourgeois mind'. In response, her body began to react with the sensation of 'drumming slightly in the veins, very cold, impotent and terrified. As if I were exposed on a high ledge in full light ... no words ... very apprehensive. As if something cold and horrible – a roar of laughter at my expense were about to happen. And I am powerless to ward it off.'[7] The fear was worse at night: 'I'm going to be beaten, I'm going to be laughed at, I'm going to be held up to scorn and ridicule.'[8] Oddly enough, given her misgivings, the book proved to be a commercial success. Virginia was 'plagued' by the mixed reviews, which were 'even more contradictory than ever' and lamented the lack of any decent critics.[9] Theodora Bosanquet in *Time and Tide* found it 'lucid, coherent and significant' and saw it as celebrating the 'rebirth of the beauty of the visible world and the marvel of the minds that recognise it'.[10] The *Times Literary Supplement* commented that having chosen the epic form, Virginia had created a 'penetrating but uneventful chronicle' and lacked events.[11] A similar point was made by Basil de Selincourt in the *Observer*, that although each sentence was 'a little poem, a shining drop of dew', the novel's form seemed 'elaborately calculated to emphasise the isolations and separations of the framework,

conditions, machinery of our existence ... as if separateness was a bugbear of her own'.[12] David 'Bunny' Garnett, by now the author of a dozen novels, reviewed *The Years* in the *New Statesman*, saying it 'would be impossible to over-praise the beauty of Mrs Woolf's prose' and found 'an immense advance from the wild disjointed poetry of *Orlando* ... a greater gravity, a ripeness and richness and warmth in the descriptive passages which she has achieved nowhere else and which marks her as the greatest living master of English'.[13] In the *Listener*, Edwin Muir found *The Years* to be a step backwards, a disappointing book, 'cold and artificial'.[14] Virginia confessed in her diary that she was 'so damnably depressed and smacked on the cheek' at being 'found out ... that odious rice pudding of a book is what I thought it – a dank failure'.[15]

At this point, Virginia was still struggling to work on the biography of Roger Fry that his sister Marjorie had requested she write soon after his death. There were piles of letters and articles to read through and the process was sometimes painful, especially those sections that dealt with the mental illness and incarceration of his wife, Helen. By way of relief, Virginia alternated between that difficult task and the composition of her last novel, *Pointz Hall*, later *Between the Acts*. She began it on 2 April 1937, wanting it to be something 'random and tentative', rejecting 'I' in favour of 'we', using another twenty-four-hour-long timeframe as the occupants of Pointz Hall and the nearby village put on a pageant symbolic of four phases of English life: Elizabethan, Restoration, Victorian and the pre-war present moment. By 11 May she had written thirty-one pages, which had expanded to 120 by the end of the year. With the darkening political climate, though, she found it easier to write non-fiction and set the novel aside in favour of her biography. She also decided to sell her half of the Hogarth Press to John Lehmann. The deal was concluded

early in 1938 and together, Leonard and Lehmann would continue to run the business until 1946, when it became incorporated into the larger publishing house of Chatto and Windus.

In June 1938, Virginia published a long political essay, *Three Guineas*, which focused on the prevention of war, the education of women and their inclusion in the public sector. In it, the gulf that divides the genders, and that of the classes, is harnessed to the drive to fight in a way that might sit uncomfortably for a twenty-first-century readership. Virginia's was by no means the first book to draw a parallel between patriarchy and war, given that the 1932 collection of essays *Man, Proud Man* had examined militarism as a masculine concept and the theme had also appeared in works by Storm Jameson, Winifred Holtby and Naomi Mitchinson. *Three Guineas* was very much of its time and elements of it dated quickly. In recent years, some critics have lauded it as a feminist, pacifist tract while others have levelled against it charges of self-pity and victimhood.[16] Virginia wrote it quickly, in a style that drew from her scrapbooks, juxtaposing journalistic responses to a series of questions. The title referred to the three guineas which her protagonist was donating to the three main causes she discussed. As the *Times Literary Supplement* noted in 1938, 'Many readers of this book will applaud, others grind their teeth,' and 'it might be said that Mrs Woolf cannot solve the whole problem if she only states it for educated women of a civilised bourgeoisie.'[17] However, her call for professional freedom and equality for women and payment for their domestic work as mothers is surely only a little less revolutionary than it was then.

War was on everyone's lips in the wake of Hitler's threat to invade Czechoslovakia in autumn 1938. From London, Virginia wrote to Vanessa of the sandbags in the street, loudspeakers, lorries delivering wooden planks, gas masks, and the sense that conflict was inevitable, including Harold Nicolson, who balanced

his role in the cabinet with his unease with Prime Minister Chamberlain. Virginia and Leonard dined with *New Statesman* journalist Kingsley Martin, who tensely awaited the latest radio broadcast and hinted that he would kill himself in the event of hostilities breaking out, in the belief that war would 'last our lifetime' and that 'we should very likely be beaten'. Virginia was concerned that 'Hitler meant to bombard London, probably with no warning ... to drop bombs ... with twenty minute intervals for forty-eight hours. Also he meant to destroy all roads and railways; therefore Rodmell would be as dangerous as Bloomsbury.'[18] Children from the East End were already being evacuated to the country as a precaution. After Chamberlain and Hitler met and signed the Munich Agreement of September 1938, Leonard was commissioned to write a book in defence of 'tolerance, the open mind, freedom of thought and discussion'. Its themes were everything that Bloomsbury stood for but, against the current political climate, Leonard was uncertain of its reception, so insisted on being allowed complete freedom of expression. However, when he submitted *Barbarians at the Gate* the following May, its publication was postponed due to 'various complications' and, after much disagreement and reluctant revisions by Leonard, it was published in November 1939 after war had broken out.

Still continuing to paint in London, Carrington's one-time lover Mark Gertler was deeply affected by the threat of war. Although he had recovered from the tuberculosis that had blighted his health in the 1920s, married and achieved success as a teacher, his status as a Jew and his family's Polish descent tuned him into the particular horror of Nazi atrocities. On 14 May, Gertler dined with the Woolfs, as Virginia wanted his opinion of Roger's paintings for her biography. He discussed his previous suicide attempts and stated that he was completely recovered. Five weeks later they learned that he had killed himself by leaving the gas on in his studio. Following

the death of Ottoline Morrell in April 1938, this seemed to draw a line under the old Garsington world with its strutting peacocks, vibrant flowers and lively conversation, its artists sunbathing on the roof or in the pond and the pacifists painting and working on the land. The happy, easy world of friends and hospitality of the 1920s must have seemed like a distant memory, a stray spark of light in the descent to war. Also, Virginia and Vanessa's half-brother Gerald, the perpetrator of the single case of abuse against Virginia at Talland House and her first publisher, had died in Italy on 28 September 1937. Virginia's old friend Ka Cox, who had nursed her during her terrible illness of 1912 to 1915, died the following year, followed by Stella's widower Jack Hills, cutting three further ties with her earlier life.

Through 1939, war moved even closer. Franco occupied Barcelona in February, winning the Spanish Civil War; in March, Hitler invaded Prague and in April, Mussolini invaded Albania. All of England, Virginia wrote, was 'thinking the same thing – the horror of war – at the same moment'. To find some relief, and perhaps in anticipation of a dimming future, she turned to the past, to record something of her memories in 'A Sketch of the Past'. Conceived as something of an autobiography, Virginia used it to compare her past and current selves, via the platform of time offered by the present moment. This allowed her to view her parents from a position of maturity and acceptance, in comparison with earlier observations she had made in 'Reminiscences'. She also read Freud's complete works for the first time, and met him in London early in 1938. The frail exile, in his eighties, dying of cancer, presented Virginia with a narcissus; she felt that having read his work, she was better able to understand and forgive her father. As the political situation in Europe darkened, she moved one by one through a series of family portraits, as if taking stock of what was most precious, assessing and preserving it. After keeping

company with ghosts for two years she left the memoir incomplete, coming to the realisation that 'there is no Shakespeare, there is no Beethoven; certainly and emphatically there is no God; we are the words; we are the music; we are the thing itself'.

In mid-August 1939, the Woolfs moved from Tavistock Square to 37 Mecklenburgh Square and implemented several improvements, including the installation of a new bathroom. At the end of the month they were at Rodmell, where Virginia wrote to Vita on 29 August, to celebrate 'another day of peace': gardening in the sunshine, playing bowls, listening to the radio and cooking. Five days later war was announced. 'This is the worst of all my life's experiences,' Virginia confessed in her diary, 'all creative power is cut off ... if one can't write, as Duncan said yesterday, one may as well kill oneself.'[19] It was a topic the Woolfs and their friends debated seriously. Vita and Harold had agreed a suicide pact, Leonard proposed to Virginia that they gas themselves in the garage and Adrian offered to supply them with deadly levels of morphia. Leonard and Virginia were correct in their assumption that both their names were literally on Hitler's blacklist and they would have been targeted by the Nazi party in the event of a successful German invasion. The Sonderfahndungselite, or Special Search List, complied in 1940, contained the names of 2,300 prominent British journalists, writers and politicians, including both Woolfs, E. M. Forster, Aldous Huxley, Rebecca West, H. G. Wells and others. Back in London that October, they were anticipating air raids, with people 'running in and out of each other's houses with torches and gas masks'. Huge 'caterpillars' were excavating trenches in the square, shops closed early, buses were rare and the blackout blinds were pulled down. 'Rats in caves live as we do,' Virginia wrote to her niece Angelica.

Early in 1940, Virginia was revising her biography of Roger but between bouts of illness, the closeness of the subject and

the difficulties of the genre, this draft fell below expectations. Leonard told her there was 'something a little dead' about it, some repression of Roger's personality as well as her own as the author, which she felt harshly, like 'being pecked by a very strong hard beak' and felt 'convinced of failure'.[20] Through the spring she worked on editing and proof reading, while she eked out some sort of 'egg shell life', listening to reports of the German invasion of Norway and the replacement of Chamberlain as Prime Minister with Churchill. This threat to civilisation was felt by all members of the Bloomsbury group: as late as 1938, Clive had still been advocating pacifism, writing in the pamphlet *War-Mongers* that war was the worst kind of tyranny. By 1940, though, he had decided that a worse kind existed, and was advocating a continual war against Hitler.

On 10 June, the Germans reached Paris, the scene of Vanessa's increasing personal and artistic freedom as a young woman, the birthplace of Post-Impressionism and, arguably, Bloomsbury's spiritual home. As the Allied troops withdrew from the beaches of Normandy in a flotilla of little fishing boats, England prepared itself for the devastating effects of battle in the skies overhead. Virginia speculated about death again but was clear in her desire for life: 'If we are beaten then … one solution is apparently suicide … book writing becomes doubtful. But I wish to go on.'[21] Yet she could not see how the future would play out: 'I can't conceive that there will be a 27 June 1941.' Leonard feared that a Nazi victory would see them both interred in a concentration camp, to which suicide was preferable: 'So to the garage,' where he had stored up enough petrol to create the deadly fumes that would be their escape.

Roger Fry: A Biography was published on 25 July, with Virginia feeling she had 'caught a good deal of that iridescent man in [her], oh so laborious, butterfly net'. While its content received some

warm praise, the book was identified as the limited product of a clique, as the Bloomsbury reputation dimmed. As Herbert Read defined, in the *Spectator*, 'Mrs Woolf belongs to the same set or coterie to which Roger Fry himself belonged ... it was an elite – of birth, no less than education; its leading members were the sons and daughters of eminent Victorians and they had passed through one or other of our public schools. Cambridge then gave them a scientific and enquiring temper ... it could never be loosely identified with Bohemianism.' Worse still, given the current climate, Read added that Bloomsbury 'turned with a shudder from the threatening advance of what it would call "the herd"'. Read criticised Roger for retreating 'into the private world of his own sensibility' when faced with 'the machine, mass-production and universal education' – in short, when faced by modernism, rather than seeing that different forms of modernism might co-exist. The Omega Galleries were dismissed as catering to a 'small and snobbish public' and, in quoting from the Vorticist manifesto, Read confirmed his animosity towards 'the charmed circle'.[22]

The opposing view came from E. M. Forster, writing in the *New Statesman* and *Nation* on 10 August, who harnessed the biography in the fight against Fascism: 'All that Fry cared for, and worked for, is being destroyed. Good sense has gone, so have the pursuit of truth, peacefulness,' to be replaced by 'pernicious idealism, propaganda, violence.' Those who found the biography wanting, Forster labelled as 'prim barbarians', of the same type who criticised the Omega yet rushed to buy its products at reduced prices when it failed. He drew out the eternal symbols that translated across life and art; Cezanne's apples and eggs that were the subject of still lifes and meal times, as signifiers of a civilised life that would continue. They 'survived one war and will survive another', he wrote, adding that Virginia's biography showed how art was dormant until woken by the artist: 'Fry was always waking up art,

shaking it up, raking it up, right back from the days when he saw a red poppy burst in his parents' garden.' Forster returned to Fry's own message about sensitivity and open-mindedness, which were 'valuable qualities even in wartime', whatever the wireless says. 'Do they help us conquer the Nazis?' he asked, replying, 'They don't. They are weapons in a larger and longer battle.'[23]

The same month as Forster's review, the Woolfs were eating lunch at Monk's House when they heard the first roars in the sky that indicated the long-anticipated Blitz had begun. Rushing outside, they saw planes painted with swastikas 'flying a few feet above the church spire, over the garden and over our roof', stripping leaves off the branches. They adopted the advised position, lying flat under the trees, hands behind their heads.[24] It was the first raid of many. Leonard joined the Rodmell fire service and helped patrol the village at night. He and Virginia attended first-aid classes at the Rectory and gave away their saucepans to be melted down. The blackout restrictions were re-enforced and the Woolfs received a warning after not closing their curtains tightly enough. In September, Mecklenburgh Square was bombed and, on the drive up to London, the Woolfs had to shelter in a roadside 'pill box' and avoid unexploded bombs on the banks of the River Ouse. Wading through the broken glass, Virginia managed to salvage twenty-four volumes of her diary, snatching her past from the jaws of death, along with plates decorated by Vanessa. Many other Bloomsbury works were not so fortunate. The following month Tavistock Square was ruined, with one side blown away to expose the murals painted by Duncan and Vanessa. They picked their way through the rubble, but there was very little to salvage from their former or current home: Virginia saw only 'rubble where I wrote so many books. Open air where we sat so many nights, gave so many parties.'[25] That November, German bombs broke down the sandbags supporting the defences of the Ouse

and the valley flooded from Lewes to the coast, making Virginia feel marooned at Rodmell. One advantage was the opportunity to write and, that December, she finally finished the novel she had been toying with since the start of 1938, *Pointz Hall*, now titled *Between the Acts*. In the aftermath, with the winter days darkening and increasing food shortages, Virginia became ill.

Leonard knew the warning signs of old: headaches, sleeplessness and the refusal to eat. He called in Dr Octavia Wilberforce, a Brighton practitioner of the method of rest, fresh air and local food, who visited Monk's House on 9 December and twice again in the New Year. By the second occasion, Virginia's hands were shaking and she had 'lost all power over words'. Wilberforce believed this could be explained by 'cold, fatigue, heavy lifting, oversmoking' and the consumption of milk and cream. Virginia's attempts to talk about her family, about whom buried emotions had been raised during the writing of 'A Sketch of the Past', were dismissed as 'balderdash'. Through January, Virginia revised *Between the Acts*, but the loss of confidence in her writing she had experienced since writing *The Years* was acute, and only intensified by *Harper's Bazaar*'s rejection of a short story she had written. Her sense of being ridiculed on the publication of *Three Guineas* had been somewhat vindicated by the silence of Keynes in response to the book, and at least one cruel comment by Lydia; although her old friends, whose opinion most mattered to her, would not attack her work as some of her most savage public critics had, she felt their lack of endorsement. Even Leonard admitted that she was the most unpolitical of animals and had lied to her about the success of *The Years*. She wrote to Wilberforce that writing was 'a washout' and she expected she was writing 'nonsense'. When she lunched with John Lehmann on 14 March, Virginia told him she knew *Between the Acts* was no good; the day before her death she urged him not to publish it.

In early 1941, Virginia's 'madness' overlaid emotions from the past and present. There were her very real fears about the course of the war, the continual stress of anticipating attack of a literal kind, and the primitive isolation of discomfort, cold and rationing at Rodmell. For at least a year, she had believed death was imminent, either in a bombing raid, or by her own hand in the event of an invasion. She had seen her beloved London and her way of life destroyed, along with the values that had defined her life, work and circle of friends. Irreplaceable friends from her youth had been lost. In addition, she had reawakened memories of her family; the deaths of her parents and Stella, her abuse at the hands of Gerald and George and her previous illnesses, which destabilised her. Worst of all, she was uncertain of the merit of her recent books *The Years*, *Three Guineas* and *Roger Fry*, the critical response to which had been coloured by attacks upon the perceived clique of Bloomsbury itself. She had even considered *On Being Despised* as an alternative title for *Three Guineas*. Although the initial stages of writing *The Years* had been exciting, her work from 1936 took a different turn from the joyful experiments of *Mrs Dalloway*, *To the Lighthouse*, *Orlando* and *The Waves*, where she had been in her element. In her mid-fifties, also suffering from the tremors, mood swings and headaches that may have been exacerbated by the menopause, Virginia's confidence left her. Perhaps as the consequence of ill-health, war, or a belief in the failure of her own abilities, she was afraid that she could no longer write. She was 'no longer Virginia, the genius', and wondering, early in 1941 'Shall I ever write again one of those sentences that gives me intense pleasure?'[26]

On 20 March, Vanessa visited her sister to discuss her health. That evening, she wrote to Virginia advising her to be sensible and 'accept the fact that Leonard and I can judge better than you can' when it came to her care. 'What should I have done all these last

three years if you hadn't been able to keep me alive and cheerful,' Vanessa asked, finally breaking the reserve of decades. 'You don't know how much I depend on you. Do please be sensible for that if no other reason.'[27] She spoke to Clive about her concerns and he wrote to Mary Hutchinson that Virginia was 'getting into one of her bad phases again'; that like everyone else, the war got on her nerves, except 'her nerves are diseased'.[28] Around this time, Leonard found Virginia walking in the countryside near Rodmell, soaked from head to foot, 'looking ill and shaken'. She explained that she had lost her footing and slipped into one of the dykes, but it is likely to have been a failed suicide attempt. Leonard was so concerned that he took Virginia to visit Octavia Wilberforce in Brighton on 27 March. For a long time, as the doctor questioned her, Virginia refused to admit anything was wrong and resisted being ordered to take a rest cure. Leonard and Dr Wilberforce discussed the possibility of committing Virginia to an asylum, or of forcing her to submit to twenty-four-hour surveillance: for the time being, they decided against drastic action and that Virginia should return home under Leonard's supervision.

The following morning, it was 'one of her bad days again'.[29] Leonard talked to Virginia in her bedroom, then tried to involve her in cleaning his study, asking the maid to give her a duster, but she soon put it down and went outside to her writing room in the garden. Leonard went out to bring her back and told her to rest for half an hour before returning to his study. Virginia did not rest. Instead, she went out for a walk, taking her coat and walking stick, letting herself out of the gate at the top of the garden and heading for the river. There, she filled her pockets with stones and waded into the Ouse. At one o'clock, the Woolf's maid called Leonard for lunch. By then, he was in the garden and thought Virginia was resting in the house. Going upstairs to hear the news on the radio,

he discovered two suicide notes she had left on the mantelpiece of the first-floor sitting room. To Vanessa, she wrote,

> I feel that I have gone too far this time to come back again. I am certain now that I am going mad again. It is just as it was the first time, I am always hearing voices and I know I shan't get over it now.
>
> All I want to say is that Leonard has been so astonishingly good, every day, always; I can't imagine that anyone could have done more for me than he has. We have been perfectly happy until the last few weeks, when this horror began. Will you assure him of this? I feel that he has so much to do that he will go on, better without me, and you will help him.
>
> I can hardly think clearly any more. If I could I would tell you what you and the children have meant to me. I think you know.
>
> I have fought against it, but I can't any longer.

To Leonard, Virginia had written,

> Dearest,
>
> I feel certain that I am going mad again. I feel we can't go through another of those terrible times. And I shan't recover this time. I begin to hear voices and I can't concentrate. So I am doing what seems the best thing to do. You have given me the greatest possible happiness. You have been in every way all that anyone could be. I don't think two people could have been happier until this terrible disease came. I can't fight any longer. I know that I am spoiling your life, that without me you could work. And you will I know. You see I can't even write this properly. I can't read. What I want to say is that I owe all the happiness of my life to you. You have been entirely patient with me and incredibly good. I want to say that – everybody knows it. If anybody could have saved me it would have been you. Everything has gone from me but the certainty of your goodness.

Living in Squares, Loving in Triangles

I can't go on spoiling your life any longer. I don't think any two
people could have been happier than we have been. V.

Leonard found Virginia's stick by the side of the river the same
day.

TWENTY-ONE

Aftermath

And all the lives we ever lived and all the lives to be are full of trees and changing leaves.[1]

Virginia's death was a shock, even if not a completely unexpected one. In the following days Leonard wrote to inform family and friends that 'she drowned herself in the river, I think ... they have not yet found the body, but there is no real hope of anything else'.[2] A formal death announcement could not be made until Virginia was found but, on 1 April, Leonard informed *The Times* of her probable fate and the first obituary appeared two days later. When Willie Robson met the usually stoic Leonard for lunch the following week, his eyes were red from weeping[3] and John Lehmann also saw Leonard in tears, as he described the day when he had found Virginia dripping wet on her walk.

By chance, Vanessa had arrived at Monk's House on the day of Virginia's disappearance and took part in the search. Later she wrote to Vita as 'the person Virginia loved most I think outside her family', describing how Leonard was 'amazingly self-controlled and calm and insisted on being left alone' and how he was working

hard, going up to London to committees. She felt that 'nothing could have prevented the possibility just then' and that Leonard realised he was 'not to blame actually'.[4] Vita visited Monk's House on 7 April, hating to leave Leonard there alone. Writing to Janie Bussy, Lytton's niece, Vanessa added that if Virginia 'could have been guarded for a time she would have recovered', but that any 'suspicion of being watched would simply have hastened disaster',[5] and praised Leonard's devotion. Clive wrote to Mary, 'One hoped against hope that she might have wandered off crazily and might be found sleeping in a barn or buying biscuits in a village shop.' It was T. S. Eliot who observed that she was 'a kind of pin which held a lot of people together, and gave them a sense of belonging, of meaning, and that these people would now become separate individuals'.[6]

Virginia's body was found on 18 April. She had become lodged somehow below the field by Asheham House, which had prevented her being carried out to sea on the tidal pull of the Ouse. The inquest took place the following day at Newhaven. Leonard had the terrible job of identifying her after three weeks underwater, but there was no room for doubt. Virginia's remains were cremated in Brighton, in Leonard's presence, as the 'Dance of the Blessed Spirits' from Gluck's *Orfeo* was played. 'Leonard had an appalling time I'm afraid last week,' Vanessa wrote to Vita; 'there are two great elms at Rodmell which she always called Leonard and Virginia. They grow together by the pond. He is going to bury her ashes under one ... poor Leonard, he did break down completely when he told me.'[7] Alone at Monk's House, Leonard listened to the sounds of the house, the spring bird song outside, the church bells. And he listened to the lack of noise. 'I know that V will not come across the garden from the Lodge, and yet I look in the direction for her. I know that she is drowned and yet I listen for her to come in at the door. I know that it is the last page and yet I turn

it over. There is no limit to one's stupidity and selfishness.[8] Vanessa did not collapse as she had with the news of the deaths of Julian or Roger; perhaps those losses had worn out her capacity for emotional drama, though it could not remove the deep constant pain of loss. Instead, having anticipated the event for years, she was grateful to Leonard that Virginia had survived as long as she had: 'One can only be glad that this did not happen as it so nearly did years ago – when nearly all her gifts would have been wasted.'[9] Obituaries appeared by Stephen Spender in the *Listener*, citing a 'light which has gone out' and an 'irreparable loss', and by T. S. Eliot in *Horizon*, who placed her at the centre of not just 'an esoteric group, but of the literary life of London', whose work 'would remain', while Hugh Walpole wrote that her loss was 'something from which I shall now never escape'.[10] *Between the Acts* was published to critical acclaim in July 1941.

Vanessa and Duncan continued to live and work at Charleston, although their immediate concern was their daughter Angelica's love affair with Duncan's old flame David 'Bunny' Garnett. Bunny had stood over Angelica's cradle in 1918 and predicted that he would marry her, but no one had thought it was anything other than a joke in bad taste. Bunny had been married already but his wife had died of cancer, leaving him with two sons. Having been brought up in the belief that Clive was her father, Angelica had been surprised to learn about her true paternity which, coupled with her affair with Bunny, caused something of a breach with her parents. The pair married in 1942; she was twenty-four, he was fifty. Duncan and Vanessa were not invited to the wedding. The Garnetts went on to have four daughters at Hilton Hall in Cambridgeshire, but in the long term, the marriage did not prove to be a happy one. Bunny published a considerable number of novels and autobiographical volumes before his death in 1981. Angelica lived on until 2012.

Vanessa's life at Charleston continued, where old friends such as Desmond, Saxon and Clive, Helen Anrep, Maynard and Lydia visited and she painted in the studio and colourful garden, increasingly preferring a quiet life. Vanessa and Duncan's work was still highly thought of, and they were asked to decorate Berwick church with huge murals, exhibit at the Lefevre Galleries and even considered reviving the Omega Galleries after an exhibition was held in Lewes. In 1944, with typical stoicism, she underwent a mastectomy after finding a lump in her breast. Duncan held a one-man show the following year and still visited London frequently, where he met a young poet named Paul Roche, who was to be the last significant love of his life and would care for him in his advancing years.

Keynes and Lydia continued to live at Tilton, just down the road from Charleston. In 1942, Maynard became the chairman of the Committee for the Encouragement of Music and the Arts and broadcast about the future of the arts at the BBC three years later. He also attended the Bretton Woods international conference in New Hampshire, also known as the United Nations Monetary and Financial Conference, to help regulate the world market after the end of the war in 1945. In 1946, Keynes was awarded the Order of Merit but, before it could be formally conferred upon him, he suffered a fatal heart attack at Tilton, at the age of sixty-two. He was survived by Lydia, who no longer danced but retired from the public eye and lived in their home until her own death in 1981.

Over the years, Vanessa and Virginia had seen less of their younger brother Adrian and his family, finding him increasingly reserved and morose. The relationship had become so distant by 1941 that Adrian had learned of Virginia's death only when he heard it broadcast on the radio. He had become an army psychologist during the war, was scientific secretary of the British Psychoanalytical Society and took over James Strachey's role as

editor of the *International Journal of Psychoanalysis*. Adrian died in 1948; his wife Karin committed suicide five years later.

In 1952, Vanessa's younger son, Quentin Bell, married Anne Olivier Popham, the granddaughter of the neopagan Brynhild Olivier. They had three children and Anne, always known as Olivier, would edit Virginia's diaries. In June of the same year, another Old Bloomsbury member, Desmond MacCarthy, died at the age of seventy-five, having been knighted but never having written his famous novel. His wife Molly died the following year. Through the 1950s, the reputation of the Bloomsbury Group and its individual members suffered a dip in popularity, accused of elitism and other crimes: the culmination of a stream of critical voices that had been first raised against the Omega Galleries. In 1956, in *Old Friends*, Clive wrote passionately in defence of his circle, refuting that a conscious movement had ever existed and stunned by descriptions of his friends that he failed to recognise. It seemed to the older members that they had been misunderstood, perhaps deliberately so, and that their reputations as writers and artists were forever tarnished.

Vanessa and Duncan held exhibitions in 1956 and 1957 respectively, followed by Duncan's retrospective at the Tate in 1959; this was also the last time that the Memoir Club met. Vanessa's painting of her friends at a meeting in the mid-'40s, with portraits of Lytton, Roger and Virginia hanging on the wall behind, now stands as a memorial to the club. Vanessa was at Charleston when she died at the age of eighty-one on 7 April 1961. Retrospective exhibitions were held of her work at the Adams Gallery in London that year and by the Arts Council three years later. In June 1962, Vita died at Sissinghurst, followed by Harold in 1968. Saxon was also lost in 1962, Clive died in London on 18 September 1964 and Leonard, having carefully guarded Virginia's legacy, died of a stroke at Monk's House on 14 August 1969.

E. M. Forster followed him in 1970. Thus, none of them lived long enough to see the resurgence in the popularity of the Bloomsbury Group, which would go from strength to strength in the last decades of the twentieth century and lead to an unparalleled interest in their lives and work.

It was Duncan who began to see the tide turn. By the 1960s, the writing of Virginia Woolf was being reclaimed by new swathes of feminist readers and her status as a minor modernist was under revision. In 1964, the exhibition 'Duncan Grant and his world' indicated the start of a more biographical interest in the group and a steady stream of publications through the next decade ensured that Bloomsbury remained in the public consciousness. Duncan outlived all his contemporaries, dying at the home of Paul Roche on 8 May 1978 at the age of ninety-three. Two years later, the Charleston Trust was established to preserve the Sussex farmhouse for future generations, where annual festivals and workshops are still held in spring and summer as the gardens bloom back into life. Monk's House and Sissinghurst were acquired by the National Trust and, along with a cluster of blue plaques in the Bloomsbury district of London, remain sites of pilgrimage for devoted fans today. In 2004, a bust of Virginia was erected in Tavistock Square by the Virginia Woolf Society. It stands alongside many memorials, not least among them the words of her beloved Vita, published in the *Observer*, a few weeks after her death:

> Many words crowd and all and each unmeaning,
> The simplest words in sorrow are the best.
>
> So, let us say, she loved the water-meadows,
> The Downs; her friends; her books; her memories
> The room which was her own
> London by twilight; shops and Mrs Brown.

Donne's church, the Strand; the buses and the large
Smell of humanity that passed her by.

I remember she told me once that she, a child,
Trapped evening moths with honey round a tree-trunk,
And with a lantern watched their antic flight.
So she, a poet, caught her special prey,
With words of honey and lamp of wit.

Frugal, austere, fine, proud
Rich in her contradictions, rich in love,
So did she capture all her moth-like self:
Her fluttered spirit, delicate and soft,
Bumping against the lamp of life, too hard, too glassy.

Yet kept a sting beneath the brushing wing
Her blame astringent and her praise supreme.

How small, how petty seemed the little men
Measured against her scornful quality.

Some say she lived in an unreal world,
Cloud cuckoo-land. Maybe. She now has gone,
Into the prouder world of immortality.

NOTES

Abbreviations

One: The Birth of Bloomsbury, 1878

1. SOTP
2. Marion Dell and Marion Wybrow, *Virginia Woolf and Vanessa Bell: Remembering St Ives* (Tabb House, 2004)
3. Geoffrey Harvey, *The Complete Critical Guide to Thomas Hardy* (Routledge, 2003)
4. *MB*
5. *Ibid.*
6. *Ibid.*
7. *Ibid.*
8. *Ibid.*
9. *Ibid.*
10. *Ibid.*
11. *Ibid.*
12. *Ibid.*
13. *Ibid.*
14. *Ibid.*
15. *Ibid.*

Two: The Stephen Children, 1879–1887

1. *MB*
2. Quentin Bell, *Virginia Woolf*, Volumes 1 and 2 (1972)
3. *Ibid.*
4. REM
5. *Ibid.*
6. *Ibid.*
7. *Ibid.*
8. *Ibid.*
9. *Ibid.*
10. Image at Smith College Libraries: [http://www.smith.edu/libraries/libs/rarebook/exhibitions/stephen/36f.htm]
11. Lee

12. Regina Marler, *Selected Letters of Vanessa Bell* (Bloomsbury, 1993)
13. Virginia Woolf, Vanessa Bell and Thoby Stephen, *Hyde Park Gate News* (ed. Lowe, Gill) (Hesperus Press Ltd, 2005)
14. *Ibid.*
15. *HPGN*
16. *Ibid.*
17. *MB*
18. *MOB*
19. *MB*
20. SOTP
21. Vanessa Curtis, *The Hidden Houses of Virginia Woolf and Vanessa Bell* (Robert Hale, 2005)
22. *LLLS*
23. Frances Spalding, *Vanessa Bell* (Weidenfeld and Nicolson, 1983)

Three: Something in the Shadows, 1887–1895

1. *TTL*
2. Quentin Bell, *Virginia Woolf*, Volumes 1 and 2 (1972)
3. *MB*
4. Hermione Lee, *Virginia Woolf* (Chatto and Windus, 1996)
5. Jean O. Love, *Virginia Woolf: Sources of Madness and Art* (University of California Press, 1978)
6. SOTP
7. *Ibid.*
8. *Ibid.*
9. *Ibid.*
10. National Down Syndrome Society: [http://www.ndss.org/Down-Syndrome/What-Is-Down-Syndrome/]
11. Lee
12. SOTP

13. *Ibid.*
14. *Ibid.*
15. *Ibid.*
16. Louise DeSalvo, *Virginia Woolf; The Impact of Childhood Sexual Abuse on her Life and Work* (1989, The Women's Press)
17. SOTP
18. Lee, *Virginia Woolf* (1996)
19. SOTP
20. *Ibid.*
21. Lenore Terr, *Too Scared to Cry: Psychic Trauma in Childhood* (Basic Books, 1992)
22. REM
23. *LLLS*
24. *HPGN*
25. *Ibid.*
26. *Ibid.*
27. Panthea Reid, *Art and Affection: A Life of Virginia Woolf* (Oxford University Press, 1996)
28. *HPGN*
29. REM
30. Lee, *Virginia Woolf*, 1996
31. *MB*
32. SOTP

Four: Tragedy, 1895–1898

1. REM
2. *Ibid.*
3. *MOB*
4. *Ibid.*
5. *Ibid.*
6. Victorian mourning etiquette: [http://www.tchevalier.com/fallingangels/bckgrnd/mourning/]
7. SOTP
8. *Ibid.*
9. Quentin Bell, *Virginia Woolf*, Volumes 1 and 2 (1972)
10. REM
11. Seymour-Jones, *Carole Painted Shadow: A Life of Vivienne Eliot* (Constable, 2001)
12. *D3*
13. Interview with Frances Garnett from Susie Harrison on YouTube, published 5 June 2013
14. Bell, *Virginia Woolf* (1972)
15. Curtis, Vanessa, *The Hidden Houses of Virginia Woolf and Vanessa Bell* (Robert Hale, 2005)
16. REM
17. *Ibid.*
18. *APA*
19. SOTP
20. *APA*
21. *Ibid.*
22. *Ibid.*
23. *Ibid.*
24. *Ibid.*

Five: Into Society, 1898–1903

1. SOTP
2. *SIPAI*
3. SOTP
4. Quentin Bell, *Virginia Woolf*, Volumes 1 and 2 (1972)
5. SOTP
6. *Ibid.*
7. Vanessa Curtis, *The Hidden Houses of Virginia Woolf and Vanessa Bell* (Robert Hale, 2005)
8. Quentin Bell, *Virginia Woolf* (1972)
9. M. S., *Old Castles* (George Coward, 1868)
10. Curtis, *Hidden Houses* (2005)
11. D. M. Craik, *Hannah* (Harper and Brothers, New York, 1872)
12. SOTP

13. John Richardson, *A Life of Picasso, Volume I, 1881–1906* (Random House, 1991)
14. SOTP
15. *Ibid.*
16. *APA*
17. *SIPAI*
18. *Ibid.*
19. *Ibid.*
20. *APA*
21. *Ibid.*
22. SOTP
23. *Ibid.*
24. *Ibid.*

Six: The Thickest Emotional Haze, 1898–1903

1. *JR*
2. Victoria Glendinning, *Leonard Woolf* (Simon and Schuster, 2006)
3. Dan B. Allender, *The Wounded Heart: Hope for Adult Victims of Childhood Sexual Abuse* (Wounded Heart Ministries, 1990)
4. REM
5. 22 HPG
6. *Ibid.*
7. OB
8. Hermione Lee, *Virginia Woolf* (Chatto and Windus, 1996)
9. 22 HPG
10. VS to VB, July 1911
11. Lee, *Virginia Woolf* (1996)
12. Allender, *Wounded Heart*
13. VW to VD, October/November 1902
14. VB to Margery Snowdon, 15 March 1903
15. *Ibid.*
16. VB to Margery Snowdon, October/November 1903

17. *APA*
18. *Ibid.*
19. Vanessa Curtis, *The Hidden Houses of Virginia Woolf and Vanessa Bell* (Robert Hale, 2005)

Seven: Cambridge, 1899–1904

1. Quoted in Victoria Glendinning, *Leonard Woolf* (Simon and Schuster, 2006)
2. *JR*
3. *SOW*
4. *Ibid.*
5. *Ibid.*
6. *Ibid.*
7. In his memoirs, *SOW*, Leonard qualifies that this might have been a real memory, or possibly his imagination.
8. *SOW*
9. *Ibid.*
10. *Ibid.*
11. *Ibid.*
12. The name given to the backs of the colleges leading down to the River Cam.
13. SOTP
14. Quentin Bell, *Virginia Woolf*, Volumes 1 and 2 (1972)
15. SOTP
16. *JR, TW*
17. Trinity in Literature: [http://www.trin.cam.ac.uk/trinity-literature#bell]
18. *SOW*
19. *Ibid.*
20. *Ibid.*
21. VW to TS, 5 November 1901
22. *SOW*

Eight: Freedom, 1904–1906

1. Virginia Woolf
2. VW to VD, February 1904
3. VW to VD, 31 December 1903
4. VW to VD, February 1904
5. Anthony Curtis, *Virginia Woolf, Bloomsbury and Beyond* (H Books, 2006)
6. Quentin Bell, *Virginia Woolf*, Volumes 1 and 2 (1972)
7. Blitheworld: [http://blog.blithewold.org/uncategorized/marjories-european-tour-1903-1904/]
8. E. M. Forster, *Room with a View* (1908)
9. VB to MS, 6 April 1904
10. *Ibid.*
11. VW to EV, 25 April 1904
12. *Ibid.*
13. Vanessa Curtis, *The Hidden Houses of Virginia Woolf and Vanessa Bell* (Robert Hale, 2005)
14. Panthea Reid, *Art and Affection: A Life of Virginia Woolf* (Oxford University Press, 1996)
15. VW to VD, September 1904
16. *SIPAI*
17. VW to VD, July 1905
18. Jane Dunn, *Virginia Woolf and Vanessa Bell: A Very Close Conspiracy* (Virago, 2001)
19. Frances Spalding, *Vanessa Bell* (Weidenfeld and Nicolson, 1983)
20. VW to VD, 3 October 1904
21. Spalding, *Vanessa Bell* (1983)
22. *APA*
23. John Woodeson, *Mark Gertler* (Sidgwick and Jackson, 1972)
24. Michael Holroyd, *Augustus John* (Vintage, 1997)
25. William Pryor (ed.), *Virginia Woolf and the Raverats: A Different Sort of Friendship* (Clear Books, 2003)
26. Michael Holroyd, *Lytton Strachey: The New Biography* (Chatto and Windus, 1994)
27. Woodeson, *Mark Gertler* (1972)
28. *Ibid.*
29. *APA*
30. Spalding, *Vanessa Bell*
31. *APA*
32. *Ibid.*
33. Curtis, *Hidden Houses*
34. VB to CB, July 1906
35. CB to VS, October 1906
36. Frederick Spotts, *The Letters of Leonard Woolf* (Bloomsbury, 1992)

Nine: Love Triangle, 1907–1910

1. Virginia Woolf, *Recent Paintings by Vanessa Bell* (Cooling Gallery, 1930)
2. *SLVW*
3. Quentin Bell, *Virginia Woolf*, Volumes 1 and 2 (1972)
4. *Ibid.*
5. Spotts, *Letters of Leonard Woolf* (1992)
6. Vanessa Curtis, *The Hidden Houses of Virginia Woolf and Vanessa Bell* (Robert Hale, 2005)
7. VW to VB, 6 February 1906
8. *Ibid.*
9. *SLVW*
10. Curtis, *Hidden Houses* (2005)
11. *SLVW*
12. *Ibid.*
13. Panthea Reid, *Art and Affection: A Life of Virginia Woolf* (Oxford University Press, 1996)
14. *Ibid.*

15. Holroyd, *Augustus John*
16. *SLVW*
17. VW to CB, August 1908
18. VW to CB, October 1908
19. CB to VW, February 1909
20. *SIPAI*
21. *Ibid.*
22. Frances Spalding, *Duncan Grant* (Pimlico, 1997)
23. Clive Bell, *Pot Boilers* (1918)
24. Jane Goldman, *The Feminist Aesthetics of Virginia Woolf* (Cambridge University Press, 1998)
25. Spalding, *Duncan Grant* (1997)
26. Stanford Patrick Rosenbaum, *The Bloomsbury Group: A Collection of Memoirs and Commentary* (University of Toronto Press, 1995)
27. Bell, *Virginia Woolf* (1972)
28. *SLVW*
29. LS to LW, 1 February 1909
30. *Ibid.*
31. Sarah M. Hall, *Before Leonard: The Early Suitors of Virginia Woolf* (Peter Owen Ltd, 2005)
32. Michael Holroyd, *Lytton Strachey: The New Biography* (Chatto and Windus, 1994)

Ten: Post-Impressionism, 1910–1911

1. Christina Walsh in the *Daily Herald*
2. Roger Fry, *Vision and Design* (1927)
3. Point made by Vanessa Bell
4. Point made by Clive Bell
5. Virginia Woolf, *Roger Fry: A Biography* (Hogarth Press, 1940)
6. F. Spalding, *Vanessa Bell*
7. VB to CB, 23 June 1910

8. VW to VB, 8 July 1910
9. Stansky
10. *Ibid.*
11. Virginia Woolf, *Roger Fry*
12. MJP
13. *Ibid.*
14. *Ibid.*

Eleven: The Opposite Sex, 1911–1912

1. Phyllis Rose, introduction to *The Voyage Out*
2. David Garnett, *The Golden Echo* (Chatto and Windus, 1953)
3. *Ibid.*
4. Keith Hale (ed.), *Friends and Apostles: The Correspondence of Rupert Brooke and James Strachey 1905–1914* (Yale University Press, 1998)
5. Katie Roiphe, *Uncommon Arrangements: Seven Marriages in Literary London 1910–1939* (Virago 2009)
6. *Ibid.*
7. VB to RF, July 1911
8. *Ibid.*
9. VB to RF, 23 June 1911
10. *Ibid.*, July 1911
11. *Ibid.*
12. VB to RF, 1911
13. Panthea Reid, *Art and Affection: A Life of Virginia Woolf* (Oxford University Press, 1996)
14. VB to VW, 19 October 1911
15. *Ibid.*, June 1911
16. *Ibid.*, July 1911
17. Lynn Garafola, *Diaghilev's Ballets Russes* (Oxford University Press, 1989)
18. Peter Stansky, *On Or About*

December 1910: Early Bloomsbury and its Intimate World (Harvard University Press, 1997)

19. *New Age* magazine, 29 June 1911
20. Douglas B. Turnbaugh, *Duncan Grant* (Lyle Stuart, 1987)
21. Garafola, *Diaghilev's Ballets Russes*
22. Hale (ed.), *Friends and Apostles*
23. *Ibid.*
24. *Ibid.*
25. VS to CB, January 1911
26. Quentin Bell, *Virginia Woolf*, Volumes 1 and 2 (1972)
27. Paul Delany, *The Neo-Pagans: Friendship and Love in the Rupert Brooke Circle* (Hamish Hamilton, 1998)
28. Stansky, *On Or About December 1910*
29. Leonard Woolf, *Growing: An Autobiography of the Years 1904–1911* (Harcourt Brace, 1961)
30. Bell, *Virginia Woolf* (1972)
31. BA
32. LW to VW, 12 January 1912
33. Bell, *Virginia Woolf* (1972)

Twelve: Leonard, 1912–1913

1. Virginia Woolf, 'On Being Ill', *Criterion Magazine* (1926)
2. SLVW
3. *Ibid.*
4. Hale, *Friends and Apostles*
5. *Ibid.*
6. *Ibid.*
7. SLVW
8. Panthea Reid, *Art and Affection: A Life of Virginia Woolf* (Oxford University Press, 1996)
9. SLVW
10. *Ibid.*
11. *Ibid.*
12. *Ibid.*
13. Victoria Glendinning, *Leonard Woolf* (Simon and Schuster, 2006)
14. Peter Dally, *Virginia Woolf: The Marriage of Heaven and Hell* (Robson Books, 1999)
15. Thomas C. Caramagno, *The Flight of the Mind: Virginia Woolf's Art and Manic Depressive Illness* (University of California Press, 1992)
16. William M. Greenslade, *Degeneration, Culture and the Novel 1880–1940* (Cambridge University Press, 1994)
17. *Ibid.*
18. Roger Poole, *The Unknown Virginia Woolf* (CUP Archive, 1995)
19. BA
20. *Ibid.*
21. *Ibid.*
22. Hermione Lee, *Virginia Woolf* (Chatto and Windus, 1996)
23. Dally, *Virginia Woolf*
24. LW to VW, 1 August 1913

Thirteen: Omega, 1913–1914

1. Roger Fry, 'Introduction to the Omega Catalogue' (exhibition catalogue)
2. SLVW
3. Isabelle Anscombe and Howard Grey, *Omega and Afterwards: Bloomsbury and the Decorative Arts* (Thames and Hudson, 1981)
4. *Ibid.*
5. *Ibid.*
6. Richard Shone, *Bloomsbury Portraits* (Phaidon, 1976)
7. Paul O'Keeffe, *Some Sort of*

Genius: A Life of Wyndham Lewis (Pimlico, 2001)

8. *BA*

9. Frederick Spotts, *The Letters of Leonard Woolf* (Bloomsbury, 1992)

10. Panthea Reid, *Art and Affection: A Life of Virginia Woolf* (Oxford University Press, 1996)

11. Victoria Glendinning, *Leonard Woolf* (Simon and Schuster, 2006)

12. Reid, *Art and Affection* (1996)

13. Frederick Spotts, *The Letters of Leonard Woolf* (Bloomsbury, 1992)

14. *Ibid.*

15. Reid, *Art and Affection* (1996)

16. *BA*

Fourteen: Pacifism, 1914–1918

1. Poem by Lytton Strachey, quoted in Zsuzsa Rawlinson, *The Sphinx of Bloomsbury: The Literary Essays and Biographies of Lytton Strachey* (Akadémiai Kiadó, 2006)

2. Spalding, *Vanessa Bell*

3. LS to Dorothy Bussy, August 1914

4. John Woodeson, *Selected Letters of Mark Gertler* (1972)

5. *D1*

6. *Ibid.*

7. Susan Chitty, *Gwen John* (Franklin Watts, 1987)

8. Keynes to LS, November 1914

9. *D1*

10. Robert Gathorne-Hardy (ed.), *Ottoline at Garsington: Memoirs of Lady Ottoline Morrell* (Faber and Faber, 1974)

11. *Ibid.*

12. Woodeson, *Letters*

13. Nina Hamnett, *Laughing Torso* (1931)

14. *D1*

15. Michael Holroyd, *Lytton Strachey: The New Biography* (Chatto and Windus, 1994)

16. Robin Majumdar, Allen McLaurin et al., *Virginia Woolf: The Critical Heritage* (Law Book Co. of Australasia, 1975)

17. LS to VW, 25 February 1916

18. Anscombe and Grey, *Omega and Afterwards*

19. *D1*

20. *BA*

Fifteen: Post-War, 1919–1921

1. From 'Winter Afternoons' in Vita Sackville-West, *Selected Works* (Palgrave Macmillian, 2003)

2. As described by Katherine Mansfield in the *Athenaeum* (November 1919)

3. *D2*

4. Majumdar et al., *Virginia Woolf*

5. *Ibid.*

6. *Ibid.*

7. *Ibid.*

8. Claire Tomalin, *Katherine Mansfield: A Secret Life* (Circe, 1991)

9. *D2*

10. Donald Moggridge, *Maynard Keynes: An Economist's Biography* (Routledge, 1995)

11. *Ibid.*

12. *BA*

13. *D2*

14. *Ibid.*

15. Alix Sargeant-Florence, wife of James Strachey

16. Barbara Baegnal

17. Nicholas Baegnal

18. John Middleton Murry, husband of Katherine Mansfield
19. Author Hope Mirrlees
20. Saxon was in love with Barbara Baegnal
21. *D2*
22. *Ibid.*
23. *Ibid.*
24. Spalding, *Duncan Grant*
25. *Ibid.*
26. *D2*
27. Panthea Reid, *Art and Affection: A Life of Virginia Woolf* (Oxford University Press, 1996)
28. *D2*
29. *Ibid.*
30. Spalding, *Duncan Grant*
31. Hermione Lee, *Virginia Woolf's Nose: Essays on Biography* (Princeton University Press, 2005)
32. *D2*
33. Gretchen Gerzina, *Carrington* (John Murray, 1989)
34. *D3*

11. *SLVB*
12. *SLVW*
13. *Ibid.*
14. Majumdar et al., *Virginia Woolf*
15. *D2*
16. *D2*
17. *D2*
18. *D2*
19. Majumdar et al., *Virginia Woolf*
20. *D2*
21. Majumdar et al., *Virginia Woolf*
22. *Ibid.*
23. *Ibid.*
24. *D2*
25. *Ibid.*
26. Gretchen Gerzina, *Carrington* (John Murray, 1989)
27. *Ibid.*
28. *Ibid.*
29. *D2*
30. Gerzina, *Carrington* (1989)
31. Frances Marshall
32. According to Clive Bell
33. Frederick Spotts, *The Letters of Leonard Woolf* (Bloomsbury, 1992)

Sixteen: Art and Life, 1919–1924

1. Letter from VW to Janet Case, 21 May 1922
2. Anscombe and Grey, *Omega and Afterwards*
3. *D3*
4. Anscombe and Grey, *Omega and Afterwards*
5. Roger Fry, *Vision and Design* (1927)
6. Virginia Woolf, *Roger Fry*
7. *SLVB*
8. *SLVB*
9. *New Age*, 11 November 1920
10. *Ibid.*

Seventeen: Ghosts, 1924–1927

1. Virginia Woolf, *Orlando* (Hogarth Press, 1928)
2. Spalding, *Vanessa Bell*
3. Although she had seen her at a recent funeral and ignored her, which she regretted
4. *D2*
5. *Ibid.*
6. *Ibid.*
7. *Ibid.*
8. *Ibid.*
9. *Ibid.*
10. *D2*
11. *TTL*

12. Majumdar et al., *Virginia Woolf*
13. *Ibid.*
14. *Ibid.*
15. *Ibid.*
16. *Ibid.*
17. *D2*
18. *Ibid.*
19. *Ibid.*
20. *Ibid.*
21. *SLVB*
22. Spalding, *Duncan Grant*
23. *D2*
24. *BA*
25. *D2*
26. *Ibid.*
27. *Ibid.*
28. *Ibid.*
29. *Ibid.*
30. *Ibid.*
31. *Ibid.*
32. Hermione Lee, *Virginia Woolf* (Chatto and Windus, 1996)
33. VW to Vita Sackville-West, 1927
34. *SLVB*
35. Majumdar et al., *Virginia Woolf*
36. *Ibid.*
37. *Ibid.*
38. *Ibid.*
39. *Ibid.*
40. *D3*

Eighteen: Vita, 1927–1930

1. Rebecca West
2. Woolf, *Orlando*
3. Mary Ann Caws, *Women of Bloomsbury* (Routledge, 1990)
4. *D3* and *SLVW*
5. *D3*
6. *SLVW*
7. *D3*
8. *SLVW*

9. *Ibid.*
10. Spalding, *Vanessa Bell*
11. Vita Sackville-West to Margaret Howard, 1941
12. *D3*
13. *Ibid.*
14. *Ibid.*
15. Majumdar et al., *Virginia Woolf*
16. *Ibid.*
17. *Ibid.*
18. *Ibid.*
19. *Ibid.*
20. *Ibid.*
21. *Ibid.*
22. *SLVB*
23. *Ibid.*
24. *Ibid.*
25. Spalding, *Vanessa Bell*
26. *Ibid.*
27. Spalding, *Duncan Grant*
28. Spalding, *Vanessa Bell*
29. Bethan Stevens, *Lost Works of Art: A Critical and Creative Study of Reception and Restitution* (Unpublished PhD thesis, Sussex University, 2012)

Nineteen: Straws to Cling to, 1931–1937

1. *The Waves*
2. SOTP
3. *D3*
4. *The Waves*
5. *SLVW*
6. *D3*
7. VW to G. L. Dickinson, October 1931
8. Majumdar et al., *Virginia Woolf*
9. *D4*
10. *DATW*
11. *SLVB*

12. *SLVW*
13. *Ibid.*
14. Majumdar et al., *Virginia Woolf*
15. *Ibid.*
16. *Ibid.*
17. *D4*
18. *SLVW*
19. *D4*
20. *SLVW*
21. *Ibid.*
22. *D4*
23. *Ibid.*
24. *SLVW*
25. *Ibid.*
26. *D4*
27. *SLVW*
28. *D4*
29. *Ibid.*
30. *Ibid.*
31. Majumdar et al., *Virginia Woolf*
32. *Ibid.*
33. *Ibid.*
34. *Ibid.*
35. *SLVB*
36. *Ibid.*
37. *Ibid.*
38. *Ibid.*
39. Julia Briggs, *Virginia Woolf: An Inner Life* (Penguin, 2006)
40. Robert Cecil, quoted in Briggs, *ibid.*
41. *SLVW*
42. *D5*
43. *Ibid.*

Twenty: Darkening Skies, 1937–1941

1. Woolf, *The Waves*
2. *SLVW*
3. *Ibid.*
4. *D5*
5. *Ibid.*
6. *Ibid.*
7. *Ibid.*
8. *Ibid.*
9. *Ibid.*
10. Majumdar et al., *Virginia Woolf*
11. *Ibid.*
12. *Ibid.*
13. *Ibid.*
14. *Ibid.*
15. *D5*
16. Specifically Theodore Dalrymple and Elizabeth Shih
17. Majumdar et al., *Virginia Woolf*
18. *D5*
19. *Ibid.*
20. *Ibid.*
21. *Ibid.*
22. Majumdar et al., *Virginia Woolf*
23. *Ibid.*
24. *D5*
25. *Ibid.*
26. *Ibid.*
27. *SLVB*
28. Hermione Lee, *Virginia Woolf* (Chatto and Windus, 1996)
29. *Ibid.*

Twenty-One: Aftermath

1. *TTL*
2. Victoria Glendinning, *Vita: The Life of Vita Sackville-West* (Penguin, 1984)
3. *Ibid.*
4. *SLVB*
5. *Ibid.*
6. Hermione Lee, *Virginia Woolf* (Chatto and Windus, 1996)
7. *SLVB*
8. Glendinning, *Vita* (1984)
9. *Ibid.*
10. Majumdar et al., *Virginia Woolf*

BIBLIOGRAPHY

Annan, Noel, *Leslie Stephen, The Godless Victorian* (Random House, 1984)

Anscombe, Isabelle and Howard Grey, *Omega and Afterwards: Bloomsbury and the Decorative Arts* (Thames and Hudson, 1981)

Bell, Clive, *Art* (1914)

Bell, Clive, *Civilisation* (1922)

Bell, Clive, *Old Friends* (1956)

Bell, Clive, *Pot Boilers* (1918)

Bell, Quentin, *Bloomsbury Recalled* (1995)

Bell, Quentin, *Virginia Woolf*, Volumes 1 and 2 (1972)

Bell, Quentin and Virginia Nicolson, *Charleston: A Bloomsbury House and Gardens* (Frances Lincoln, 2004)

Bell, Vanessa, *Sketches in Pen and Ink: A Bloomsbury Notebook* (Hogarth Press, 1997)

Blythe, Ronald, *First Friends* (Fleece Press, 1997)

Briggs, Julia, *Virginia Woolf: An Inner Life* (Penguin, 2006)

Caine, Barbara, *Bombay to Bloomsbury: A Biography of the Strachey Family* (Oxford University Press, 2005)

Caramagno, Thomas C. *The Flight of the Mind: Virginia Woolf's Art and Manic Depressive Illness* (University of California Press, 1992)

Caws, Mary Ann and Sarah Bird Wright, *Bloomsbury and France: Art and Friends* (Oxford University Press, 2000)

Caws, Mary Ann, *Women of Bloomsbury* (Routledge, 1990)

Chitty, Susan, *Gwen John* (Franklin Watts, 1987)

Curtis, Anthony, *Virginia Woolf, Bloomsbury and Beyond* (H Books, 2006)

Curtis, Vanessa, *The Hidden Houses of Virginia Woolf and Vanessa Bell* (Robert Hale, 2005)

Curtis, Vanessa, *Virginia Woolf's Women* (Robert Hale, 2002)

Dally, Peter, *Virginia Woolf: The Marriage of Heaven and Hell* (Robson Books, 1999)

Delany, Paul, *The Neo-Pagans: Friendship and Love in the Rupert Brooke Circle* (Hamish Hamilton, 1998)

Dell, Marion and Marion Wybrow, *Virginia Woolf and Vanessa Bell: Remembering St Ives* (Tabb House, 2004)

DeSalvo, Louise, *Virginia Woolf; The Impact of Childhood Sexual Abuse on her Life and Work* (1989, The Women's Press)

Dunn, Jane, *Virginia Woolf and Vanessa Bell: A Very Close Conspiracy* (Virago, 2001)

Fry, Roger, *A Roger Fry Reader* (University of Chicago Press, 1996)

Fry, Roger, *Vision and Design* (1927)

Garafola, Lynn, *Diaghilev's Ballets Russes* (Oxford University Press, 1989)

Garnett, Angelica, *Deceived with Kindness: A Bloomsbury Childhood* (Pimlico, 1995)

Garnett, David, *The Golden Echo* (Chatto and Windus, 1953)

Gathorne-Hardy, Robert (ed.), *Ottoline at Garsington: Memoirs of Lady Ottoline Morrell* (Faber and Faber, 1974)

Gerzina, Gretchen, *Carrington* (John Murray, 1989)

Glendinning, Victoria, *Leonard Woolf* (Simon and Schuster, 2006)

Glendinning, Victoria, *Vita: The Life of Vita Sackville-West* (Penguin, 1984)

Goldman, Jane, *The Feminist Aesthetics of Virginia Woolf* (Cambridge University Press, 1998)

Greenslade, William M., *Degeneration, Culture and the Novel 1880–1940* (Cambridge University Press, 1994)

Hale, Keith (ed.), *Friends and Apostles: The Correspondence of Rupert Brooke and James Strachey 1905–1914* (Yale University Press, 1998)

Hall, Sarah M., *Before Leonard: The Early Suitors of Virginia Woolf* (Peter Owen Ltd, 2005)

Hamnett, Nina, *Laughing Torso* (1931)

Harris, Alexandra, *Romantic Moderns: English Writers, Artists and the Imagination from Virginia Woolf to John Piper* (Thames and Hudson, 2010)

Harris, Pippa, *Song of Love: The Letters of Rupert Brooke and Noel Olivier* (Bloomsbury 1991)

Harvey, Geoffrey, *The Complete Critical Guide to Thomas Hardy* (Routledge, 2003)

Haycock, David, *A Crisis of Brilliance: Five Young British Artists and the Great War* (Old Street Publishing, 2010)

Holroyd, Michael, *Augustus John* (Vintage, 1997)

Holroyd, Michael (ed.), *Lytton Strachey by Himself: A Self Portrait* (Vintage, 1994)

Holroyd, Michael, *Lytton Strachey: The New Biography* (Chatto and Windus, 1994)

Hooker, Denise, *Nina Hamnett: Queen of Bohemia* (Constable 1986)

Bibliography

Humm, Maggie, *Snap Shots of Bloomsbury: The Private Lives of Virginia Woolf and Vanessa Bell* (Tate Publishing, 2006)

Kopelson, Kevin, *The Queer Afterlife of Vaslav Nijinsky* (Stanford University Press, 1997)

Lee, Hermione, *Virginia Woolf* (Chatto and Windus, 1996)

Lee, Hermione, *Virginia Woolf's Nose: Essays on Biography* (Princeton University Press, 2005)

Majumdar, Robin, Allen McLaurin et al., *Virginia Woolf: The Critical Heritage* (Law Book Co. of Australasia, 1975)

Marder, Herbert, *The Measure of Life: Virginia Woolf's Last Years* (Cornell University Press, 2001)

Marler, Regina, *Selected Letters of Vanessa Bell* (Bloomsbury, 1993)

Meyers, Jeffrey, *Married to Genius* (Southbank Publishing, 2005)

Moggridge, Donald, *Maynard Keynes: An Economist's Biography* (Routledge, 1995)

Nicolson, Virginia, *Among the Bohemians, Experiments in Living 1900–1939* (Penguin 2003)

O'Keeffe, Paul, *Some Sort of Genius: A Life of Wyndham Lewis* (Pimlico, 2001)

Partridge, Frances, *Friends in Focus* (Chatto and Windus, 1987)

Poole, Roger, *The Unknown Virginia Woolf* (CUP Archive, 1995)

Pryor, William (ed.), *Virginia Woolf and the Raverats: A Different Sort of Friendship* (Clear Books, 2003)

Randall, Bryony and Jane Goldman, *Virginia Woolf in Context* (Cambridge University Press, 2012)

Rawlinson, Zsuzsa, *The Sphinx of Bloomsbury: The Literary Essays and Biographies of Lytton Strachey* (Akadémiai Kiadó, 2006)

Reid, Panthea, *Art and Affection: A Life of Virginia Woolf* (Oxford University Press, 1996)

Roiphe, Katie, *Uncommon Arrangements: Seven Marriages in Literary London 1910–1939* (Virago 2009)

Rosenbaum, Stanford Patrick, *The Bloomsbury Group: A Collection of Memoirs and Commentary* (University of Toronto Press, 1995)

Seymour, Miranda, *Life on the Grand Scale* (Hodder and Stoughton, 1993)

Smith College Libraries: [http://www.smith.edu/libraries/libs/rarebook/exhibitions/stephen/36f.htm]

Shone, Richard, *Bloomsbury Portraits* (Phaidon, 1976)

Spalding, Frances, *Duncan Grant* (Pimlico, 1997)

Spalding, Frances, *Vanessa Bell* (Weidenfeld and Nicolson, 1983)

Spalding, Frances, *Virginia Woolf: Art, Life and Vision* (National Portrait Gallery, 2014)

Spotts, Frederick, *The Letters of Leonard Woolf* (Bloomsbury, 1992)

Stansky, Peter, *On Or About December 1910: Early Bloomsbury and its Intimate World* (Harvard University Press, 1997)

Stephen, Leslie, *Mausoleum Book* (Oxford University Press, 2001)

Stevens, Bethan, *Lost Works of Art: A Critical and Creative Study of Reception and Restitution* (Unpublished Phd thesis, Sussex University, 2012)

Szasz, Thomas, *My Madness Saved Me: The Madness and Marriage of Virginia Woolf* (Transaction Publishers, New Brunswick, 2006)

Terr, Lenore, *Too Scared to Cry: Psychic Trauma in Childhood* (Basic Books, 1992)

Todd, Pamela, *Bloomsbury at Home* (Pavilion, 1999)

Tomalin, Claire, *Katherine Mansfield: A Secret Life* (Circe, 1991)

Turnbaugh, Douglas B., *Duncan Grant* (Lyle Stuart, 1987)

Woodeson, John, *Mark Gertler* (Sidgwick and Jackson, 1972)

Woodeson, John, *Selected Letters of Mark Gertler* (Rupert Hart-Davis, 1965)

Woolf, Leonard, *Sowing: An Autobiography of the Years 1880–1904* (Harcourt Brace, 1960)

Woolf, Leonard, *Growing: An Autobiography of the Years 1904–1911* (Harcourt Brace, 1961)

Woolf, Leonard, *Beginning Again: An Autobiography of the Years 1911–1919* (Harcourt Brace, 1964)

Woolf, Leonard, *Downhill all the Way: An Autobiography of the Years 1919–1939* (Harcourt Brace, 1967)

Woolf, Virginia, Vanessa Bell and Thoby Stephen, *Hyde Park Gate News* (ed. Lowe, Gill) (Hesperus Press Ltd, 2005)

Woolf, Virginia, *The Voyage Out* (Duckworth, 1915)

Woolf, Virginia, *Night and Day* (Duckworth, 1919)

Woolf, Virginia, *Jacob's Room* (Hogarth Press, 1922)

Woolf, Virginia, *To The Lighthouse* (Hogarth Press, 1927)

Woolf, Virginia, *Orlando* (Hogarth Press, 1928)

Woolf, Virginia, *A Room of One's Own* (Hogarth Press, 1929)

Woolf, Virginia, *The Waves* (Hogarth Press, 1931)

Woolf, Virginia, *The Years* (Hogarth Press, 1937)

Woolf, Virginia, *Three Guineas* (Hogarth Press, 1938)

Woolf, Virginia, *Roger Fry: A Biography* (Hogarth Press, 1940)

Woolf, Virginia, *Between the Acts* (Hogarth Press, 1941)

Woolf, Virginia, *A Passionate Apprentice: The Early Journals* (ed. Mitchell A. Leaska) (Hogarth Press, 1990)

Woolf, Virginia, *Selected Letters* (ed. Joanne Trautmann Banks) (Vintage, 2008)

INDEX

Index

ACKNOWLEDGEMENTS

Thanks go to the team at Amberley; Jonathan, Christian and others for their continuing support and promotion. Thanks also to all my family, to my husband Tom for his love and support; also the Hunts, for Sue's generosity and John's local knowledge and continual supply of interesting and unusual books. Thanks again to Paul for his support. Most of all, this is for my mother for her invaluable proofreading skills and for my father for his enthusiasm. This is the result of the books they read me, the museums they took me to as a child and the love and imagination with which they encouraged me.